DAVID BUSCH'S

SONY® CC a68/ILCA-68

GUIDE TO DIGITAL PHOTOGRAPHY

David D. Busch

rockynook

David Busch's Sony® α a68/ILCA-68 Guide to Digital Photography David D. Busch

Project Manager: Jenny Davidson

Series Technical Editor: Michael D. Sullivan

Layout: Bill Hartman

Cover Design: Mike Tanamachi Indexer: Valerie Haynes Perry Proofreader: Mike Beady

ISBN: 978-1-68198-166-6

1st Edition (1st printing, December 2016)

© 2017 David D. Busch

All images @ David D. Busch unless otherwise noted

Rocky Nook, Inc. 1010 B Street, Suite 350 San Rafael, CA 94901 USA www.rockynook.com

Distributed in the U.S. by Ingram Publisher Services
Distributed in the UK and Europe by Publishers Group UK

Library of Congress Control Number: 2016936446

All rights reserved. No part of the material protected by this copyright notice may be reproduced or utilized in any form, electronic or mechanical, including photocopying, recording, or by any information storage and retrieval system, without written permission of the publisher.

Many of the designations in this book used by manufacturers and sellers to distinguish their products are claimed as trademarks of their respective companies. Where those designations appear in this book, and Rocky Nook was aware of a trademark claim, the designations have been printed in caps or initial caps. All product names and services identified throughout this book are used in editorial fashion only and for the benefit of such companies with no intention of infringement of the trademark. They are not intended to convey endorsement or other affiliation with this book.

While reasonable care has been exercised in the preparation of this book, the publisher and author assume no responsibility for errors or omissions, or for damages resulting from the use of the information contained herein or from the use of the discs or programs that may accompany it.

This book is printed on acid-free paper. Printed in Korea

of to the state of the state of

 $rac{1}{2} rac{1}{2} rac{1}{2$

Acknowledgments

Thanks to everyone at Rocky Nook, including Scott Cowlin, managing director and publisher, for the freedom to let me explore the amazing capabilities of the Sony a68 in depth. I couldn't do it without my veteran production team, including project manager, Jenny Davidson and series technical editor, Mike Sullivan. Also thanks to Bill Hartman, layout; Valerie Hayes Perry, indexing; Mike Beady, proofreading; Mike Tanamachi, cover design; and my agent, Carole Jelen, who has the amazing ability to keep both publishers and authors happy.

About the Author

With more than two million books in print, **David D. Busch** is the world's #1 bestselling camera guide author, and the originator of popular series like *David Busch's Pro Secrets, David Busch's Compact Field Guides*, and *David Busch's Quick Snap Guides*. He has written more than 100 hugely successful guidebooks for Sony and other digital SLR models, including the all-time #1 bestsellers for several different cameras, additional user guides for other camera models, as well as many popular books devoted to dSLRs, including *Mastering Digital SLR Photography, Fourth Edition* and *Digital SLR Pro Secrets*. As a roving photojournalist for more than 20 years, he illustrated his books, magazine articles, and newspaper reports with award-winning images. He's operated his own commercial studio, suffocated in formal dress while shooting weddings, and shot sports for a daily newspaper and an upstate New York college. His photos and articles have appeared in *Popular Photography, Rangefinder, Professional Photographer*, and hundreds of other publications. He's also reviewed dozens of digital cameras for CNet and other CBS publications.

When About.com named its top five books on Beginning Digital Photography, debuting at the #1 and #2 slots were Busch's *Digital Photography All-In-One Desk Reference for Dummies* and *Mastering Digital Photography*. He has had as many as 18 books listed in the Top 100 of Amazon.com's Digital Photography Bestseller list—simultaneously! Busch's 200-plus other books published since 1983 include bestsellers like *Digital SLR Cameras and Photography for Dummies*.

Busch is a member of the Cleveland Photographic Society (www.clevelandphoto.org), which has operated continuously since 1887. Visit his website at www.sonyguides.com.

ancomposition of

Contents

Preface	xvii
Introduction	xix
Chapter 1	
Getting Started with Your Sony a68	1
Your Out-of-Box Experience	3
Initial Setup	5
Battery Included	5
Final Steps	6
Formatting a Memory Card	
Selecting a Shooting Mode	
Choosing a Metering Mode	
Choosing a Focus Mode	
Selecting a Focus Point	
Other Settings	
Adjusting White Balance and ISO	
Using the Self-Timer	19
Using the Built-In Flash	
An Introduction to Movie Making	
Reviewing the Images You've Taken	
Transferring Photos to Your Computer	

Chapter 2	
Sony a68 Roadmap	25
Front View	
The Sony a68's Business End	
What You See, and What You Get	
LCD vs. EVF	
Choosing Your View	
Tilting the Screen	
Going Topside	
Underneath Your Sony a68	
Lens Components	49
Chapter 3	
Camera Settings Menu	51
Anatomy of the Menus	52
Camera Settings Menu	54
Image Size (Stills)	55
Aspect Ratio (Stills)	56
Quality (Stills)	57
Panorama: Size	60
Panorama: Direction	62
File Format (Movies)	65
Record Setting (Movies)	66
Drive Mode	66
Flash Mode	68
Flash Compensation	
Flash Control	69
Power Ratio	
Red Eye Reduction	70
Focus Mode	71
Focus Area	
AF Illuminator (Stills)	73
AF Drive Speed (Stills)	73
AF Track Sensitivity (Stills)	74
AF Track Sensitivity (Movies)	
Exposure Compensation	
Exposure Step	

ISO	76
Metering Mode	78
White Balance	78
DRO/Auto HDR	80
Creative Style	81
Picture Effect	81
Zoom	83
Focus Magnifier	86
Long Exposure NR/High ISO NR (Stills)	87
Center Lock-on AF	89
Smile/Face Detect	90
Soft Skin Effect (Stills)	91
Auto Object Framing (Stills)	91
Auto Mode	92
Scene Selection	93
Movie	
SteadyShot (Stills)	
SteadyShot (Movies)	
Color Space (Stills)	94
Auto Slow Shutter (Movies)	
Audio Recording	
Audio Recording Level	
Wind Noise Reduction	98
Memory	98
Chapter 4	
Custom Settings, Playback, and Setup Menus	101
Sastoni Settings, Flay Saekt, and Setup Wellas	101
ustom Settings Menu	
Zebra	
Focus Magnifier Time	
Grid Line	
Audio Level Display	
Auto Review	
DISP Button	
Peaking Level	
Peaking Color	
Exposure Settings Guide	
Live View Display	109

	AF Range Control Assist	10
	AF Area Auto Clear	12
	AF Area Points	12
	Flexible Spot Points	14
	Wide AF Area Display	14
	Zoom Setting	14
	Eye-Start AF	16
	FINDER/MONITOR	17
	Release w/o Lens	18
	Priority Setup	18
	AF w/ Shutter	19
	AEL w/ Shutter1	19
	SteadyShot w/ Shutter	20
	e-Front Curtain Shutter	21
	Superior Auto	22
	Exp. Comp. Set	23
	Bracket Order	24
	Face Registration	24
	AF Micro Adjustment	25
	Lens Compensation	
	Function Menu Settings	27
	Custom Key Settings	29
	Dial/Wheel Setup	32
	Dial/Wheel Ev Comp	32
	MOVIE Button	33
	Dial/Wheel Lock	33
Pla	yback Menu	34
	Delete	34
	View Mode	35
	Image Index	35
	Display Rotation	
	Slide Show	37
	Rotate	
	Enlarge Image	
	4K Still Image Playback	
	Protect	
	Specify Printing	

Setup Menu	
Monitor Brightness	140
Viewfinder Brightness	
Finder Color Temperature	
Volume Settings	
Audio Signals	
Upload Settings	
Tile Menu	
Mode Dial Guide	
Delete Confirm	
Power Save Start Time	
Cleaning Mode	
Demo Mode	
HDMI Settings	
USB Connection	
USB LUN Setting	
Language	
Date/Time Setup	
Area Setting	
Format	
File Number	
Select REC Folder	
New Folder	
Folder Name	
Recover Image Database	
Display Media Information	
Version	
Setting Reset	153
Chapter 5	
Chapter 5	155
Shooting Modes and Exposure Control	155
Getting a Handle on Exposure	156
Equivalent Exposure	
How the a68 Calculates Exposure	162
Correctly Exposed	162
Overexposed	
Underexposed	
Metering Mid-Tones	164

The Importance of ISO	166
Choosing a Metering Method	167
Choosing an Exposure Mode	170
Aperture Priority (A) Mode	
Shutter Priority (S) Mode	173
Program Auto (P) Mode	
Making Exposure Value Changes	174
Manual Exposure (M) Mode	176
Exposure Bracketing	
Using Dynamic Range Optimizer	182
Working with HDR	182
Auto HDR	
Bracketing and Merge to HDR	185
Exposure Evaluation with Histograms	189
Tonal Range	
Histogram Basics	190
Understanding Histograms	192
Automatic and Specialized Shooting Modes	198
Auto and Scene Modes	198
Sweep Panorama Mode	202
Dealing with Digital Noise	
High ISO Noise	203
Using Creative Styles	
Chapter 6	
Mastarias the Mastarias of Autofering	209
-	
Getting into Focus	
Phase Detection	
Contrast Detection	
Adding Circles of Confusion	
Components of Autofocus	
Focus Modes—Begin/Stop	
Area to Focus On	
Lock-On, Object Detection, and Tracking	
Manual Focus	
Focus Peaking	
Autofocus Summary	
Focus Stacking	236

Chapter 7	
Advanced Techniques for Your Sony a68	239
Exploring Ultra-Fast Exposures	240
Long Exposures	
Three Ways to Take Long Exposures	
Working with Long Exposures	
Continuous Shooting	
Tele-Zoom Continuous AE	
Setting Image Parameters	253
Customizing White Balance	
Setting White Balance by Color Temperature	
Setting a Custom White Balance	
Image Processing	
Using Creative Styles	
Picture Effects	
Shooting Movies	
Basic Settings	
File Format	
Record Setting	
Exposure Settings	
Movie	
Zebra	
Auto Slow Shutter	
Audio Settings	
Audio Recording	
Audio Recording Level	
Wind Noise Reduction.	
Other Settings	
AF Track Duration (Movies)	
SteadyShot	
Recording Video	
Steps During Movie Making	2.73

Tips for Shooting Better Video	274
Stop That!	275
Lens Craft	
Keep Things Stable and on the Level	
Shooting Script	278
Storyboards	
Storytelling in Video	
Composition	
Lighting for Video	
Audio	
Chapter 9	
Working with Lenses	287
But Don't Forget the Crop Factor	
Sony's Alpha-bet Soup	289
Lens Mounts and Motors	292
Your First Lens	294
Buy Now, Expand Later	295
Your Second (and Third) Lens	297
Your Wide Angle/Normal Options	298
Longer Lenses	299
What Lenses Can Do for You	
Zoom or Prime?	
Categories of Lenses	306
Using Wide-Angle and Wide-Zoom Lenses	306
Avoiding Potential Wide-Angle Problems	307
Using Telephoto and Tele-Zoom Lenses	310
Avoiding Telephoto Lens Problems	312
Telephotos and Bokeh	313
Add-ons and Special Features	
Lens Hoods	
Telephoto Extenders	315
Macro Focusing	
SteadyShot and Your Lenses	
Fine-Tuning the Focus of Your Lenses	
Lens Tune-Up	

Chapter 10
Making Light Work for You 323
The Elements of Light
Continuous Lighting—or Electronic Flash?
Continuous Lighting Basics
Daylight
Incandescent/Tungsten Light
Fluorescent Light/Other Light Sources
Adjusting White Balance
Electronic Flash Basics
How Electronic Flash Works
Using the Built-In Flash
Setting Flash Modes
Flash Exposure Compensation
Flash Control
Red Eye Reduction
Using the External Electronic Flash
Guide Numbers, Hot Shoes, and More345
HVL-F60M Flash Unit347
HVL-F58AM Flash Unit
HVL-F43M Flash Unit349
HVL-F36AM Flash Unit
HVL-F32M Flash Unit350
HVL-F20M Flash Unit351
Wireless and Multiple Flash
Channels
Groups (RMT and RMT2)354
Radio Control
More Advanced Lighting Techniques
Diffusing and Softening the Light
Using Multiple Light Sources
Other Lighting Accessories
Index 361

Preface

A camera with 24 megapixels of resolution, continuous shooting at 8 frames per second, and a full range of features priced at less than \$600 for the body alone? No wonder you're excited about the new Sony a68 camera! You don't expect to take good pictures with such a camera—you demand *outstanding* photos. After all, this model is one of the most innovative cameras that Sony has ever introduced. But your gateway to pixel proficiency is dragged down by the scant instructions provided by Sony. You know everything you need to learn is in there, somewhere, but you don't know where to start. In addition, the camera manual doesn't offer much information on photography or digital photography. Nor are you interested in spending hours or days studying a comprehensive book on digital SLR photography that doesn't necessarily apply directly to your a68.

What you need is a guide that explains the purpose and function of this camera's basic controls, how you should use them, and *why*. Ideally, there should be information about file formats, resolution, exposure, and special autofocus modes available, but you'd prefer to read about those topics only after you've had the chance to go out and take a few hundred great pictures with your new camera. Why isn't there a book that summarizes the most important information in its first two or three chapters, with lots of full-color illustrations showing what your results will look like when you use this setting or that?

Now there is such a book. If you want a quick introduction to focus controls, flash synchronization options, how to choose lenses, or which exposure modes are best, this book is for you. If you can't decide on what basic settings to use with your camera because you can't figure out how changing ISO or white balance or focus defaults will affect your pictures, you need this guide.

Introduction

The Sony Alpha a68 is the latest entry in the company's dSLR-like camera line that uses an APS-C-size sensor and has a fixed semi-transparent (what Sony calls *semi translucent*) mirror. Following on the heels of the upscale Sony Alpha a77 II, the a68 is more affordable and still has a full complement of the features most-wanted by serious photographers, seasoned with Sony's innovative technology.

If you're new to Sony's A-mount cameras, you may not know that the a68, strictly speaking, isn't a traditional digital single-lens reflex at all, despite its outward appearance. Conventional dSLRs rely on a pivoting mirror that flips up during exposure to allow light to continue unimpeded to the sensor when the shutter opens. Sony's A-mount lineup, which in the past was badged using the (now-abandoned) *SLT* nomenclature (for *single lens translucent*), replaces that moving part with an innovative semi-transparent mirror that remains fixed while you take pictures. That mirror allows 70 percent of the light passed by the lens to continue to the sensor, while reflecting the rest to the AF system, making it possible to use live view and advanced phase detection autofocus *all the time*.

However, for most intents and purposes, a camera like the a68 is simply a single-lens reflex model in which the reflex mirror is stationary (except when it's flipped up for sensor cleaning), and which uses an electronic viewfinder and/or back-panel LCD monitor for viewing instead of an optical system. In use, the a68 operates much like a digital SLR. The two share many of the same kind of controls. Lenses can be changed, and, in the case of the a68 and its A-mount stablemates, you can choose from a vast treasure trove of lenses produced by Sony and other vendors, including Minolta, which developed much of the early technology incorporated into the a68. Most of us opt for eyelevel viewing for shooting, and don't care that the a68 uses an *electronic viewfinder* rather than the optical viewfinder found in dSLR cameras. Many of the capabilities of the a68 are the same as those found in conventional dSLRs. The chief difference is that the Sony a68 and its companion models have *additional* capabilities not found in the traditional digital SLR.

As I noted earlier, the a68 provides a live view image of what the sensor sees *all the time*, not just during a special "live view" mode. Your camera is able to use fast, accurate phase detection autofocus (which I'll describe in detail in Chapter 6) in any mode, even during video capture. Because it lacks a mirror that must be flipped up and down for each exposure, the a68 is capable of much faster shooting rates—as fast as 8 frames per second.

Who Am I?

After spending years as the world's most successful unknown author, I've become slightly less obscure in the past few years, thanks to a horde of camera guidebooks and other photographically oriented tomes. You may have seen my photography articles in *Popular Photography, Rangefinder, Professional Photographer*, and dozens of other photographic publications. But, first, and foremost, I'm a photojournalist and made my living in the field until I began devoting most of my time to writing books. Although I love writing, I'm happiest when I'm out taking pictures, which is why I spent this last winter ensconced in the Florida Keys, dividing my time between writing this book and taking photographs. You'll find images of many of these visual treats within the pages of this book.

Like all my digital photography books, this one was written by someone with an incurable photography bug. One of my first SLRs was a Minolta SRT-101, from the company whose technology was eventually absorbed by Sony in 2006. I've used a variety of newer models since then. I've worked as a sports photographer for an Ohio newspaper and for an upstate New York college. I've operated my own commercial studio and photo lab, cranking out product shots on demand and then printing a few hundred glossy 8 × 10s on a tight deadline for a press kit. I've served as a photo-posing instructor for a modeling agency. People have actually paid me to shoot their weddings and immortalize them with portraits. I even prepared press kits and articles on photography as a PR consultant for formerly dominant (and now vestigial) Rochester, NY, company, which shall remain nameless. My trials and travails with imaging and computer technology have made their way into print in book form an alarming number of times, including hundreds of volumes on photographic topics.

Like you, I love photography for its own merits, and I view technology as just another tool to help me get the images I see in my mind's eye. But, also like you, I had to master this technology before I could apply it to my work. This book is the result of what I've learned, and I hope it will help you master your a68.

I'd like to ask a special favor: let me know what you think of this book. If you have any recommendations about how I can make it better, visit my website at www.sonyguides.com, click on the E-Mail Me tab, and send your comments, suggestions on topics that should be explained in more detail, or, especially, any typos. (The latter will be compiled on the Errata page you'll also find on my website.) I really value your ideas, and appreciate it when you take the time to tell me what you think! Some of the content of the book you hold in your hands came from suggestions I received from readers like you. If you found this book especially useful, tell others about it. Visit http://www.amazon.com/dp/1681981661 and leave a positive review. Your feedback is what spurs me to make each one of these books better than the last. Thanks!

Getting Started with Your Sony a68

This chapter is a Quick Start you can use to learn all the basic steps you need to know to begin taking pictures. The Sony a68 is a remarkably versatile camera, so each of the features introduced here has many other options that I'll explain in subsequent chapters of the book. In the sections that follow, I'll show you how to make the most basic settings, such as setting exposure, but won't weigh you down by listing all the different ways you can do these things, nor every single variation.

Of course, I fully expect that you took several hundred or a thousand (or two) photos before you ever cracked the cover of this book. First, and foremost, the Sony a68 camera is not only versatile, it's incredibly easy to use, especially for the absolute beginner. Even the rawest digital camera newbie can rotate the mode dial to the green Auto position and go out and begin taking great pictures. Getting to that point by charging the battery, mounting a lens, and inserting a memory card isn't exactly rocket science, either. Sony has cleverly marked the power switch (located concentrically with the shutter release button) with large ON and OFF labels, and the button with the bright red dot labeled MOVIE to the right of the viewfinder window will provide a major clue for anyone interested in taking advantage of this camera's advanced motion-picture capabilities.

So, budding photographers are likely to muddle their way through getting the camera revved up and working well enough to take a bunch of still pictures or video sequences without the universe collapsing. Eventually, though, many may turn to this book when they realize that they can do an even better job with a little guidance.

Second, I know that many of you will be previous owners of the predecessors of this camera, including the SLT series that included this camera's immediate predecessor, the Sony SLT-A65. The SLT nomenclature is gone completely, and the Alpha label deprecated to a lowercase *a*. So you may be a newcomer or an old friend of the company's cameras.

Most of the basic operations of the Sony a68 are quite similar to those of any previous model you might have owned. As I noted in the Introduction to this book, the semi-transparent (*not* translucent) mirror does not swing up and down like the mirror in an old-school SLR. Rather, it stays put and it allows 70 percent of the light that strikes it to pass through to the 24.2 MP CMOS sensor while the remaining light is reflected upward to a large 79-point phase detection AF area. This AF area always receives light, and as a result this camera can focus with lightning speed for both still photography *and* movies, even during exposure. The penalty for this magic is about a 30 percent reduction in light for live view and image capture but without a swinging mirror and related optical system, the sensor is always receiving light. You won't notice the 30 percent light loss, however, because the a68 simply amplifies the signal to give you a bright electronic viewfinder/LCD image for composing your photo.

Finally, I realize that most of you didn't buy this book at the same time you purchased your Sony a68. As much as I'd like to picture thousands of avid photographers marching out of their camera stores with an a68 box under one arm, and my book in hand, I know that's not going to happen *all* the time. A large number of you had your camera for a week, or two, or a month, became comfortable with it, and sought out this book in order to learn more. So, a chapter on "setup" seems like too little, too late, doesn't it?

In practice, though, it's not a bad idea, once you've taken a few orientation pictures with your camera, to go back and review the basic operations of the camera from the beginning, if only to see if you've missed something. This chapter is my opportunity to review the setup procedures for the camera for those among you who are already veteran users, and to help ease the more timid (and those who have never worked with a digital camera with interchangeable lenses before) into the basic pre-flight checklist that needs to be completed before you really spread your wings and take off. For the uninitiated, as easy as it is to use initially, the Sony a68 *does* have lots of dials, buttons, and settings that might not make sense at first, but will surely become second nature after you've had a chance to review the instructions in this chapter.

But don't fret about wading through a manual to find out what you must know to take those first few tentative snaps. I'm going to help you hit the ground running with this chapter (or keep on running if you've already jumped right in). If you *haven't* had the opportunity to use your a68 yet, I'll help you set up your camera and begin shooting in minutes. You won't find a lot of detail in this chapter. Indeed, I'm going to tell you just what you absolutely *must* understand, accompanied by some interesting tidbits that will help you become acclimated. I'll go into more depth and even repeat some of what I explain here in later chapters, so you don't have to memorize everything you see. Just relax, follow a few easy steps, and then go out and begin taking your best shots—ever.

Your Out-of-Box Experience

Your Sony a68 comes in an impressive box filled with stuff, including connecting cords and lots of paperwork. The most important components are the camera and lens, battery, battery charger, and, if you're the nervous type, the neck strap. You'll also need a Secure Digital or Memory Stick card, as one is not included.

The first thing to do is to carefully unpack the camera and double-check the contents with the checklist on one side of the box. (The list is also shown on Page 10 of the 56-page mini-manual included with the camera, and on page 15 of the Sony 205-page PDF reference manual.) While this level of setup detail may seem as superfluous as the instructions on a bottle of shampoo, checking the contents *first* is always a good idea. No matter who sells a camera, it's common to open boxes, use a particular camera for a demonstration, and then repack the box without replacing all the pieces and parts afterward. Someone might actually have helpfully checked out your camera on your behalf—and then mispacked the box. It's better to know *now* that something is missing so you can seek redress immediately, rather than discover two months from now that the USB cable you thought you'd never use (but now *must* have) was never in the box.

So, check the box at your earliest convenience, and make sure you have (at least) the following:

- Sony a68 camera. This is hard to miss. The camera is the main reason you laid out the big bucks, and it is tucked away inside a nifty bubble-wrap envelope you should save for protection in case the Alpha needs to be sent in for repair. It almost goes without saying that you should check out the camera immediately, making sure the color LCD monitor on the back isn't scratched or cracked, the memory card and battery compartment door opens properly, and, when a charged battery is inserted and lens mounted, the camera powers up and reports for duty. Out-of-the-box defects in these areas are rare, but they can happen. It's probably more common that your dealer played with the camera or, perhaps, it was a customer return. That's why it's best to buy your Alpha from a retailer you trust to supply a factory-fresh camera.
- Eyepiece cup. This slide-on soft-rubber eyecup should be attached to the viewfinder when you receive the camera. It helps you squeeze your eye tightly against the window, excluding extraneous light, and also protects your eyeglasses (if you wear them) from scratching.
- Body cap. The plastic twist-off body cap keeps dust from entering the camera when no lens is mounted. Even with automatic sensor cleaning built into the a68, you'll want to keep the amount of dust to a minimum. The body cap belongs in your camera bag if you contemplate the need to travel with the lens removed.
- Lens (if purchased). The Sony a68 may come as a body only, or in a kit with the SAL 18135 18-135mm f/3.5-5.6 zoom lens. Or, you may purchase the camera with another lens, as some retailers offer it with an SAL-1650 DT 16-50mm F2.8 SSM zoom or some other lens combo. The lens will come with a lens cap on the front, and a rear lens cap aft.
- Battery pack NP-FM500H. The power source for your Sony a68 is packaged separately. The battery should be charged as soon as possible (as described next) and inserted in the camera. It's

4

smart to have more than one battery pack (a spare costs about \$60, although the Sony list price is about \$70), so you can continue shooting when your battery is discharged or, after many uses, peters out entirely. Make sure you get this model number of battery. It's the same one used by the Sony a77 II, SLT-77, SLT-A65, A58, A55, DSLR-A560/A580, and a few other models.

- Battery charger BC-VM10A. This battery charger will be included. Outside of the United States and Canada, the camera ships with a power cord that attaches to the charger (which allows Sony to package each charger with a cord that fits the specific power outlets of the country where it's sold). In the United States, the charger is plugged in using its integrated US-style AC plug.
- Shoulder strap. Sony provides you with a suitable neck or shoulder strap, emblazoned with Sony advertising. While I am justifiably proud of owning a fine Sony camera, I never attach the factory straps to my cameras, and instead opt for a more serviceable strap from UPstrap (www.upstrap-pro.com). If you carry your camera over one shoulder, as many do, I particularly recommend UPstrap (shown in Figure 1.1). It has a patented non-slip pad that offers reassuring traction and eliminates the contortions we sometimes go through to keep the camera from slipping off. I know several photographers who refuse to use anything else. If you do purchase an UPstrap, be sure to tell photographer-inventor Al Stegmeyer that I sent you hence.
- Micro-B USB cable. This is a USB cable that can be used to link your Sony a68 to a computer, and it is especially useful when you need to transfer pictures but don't have a card reader handy.
- Paperwork. My Sony a68 was destined for the US/Canada market, and so included the brief printed instruction manual I mentioned earlier, in English and French (numbering 56 and cinquante-six pages, respectively). In my box there was also a bilingual Limited Warranty, and an entreaty to register my camera with Sony. If you bought the camera in a kit with a lens, you should also find a folded instruction sheet for the lens.

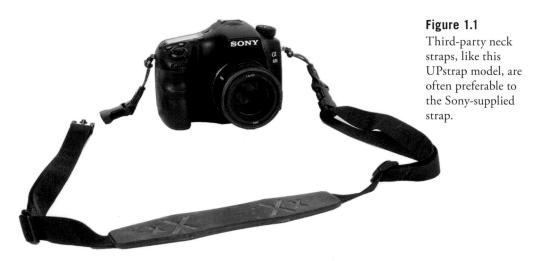

Initial Setup

The initial setup of your Sony a68 is fast and easy. Basically, you just need to charge the battery, attach a lens, and insert a memory card. I'll address each of these steps separately, but if you already feel you can manage these setup tasks without further instructions, feel free to skip this section entirely. You should at least skim its contents, however, because I'm going to list a few options that you might not be aware of.

Battery Included

Your Sony a68 is a sophisticated hunk of machinery and electronics, but it needs a charged battery to function, so rejuvenating the NP-FM500H lithium-ion battery pack furnished with the camera should be your first step. A fully charged power source should be good for approximately 510 shots under normal temperature conditions, based on standard tests defined by the Camera & Imaging Products Association (CIPA) document DC-002. If most of your pictures use the built-in flash, you can expect somewhat fewer shots before it's time for a recharge. While those figures sound like a lot of shooting, activities like picture review can use up more power than you might expect. If your pictures are important to you, always take along one spare, fully charged battery.

And remember that all rechargeable batteries undergo some degree of self-discharge just sitting idle in the camera or in the original packaging. Lithium-ion power packs of this type typically lose a small amount of their charge every day, even when the camera isn't turned on. Li-ion cells lose their power through a chemical reaction that continues when the camera is switched off. So, it's very likely that the battery purchased with your camera, even if charged at the factory, has begun to poop out after the long sea voyage on a banana boat (or, more likely, a trip by jet plane followed by a sojourn in a warehouse), so you'll want to revive it before going out for some serious shooting.

Charging the Battery

When the battery is inserted into the charger properly (it's impossible to insert it incorrectly), a Charge light begins glowing yellow-orange, without flashing. It continues to glow until the battery completes the charge and the lamp turns off. (See Figure 1.2.) It should take about 175 minutes to completely rejuvenate a fully discharged battery.

If the charging lamp flashes when you insert the battery, that flashing indicates an error condition. Make sure you have the correct model number battery and that the charger's contacts (the shiny metal prongs that connect to the battery) are clean.

When the battery is charged, slide the latch on the bottom of the camera, open the battery door, and ease the battery in with the three contact openings facing down into the compartment so they will meet up with the contacts at the bottom of the compartment (see Figure 1.3). To remove the battery, you must press a blue lever in the battery compartment that prevents the pack from slipping out when the door is opened.

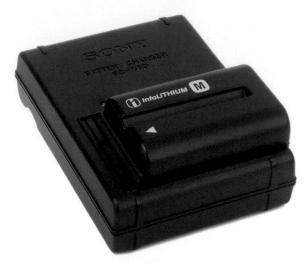

Figure 1.2 The BC-VM10A charger takes about three hours to provide a normal charge to a fully depleted battery pack.

Figure 1.3 Insert the battery in the camera; it only fits one way.

Final Steps

Your Sony a68 is almost ready to fire up and shoot. You'll need to select and mount a lens, adjust the viewfinder for your vision, and insert a memory card. Each of these steps is easy, and if you've used any Sony camera in the past, you already know exactly what to do. I'm going to provide a little extra detail for those of you who are new to the Sony or digital worlds.

Mounting the Lens

As you'll see, my recommended lens-mounting procedure emphasizes protecting your equipment from accidental damage, and minimizing the intrusion of dust. If your camera has no lens attached, select the lens you want to use and loosen (but do not remove) the rear lens cap. I generally place the lens I am planning to mount vertically in a slot in my camera bag, where it's protected from mishaps but ready to pick up quickly. By loosening the rear lens cap, you'll be able to lift it off the back of the lens at the last instant, so the rear element of the lens is covered until then.

After that, remove the body cap by rotating the cap toward the shutter release button. You should always mount the body cap when there is no lens on the camera, because it helps keep dust out of the interior of the camera, where it can settle on the mirror, and potentially find its way past the shutter onto the sensor. (While the Alpha's automatic sensor cleaning mechanism works fine, the less dust it has to contend with, the better.) The body cap also protects the vulnerable mirror from damage caused by intruding objects (including your fingers, if you're not cautious).

Once the body cap has been removed, remove the rear lens cap from the lens, set it aside, and then mount the lens on the camera by matching the red-orange alignment indicator on the lens barrel with the red-orange dot on the camera's lens mount (see Figure 1.4). Rotate the lens clockwise,

Figure 1.4
Match the redorange dot on the lens with the redorange dot on the camera mount to properly align the lens with the bayonet mount.

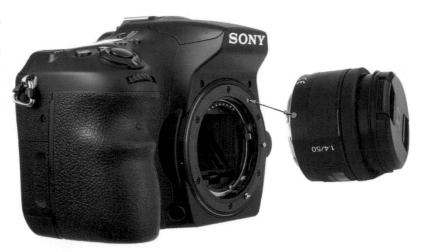

toward the side of the camera with the mode dial, until the lens seats securely. (Don't press the lens release button during mounting.) If a lens hood is bayoneted on the lens in the reversed position (which makes the lens/hood combination more compact for transport), twist it off and remount with the rim facing outward (see Figure 1.5). A lens hood protects the front of the lens from accidental bumps, and reduces flare caused by extraneous light arriving at the front element of the lens from outside the picture area.

Adjusting Diopter Correction

Those of us with less than perfect eyesight can often benefit from a little optical correction in the viewfinder. Your contact lenses or glasses may provide all the correction you need, but if you are a glasses wearer and want to use the Sony a68 without your glasses, you can take advantage of the camera's built-in diopter adjustment correction to match that of your glasses or your eyesight with your glasses on. Turn on the camera, look into the electronic viewfinder, focus your eye on the numbers and other indicators on the viewfinder's screen, then rotate the diopter adjustment dial (see Figure 1.6) while looking into the viewfinder until the numbers and indicators appear sharp.

Figure 1.5
A lens hood protects the lens from extraneous light and accidental bumps.

Figure 1.6
Viewfinder diopter
correction can be
dialed in.

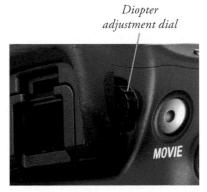

Inserting a Memory Card

You can't take actual photos without a memory card inserted in your Sony a68. If you don't have a card installed, the camera will upbraid you with a flashing No Card warning shown at the upper left of the LCD and viewfinder. If you press the shutter button, though, the shutter will operate and it will sound as if a picture has been taken. If you didn't notice the No Card warning, you will be faced with a sad situation when you try to play back the image you thought you had recorded. So, your final step will be to insert a memory card.

The Alpha accepts both Secure Digital (or Secure Digital High Capacity) and Sony Memory Stick PRO Duo (or Memory Stick PRO-HG Duo) cards. It doesn't matter which type you use, but you can only use one or the other; there is only one memory card slot in the camera. If you decide on the Sony Memory Stick option (probably because you have some left over from an earlier camera), you probably want to use a PRO-HG Duo HX card, which are still available in capacities of up to 32GB. If you go the Secure Digital (SD) route, there are several options. The most common SD card comes in sizes up to 32GB. If you really want to flex your storage muscles, you can spring for one of the newest types of SD card, called the SDXC, for extended capacity. SDXC cards are currently available in capacities of 64GB, 128GB, and 256GB, which is more than enough for any application, except maybe doing photo IDs for the entire population of a small city. Theoretically, these cards can be produced in capacities up to 2TB (terabytes), the equivalent of about 2,000GB. Nowadays, all new computers should be compatible with SDHC cards. You might need to get a new card reader if you are using a very old reader, because the older SD card readers cannot read SDXC cards.

Whether you ultimately opt for a Memory Stick PRO Duo or a variety of SD card, either type of card fits in the same slot underneath the door on the right side of the camera. You should only remove the memory card when the camera is switched off. Insert the memory card with the label facing the back of the camera (for a Secure Digital card), or toward the front of the camera if inserting a Memory Stick. In either case, the card should be oriented so the edge with the metal contacts goes into the slot first. (See Figure 1.7.)

Close the door, and your pre-flight checklist is done! (I'm going to assume you remember to remove the lens cap when you're ready to take a picture!) When you want to remove the memory card later, just press down on the card edge that protrudes from the slot, and it will pop right out.

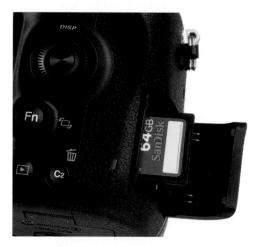

Figure 1.7 The memory card is inserted in the slot on the side of the camera.

Turning on the Power

Slide the ON/OFF switch that surrounds the shutter release button clockwise, to the ON position. The camera will remain on or in a standby mode until you manually turn it off. After one minute of idling, the a68 goes into the standby mode to save battery power. Just tap the shutter release button to bring it back to life. (The one-minute time is the default; you can adjust this setting to as long as 30 minutes through the menu system, as I discuss in Chapter 4.)

When the camera first powers up, you may be asked to set the date and time, using the Setup menu, which has an icon resembling a tool box at the far right of the menu tabs. The procedure is fairly self-explanatory (although I'll explain it in detail in Chapter 4). You can use the left/right directional buttons to navigate among the Daylight Savings Time setting, date, year, time, and date format; and you can use the up/down directional buttons to enter the correct settings. When finished, press the center button, choose Enter on the screen that pops up, and press the center button again to confirm the date.

TAKING CONTROL

Sony's nomenclature for the a68's controls can be confusing, as you have both a *control dial*, on the front of the camera, and a *control wheel* on the back surface, immediately above the Fn button.

The rotating *control wheel* includes a button in the center. You can rotate the dial clockwise and counterclockwise to make settings adjustments (such as shutter speed or aperture) or within menus to move up or down among selections. The center button serves as an Enter button to confirm your choices.

The edges of the control wheel can also be used as directional controls by pressing in the desired direction. I'll just say "Press up/down" or "Press left/right" when you need to use the directional controls, rather than state "Press the edges of the control wheel up or down" each time.

Once the Sony a68 is satisfied that it knows what time it is, the recording information display should appear on the LCD, overlaid over the live view of the scene in front of the camera. Press the DISP button (the upper edge of the control *wheel*) to produce this screen if you want to activate this display when it has gone dark. There are five versions: a graphic display (Figure 1.8), a standard Show All Info display (Figure 1.9), a No Display Info display with just basic information, and an identical screen with a live histogram included (Figure 1.10). The fifth display is called For Viewfinder (even though it is shown on the LCD monitor) that has no live view preview image at all. It displays a wealth of shooting status information, as you can see in Figure 1.11.

When the For Viewfinder display is visible on the LCD monitor, you can press the Fn button to switch to what Sony calls a Quick Navi screen (see Figure 1.12), where you can highlight many settings, press the center button, and select from options for that setting. I'll explain how to use Quick Navi later on.

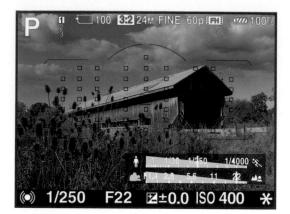

Figure 1.8 Graphic Display.

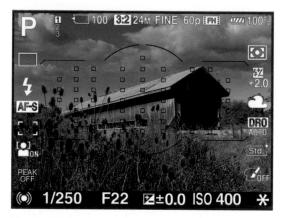

Figure 1.9 Standard Show All Display.

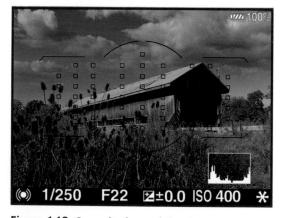

Figure 1.10 Same display with live histogram.

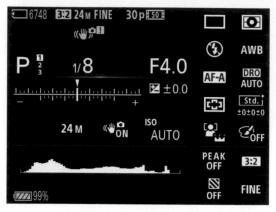

Figure 1.11 The For Viewfinder display provides settings data, but no image preview.

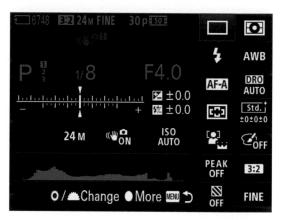

Figure 1.12 When you press the Fn button while the For Viewfinder display is active, the Quick Navi settings screen appears, with the current function highlighted in orange.

When you're looking through the electronic viewfinder instead of at the LCD, the camera presents you with five displays that are similar to the LCD monitor displays (except that the For Viewfinder version is not available). There are some differences, including an exposure scale shown along the bottom of the screen.

You can switch among the viewfinder and LCD displays independently of each other, so you may see different versions in the viewfinder than on the LCD at any given time. In addition, you can disable any (but not all) of these screens using the DISP entry in the Custom Settings 2 menu, as I'll explain in Chapter 4. So, if you find a particular information screen not useful, you can turn it off. You can't disable all the screen versions; at least one must be enabled at all times.

The recording information displays show the basic settings of the camera, including current shutter speed and lens opening, shooting mode, ISO sensitivity, and other parameters. I'll explain these features in more detail in later chapters of this book (especially in Chapter 5, which deals with exposure).

Formatting a Memory Card

There are three ways to create a blank Secure Digital or Memory Stick PRO Duo card for your Sony a68, and two of them are at least partially wrong. Here are your options, both correct and incorrect:

- Transfer (move) files to your computer. When you transfer (rather than copy) all the image files to your computer from the memory card (either using a direct cable transfer or with a card reader and appropriate software, as described later in this chapter), the old image files can, at your option, be erased from the card, leaving the card blank. Theoretically. Unfortunately, this method does *not* remove files that you've labeled as Protected (by choosing Protect from the Playback menu during playback), nor does it identify and lock out parts of your card that have become corrupted or unusable since the last time you formatted the card. Therefore, I recommend always formatting the card, rather than simply moving the image files, each time you want to make a blank card. The only exception is when you *want* to leave the protected/ unerased images on the card for a while longer, say, to share with friends, family, and colleagues.
- (Don't) Format in your computer. With the memory card inserted in a card reader or card slot in your computer, you can use Windows or Mac OS to reformat the memory card. Don't! The operating system won't necessarily arrange the structure of the card the way the Alpha likes to see it (in computer terms, an incorrect *file system* may be installed). The only way to ensure that the card has been properly formatted for your camera is to perform the format in the camera itself. The only exception to this rule is when you have a seriously corrupted memory card that your camera refuses to format. Sometimes it is possible to revive such a corrupted card by allowing the operating system to reformat it first, then trying again in the camera.

■ Setup menu format. To use the recommended method to format a memory card, press the MENU button, and press left/right (remember, using the directional buttons) or rotate the rear control wheel to choose the Setup 4 menu (Setup is represented by a toolbox icon). Highlight the Format entry, which is the third line of this menu. Press the center button, and select Enter from the screen that appears. Press the center button once more to begin the format process.

Table 1.1 shows the typical number of shots you can expect using a 16GB SD memory card. Take those numbers and double them if you're using a 32GB card; cut them in half if you're using an 8GB SD card.

Table 1.1 Typical Shots with a 16GB Memory Card				
		Large	Medium	Small
3:2 Aspect Ratio	JPEG Standard	2,868	4,277	5,669
	JPEG Fine	1,735	3,105	4,473
	RAW	627	N/A	N/A
	RAW+JPEG	460	N/A	N/A
16:9 Aspect Ratio	JPEG Standard	3,186	4,599	5,946
	JPEG Fine	1,974	3,409	4,827
	RAW	623	N/A	N/A
	RAW+JPEG	473	N/A	N/A

HOW MANY SHOTS?

The Sony a68 provides a fairly accurate estimate of the number of shots remaining on the LCD. It is only an estimate, because the actual number will vary, depending on the capacity of your memory card, the file format(s) you've selected (more on those later), the aspect ratio (proportions) of the image (the Alpha can use both traditional 3:2 proportions and 16:9—HDTV—aspect ratios), and the content of the image itself. (Some photos may contain large areas that can be more efficiently squeezed down to a smaller size.)

Selecting a Shooting Mode

You can choose a shooting method from the mode dial located on the top left of the Sony a68 (see Figure 1.13). There are five special shooting modes, in some of which the camera makes many or most of the decisions for you (apart from when to press the shutter), and four semi-automatic and manual modes, which allow you to provide the maximum input over the exposure and settings the camera uses. The mode dial also includes three numbered Memory Recall registers that keeps sets of favorite settings that you can activate instantly by rotating the dial to the 1, 2, or 3 positions.

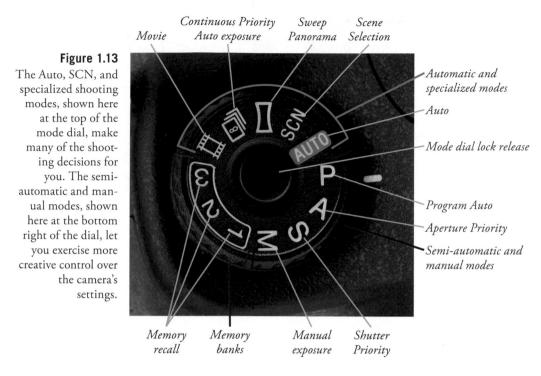

You'll find a complete description of the special, automatic, and semi-automatic and manual modes in Chapter 5.

Turn your camera on by flipping the power switch to ON. Next, you need to select which shooting mode to use. If you're very new to digital photography, you might want to set the camera to automatic mode (Auto), which actually has *two* different automated modes. I'll show you how to enable either *Intelligent Auto* or *Superior Auto* (in Chapter 3) or the P (Program mode) setting and start snapping away. Any of these modes will make all the appropriate settings for you for many shooting situations. If you have a specific type of picture you want to shoot, you can turn the mode dial to one of several specialized settings that suit various types of photographic situations.

For specific types of subject matter, you may want to turn the mode dial to the SCN setting position. Once you've done that, there are three ways to select a specific Scene mode:

- Camera Settings menu. Press the MENU button and navigate to the Camera Settings 8 menu, highlight the Scene Selection entry, and press the center button. You can then rotate the control wheel to choose a specific Scene mode. (See Figure 1.14.) I'll show you how to use the a68's menus in Chapters 3 and 4.
- Mode Dial Guide. If Mode Dial Guide has been activated using the entry in the Setup 2 menu (as I'll describe in Chapter 4), once you've rotated the mode dial to the SCN position, you can press the center button, and then rotate the control wheel to choose a specific Scene mode.

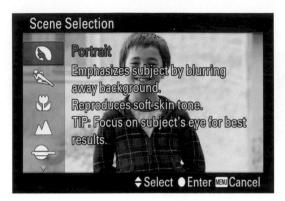

Figure 1.14 The Scene mode types appear on the screen when you turn the mode dial to the SCN setting and press the center button. You can choose one of these settings to fit the particular type of subject you are trying to photograph. Shown here, top to bottom, are Portrait, Sports Action, Macro, Landscape, and Sunset; not shown are Night View, Hand-held Twilight, and Night Portrait.

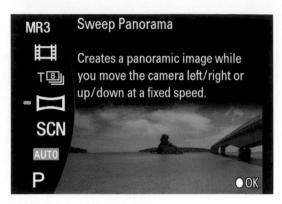

Figure 1.15 This Help Guide screen appears when you first select a shooting mode.

When you first switch to a shooting mode, if Mode Dial Guide is enabled, a help screen like the one shown in Figure 1.15 appears on the LCD display to provide a "briefing" about that mode. The help screen disappears when you touch the shutter release and is replaced by one of the standard viewing screens shown earlier, or by whatever screen was produced by pressing the directional buttons.

These are your options:

■ Auto. Two automatic modes actually reside at this mode dial position: Intelligent Auto (iAuto) and Superior Auto (iAuto+). I'll show you in Chapter 3 how to specify which of the two modes is used when you rotate the dial to Auto. In either case, the a68 makes all the exposure decisions for you, and will pop up the flash if necessary under low-light conditions. In addition, when Superior Auto is activated, the camera will use its programming to select certain additional functions as appropriate for the shooting conditions. For example, in certain situations the camera will take multiple shots and then combine them internally in order to achieve an improved final image. The a68 also invokes Scene Recognition, in which the camera attempts to recognize certain scene types, which span "normal" scene modes (described next), such as Portrait, Night Portrait, Night Scene, Landscape, Hand-held Twilight, and Macro; as well as some "secret" (not directly accessible) scene modes, including Infant, Backlight Portrait, Backlight, Spotlight, Low Light, and Night Scene Tripod.

- **SCN.** There are three ways to choose among the eight Scene options:
 - Rotate the mode dial to SCN, and then press the MENU button and navigate to the Scene Selection entry in the Camera Settings 8 menu. You can choose a Scene mode from the list.
 - Any time the mode dial is set to SCN, you can press the Fn button on the back of the camera
 to activate the Function menu, then highlight the scene selection icon at far right in the bottom row, press the center button, and scroll through the choices to select a different scene
 type.
 - You can also access Scene modes if you've previously visited the Setup 2 menu and set the Mode Dial Guide entry to On. Then, when you initially switch the mode dial to SCN and press the center button, the left side of the LCD (or viewfinder) presents you with a menu of scene types to select from. Scroll through this list using the front control dial or press up/down to choose.
 - **Portrait.** Use this mode when you're taking a portrait of a subject positioned relatively close to the camera and want to de-emphasize the background, maximize sharpness of the subject, and produce flattering skin tones.
 - **Sports Action.** Use this mode to freeze fast-moving subjects. The camera uses a fast shutter speed and shoots continuously while you hold down the shutter button, to capture the action as it unfolds.
 - Macro. This mode is helpful when you are shooting close-up pictures of a subject from about one foot away or less.
 - Landscape. Select this mode when you want extra sharpness and rich colors of distant scenes.
 - Sunset. This is a great mode to accentuate the reddish hues of a sunrise or sunset.
 - **Night Scene.** This mode is suited for night-time scenes at a distance, such as city skylines. The camera will use a slow shutter speed and will not fire the flash, so it is a good idea to use a tripod to avoid blur from camera movement during the exposure.
 - Hand-held Twilight. Use this mode for night scenes when it's not practical to use a tripod. The camera sets itself to use a higher ISO (light sensitivity) setting so that it can use a faster shutter speed. It takes a continuous burst of several images, then processes them together internally into a single image that removes the visual "noise" that can result from high ISO settings.
 - Night Portrait. Choose this mode when you want to illuminate a subject in the foreground with flash, but still allow the background to be exposed properly by the available light. Be prepared to use a tripod or to rely on the SteadyShot feature to reduce the effects of camera shake. (You'll find more about image stabilization and camera shake in Chapter 9.) If there is no foreground subject that needs to be illuminated, you may do better by using the Night View mode.

- Sweep Panorama. When you turn the dial to this next setting, marked by the icon of a stretched rectangle, the camera presents a brief menu at the left side of the screen or viewfinder. This special mode lets you "sweep" the camera across a scene that is too wide for a single image. The camera takes multiple pictures and combines them in the camera into a single, wide panoramic final product.
- Continuous Advance Priority AE. This shooting mode, the last of the automatic or specialized modes, is marked on the mode dial by a stack of rectangles containing the number 8, indicating the maximum number of continuous shots per second that the camera will take in this mode. The camera initially sets itself to optimize continuous shooting by choosing a high ISO setting and other options, but you can change most of the settings if you want to, as I'll discuss later.
- Movie. Choose this mode when you want to shoot video clips. You can also shoot video when using any other mode simply by pressing the red Movie button located to the immediate right of the optical viewfinder window, as long as you've selected Always in the Custom Settings 7's Movie Button entry. (If not, you must indeed rotate to the Movie slot on the mode dial.)
- MR 1, 2, 3 (Memory Recall). This isn't a shooting mode, as such, but a set of three storage positions you can use to memorize sets of camera settings, and then recall them quickly.

If you have more photographic experience, you might want to opt for one of the semi-automatic or manual modes, also shown at lower right in Figure 1.13. These, too, are described in more detail in Chapter 5. These modes let you apply a little more creativity to your camera's settings. These modes are indicated on the mode dial by the letters P, A, S, and M:

- P (Program auto). This mode allows the a68 to select the basic exposure settings, as with Intelligent Auto, but you can still override the camera's other choices to fine-tune your image.
- A (Aperture Priority). Choose this mode and select the f/stop with the front or rear control dial when you want to use a particular lens opening, especially to control sharpness, isolate a background using a wide lens opening, or to manage how much of your image is in focus. The Alpha will select the appropriate shutter speed for you.
- S (Shutter Priority). This mode is useful when you want to select a particular shutter speed with the front or rear control dial to stop action or produce creative blur effects. The Alpha will select the appropriate f/stop for you.
- M (Manual). Select this mode when you want full control over the shutter speed (with the rear control dial) and lens opening (with the front control dial), either for creative effects or because you are using a studio flash or other flash unit not compatible with the Alpha's automatic flash metering. In Manual mode, the camera will still display a suggested exposure.

Choosing a Metering Mode

You might want to select a particular metering mode for your first shots, although the default Multi metering is probably the best choice as you get to know your camera. (It is set automatically and cannot be changed when you choose a Scene mode, Superior/Intelligent Auto, or use the a68's digital zoom functions.) To change metering modes, press the Fn button (located on the back of the camera to the right of the LCD) and using the directional buttons, navigate to the Metering Mode icon (second from the left in the bottom row), and press the center button. Then, use the up/down keys or turn the front control dial, and select one of the three modes described below. Press the center button or press halfway down on the shutter button to confirm your choice. The three metering options are shown in Figure 1.16:

- Multi metering. The standard metering mode, and the only choice available in Auto or Scene modes; the a68 attempts to intelligently classify your image and choose the best exposure based on readings from 1,200 different zones in the frame.
- Center metering. The Alpha meters the entire scene, but gives the most emphasis to the central area of the frame.
- **Spot metering.** Exposure is calculated from a smaller central spot.

You'll find a detailed description of each of these modes in Chapter 5.

Figure 1.16 Metering modes (top to bottom) Multi, Center, and Spot.

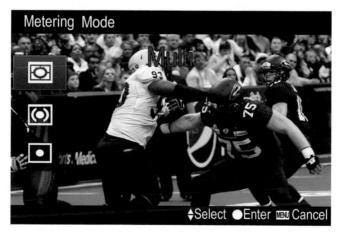

Choosing a Focus Mode

You can easily switch between automatic and manual focus by moving the AF/MF switch on the lens mounted on your camera. If the lens doesn't have this switch, then you need to use the focus mode switch, labeled AF/MF on the front of the camera, on the left side as you hold the camera in the shooting position.

You can also select Focus modes by visiting the Fn menu, highlighting the Focus icon (fourth from the left in the top row), pressing the center button, and then choosing from among MF (Manual focus), AF-C (Continuous AF), AF-A (Automatic AF), and AF-S (Single-shot AF). The same choices are also available from the Camera Settings 3 menu.

If you're using a Scene, Auto, or Panorama shooting mode, the focus method is set for you automatically, and the AF mode selection will be grayed out and unavailable for selection. (You can read more on selecting focus parameters in Chapter 6.)

- Single-shot. This mode, sometimes called *single autofocus*, locks in a focus point when the shutter button is pressed down halfway, and the green focus confirmation circle glows in the viewfinder or on the LCD. The focus will remain locked until you release the shutter button or take the picture. If the camera is unable to achieve sharp focus, the focus confirmation indicator at the lower left of the viewfinder and LCD will blink. This mode is best when your subject is relatively motionless.
- Automatic AF. In this mode, the a68 switches between Single-shot and Continuous AF as appropriate. That is, it locks in a focus point when you partially depress the shutter button (Single-shot mode), but switches automatically to Continuous AF if the subject begins to move. This mode is handy when photographing a subject, such as a child at quiet play, who might move unexpectedly.
- **Continuous AF.** This mode, sometimes called *continuous servo*, sets focus when you partially depress the shutter button, but continues to monitor the frame and refocuses if the camera or subject is moved. This is a useful mode for photographing sports and moving subjects.
- Manual Focus. In this mode, you focus the a68 by rotating the focus ring on the lens.

Selecting a Focus Point

The Sony a68 uses 79 different focus points to calculate correct focus. In the Auto and SCN modes, as well as the Sweep Panorama mode, or when the Smile Shutter is activated, the focus point is selected automatically by the camera. In the semi-automatic and manual modes, you can allow the camera to select the focus point automatically, or you can specify which focus point should be used.

You make your decision about how the focus point is chosen by setting the AF area through the Function menu. The AF area options are described in Chapter 6. Press the Fn button, navigate to the AF area selection at the bottom of the screen (it's the fourth from the left in the top row), press the center button, and select one of these choices. Press the center button again to confirm.

■ Wide. The a68 automatically chooses the appropriate focus area or areas; often several subjects will be the same distance from the camera as the primary subject. The active AF area or areas are then displayed in green on the LCD or in the viewfinder, depending on which display you're using.

- **Zone.** In this mode, a grid consisting of nine focus areas appears on the LCD while you're shooting. You can move this grid around the frame with the directional buttons, and the camera will select which of the focus areas to use to focus. (I'll show you the location of these zones in Chapter 6.)
- **Center.** The camera always uses the focus area in the center of the frame, so it will focus on the subject that's closest to the center in your composition.
- Flexible Spot. After you select this option from Focus Area, while viewing your subject you can use the directional controls to move the focus frame (rectangle) around the screen to your desired location. Move the frame so it covers the most important subject in the scene; then press the center button to lock it into place. I'll discuss this topic in more detail in Chapter 6, where I'll cover many aspects of autofocus (as well as manual focus), including some not covered in this chapter.
- Expanded Flexible Spot. This option is similar to Flexible Spot; you choose the exact focus area as just described, but the a68 gives secondary priority to the eight focus spots surrounding the selected spot.
- Lock-on AF. With this mode, you can select any of the five area selection modes listed above, with tracking added to follow your subject as it moves. I'll show you how to use this useful mode in Chapter 6.

Other Settings

There are a few other settings you can make if you're feeling ambitious, but don't feel bad if you postpone using these features until you've racked up a little more experience with your Sony a68.

Adjusting White Balance and ISO

If you like, you can custom-tailor your white balance (color balance) and ISO sensitivity settings, as long as you're not using one of the Auto or SCN shooting modes. In the Sweep Panorama modes, you can adjust white balance but not ISO. To start out, it's best to set white balance (WB) to Auto, and ISO to ISO 200 for daylight photos, and to ISO 400 for pictures in dimmer light. White balance and ISO both have direct-setting buttons located on the right top panel of the a68. Or, if you prefer, you can get access to both settings by pressing the Fn button and navigating to these settings on the Function menu.

Using the Self-Timer

If you want to set a short delay before your picture is taken, you can use the self-timer. Press the drive button (on the top-right panel of the camera, to the left of the WB button), and press either the up/down buttons of the control wheel or rotate the front control dial to highlight the self-timer icon, then press the left/right buttons to select from either the 10-second or 2-second self-timer.

Press the center button to confirm your choice and a self-timer icon will appear on the full recording information display on the back of the Sony a68 and in the viewfinder. Press the shutter release to lock focus and exposure and start the timer. The red self-timer lamp in the hand grip will flash and the beeper will count down (unless you've silenced it in the menus) until the final two seconds (in 10-second mode), when the lamp stays lit and the beeper beeps more rapidly. In the 2-second mode, the lamp stays lit and the beeper sounds off rapidly for the entire time.

In addition to the Self-timer, Continuous shooting, and Single-shot choices in the Drive menu, there are also bracketing and infrared remote control options. The Drive menu is also available from the Function menu. (Press Fn and navigate to the first icon on the left in the top row.)

Using the Built-In Flash

Working with the a68's built-in flash unit deserves a chapter of its own, and I'm providing one. (See Chapter 10.) But the camera's flash is easy enough to work with that you can begin using it right away, either to provide the main lighting of a scene or as supplementary illumination to fill in the shadows. The camera will automatically balance the amount of light emitted from the flash so that it illuminates the shadows nicely, without overwhelming the highlights and producing a glaring "flash" look. (Think *Baywatch* when they're using too many reflectors on the lifeguards!)

Your options for using the flash depend on what shooting mode the camera is set to. For example, in the two Auto modes, the SCN modes, and the Sweep Panorama modes, the camera decides whether or not to pop up the flash, and you cannot pop it up even if you press the round Flash button on the side of the camera below the flash unit. If the camera's programming determines that

flash is needed, it will pop up the unit. Once it is popped up though, you will have some options for controlling it, by pressing the Fn key and selecting Flash Control from the Function menu. You can choose to leave the flash on its initial setting of Autoflash, to force it off, or to force it on, for fill flash. (In the Flash Off shooting mode, not surprisingly, the camera will not pop up the flash unit and neither can you.)

In the other shooting modes—P, A, S, M, and Continuous Advance Priority AE—you have more control over the built-in flash. The camera will not use it unless you manually pop it up by pressing the Flash button (see Figure 1.17). Once it is popped up, you can use the Flash Mode item in the Camera Settings 2 menu and on the Function menu to select from various flash options available to choose: Forced on (Fill-flash),

Figure 1.17 The a68 has a built-in flash unit that pops up automatically or on your command when it is needed to provide extra illumination for a scene.

Slow Sync, and Rear Sync. In those shooting modes, you don't have the Forced off or Auto-flash options available. You also have one other setting available—Wireless (WL), which enables you to fire a remote flash unit using the flash as the master controller.

You can read about all of the above settings, as well as flash exposure compensation, red-eye reduction options, and other flash features in Chapter 10.

An Introduction to Movie Making

I'm going to talk in more detail about your movie-making options with the a68 in Chapter 8. For now, though, I'll give you enough information to get started, in case a cinematic subject wanders into your field of view before you get to that chapter.

The cameras have advanced motion-picture capabilities, including the ability to produce excellent-quality high-definition (HD) movies. You can adjust several shooting settings, including exposure compensation, white balance, AF area, and others. The cameras also provide a breakthrough ability in that they can continuously autofocus on your scene using phase detection focusing with live view. This ability greatly enhances the sharpness and quality of your video footage.

You get access to the settings for the movie file formats through the Camera Settings 2 menu in the main menu system. For now, just press the MENU button at the left of the camera's top, make sure the Movie menu list at the left is highlighted (it has a "film" icon), and, using the front control dial or by pressing the control wheel's down directional button, scroll down to highlight the File Format line. Make sure the AVCHD option is selected. If it isn't, use the directional controls and the center button to scroll to that option and highlight it, then exit from the menu by pressing the MENU button again.

Now let's just make a basic movie. With the camera turned on in any shooting mode, aim at your subject and locate the red Movie button just to the right of the viewfinder, angled toward the back of the camera. Press that button once to start the recording, and again to stop it; don't hold down the button. You can record for up to about 29 minutes consecutively if you have sufficient storage space on your memory card and charge in your battery, if you have the SteadyShot image stabilizing system turned off. If SteadyShot is turned on, the continuous-shooting limit is about 9 minutes for the a68.

The camera will adjust the focus and exposure automatically, and you can zoom while recording, if you have a zoom lens attached to the camera. When the movie has been recorded, you can press the Play button on the back of the camera to view it immediately. (To play a movie after you have taken some still photos, so the movie is not the latest item available to play, you need to use the index screen; see the last bullet of the section below on "Reviewing the Images You've Taken" for that procedure.)

While a movie is playing, the directional controls (which you can summon by pressing the down button if necessary) act like VCR buttons, as follows:

- Pause/Resume. Press the center button.
- **Fast-forward.** Press right while the movie is playing.
- **Fast-rewind.** Press left while the movie is playing.
- Forward slow playback. Turn the front control dial to the right while the movie is paused.
- Reverse slow playback. Rotate the front control dial to the left while the movie is paused.
- **Adjust sound volume.** Press down to bring up the volume control on the screen, then raise or lower the volume by pressing up or down, by turning the front control dial.
- Turn recording information on or off. Press the DISP button.

Reviewing the Images You've Taken

The Sony a68 has a broad range of playback and image review options. Here is all you really need to know at this time, as shown in Figure 1.18.

- Press the Playback button (the bottom button immediately to the lower right of the LCD, marked with a hard-to-see dark blue right-pointing triangle) to display the most recent image on the LCD.
- Press left or scroll the front control dial on the front of the camera to the left, to view a previous image.

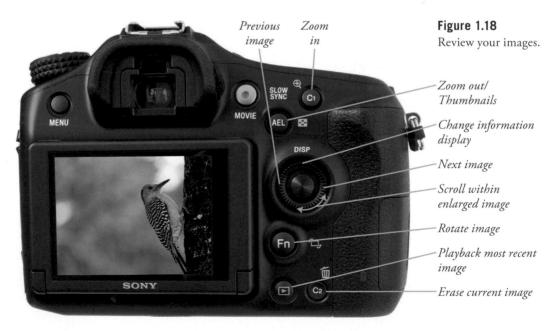

- Press right, or scroll the front control dial to the right, to view the next image.
- Press the Trash button to delete the currently displayed image.
- Press the Zoom In (C1 button) and Zoom Out (AEL) buttons at the top of the camera's back to select zoomed and full-screen views. Press either button repeatedly to change the zoom level. You can press the Playback button to resume normal viewing quickly. You can rotate the control wheel to zoom in and out, as well.
- Rotate the front control dial to display a different image at the same zoom level.
- Press left/right/up/down to scroll around within a magnified image. An inset box shows the relationship of the magnified image to the entire frame.
- Press the DISP button repeatedly to cycle among views that have no recording data, full recording data (f/stop, shutter speed, image quality/size, etc.), and a thumbnail image with histogram display. (I'll explain all these in Chapter 2.)
- Press the Zoom Out (AEL) button to display an index screen showing 9 or 25 thumbnail images, or a useful Calendar view that arranges images by date captured. (You can select whether 9 or 25 images appear using the Image Index entry of the Playback 1 menu, as I'll discuss in Chapter 4.) Press the Zoom In button to return to the single-image display.

Transferring Photos to Your Computer

The final step in your picture-taking session will be to transfer the photos you've taken to your computer for printing, further review, or image editing. (You can also take your memory card to a retailer for printing if you don't want to go the do-it-yourself route.) Your a68 allows you to print directly to PictBridge-compatible printers and to create print orders right in the camera, plus you can select which images to transfer to your computer.

Transfer your images either using a cable transfer from the camera to the computer or by removing the memory card from the a68 and transferring the images with a card reader. The latter option is usually the best, because it's usually much faster and doesn't deplete the battery of your camera. However, you can use a cable transfer when you have the cable and a computer but no card reader (perhaps you're using the computer of a friend or colleague, or you're at an Internet café).

To transfer images from a memory card to the computer using a card reader:

- 1. Turn off the camera.
- 2. Slide open the memory card door, and press on the card, which causes it to pop up so it can be removed from the slot. (You can see a memory card being removed in Figure 1.7.)
- 3. Insert the memory card into a memory card reader that is plugged into your computer. Your installed software detects the files on the card and offers to transfer them. The card can also appear as a mass storage device on your desktop, which you can open and then drag and drop the files to your computer.

To transfer images from the camera to a Mac or PC computer using the USB cable:

- 1. Turn off the camera.
- 2. Open the port door on the left side of the camera and plug the USB cable furnished with the camera into the USB port, shown in Figure 1.19.
- 3. Connect the other end of the USB cable to a USB port on your computer.
- 4. Turn on the camera. Your installed software usually detects the camera and offers to transfer the pictures, or the camera appears on your desktop as a mass storage device, enabling you to drag and drop the files to your computer

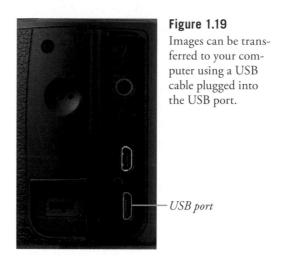

Sony a68 Roadmap

Traditionally, there have been two ways of providing a roadmap to guide you through the maze of features found in a sophisticated camera like the a68. One approach uses a few tiny black-and-white line drawings or photos impaled with dozens of callouts labeled with cross-references to the actual pages in the book that tell you what these components do. You'll find this tactic used in the printed, online, and PDF manuals Sony provides with the a68, and most of the other third-party guide-books as well. Deciphering one of these miniature camera layouts is a lot like being presented with a world globe when what you really want to know is how to find the capital of Belgium.

I originated a more useful approach in my field guides, providing you, instead of a satellite view, a street-level map that includes close-up full-color photos of the camera from several angles, with a smaller number of labels clearly pointing to each individual feature. And, I don't force you to flip back and forth among dozens of pages to find out what a particular component does. Each photo is accompanied by a *brief* description that summarizes the control, so you can begin using it right away. Only when a particular feature deserves a lengthy explanation do I direct you to a more detailed write-up later in the book.

So, if you're wondering what the ISO button does, I'll tell you up front in this chapter. The printed manual supplied by Sony, in contrast, shows you on page 14 where the ISO button is, but doesn't point you to further explanations of how to use it. This book is not a scavenger hunt. But after I explain the use of the ISO button to change the sensitivity of the a68, I will provide a cross-reference to longer explanations later in the book that clarifies noise reduction, ISO, and its effects on exposure. I've had some readers write me and complain about even my minimized cross-reference approach; they'd like to open the book to one page and read everything there is to know about bracketing, for example. Unfortunately, it's impossible to understand some features without having a background in what related features do. To understand bracketing fully, you also need to know how exposure and some other aspects work. So, I'll provide you with introductions in the earlier chapters like this one, covering simple features completely, and relegating some of the really

in-depth explanations to later chapters. I think this kind of organization works best for a camera as sophisticated as the Sony a68.

By the time you finish this chapter, you'll have a basic understanding of every control and what it does. I'm not going to delve into menu functions here—you'll find a discussion of your Camera Settings, Custom Settings, as well as Playback and Setup options in Chapters 3 and 4. Everything here is devoted to the button pusher and dial twirler in you.

Front View

When we picture a given camera, we always imagine the front view. That's the view that your subjects see as you snap away, and the aspect that's shown in product publicity and on the box. The frontal angle is, essentially, the "face" of a camera like the Sony a68. But, not surprisingly, most of the "business" of operating the camera happens *behind* it, where the photographer resides. The front of the a68 actually has very few controls and features to worry about. In Figure 2.1, you can see the components revealed when the lens is removed:

- **Translucent mirror.** This semi-transparent (*not* actually translucent, despite Sony's nomenclature) mirror allows 70 percent of the light passing through the lens to continue on to the sensor. The remaining 30 percent is reflected upward toward the camera's autofocus sensor. This system gives the a68 the ability to automatically focus at all times, even while providing a bright, amplified live view of the sensor image when shooting both stills and movies.
- Electrical contacts. These contacts mate with matching electrical components on the back of the lens to allow the camera and lens to communicate focus and exposure information.

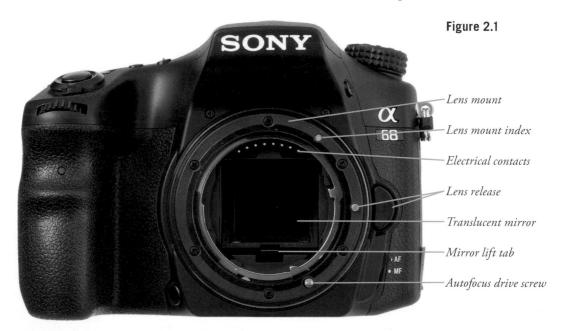

- Lens mount index. Match up this mark with an indicator on the lens to align the two when attaching a lens to the camera.
- Lens mount. This bayonet mount holds the lens securely.
- Mirror lift tab. Grip this tab with a fingertip to gently flip up the mirror for sensor cleaning.
- Lens release. Press the button on the side of the lens mount (at the three o'clock position) to drop the lens lock pin (on the lens mount itself) to allow removing the lens.
- Autofocus drive screw. This tiny blade is attached to a focus motor located within the body of the a68 itself, and rotates as necessary to adjust the focus of compatible lenses. Not all A-mount lenses require or use this feature. Newer lenses include a built-in motor that is controlled electronically with information received from the camera. These include all lenses with SSM (SuperSonic Motor) or SAM/SAM II (Smooth Autofocus Motor) in their name. Other lenses use the early (1985) autofocus system of the original Minolta A-mount film cameras, and need the camera's built-in motor to mechanize focus. I'll cover this aspect in more detail in Chapter 9.

Other components are located on the side of the camera that's gripped by your right hand when holding the a68 in the shooting position (see Figure 2.2). They include:

■ Shutter release button. Angled on top of the hand grip is the shutter release button. Press this button down halfway to lock exposure and focus (in Single-shot mode and Continuous autofocus mode with non-moving subjects). The a68 assumes that when you tap or depress the shutter release, you are ready to take a picture, so the release can be tapped to activate the exposure meter or to exit from most menus.

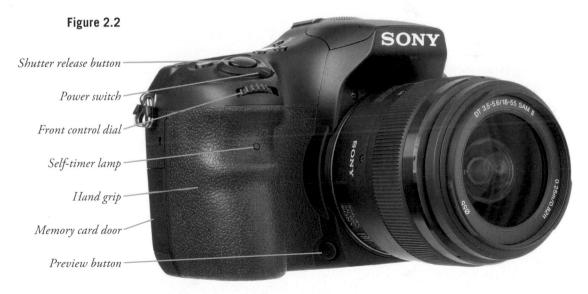

- Power switch. Rotate clockwise to turn the camera on; counterclockwise to power down.
- Front control dial. This dial is used to change shooting settings. When settings are available in pairs (such as shutter speed/aperture), this dial will be used to make one type of setting, such as aperture. The other setting, the shutter speed, is made using an alternate control, such as spinning the rear control wheel. This dial also advances through your images in Playback mode.
- Self-timer lamp. This LED flashes red while your camera counts down the 10-second self-timer, intermittently at first, then switching to a constant glow in the final moments of the countdown. With the 2-second self-timer, the lamp stays lit during the entire countdown.
- Hand grip. This provides a comfortable hand-hold, and also contains the a68's battery and memory card.
- Preview button. This control, sometimes known as a "depth-of-field preview button," lets you see how your image will look with the aperture stopped down to its actual value, before you press the shutter button. Normally, when you are viewing the image on the LCD or in the viewfinder in Recording mode, the lens is always at its widest aperture, such as f/3.5, for example. Because the depth-of-field changes as the aperture gets smaller (with a larger number, such as f/8), viewing through the wide-open lens does not let you judge how much of the image will be in focus when the picture is actually recorded. When you press the Preview button, the lens stops down to the actual shooting aperture so you can judge what areas of the image will be in sharp focus at that aperture. As I'll explain in Chapter 4, you can redefine the Preview button so it also shows lens corrections, Dynamic Range Optimization, and other effects.
- **Memory card door.** Slide this panel toward the back of the camera to reveal the SD/Memory Stick card slot.

You'll find more controls on the other side of the a68, shown in Figure 2.3.

- Autofocus/Manual focus switch (on lens and body). Slide this switch to either AF or MF to set the a68 for automatic focus or manual focus.
- **Neck strap mounting ring.** Attach the strap that comes with your a68 to this ring, or use a third-party strap of your choice.
- **Port covers.** The a68's connectors for remote controls, microphones, DC power, HDMI output, and USB cables are stowed under these covers.
- Flash button. This is the button you push to pop up the camera's built-in flash unit. As noted above, you can do this manually only when the camera is set to Program Auto, Aperture Priority, Shutter Priority, Manual, or Continuous Advance Priority AE mode. (Shown in Figures 2.3 and 2.4.)
- Speaker. Sounds emitted by your a68 emerge here.

■ Pop-up flash. This is your a68's internal flash. (See Figure 2.4.) It pops up automatically when needed while using any of the Auto or Scene modes except (not surprisingly) Flash Off, and may be manually flipped up by pressing the Flash button on the left side of the camera when you're using the Program, Aperture Priority, Shutter Priority, Manual exposure, and Continuous Advance Priority AE modes. In the Scene and Auto modes, you cannot pop up the flash using the Flash button; the camera will give you an error message if you try.

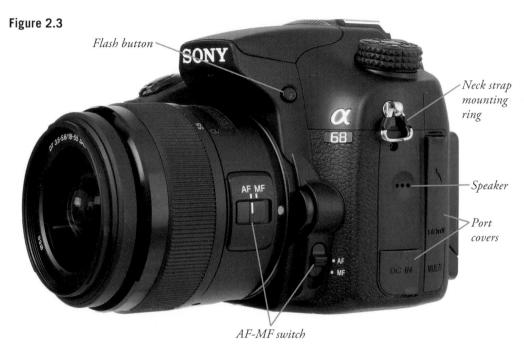

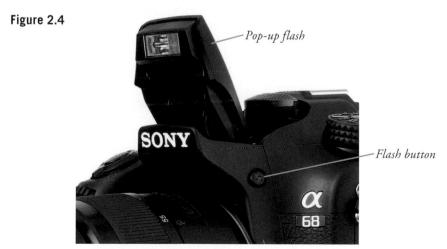

The main features on the left side of the Sony a68 are two hinged doors that provide a modicum of protection for the ports underneath from dust and moisture. The connectors hidden under those doors, shown in Figure 2.5, are as follows:

■ HDMI port. If you'd like to see the images from your camera on a television screen, you'll need to buy an HDMI cable (not included with the camera) to connect this port to an HDTV set or monitor. Be sure to get a cable that has a male type-D micro-HDMI connector at the camera end and a standard male HDMI connector at the TV end. Once the cable is connected, you can not only view your stored images on the TV in Playback mode, you can also use the camera in Recording mode and see on your TV screen what the camera sees. So, in effect, you can use your HDTV set as a large monitor to help with composition, focusing, and the like.

One unfortunate point is that these Alpha models no longer support video output to an old-style TV's yellow composite video jack. If for some reason it's important to you to connect the camera to one of those inputs, you'll need to find a device that can "down-scale" the HDMI signal to composite video. I have done this successfully with a device by Gefen called the HDMI to Composite Scaler, which costs somewhat more than \$200 at Amazon.com, svideo.com, and other sites. It's likely you'd have to *really* need a converter like that to justify the cost.

The good news is that if you own a TV that supports Sony's Bravia sync protocol, you can use your Bravia remote control to control image display, mark images for printing, switch to index view, or perform other functions.

- Multi/Micro USB port. Connect your camera to your computer by means of this port, using the USB cable that is supplied with the camera. Other accessories, such as an RM-VPR1 remote control cable can also be plugged in here.
- **DC power port.** You can plug the optional AC-PW10AM adapter into this connector to provide continuous power to the camera.

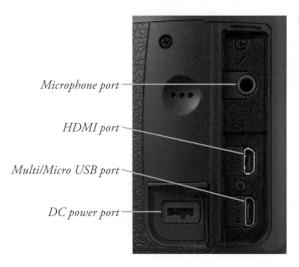

Figure 2.5

■ Microphone port. This small opening is of considerable value to those who want to delve into high-quality videography with the a68. This port accepts a stereo mini-plug from a standard external microphone, allowing you to achieve considerably higher audio quality for your movies than is possible with the camera's built-in microphones. The port also can provide plug-in power for microphones that can take their power from this sort of outlet rather than from a battery in the microphone. Sony provides optional compatible microphones such as the ECM-ALST1 and the ECM-CG50; you also may find suitable microphones from companies such as Shure and Audio-Technica. When a microphone is plugged into this port, the internal microphones are disabled.

The Sony a68's Business End

The back panel of the Sony a68 bristles with more than a dozen different controls, buttons, and knobs (see Figure 2.6). That might seem like a lot of controls to learn, but you'll find, as I noted earlier, that it's a lot easier to press a dedicated button and spin a dial than to jump to a menu every time you want to change a setting.

Most of the controls on the back panel of the a68 are clustered on the right side of the body, with the exception of the MENU button perched on the back slope, just northwest of the LCD, and a few other items of note.

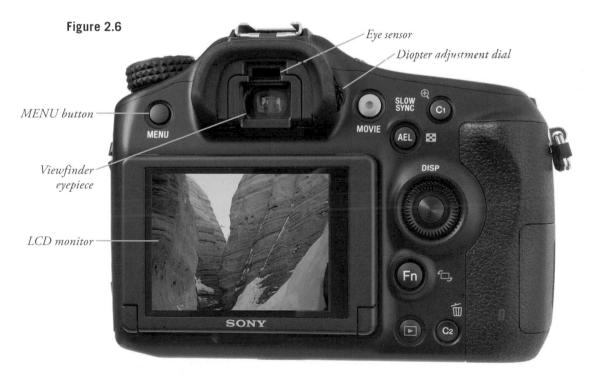

The key components labeled in Figure 2.6 include:

- **MENU button.** Summons/exits the menus displayed on the rear LCD and electronic view-finder display of the a68. When you're working with submenus, this button also serves to exit a submenu and return to the main menu.
- Viewfinder eyepiece. You can frame your composition and see the information on the electronic viewfinder's display, including shooting settings, recorded images, and menu screens, by peering into this eyepiece. It's surrounded by a removable soft rubber frame that seals out extraneous light when pressing your eye tightly up to the viewfinder, and it also protects your eyeglass lenses (if worn) from scratching.
- Eye Sensor. This sensor detects when your face or some other object approaches the viewfinder, and turns off the LCD display. Some find this feature annoying, because it can be triggered by other objects (such as your body when carrying the camera, switched on, over your shoulder or around your neck). In Chapter 4, I'll show you how to disable this function. You might also want to turn it off when using the optional FDA-M1AM magnifying eyepiece or FDA-A1AM right-angle finder, because these accessories could activate the sensors. The eye sensor also activates Eye-Start automatic focusing, if you've enabled it in the Custom Settings 4 menu, as I'll explain in Chapter 4.
- **Diopter adjustment dial.** Rotate this to adjust eyesight correction applied when looking through the a68's viewfinder.
- LCD monitor. This tilting 2.7-inch display shows your live view preview; image review after the picture is taken; recording information display before the photo is snapped; and all the menus used by the Sony a68.

The control cluster on the right side of the back of the camera includes these buttons, shown in Figure 2.7:

- Movie button. This red button is your gateway to movie making with the a68 camera. Its operation is about as simple as it gets—just press the button once to start recording a movie, and press it again to stop the recording. By default, the Movie button will begin video capture regardless of the position of the mode dial; if you want to eliminate "accidental" activation, you can specify that the button is active only when the dial is set to the Movie position. (Use the Custom Settings 7 menu, as described in Chapter 4.) The more involved aspects of video recording are handled through the menu system. I'll discuss your movie-making options in Chapter 8.
- **Custom 1/Zoom In button.** Like several of the a68's buttons, this one has several functions, depending on the active mode of the camera.
 - **Shooting mode.** When taking photos, pressing the C1 button invokes the defined function for this control. The default action is to produce the Focus Mode screen, so you can select from AF-S, AF-C, AF-A, or MF. You can select another behavior using the Custom Key Settings entry of the Custom Settings 6 menu, as I'll describe in Chapter 4.

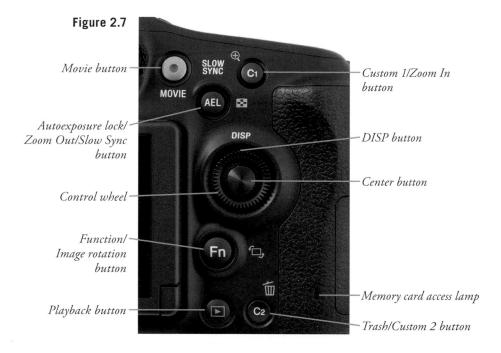

- **Playback mode.** This button functions as a Zoom In (Enlarge) button during picture review, to zoom in on full-screen images, and to back out of Calendar and Index views (described next).
- Autoexposure Lock/Zoom Out/Slow Sync button. This button also has several functions:
 - Shooting mode (without flash). In any exposure mode other than Manual, press and hold this button to lock the exposure. A * symbol appears in the lower-right corner of the display to indicate that the exposure is locked. If you continue to hold the button while shooting, subsequent images will be taken using the same exposure. Exposure lock is released when the button is no longer depressed.

With the exposure locked, you can first aim the camera at a subject whose brightness will yield your desired results. Once you have made that exposure reading by pressing the shutter button halfway, press and hold the AEL button, and that exposure reading will remain locked in. Now, aim the camera at your actual subject, and press the shutter button to re-focus and take the picture, using the locked-in exposure setting.

You can change the default (and sometimes clumsy) behavior of the AEL button in Shooting mode using the Custom Key Settings entry in the Custom 6 menu, and choosing the AEL Button item. If you set it to Hold (the default), you have to hold the button down to keep the exposure locked; if you set it to Toggle, you can press and release it to lock exposure; then press it again to cancel that setting. Either way, whenever you have exposure locked with this button, an asterisk (*) appears in the viewfinder or on the LCD. I'll describe other behaviors for this button in Chapter 4.

- Shooting mode (with flash). With the built-in flash elevated or with an external flash attached and powered up, this button functions as a Slow Sync. control. If you want to use a slow shutter speed in conjunction with the flash (to allow background illumination to register), flip up the flash and hold this button down while shooting. An asterisk (*) appears at lower right in the viewfinder or LCD to indicate that slow sync is in effect. This feature is not available when using Shutter Priority or Manual exposure modes, or when you've redefined this button so that its main shooting mode function is not Auto Exposure Lock (as outlined in Chapter 4).
- Playback mode. Press this button to display an index screen showing 9 or 25 of your images at a time (choose which of the two is shown using the Image Index entry in the Playback 1 menu). Press again to enter Calendar mode. To back out of these modes, press the Zoom In button, described above.
- DISP button. In both Shooting and Playback modes, when using the LCD or EVF, press the DISP button repeatedly to cycle among the information displays available. I'll describe the data shown in these displays in Shooting mode, and additional options in the Choose Your View section. In Playback mode, the button cycles among the three available playback screens: full recording data; histogram with recording data; and no recording data. For movies, there are only two playback screens; there is no histogram screen.
- Control wheel/Center button. In both Shooting and Playback modes, these controls function as navigational tools. You can push the control wheel up/down/left/right or diagonally to navigate within menus or to move around the frame when zooming, choosing autofocus points or other functions. Press the control wheel center button to confirm menu choices when a menu is shown on the screen. If you've activated Object Tracking, pressing the button also tells the camera to follow a moving subject to retain focus. (I'll discuss autofocus options in detail in Chapter 6.)
- Fn (Function)/Image Rotation button. This button has separate functions for Shooting and Playback modes.
 - Shooting mode. Pressing this button pops up a screen on the LCD or in the viewfinder with options for selecting various settings, depending on what Shooting mode the camera is set to. When you're shooting in one of the semi-automatic or manual modes (P, A, S, or M), you have the greatest number of settings available: Drive mode, Flash mode, AF Area, Face Detection, ISO, Metering mode, Flash Exposure Compensation, White Balance (color bias), the Dynamic Range Optimizer (to improve highlight/shadow detail), and a Creative Style (such as Vivid, Portrait, or Sunset).
 - Note that the Function menu options shown in Figure 2.8 represent the *default* configuration. This marvelously configurable camera allows you to rearrange the functions and/or substitute new ones, as I'll explain in Chapter 4.

Playback mode. Pressing the button rotates the current image on the screen.

Figure 2.8

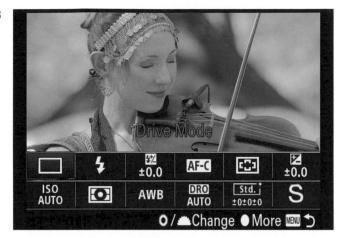

- **Trash/Custom C2 button.** This is another button that can be programmed for use when in Shooting mode:
 - Shooting mode. This button summons the behavior you've specified in the Custom Keys menu of the Custom Settings 6 menu, as explained in Chapter 4. The default is AF Range Control, but you can also select from 48 other choices, plus Not Set, as described in Chapter 4. (See Figure 2.9.)
 - Playback mode. Press this button once if you want to delete the image displayed on the LCD. Then press up/down to choose Delete (to confirm your action) or Cancel (if you change your mind). Press the control wheel button (Enter) to confirm your choice. You can specify whether you want Delete or Cancel to be the default selection, as explained in Chapter 4.

Figure 2.9

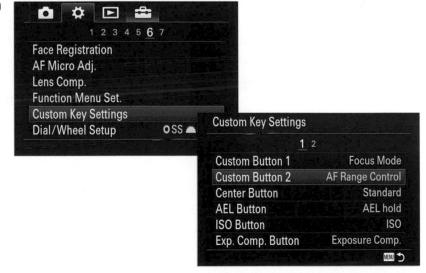

- Memory card access lamp. When lit or blinking, this lamp indicates that the memory card is being read from or written to. Do not remove the battery, turn off the power, or remove the card while this lamp is lit, or your image data could be corrupted.
- Playback button. Displays the last picture taken. Thereafter, you can move back and forth among the available images by pressing left/right or spinning the front dial or rear control wheel to advance or reverse one image at a time. To quit playback, press this button again. The a68 also exits Playback mode automatically when you press the shutter button (so you'll never be prevented from taking a picture on the spur of the moment because you happened to be viewing an image).

What You See, and What You Get

Your a68 has two display screens, of course: the internal 0.39-inch, 1,440,000-dot OLED (organic light-emitting diode) electronic viewfinder, and the external 2.7-inch 460,800-dot back-panel color TFT (thin film transistor) LCD monitor. You can use either of them at any time. The a68 will be kind enough to switch back and forth automatically by using its Eye Sensor to decide whether the camera is held up to your eye (thereby activating the EVF), or held at arm's length (in which case, you probably want to work with the back-panel LCD). You can disable this behavior so that it will be necessary to press the FINDER/MONITOR button on top of the camera (as described later), rather than rely on automatic switching.

LCD vs. EVF

Although you can alternate between them, these two viewing systems are not completely interchangeable. Each has its own advantages and disadvantages. Whether you use the LCD or EVF in a given shooting situation is largely a matter of personal preference and/or convenience. But there are some things to consider about your two viewing systems:

- EVF has higher resolution. With 1.4 million dots, the EVF has roughly three times the resolution of the LCD monitor, making it a better choice for examining small details while framing and composing an image and, especially, when manually focusing. The LCD does have plenty of detail for framing an image, however.
- LCD prone to washout. The back-panel LCD is exposed to ambient lighting and can, in fact, be washed out or reduced in contrast when used under bright lighting conditions. The internal EVF, on the other hand, is shielded from ambient light, and is usually the better choice when photographing outdoors. But keep in mind that you can adjust the brightness of either one to suit the shooting environment.
- LCD has better viewing angles. The internal EVF must be viewed more or less from directly behind the viewfinder window, although your eye needn't be pressed right up against the frame. Your eye can be as far as 23mm from the removable viewfinder frame, and 26.5mm from the window itself (this is known as the *eyepoint* distance), which is a benefit for eyeglass wearers. The tilting LCD, on the other hand, can be viewed from any distance that allows you

to view the detail you need to see, and can be canted at a variety of angles, from 135 degrees upward to 55 degrees downward. You can capture low-angle shots, say of ground-hugging flora, without prostrating yourself, or hold the camera overhead and use the angled LCD like a periscope to capture a parade or shoot over the heads of the other paparazzi.

■ EVF encourages solid shooting stance. Using the EVF, with the a68 pressed up against your forehead, helps steady the camera and reduce potential blur at slow shutter speeds. (SteadyShot is *not* a panacea and, actually, works even better when the camera is fairly stable to begin with.) When taking several pictures in succession, the EVF and camera held at eye-level provide a familiar shooting platform. Most sports photos, for example, are best captured with the camera pressed tightly to your eye. The LCD's shooting stance, especially when you hold the camera out at arm's length, tends to increase the unsteadiness of hand-held photography. The LCD might be your preferred viewfinder for casual or stealth photography.

EVF/LCD VS. OPTICAL VIEWFINDERS

Traditional SLRs have eye-level optical viewfinders, with "Live View" LCD preview for dSLRs only introduced within the last few years. Generally, those optical viewfinders have been bigger and brighter than the electronic viewfinders offered for other types of digital cameras, including those found in the SLT-era predecessors of your camera. The 1.4MP OLED (organic LED) EVF provided with the a68 is a great leap forward. This newest Sony EVF has several improvements:

- Big, bright view. The view the a68's EVF provides is as large (that is, provides roughly the same magnification) and virtually as bright as that of full-frame digital SLRs, and *better* in those respects than the optical viewfinders in dSLR models with APS-C-format sensors comparable in size to the a68's imager.
- No smearing. The a68's OLED viewfinder uses a progressive display—each of the 768 lines of pixels is revealed and refreshed in order, rather than one color at a time (as was done with earlier models in the SLT lineup), so the display is free from the "tearing" effect that can cause a smeared image when you move your eye while viewing.
- Adjustable brightness. You can adjust the viewfinder's relative brightness in the Setup 1 menu (I'll show you how later) to produce a view that's as bright or as dim as you like (the brightness of the back-panel LCD can also be adjusted separately).
- Gain, no pain. The EVF can automatically amplify the image for better viewing under dim lighting conditions, unlike an optical viewfinder, which grows dimmer as the illumination decreases.
- Preview effects. The EVF and LCD can be set to show the effects of your settings, such as exposure or color balance, as you view the image prior to taking the picture. With an optical view-finder, what you see is not necessarily what you get.
- Live histogram. Some cameras offer a live histogram display during preview on their back-panel LCD, so you can use the histogram's chart to judge exposure. (I'll explain how to use histograms in Chapter 5.) However, no eye-level *optical* viewfinder is able to show a histogram under any circumstances. You can easily enable your a68's optional EVF histogram display (and I'll show you how later in this chapter).

Choosing Your View

When reviewing images, the a68 provides three views, which you can cycle through by pressing the DISP button. Press the Playback button and you'll see a plain vanilla, no-information full-screen display with nothing but the image; a full-screen display with basic shooting information overlaid; or a more detailed display that includes more shooting data, a reduced-size thumbnail of your image, and a quartet of histograms (one each for brightness, red, green, and blue color channels). (See Figure 2.10.) I'm going to leave the discussion of using histograms for Chapter 5, which deals with the wonders of exposure.

The shooting mode displays are a little more complicated. When you're in shooting mode, both the EVF and LCD show a preview of the image you've framed with the camera, as well as a recording information display of relevant shooting data, such as exposure information, focus point, and other settings. The amount of information shown varies, and can be changed from one display to the next by pressing the DISP button. The EVF and LCD can be set individually, and each can show a different information display. That's very handy, as you can have a detailed display on the back-panel LCD, and minimal information overlaid on the EVF if you want a cleaner display while framing and shooting your image with the viewfinder. There are five different displays for the EVF, and six for the LCD, and several optional informational variations. You can enable or disable each of these displays individually, so if you decide you no longer want to view the graphic display in the EVF, you can turn it off there, while retaining that display option on the LCD. I'll show you how to do that shortly.

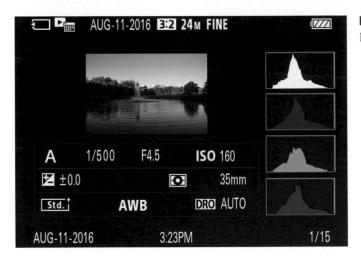

Figure 2.10 Histogram display.

But first, a discussion of the available displays:

- Graphic display. This display is graphic to the extent that the shutter speed and aperture value settings are shown as graphs, with indicators pointing to the current values. The LCD version is shown in Figure 2.11. The EVF version is similar, but has a black background band at the top of the frame to make the information displayed in the top row of icons more easily visible. In addition, the +/− EV (exposure compensation) icon on the bottom row of the LCD is replaced by a scale showing the amount of exposure compensation you've dialed in. The graphic display is an excellent choice for beginners who are just learning about shutter speeds and f/stops. Notice that the shutter speed graph has icons of a standing figure at left, and a running figure at right, providing a quick clue that faster shutter speeds are better for movement and action. Similarly, the aperture graph has a cloud at the "wide" end (because wider, larger apertures are best for dimmer conditions), and a landscape icon at the right that brings typical brightly lit scenes to mind. Unless you find the complete graphic display helpful, you'll probably abandon it as you become more proficient with your a68. Not all of its indicators will be displayed at once. The LCD display is shown; the EVF version is slightly different, with an exposure scale (which appears in all views) at the center bottom of the frame.
- **Display all information.** This display (the LCD version is shown in Figure 2.12) really clutters up your screen, although, fortunately, not all of this information is overlaid on your image at once. The top rows and bottom row are the same as in the graphic display, and two columns of additional information are stacked at left and right of the frame. These are reminders of the settings you can change by pressing the Fn button, and indicate their current values. To change any of them, press the Fn button, and use the left/right and up/down directional buttons to navigate from one row and column to the other to highlight the icon of the setting you want to adjust. Press the center button, and a screen will appear with that setting's options. Select and press the center button to confirm and exit. As with the graphic display, the EVF version is almost identical, with the addition of the EV scale at the bottom.

Figure 2.11 Graphic display.

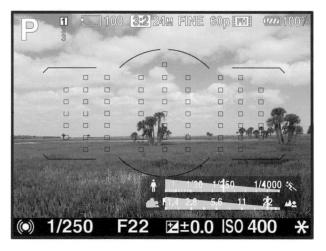

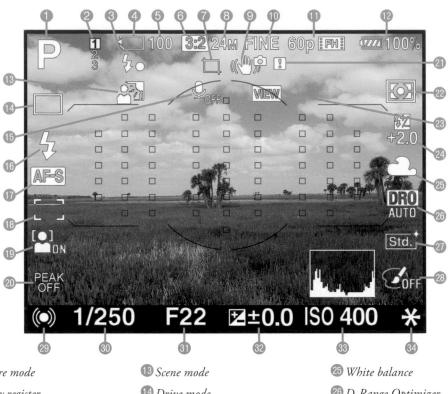

- 1 Exposure mode
- 2 Memory register
- 3 Flash charge progress
- 4 Memory card
- 6 Images remaining
- 6 Aspect ratio
- Object framing
- 8 Image resolution
- SteadyShot warning
- 1 Image quality
- Movie resolution
- 12 Battery status

- Drive mode
- 1 Setting effect off
- 16 Flash mode
- Tocus mode
- 18 AF Focus area
- Face detection
- 20 Focus peaking
- 2 Overheating warning
- 22 Metering mode
- 23 Database file full error
- 24 Flash compensation

- 26 D-Range Optimizer
- 2 Creative Style
- 23 Picture Effect
- 29 Focus
- 30 Shutter speed
- Aperture
- 32 Exposure compensation
- 33 ISO sensitivity
- 34 AE Lock

Figure 2.12 Display all information.

- No Display info. This display minimizes the clutter on the LCD or EVF. The LCD version, shown in Figure 2.13, has just a narrow band of information at the bottom. The EVF rendition adds a black band with exposure mode, shots remaining, and image quality at the top. This display mode eliminates the distractions of the first two screens I described. Battery status and shooting mode appear briefly, then disappear to give you the uncluttered screen shown in the figure.
- Grids. You can add any of three types of grids to the display screens as an aid for alignment and composition. These grids include Rule of Thirds, Square Grid, and Diagonal+Square Grid, and can be activated from the Custom Settings 1 menu. I'll show you what these grids look like and how to access them in Chapter 4.
- **Histograms.** These charts appear when activated in the Custom menu, and show the relationship of the black, white, and gray tones in the image.
- For Viewfinder mode. There is one more optional screen, which, despite its misleading name, is available *only* for display on the back-panel LCD. It's a non–live view mode that shows no image at all. Only your current settings information is displayed. It's a useful screen for those times when you want to use the EVF exclusively to frame and evaluate your image (which Sony calls Viewfinder mode), and would prefer that the LCD display only shooting information. The data is shown large and in an easy-to-read display, as you can see in Figure 2.14, which illustrates the display as seen when using PASM modes, or Continuous Advance Priority AE mode. The screen is slightly simplified for iAuto, iAuto+, and Scene Selection modes, displaying only the settings that the user can adjust. I'll explain how to activate this option, as well as other display options, in the next section.

Figure 2.13
Minimal information display.

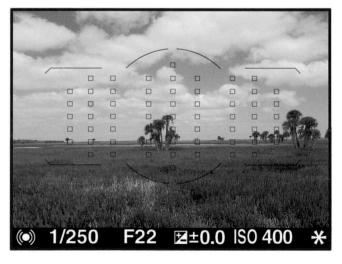

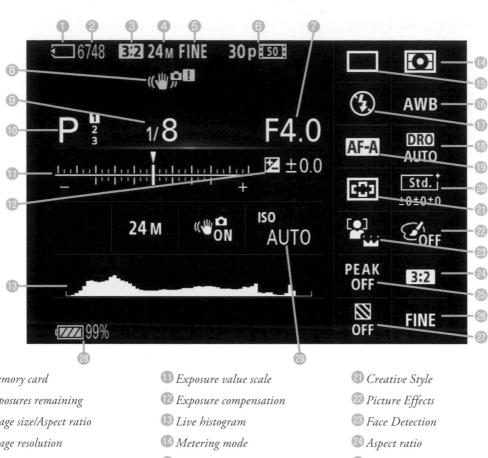

- Memory card
- 2 Exposures remaining
- (3) Image size/Aspect ratio
- 4 Image resolution
- 6 Image quality
- Movie resolution
- Aperture indicator
- 3 SteadyShot status
- Shutter speed
- 1 Exposure mode

- 1 Drive mode
- 11 White balance
- Telash mode
- 18 Dynamic Range Optimizer
- 19 Focus mode
- 20 Autofocus area

- 25 Focus peaking
- 26 Image quality
- 2 Zebra mode
- ²⁸ Battery status
- 29 ISO setting

Figure 2.14 LCD display for Viewfinder mode.

Typical Information Display

As you work your way through this book, you'll learn how to use and work with all the information shown in a typical information display. As I noted earlier, not all of the possible indicators appear at the same time and thus may not have been shown in the previous four figures. The key indicators you'll find include:

- Exposure mode. Shows whether you're using Program Auto, Aperture Priority, Shutter Priority, Manual, or one of the Auto, Scene, or specialized modes. (If the camera is set to Auto or any of the other Scene modes, the information shown on the two recording information displays is considerably less than the full amount that appears in the P, A, S, or M modes.)
- Image quality. Your image quality setting (JPEG Fine, JPEG Standard, RAW, or RAW & JPEG).
- Image size/Aspect ratio. Shows whether you are shooting Large, Medium, or Small resolution images, and whether the a68 is set for the 3:2 aspect ratio or wide-screen 16:9 aspect ratio (the image size icon changes to a "stretched" version when the aspect ratio is set to 16:9). If you're shooting RAW images, there is no symbol shown, because all RAW images are the same size and no size choice is available.
- **Memory card.** This icon appears when a memory card (either SD or Memory Stick) is present in the camera.
- Exposures remaining. Shows the approximate number of shots available to be taken on the memory card, assuming current conditions, such as image size and quality.
- Movie resolution. This icon gives the movie file format and resolution. The choices are: FH, for Full High Definition (AVCHD) at 11230 × 1080 pixels; 1080, for MP4 at 1440 × 1080; and VGA, for MP4 at 640 × 510.
- Battery status. Remaining battery life is indicated by this icon.
- Flash mode. Provides flash mode information. The possible choices are Flash Off, Autoflash, Fill-flash, Slow Sync, Rear Sync, and Wireless. Not all of these choices are available at all times.
- **Drive mode.** Shows whether the camera is set for Single-shot, Continuous shooting (Low- or High-speed), Self-timer, Exposure Bracketing, White Balance Bracketing, or Remote Commander.
- Autofocus area. Shows the AF area mode in use: Wide (the camera chooses one or more of the 79 AF areas to use); Zone (you select which group of AF areas to use); Spot (the camera uses the center AF area exclusively); Center (the center spot is used); Flexible Spot (you can specify which of the 79 areas are used); and Expand Flexible Spot (the a68 can use the spot you select, plus the eight adjacent spots). I'll explain autofocus options in more detail in Chapter 6.
- White balance. Shows current white balance setting. The choices are Auto White Balance, Daylight, Shade, Cloudy, Incandescent, Fluorescent, Flash, Color Temperature, and Custom.
- **D-Range Optimizer.** Indicates the type of D-Range optimization (highlight/shadow enhancement) in use: Off, Auto, Level 1 through 5, or Auto HDR, as described in Chapter 7.

- Creative Style. Indicates which of the 13 Creative Style settings (Standard, Vivid, Neutral, Clear, Deep, Light, Portrait, Landscape, Sunset, Night Scene, Autumn Leaves, Black & White, and Sepia) is being applied. This setting is discussed in Chapter 7.
- Picture Effects. Various special effects (Toy Camera, Pop Color, Posterization, Retro Photo, Soft High Key, Partial Color, High Contrast Monochrome, Soft Focus, HDR Painting, Rich Tone Monochrome, Miniature, Watercolor, Illustration, or Off) can be applied to your image as you shoot.
- **ISO** setting. Indicates the sensor ISO sensitivity setting, either Auto ISO or a numerical value from 100 to 25600. This icon also may indicate that Multi Frame Noise Reduction is in effect, in which case the ISO icon includes a stack of multiple rectangular frames.
- **Metering mode.** The icons represent Multi, Center, or Spot metering. (See Chapter 5 for more detail.)
- **Flash exposure compensation.** This icon is shown whenever the built-in flash is popped up or a compatible external flash is attached to the hot shoe.
- Exposure value scale. On both the standard and graphic displays when viewing through the EVF, this scale is displayed along with an indicator to show the amount of exposure compensation that is being applied. In Manual exposure mode, on the display without Live View, the icon next to this scale changes to the M.M. icon, meaning that manual metering is in effect.
- **Shutter speed.** Shows the current shutter speed.
- Aperture indicator. Displays the current f/stop.
- Exposure compensation. On all of the information displays, the amount of exposure compensation, even if zero, is shown by an indicator on the EV scale. On the full display without Live View, if there is some exposure compensation, in addition to the scale, a number appears at the bottom right of the screen indicating the positive or negative amount of compensation.
- AEL button status. An asterisk is displayed whenever the AEL button is activated, whether it is being used to lock the exposure setting or to allow the use of the front control dial to vary the settings of aperture and shutter speed in Manual exposure mode (the "Manual Shift") feature.
- **SteadyShot status.** Shows whether the a68's anti-shake features are turned on or off.
- Shutter speed indicator (graphic display only). Graphically illustrates that faster shutter speeds are better for action/slower for scenes with less movement.
- Aperture indicator (graphic display only). Icons indicate that wider apertures produce less depth-of-field (represented by a "blurry" background icon).
- Face Detection. When this feature is activated, the camera attempts to detect faces in the scene before it, and, if it does, it adjusts autofocus and exposure accordingly.
- Smile Shutter. With this feature turned on, the camera will automatically trigger the shutter when the subject smiles. I discuss its operation in Chapter 3.

Enabling/Disabling LCD/EVF Displays

Once you've gotten used to your a68, you will probably develop some preferences as to which of the displays are available when pressing the DISP button. You can activate or deactivate any of them, so that only those you prefer are shown. You'll need to visit the Setup menu, which I'll explain in more detail in Chapter 4, but the process is easy. Just follow these steps:

- 1. **View menus.** Press the MENU button, located on the upper-left corner of the back of the a68. Press left/right to highlight the Custom Settings 2 menu. The tab with the four Custom Settings menu listings is represented by a gear icon, as you can see at left in Figure 2.15.
- 2. **Choose DISP Button.** Then select Monitor or Viewfinder. Press up/down to highlight either choice; the former controls the displays offcred for the LCD monitor, while the latter is used to set the displays for the EVF. Press OK to view the selection screen, like the one at right in Figure 2.15, which shows the LCD version.
- 3. **Use up/down to highlight any of the display choices.** Press the center button to mark or unmark any of them. You must have at least one display option selected, however. Four of the options, Graphic Display, Display All Info., No Disp. Info., and For Viewfinder (not available with the LCD monitor) should be familiar to you from the discussion in the previous section. The fifth, Histogram, adds a screen that is similar to the No Disp. Info screen, but with a histogram chart lodged in the lower-right corner of the screen. The histogram provides a live view of exposure data, representing the number of black, white, and gray tones that will be captured in your image. I'll show you how to work with histograms in Chapter 5 (their use is beyond the scope of this Roadmap chapter).
- 4. **Confirm your choice.** When you've finished marking/unmarking the display screens, highlight Enter and press the center button to confirm and exit.
- 5. **Repeat for the other type of display.** You may want a different set of choices for the EVF and LCD. The setup screens for each are identical, except that the For Viewfinder option is not available for the electronic viewfinder.

Figure 2.15 Navigate to the Custom Settings 2 menu (left). Mark or unmark the displays (right).

Tilting the Screen

With the a68, the LCD monitor can be pulled away from the camera body and tilted up or down (but not rotated or swiveled) to provide a variety of views from different viewing positions. With the screen swiveled up, you can easily hold the camera down at waist level and compose your image without bending over. In this way, you can compose a photograph that looks better when taken from a low angle, and you don't have to get down on your belly or crouch in a squat.

On the other hand, if you flip the screen so it aims downward you can hold the camera above your head to peer over the tops of crowds or

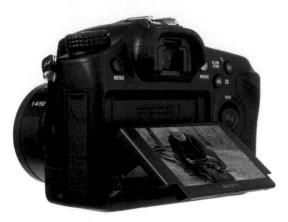

Figure 2.16

physical obstructions, and compose the image in the LCD, sort of like submarine commanders with their raised periscopes. I appreciate this mode at concerts, because I can raise the camera up over the heads of the multitude milling around in front of me.

Going Topside

The top surface of the Sony a68 has several frequently accessed controls of its own. They are labeled in Figure 2.17:

- Mode dial. Rotate this dial to switch among Scene modes and semi-automatic and manual exposure modes. You'll find these exposure modes and options described in more detail in Chapter 5.
- ISO button. This button gives you access to a menu for specifying ISO sensor sensitivity settings, from ISO 100 to ISO 25600, plus Auto and Multi Frame Noise Reduction. Some of these settings may not be available, depending on the camera's other settings, including Shooting mode and image quality. Scroll down through the list of these choices one line at a time using the up/down buttons or the front control dial. If you prefer not to use this button, you can get to the same selection screen by using the Fn button and navigating through the Function menu. I'll provide more details about ISO settings in Chapter 5.
- Exposure button. In Shooting mode, with the mode dial set to Program, Aperture Priority, Shutter Priority, Panorama, or Continuous Advance Priority AE, press this button to produce the exposure compensation display. Then, press the left/right control wheel keys or turn the front control dial to add or subtract from the camera's exposure setting.

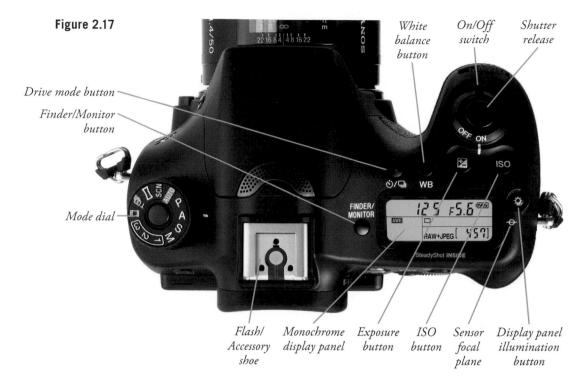

- Flash/Accessory shoe. Slide an electronic flash into the Sony multi interface shoe to mount a more powerful strobe. A dedicated flash unit, like those from Sony, can use the multiple contact points shown to communicate exposure, zoom setting, white balance information, and other data between the flash and the camera. There's more on using electronic flash in Chapter 10. Some earlier model Sony cameras, like their Minolta predecessors (since 1988), used a non-standard accessory/flash shoe mount, rather than the industry-standard ISO 518 configuration. That kept you from attaching electronic flash units, radio triggers, and other accessories built for the standard shoe, unless you use one of the adapters that are available. This update to the original design does use the standard shoe with some extra contacts for Sony accessories; you'll need an adapter for the Sony multi interface shoe only if you have older flash or other accessories designed for the original Sony shoe and want to use them on your new camera.
- Microphones. These openings just aft of the flip-up flash house the right and left microphones that record the stereo sound for your movies. Be careful not to cover these holes with your hand or anything else while recording a movie.
- Finder/Monitor button. This control switches the display between the EVF and Monitor. If you've disabled automatic switching using the Eye-Start sensor, you can manually toggle between the two displays with this button.

- **Drive mode button.** Press this button to produce a screen that lets you choose a drive mode. Then press up/down to select from Single-shot advance; Continuous advance (with high- and low-speed options selectable with the left/right buttons); Self-timer (with 10- and 2-second options available with the left/right buttons); Self-timer (Continuous) that offers the option of taking 3 or 5 pictures once the delay has elapsed; Continuous exposure bracketing (three or five shots with one shutter press, with exposure interval from 1/3 to 3 stops selected using left/right buttons); Single Bracketing, with the same exposure options; White Balance bracketing (a series of three shots with a specified variation in white balance, selectable with left/right buttons); and DRO (Dynamic Range Optimizer) bracketing also with Hi or Lo increments. You'll find more about bracketing in Chapter 5; the self-timer, continuous advance, and the Remote Commanders are discussed in Chapter 7. Here again, the drive mode button is a convenient shortcut; you can get to the same options by pressing the Fn button and navigating through the Function menu.
- WB button. This button gives you immediate access to an important function that otherwise would require a trip to the Function menu using the Fn button. With this button, one push takes you straight to the screen for selecting among the various white balance options: Auto, Daylight, Shade, Cloudy, Incandescent, Fluorescent, Flash, Color Temperature, Color Filter, and Custom. You navigate through these choices. Press left/right to make further adjustments to any of the individual settings. I'll discuss white balance in more detail in Chapter 7.
- On/Off switch. Rotate all the way clockwise to turn the a68 on; in the opposite direction to switch it off.
- **Top monochrome display panel.** This LCD display provides a quick look at essential information, such as white balance setting, shutter speed, f/stop, battery status, drive mode, image quality, and exposures remaining.
- Display panel illumination button. Press to light up the top monochrome display panel.
- Shutter release button. Partially depress this button to lock in exposure and focus. Press all the way to take the picture. Tapping the shutter release when the camera has turned off the autoexposure and autofocus mechanisms reactivates both. When a review image is displayed on the back-panel color LCD, tapping this button removes the image from the display and reactivates the autoexposure and autofocus mechanisms.
- Sensor focal plane. Precision macro and scientific photography sometimes requires knowing exactly where the focal plane of the sensor is. The symbol displayed on the top of the camera marks that plane.

Underneath Your Sony a68

The bottom panel of your Sony a68 is pretty bare. You'll find a tripod socket and the battery compartment door. Figure 2.18 shows the underside view of the camera.

- **Tripod socket**. Attach the camera to a vertical grip, flash/microphone bracket, tripod, monopod, or other support using this standard receptacle.
- Battery compartment door. Your NP-FM500H battery goes in here.

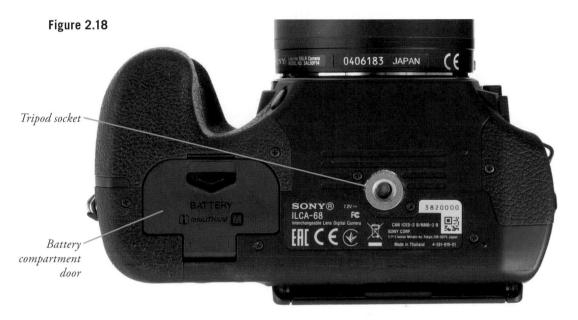

Lens Components

There's not a lot going on with most Sony lenses in terms of controls because, in the modern electronic age, most of the functions previously found in lenses in the ancient film era, such as autofocus options, are taken care of by the camera itself. Nor do Sony lenses require an on/off switch for image stabilization, because SteadyShot is built into the sensor components. Not every lens has every feature or component, so I've illustrated two common types—a zoom and a fixed focal length ("prime") lens that contain many of the basic components, in Figure 2.19.

- Lens hood bayonet. This is used to mount the lens hood for lenses that don't use screw-mount hoods (the majority).
- **Zoom ring.** Turn this ring to change the zoom setting.
- Zoom scale. These markings on the lens show the current focal length selected.
- Focus ring. This is the ring you turn when you manually focus the lens.

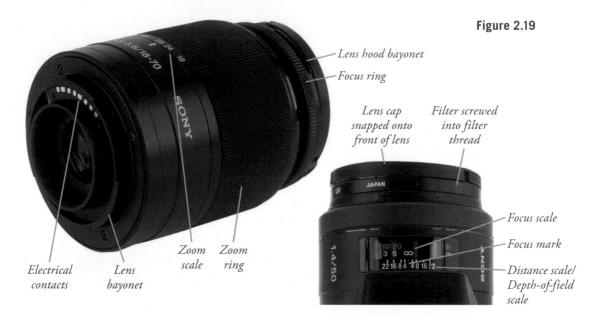

- Electrical contacts. On the back of the lens are electrical contacts that the camera uses to communicate focus, aperture setting, and other information.
- Lens bayonet. This mount is used to attach the lens to a matching bayonet on the camera body.
- Filter screwed into filter thread. Lenses (including those with a bayonet lens hood mount) have a thread on the front for attaching filters and other add-ons. Some also use this thread for attaching a lens hood (you screw on the filter first, and then attach the hood to the screw thread on the front of the filter). A filter is shown screwed into the filter thread at lower right in Figure 2.19.
- Distance scale/Depth-of-field scale. Some lenses, especially prime lenses like the one at lower right in the figure, have this readout that rotates in unison with the lens's focus mechanism to show the distance at which the lens has been focused. It's a useful indicator for double-checking autofocus, roughly evaluating depth-of-field, and for setting manual focus guesstimates.
- AF/MF switch (not shown). Some Sony lenses have a switch to choose between autofocus and manual focus; some do not. With the Sony a68, you need to switch focus modes on the lens, if it has such a switch. If the lens does not have such a switch, then you need to use the switch on the camera to change from autofocus to manual focus and vice-versa.

Camera Settings Menu

The Sony a68 has a remarkable number of features and options you can use to customize the way your camera operates. Not only can you change settings used at the time the picture is taken, but you can adjust the way your camera behaves. This chapter and the next will help you sort out the settings for all of the menus. These include the Camera Settings, Custom Settings, Playback, and Setup menus. This chapter details options with the Camera Settings menu; the Custom Settings, Playback, and Setup menus will be addressed in Chapter 4.

If you haven't owned a Sony A-mount camera before, you *really* need these chapters. Sony apparently thinks that even a complex camera like the a68 is so easy to use that comprehensive printed manuals are no longer necessary. Only the briefest of quick start information is included in the box in the form of a 99-page booklet, and the company offers a marginally more complete Help Guide that can be accessed over the Internet—assuming you're using your camera alongside your computer or other Internet-capable device. A PDF version of this Help Guide can sometimes be located for downloading from third-party websites (which is how I got mine). Check the eSupport pages of your country's Sony website to download relevant manuals. Sony also will *sell* you a printed copy of the manuals for the a68, from True Manuals. The price is apparently a secret. I was required to submit an e-mail request for the price, and they never responded.

I'm not going to waste a lot of space on some of the more obvious menu choices in these chapters, especially those with only On/Off options. Instead, I'll devote no more than a sentence or two to the blatantly obvious settings and concentrate on the more complex aspects of setup, such as autofocus. I'll start with an overview of using the camera's menus themselves.

Anatomy of the Menus

To enter the menu system, press the MENU button. Your camera may have been set up by a well-meaning employee of a camera store and a Tile menu with icons for each of the four main menu headings appears. (See Figure 3.1.) That screen is essentially useless, as the only thing you can do with it is move to the conventional menu system Sony now uses. Your best bet is to disable it and leave it turned off for the rest of your life to eliminate the extra step. Use the Setup 2 menu's Tile Menu setting to disable it, described in the next chapter.

Thereafter, pressing the MENU button takes you without further ado directly to a screen similar to the one shown in Figure 3.2. When the upper tab bar is active, the currently selected menu tab will be highlighted in orange, as you can see in the figure. Press the down button or rotate the control dial to move the highlighting down into the selected tab. You can choose any item in the

Figure 3.1
Pressing the MENU
button reveals the
Tile menu, which
displays icons representing the four
menu categories.

Figure 3.2 You can bypass the Tile menu and go directly to the a68's conventional menu system.

displayed tab, and press the center button to produce a screen where you can adjust the highlighted entry. While navigating within any menu tab, use the left/right presses of the multi-selector, or rotate the control dial to move to the next tab in that menu group, and then to wrap around to the first tab in the next group.

For example, if you are using the Camera Settings menu, the right key will take you from Camera Settings 1 to Camera Settings 2, Camera Settings 3, Camera Settings 4, Camera Settings 5, Camera Settings 6, Camera Settings 7, Camera Settings 8, and Camera Settings 9, and thence onward to Custom Settings 1. Each of the main tabs may have several sub-tabs: the Camera Settings menu has tabs 1–9; the Custom Settings menu has tabs 1–7; the Playback menu has tabs 1–2; and the Setup Settings menu boasts tabs 1–5. The advantage to having so many menu tabs is that all the entries for a given page can be shown on a single screen, with no downward scrolling required.

Of course, not everything has to be set using these menus. The a68 has some convenient direct setting controls, such as buttons that provide quick access to the drive modes, white balance, exposure compensation, and ISO options (on top of the camera's right shoulder). These buttons allow you to bypass the multi-tabbed menus for many of the most commonly used camera functions and a pair of Custom buttons (C1 and C2) can be assigned any of several different behaviors, as described in Chapter 4. There is also a Function menu that appears when you press the Fn button, with a set of shooting setting options, as I outlined earlier in Chapter 2.

At times you will notice that some lines on various menu screens are "grayed out"; you cannot select them given the current camera settings. For example, if you decide to shoot a panorama photo, you may find that the Panorama: Size and Panorama: Direction choices are grayed out. Want to know why? Scroll to the grayed out item and press the center button. The camera then displays a screen that explains why this feature is not available: because the feature is not available when Shutter Priority shoot mode is active, in this example. Unfortunately, that's not very helpful. The screen should have instead told you that the Sweep Panorama settings are not available when the Shoot mode is anything other than Sweep Panorama. Given the incomplete information (and lacking this book), you might have spent several frustrating minutes switching to other shooting modes, still to find that no Panorama settings are possible. In addition, there are many grayed out menu entries with advice that boils down to "Not Available" with no reason given. Thanks, Sony!

After this long intro, let's finally get to a description of every item in the four feature-packed menu categories. I do not intend the following to be a laundry list of items. Instead, it should be an important part of the education process into most aspects of the a68; it should also guide you in setting up the camera with the most useful options that Sony has provided.

As an aid to choosing your own settings, I'm going to provide my own preferences that I use for most shooting situations. You can use those as a starting point, and adjust from there to suit your needs.

ABOUT THOSE ICONS

Menu entries are preceded by an icon, such as the "mountain" icon shown next to the Image Size, Aspect Ratio, and Quality entries in Figure 3.2. A mountain icon indicates that the particular menu entry applies *only* to still photography; an icon resembling a film frame that appears in other menus shows that the menu entry applies *only* to movie making. Presumably, entries without any icon can be used with both. The Enlarge entry in the Playback menu, and Language entry in the Setup menu are preceded by magnifying glass and text icons, respectively, and apparently are used just for decorative purposes. To avoid superfluous detail, I may not always explicitly say that a given menu entry is for still photography (only) or movie shooting (only). The icons on the menu listing should be your tip-off.

Camera Settings Menu

Figure 3.2, earlier, shows the first screen of the Camera Settings menu. As you can see, at most only a half dozen items are displayed at one time. The items found in this menu include:

- Image Size (Stills)
- Aspect Ratio (Stills)
- Quality (Stills)
- Panorama: Size
- Panorama: Direction
- File Format (Movies)
- Record Setting (Movies)
- Drive Mode
- Flash Mode
- Flash Compensation
- Flash Control
- Power Ratio
- Red Eye Reduction
- Focus Mode
- Focus Area
- AF Illuminator (Stills)
- AF Drive Speed (Stills)

- AF Track Sensitivity (Stills)
- AF Track Sensitivity (Movies)
- Exposure Compensation
- Exposure Step
- ISO
- Metering Mode
- White Balance
- DRO/Auto HDR
- Creative Style
- Picture Effect
- Zoom
- Focus Magnifier
- Long Exposure Noise Reduction (Stills)
- High ISO Noise Reduction (Stills)

- Center Lock-on AF
- Smile/Face Detection
- Soft Skin Effect (Stills)
- Auto Object Framing (Stills)
- Auto Mode
- Scene Selection
- Movie
- SteadyShot (Stills)
- SteadyShot (Movies)
- Color Space (Stills)
- Auto Slow Shutter (Movies)
- Audio Recording
- Audio Rec. Level
- Wind Noise Reduction
- Memory

Image Size (Stills)

Options: L, M, S

Default: L

My preference: L

Here you can choose between the a68's Large, Medium, and Small settings for JPEG still pictures. The larger the size that's selected, the higher the resolution: the images are composed of more megapixels. (If you select RAW or RAW & JPEG for Quality [described shortly], you'll find that the Image Size option is grayed out, because the camera will always shoot large photos.) As you scroll among the options, you'll note that the Large size shows 24M for 24 megapixels, while Medium indicates 12 megapixels, and Small shows 6 megapixels as the size/resolution. This assumes that you are using the standard 3:2 aspect ratio; the image sizes are smaller if you set the 16:9 option. Both are discussed below in the Aspect Ratio item, but I'll provide Table 3.1 now as a comparison.

Scroll to this menu item, press the center button, and scroll to the desired option: L, M, or S. Then press the center button to confirm your choice. The actual size of the images depends on the aspect ratio you have chosen in the subsequent menu item (discussed below), either the standard 3:2 or the wide-screen 16:9 format.

There are few reasons to use a size other than Large with this camera, even if reduced resolution is sufficient for your application, such as photo ID cards or web display. Starting with a full-size image gives you greater freedom for cropping and fixing problems with your image editor. An 800×600 –pixel web image created from a full-resolution (large) original often ends up better than one that started out as a small JPEG.

Table 3.1 Image Sizes Available					
Image Size	Megapixels 3:2 Aspect Ratio	Resolution 3:2 Aspect Ratio	Megapixels 16:9 Aspect Ratio	Resolution 16:9 Aspect Ratio	
Large (L)	24M	6000 × 4000 pixels	20M	6000 × 3376 pixels	
Medium (M)	12M	4240×2832 pixels	10M	4240×2400 pixels	
Small (S)	6M	3008 × 2000 pixels		3008 × 1688 pixels	

Aspect Ratio (Stills)

Options: 3:2, 16:9 aspect ratios

Default: 3:2

My preference: 3:2

The aspect ratio is simply the proportions of your image as stored in your image file. The standard aspect ratio for digital photography is approximately 3:2; the image is two-thirds as tall as it is wide, as shown by the outer green rectangle in Figure 3.3. These proportions conform to those of the most common snapshot size in the USA, 4×6 inches. Of course, if you want to make a standard 8×10 —inch enlargement, you'll need to trim some of the length of the image area since this format is closer to square; you (or a lab) would need 8×12 —inch paper to print the full image area. The 3:2 aspect ratio was also the norm in photography with 35mm film.

If you're looking for images that will "fit" a wide-screen computer display or a high-definition television screen, you can use this menu item to switch to a 16:9 aspect ratio which is much wider than it is tall. The camera performs this magic by cutting off the top and bottom of the frame (as illustrated by the yellow boundaries in Figure 3.3), and storing a reduced-resolution image (when shooting in JPEG mode). In 16:9 mode, the camera crops the preview image in live view to show you the actual area covered in the final image.

When shooting RAW, the camera always captures the full frame, but includes a parameter in the RAW file data that notes your aspect ratio setting. Software like Sony's Image Data Converter will allow you to make the desired 16:9 crop when the image is imported. So, if you need the wide-screen look, this menu option can save you some time in image editing.

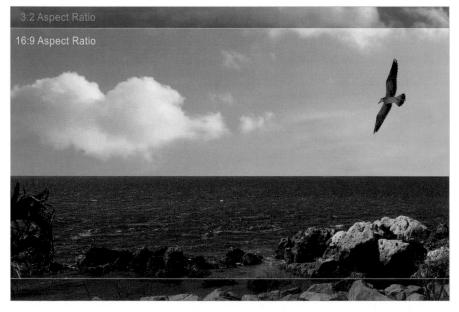

Figure 3.3
The 3:2 aspect ratio is shown by the outer green box. The yellow bars indicate the 16:9 aspect ratio (achieved either incamera or later by cropping in software).

You can still achieve the same proportions (or any other aspect ratio) by trimming a full-resolution image with your software. Your 24M image becomes a 20M shot if you set the camera to shoot in 16:9 aspect ratio for JPEGs instead of using the default 3:2 option. In either case, you're discarding pixels and losing some resolution.

Quality (Stills)

Options: RAW, RAW & JPEG, Extra Fine, Fine, Standard

Default: Fine

My preference: Fine for sports/action; RAW & JPEG for general shooting

This menu item lets you choose the image quality settings that will be used by the a68 to store its still photo files. You have four options: RAW, RAW & JPEG, Fine, and Standard. In truth, RAW is a file format and not a quality item at all, but nearly all cameras include this option in the Quality section of their menus. (The Extra Fine, Fine, and Standard options are relevant only to JPEGs.) Here's what you need to know to choose intelligently:

- JPEG compression. To reduce the size of your image files and allow more photos to be stored on a given memory card, the camera's processor uses JPEG compression to squeeze the images down to a smaller size. This compacting reduces the image quality a little, so you're offered your choice of Extra Fine, Fine, and Standard compression. Standard compression is quite aggressive; the camera discards a lot of data. When you open a JPEG in a computer, the software restores the missing data, but this is an imperfect process so there's some loss of quality. Fine is somewhat better and can be used for general-purpose shooting. It's a good compromise when you want high quality, but need fast continuous speeds for sports and other fast-moving subjects. You'll find that Extra Fine provides even better results so it should really be your standard when shooting JPEG photos.
- JPEG, RAW, or both. You can elect to store only JPEG versions of the images you shoot (Extra Fine, Fine, or Standard), or you can save your photos as "unprocessed" RAW files, which consume several times as much space on your memory card. Or, you can store both file types at once as you shoot. The JPEG will then be Large/Fine; the camera provides no options for modifying JPEG size or quality in the RAW & JPEG option.

Many photographers elect to shoot *both* a JPEG and a RAW file (RAW & JPEG), so they'll have a JPEG Fine version that might be usable as-is, as well as the original "digital negative" RAW file in case they will later want to make some serious editing of the photo with imaging softwarc for reasons discussed shortly. If you use the RAW & JPEG option, the camera will save two different versions of the same file to the memory card: one with a JPG extension, and one with the .ARW extension that signifies Sony's proprietary RAW format that consists of raw data.

Note that the a68 saves a *Fine JPEG* when shooting RAW & JPEG, rather than an *Extra Fine* version. The reasoning is that you can always extract an Extra Fine—equivalent JPEG image from the RAW file and the Fine JPEG is good enough for general-purpose use. So, if you are shooting JPEG only and want the best quality, choose Extra Fine.

As I noted under Image Size, there are some limited advantages to using the Medium and Small resolution settings, and similar space-saving benefits accrue to the Standard JPEG compression setting. All of these options help stretch the capacity of your memory card so you can shoehorn quite a few more pictures onto a single card. That can be useful when you're away from home and are running out of storage, or when you're shooting non-critical work that doesn't require full resolution (such as photos taken for real estate listings, web page display, photo ID cards, or similar applications).

But for most work, using lower resolution and extra compression is false economy. You never know when you might actually need that extra bit of picture detail. Your best bet is to have enough memory cards to handle all the shooting you want to do until you have the chance to transfer your photos to your computer or a personal storage device.

JPEG vs. RAW

You'll sometimes be told that RAW files are the "unprocessed" image information your camera produces, before it's been modified. That's nonsense. RAW files are no more unprocessed than your camera film is after it's been through the chemicals to produce a negative or transparency. A lot can happen in the developer that can affect the quality of a film image—positively and negatively—and, similarly, your digital image undergoes a significant amount of processing before it is saved as a RAW file. Sony even applies a name (BIONZ X) to the digital image processor used to perform this magic in the Sony Alpha cameras.

A RAW file is closer in concept to a film camera's processed negative. It contains all the information, with no compression, no sharpening, no application of any special filters or other settings you might have specified when you took the picture. Those settings are stored with the RAW file so they can be applied when the image is converted to JPEG, TIF, or another format compatible with your favorite image editor. However, using RAW converter software such as Adobe Camera Raw (in Photoshop, Elements, or Lightroom) or Sony's Image Data Converter (available for download from various Sony websites worldwide), you can override a RAW photo's settings (such as White Balance and Saturation) by applying other settings in the software. You can make essentially the same changes there that you might have specified in your camera before taking a photo.

Making changes to settings such as White Balance is a non-destructive process when making the conversion with a RAW converter since the adjustments are made before the photo is fully processed by the software program. Changing settings does not affect image quality, except for adjustments to exposure, highlight or shadow detail, and saturation; the loss of quality is minimal, however, unless the changes you make for these aspects are significant.

The RAW format exists because sometimes we want to have access to all the information captured by the camera, before the camera's internal logic has processed it and converted the image to a standard file format. A RAW photo does take up more space than a JPEG and it preserves all the information captured by your camera after it's been converted from analog to digital form. Since

we can make changes to settings after the fact while retaining optimal image quality, errors in the settings we made in-camera are much less of a concern than in JPEG capture. When you shoot JPEGs, any modification you make in software is a destructive process; there is always some loss of image quality, although that can be minimal if you make only small changes or are skilled with the use of adjustment layers.

Note too that JPEG provides smaller files by compressing the information in a way that loses some image data. (RAW compression is lossless, however.) The lost data is reconstructed when you open a JPEG in a computer, but this is not a perfect process. If you shoot JPEGs at the highest quality (Extra Fine) level, compression (and loss of data) are minimal; you might not be able to tell the difference between a photo made with RAW capture and a Large/ Extra Fine JPEG. If you use the lower quality level, you'll usually notice a quality loss when making big enlargements or after cropping your image extensively.

JPEG was invented as a more compact file format that can store most of the information in a digital image, but in a much smaller size. JPEG predates most digital SLRs, and was initially used to squeeze down files for transmission over slow dialup connections and for use with computers that had one or two GB of storage capacity. These days, we have plenty of storage capacity with 1 to 5 terabyte hard drives, but it's still useful to be able to send JPEG images by e-mail. And you cannot upload a RAW file to a website. Of course, you could simply shoot all your photos in RAW format and later convert them to JPEGs of a suitable size.

So, why don't we always use RAW? Although some photographers do save only in RAW format, it's more common to use either RAW plus the JPEG option or to just shoot JPEG and eschew RAW altogether. While RAW is overwhelmingly helpful when an image needs to be modified, working with a RAW file can slow you down significantly. The RAW images take longer to store on the memory card so you cannot shoot as many in a single burst. Also, after you shoot a series, the camera must pause to write them to the memory card so you may not be able to take any shots for a while (or only one or two at a time) until the RAW files have been written to the memory card. When you come home from a trip with numerous RAW files, you'll find they require more post-processing time and effort in the RAW converter, whether you elect to go with the default settings in force when the picture was taken or make minor adjustments.

As a result, those who often shoot long series of photos in one session, or want to spend less time at a computer, may prefer JPEG over RAW. Wedding photographers, for example, might expose several thousand photos during a bridal affair and offer hundreds to clients as electronic proofs on a DVD disc. Wedding shooters take the time to make sure that their in-camera settings are correct, minimizing the need to post-process photos after the event. Given that their JPEGs are so good, there is little need for them to get bogged down working with RAW files in a computer. Sports photographers also avoid RAW files because of the extra time required for the camera to record a series of shots to a memory card and because they don't want to spend hours in extra post-processing. As a bonus, JPEG files consume a lot loss memory in a hard drive.

As I mentioned earlier, when shooting sports I'll switch to shooting Large/Fine JPEGs (with no RAW file) to minimize the time it takes for the camera to write a series of photos to the card; it's great to be able to take another burst of photos at any time, with little or no delay. I also appreciate the fact that I won't need to wade through long series of photos taken in RAW format.

In most situations, however, I shoot virtually everything as RAW & JPEG. Most of the time, I'm not concerned about filling up my memory cards, as I usually carry at least three 32GB (or larger!) memory cards with me. (A fast SanDisk Extreme 95MB/s card like this costs as little as \$35 through some major online retailers in the U.S.) On my last trip to Europe, I took only RAW photos and transferred them onto my laptop computer each evening, since I planned on doing at least some post-processing on many of the images for a travel photography book I was working on.

Panorama: Size

Options: Standard, Wide

Default: Standard **My preference:** Wide

This item is available only when the shooting mode is set to Sweep Panorama mode (usually abbreviated as Panorama). This item offers only two options: the default Standard and the optional Wide, which can produce a longer panorama photo.

With the Standard setting, if you are shooting a horizontal panorama, the size of your images will be 8192×1856 pixels. If your Standard panorama photos are vertical, the size will be 3872×2160 pixels. (The options for panorama direction are covered in the next section.) If you activate the Wide option instead, horizontal panoramas will be at a size of 12416×1856 pixels, and vertical panoramas will be 5536×2160 pixels. Of course, vertically panned panorama photos are actually "tall" rather than wide regardless of the option you select.

The a68 uses identical processing to capture both standard and wide panoramas; it simply *stops* the capture process sooner with the Standard specification, and continues to grab picture information for a longer period of time when Wide is selected. So, the main reasons for using Standard include subjects that don't lend themselves to an ultra-wide perspective and/or a desire to grab a decent panorama quickly. Figure 3.4 shows the relative proportions of the Standard and Wide horizontal panorama formats, an image of the quaint Low Key Hideaway in Cedar Key, Florida, where I spent the worst of one winter as my photography base of operations. Tilting the camera sideways and panning upward yielded the image captured using Standard and Wide proportions.

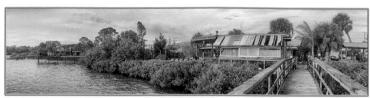

Figure 3.4 Horizontal wide format (yellow box) and standard format (green box).

Figure 3.5 Vertical "wide" format (yellow box) and standard format (green box).

Panorama: Direction

Options: Right, Left, Up, Down

Default: Right

My preference: Right or Down

When the shooting mode is set to Sweep Panorama, this menu item gives you four options for the direction in which the camera will prompt you to pan: right, left, up, or down. The camera actually is processing the image pieces you have already captured *as you continue to shoot*, so you have to select one of these so the camera will know ahead of time how to perform this processing of the many JPEGs you'll shoot while panning. Within seconds of finishing the capture, all your shots will be aligned and stitched together into the final panorama photo. The default, right, is probably the most natural way to sweep the camera horizontally, at least for those of us who read from left to right. Of course, you may have occasions to use the other options, depending on the scene to be photographed; for a panorama photo of a very tall building, for example, you'd want to use one of the vertical options (up or down).

Note that when the live view screen is displayed on the LCD or EVF, you can cycle among the four shooting directions by rotating the control dial.

Sony cameras use identical cropping schemes to produce their panorama pictures, so the resulting images have the same pixel dimensions/resolution regardless of which camera was used to produce them. Table 3.2 shows the size and resolution of Wide and Standard panoramas in both horizontal and vertical camera orientations.

Shooting Panoramas

I spend most winters in the Florida Keys and expend a lot of time taking panoramas. While the process is simple in concept, it can be frustrating in execution, chiefly because it's easy for your "sweeping" motion to be too fast or too slow, and you may be 80 percent through the process when the a68 informs you that your movement was at the wrong pace.

Table 3.2 Sweep Panorama Image Sizes Available					
a68	Megapixels	Resolution			
Standard Panorama—Horizontal	15M	8192 × 1856			
Wide Panorama—Horizontal	23M	12416 × 1856			
Standard Panorama—Vertical	8.4M	2160 × 3872			
Wide Panorama—Vertical	12M	2160 × 5536			

Here's a procedure that will help you minimize the frustration.

- 1. Know that if your a68 is set to RAW or RAW & JPEG, the camera will temporarily switch to JPEG mode for the panorama (panos cannot be shot using RAW format), but will restore your original setting when you rotate the mode dial out of the Panorama position.
- 2. Your "wide" panorama will encompass roughly 220 degrees, so plant your feet firmly such that the center of your picture is straight in front of you. Keep the camera as near to your body as possible (use the EVF—please don't shoot panos with the LCD monitor!) so that the rotation point as your body twists is as close as possible to the sensor plane.
- 3. Lock focus and exposure before you start shooting, as the a68 doesn't adjust once capture begins.
- 4. With your feet securely anchored, twist your body as far as you can toward the angle you'll use for the beginning of the exposure. That is, if you choose Right, twist as far as you can to the right.
- 5. While viewing through the electronic viewfinder, begin shooting, slowly "untwisting" to pan the camera until you're facing forward again.
- 6. Continue twisting smoothly toward the finish position. It's important to keep a constant speed.
- 7. As you shoot, the camera will provide a highlighted view of the area currently being captured, as it takes a series of overlapping shots. An arrow is shown on the screen (either EVF or LCD) to indicate the direction you should be moving.
- 8. If you rotate too slowly or too quickly, a message that the a68 could not shoot the panorama will appear, advising you to move more slowly or more quickly.
- 9. You'll finish twisted all the way in the opposite direction from your initial position. When you have successfully captured a panorama, the screen will blank for a few seconds while the camera stitches your exposures together. It will then display your finished shot.
- 10. The preview shows a reduced-size version of the entire panorama; press the center button to see a scrolling display of the entire shot.

There are a couple aspects of panorama shooting that you might not have considered:

- Accidental "Multiple" exposures. Panoramas are best rendered with subjects that do not move. If something is in motion as you sweep the camera, you may get multiple renditions of that subject, as shown in Figure 3.6.
- Collateral "damage" from cropping. Avoid including very important information at the very top and bottom of your frames (when shooting in left/right mode, for example). Because you probably won't hold the camera perfectly level as you pan, the a68 will automatically align your images as they are stitched together, and there will often be some "excess" image above and/or below that is cropped out to produce a seamless image.

■ Yes, you can use vertical orientation for horizontal pans. It may seem counter-intuitive, but you can rotate the camera to vertical orientation and still shoot a horizontal panorama. Because each of the frames that are captured has a 2:3 aspect ratio, rather than the standard 3:2 aspect ratio, you'll end up with a pano that's less wide, and encompasses more of the scene vertically. Simply set Panorama: Direction to Up and pan right to left, or Down and pan left to right when the camera has been rotated 90 degrees counterclockwise. You'll end up with a different aspect ratio that is less widescreen in appearance, as you can see in Figure 3.7.

Figure 3.6 Moving subjects in your panorama may appear multiple times.

Figure 3.7
Horizontal panorama with the camera rotated to vertical orientation, and Panorama: Size set to Standard (top); Standard horizontal panorama (bottom).

File Format (Movies)

Options: XAVCS S, AVCHD, MP4

Default: AVCHD

My preference: AVCHD

This is the first entry in the Camera Settings 2 menu (see Figure 3.8). The a68 offers full HD (high-definition) video recording in the AVCHD format in addition to the somewhat lesser quality MP4 format. Advanced video shooters can also choose XAVC S HD, which supports faster recording speeds (up to 50 Mbps, compared to 28 Mbps for AVCHD) for improved quality.

By default, movies are recorded in AVCHD, but this menu item allows you to switch to XAVC S or MP4. The MP4 format can be edited by many software programs and is more likely to be supported by older computers than AVCHD or either XAVC S choice. The MP4 format is lower in resolution (1440×1080 pixels) and more "upload friendly"; in other words, it's the format you'll want to use if you plan to post video clips on a website. I prefer it for those just getting into movie making. If you elect to use XAVC S, you'll need a fast memory card of at least 64GB capacity to support the higher frame rates possible with this pro format. I'll be discussing all these aspects and many other video shooting features in Chapter 8.

File Format is the first entry in the Camera Settings 2

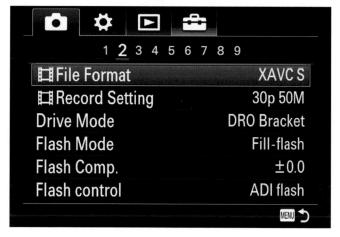

Record Setting (Movies)

Options: Varies (See Table 3.3)
Default: AVCHD: 60i (FH) 17M

My preference: AVCHD: 60i (FH) 17M

This item allows you to choose from various options if you are using AVCHD, XAVC S, or MP4. The quality provided by the default (FX) in AVCHD is very good, but you can get even higher quality with some of the other options, and you'll get a "cinematic" feel with a framing rate of 24 fps (or 25 fps). If you use the MP4 format instead, you'll get 30p (30 fps) in NTSC countries and 25p (25 fps) in PAL countries when recording with the high-resolution option; the VGA option is always at 30p (30 fps). All of the terminology and concepts will make more sense when you read Chapter 8, which provides more of an education on many aspects of movie making.

Table 3.3 Record Setting Options							
File Format	Record Setting	g					
XAVC S	60/50p 50M	30/25p 50M	24p 50M				
AVCHD	60/50i 24M (FX)	6050i 17M (FH)	60/50p 28M (PS)	24/25p 24M (FX)	24/25p 17M (FH)		
MP4	1440 × 1080 12M	VGA 3M					

Drive Mode

Options: Single Shooting, Cont. Shooting (Lo/Hi), Self-timer (2/10 seconds), Self-timer Continuous (3 or 5 shots), Continuous Bracket (3 or 5 images at 0.3/0.7/1.0/2.0/3.0 increments), Single Bracket (3 or 5 images at 0.3/0.7/1.0/2.0/3.0 increments), White Balance Bracket (Lo/Hi), DRO Bracket (Lo/Hi)

Default: Single Shooting

My preference: Continuous Bracket (3 images, 0.7 increment) for serious shooting; Single Shooting for everyday subjects; Continuous Shooting for action

Just as with the drive button on the top of the camera (just left of the WB button) and the drive mode settings in the Fn menu, there are several choices available through this single menu item. You cannot change drive mode if the camera is set for HDR or Multi-Frame Noise Reduction; in those cases, continuous shooting is mandatory.

All of the choices below other than Single Shooting have options (as noted in their descriptions) that you can access by pressing the left/right directional buttons or rotating the control wheel.

- **Single Shooting.** Takes one shot each time you press the shutter release button.
- Continuous Shooting (Hi, Low). Captures images at a rate of up to 5 frames per second at the Hi setting (the default). At the Lo, you can grab about 2.5 frames per second. Exposure and focus will change as necessary for each shot. If you'd like to use the same exposure and focus for subsequent shots, change the AEL w/shutter entry in the Custom Settings menu to Auto or Off, and the Focus Mode setting in the Shooting menu to Continuous AF or Automatic AF.
- Self Timer (2 sec./10 sec.). Takes a single picture after two or ten seconds have elapsed. When this choice is highlighted, press the left/right buttons to toggle between the two durations. The 2 sec. choice is excellent when you just want to avoid camera shake from "punching" the shutter button; a short delay allows any residual motion in the camera to subside. The 10 sec. option is the one you'll want to use if you plan to jump into the picture yourself. The best part about self-timer mode is that it's always available; you don't have to bring your remote control.
- **Self Timer Continuous.** The self-timer counts down, and then takes either 3 or 5 images. The left/right buttons toggle between the two. This feature is most useful when there is something moving in the frame that can be captured in different positions or moods. While either self-timer is counting down, you can halt the process by pressing the drive mode button again.
- Continuous Bracket. Captures three or five images in one burst when the shutter release is held down, bracketing them 0.3, 0.7, 1.0, 2.0, or 3.0 stops apart. The left/right buttons are used to select the increment and number of shots. In Manual exposure (when ISO Auto is disabled), or in Aperture Priority, the shutter speed will change. If ISO Auto is set in Manual exposure, the bracketed set will be created by changing the ISO setting. In Shutter Priority, the aperture will change. Use continuous mode when you want all the images in the set to be framed as similarly as possible, say, when you will be using them for manually assembled high dynamic range (HDR) photos. I bracket a *lot* so Continuous Bracket is my default drive mode when I am shooting. I'll provide more tips on bracketing in Chapter 5.
- Single Bracket. Captures one bracketed image in a set of three or five shots each time you press the shutter release, bracketing them 0.3, 0.7, 1.0, 2.0, or 3.0 stops apart. The left/right buttons are used to select the increment and number of shots. In this mode, you can separate each image by an interval of your choice. You might want to use this variation when you want the individual images to be captured at slightly different times, say, to produce a set of images that will be combined in some artistic way.
- White Balance Bracket. Shoots three images, making adjustments to the color temperature for each. While you can't specify which direction the color bias is tilted, you can select Lo (the default) for small changes, or Hi, for larger changes.
- **DRO Bracket.** Shoots three images and makes adjustments to the dynamic range optimization for each. While you can't specify the amount of optimization, you can select Lo (the default) for small changes, or Hi, for larger changes.

TIP

Bracket order for exposure and white-balance bracketing can be set using the Bracket Order entry in the Custom Settings 5 menu, as described later in this chapter. One of the most frustrating things about Sony's menu design is the tendency to scatter related adjustments among different pages and even different menu tabs.

Flash Mode

Options: Flash Off, Auto Flash, Fill Flash, Slow Sync., Rear Sync., Wireless, Flash Exposure Compensation, Red Eye Reduction

Default: Depends on shooting mode

My preference: Fill Flash

This item offers options for the several flash modes that are available. Not all of the modes can be selected at all times as shown in Table 3.4. I'll describe the use each of the options listed below in detail in Chapter 10.

Table 3.4 Flash Modes								
Exposure Mode	Flash Off	Auto Flash	Fill Flash	Slow Sync.	Rear Sync.	Wireless	Flash Exposure Compensation	Red-Eye Reduction
Intelligent Auto								
Superior Auto							3	
Program Auto								
Aperture Priority								
Shutter Priority								
Manual Exposure								

Flash Compensation

Options: -3 to +3 in 1/3 or 1/2 EV steps

Default: 0.0

My preference: 0.0, but apply as required.

This feature controls the flash output. It allows you to dial in plus compensation for a brighter flash effect or minus compensation for a more subtle flash effect. If you take a flash photo and it's too dark or too light, access this menu item. Scroll up/down to set a value that will increase flash intensity (plus setting) or reduce the flash output (minus setting) by up to three EV (exposure value) steps. You can select between 1/3 and 1/2 EV increments in the Exposure Step entry described later in this chapter. Flash compensation is "sticky" so be sure to set it back to zero after you finish shooting. This feature is not available when you're using Intelligent Auto, Superior Auto, many of the Scene modes, or when using Sweep Panorama. I discuss many flash-related topics in Chapter 10.

Flash Control

Options: ADI flash, Pre-Flash TTL, Manual

Default: ADI flash

My preference: ADI flash

The Flash Control setting specifies the method the a68 uses to determine the intensity of the built-in or optional flash. You can select from two automatic methods that will calculate the appropriate flash output for you, and manual (in which case you calculate or estimate the flash level yourself). I'll provide more instructions on auto flash control and how to set manual flash output in Chapter 10. Select from:

- ADI (Advanced Distance Integration) flash. This setting takes advantage of a distance encoding feature built into most Sony lenses, which uses focusing data to provide the flash with more accurate distance information. The distance data is combined with light-metering data from the pre-flash to provide more precise flash exposure control. ADI enables the camera to avoid being deceived by highly reflective or very dark subjects.
- Pre-Flash TTL. In this mode, only information from measuring the amount of light reflected from the subject during the pre-flash is used to calculate exposure. The system can be fooled by subjects that have highly reflective or very dark areas. You might need to use this mode when working with lenses that don't have the distance encoder feature. (Most Sony lenses do. Exceptions are the SAL16F28 16mm f/2.8 fisheye; SAL20F28 20mm f/2.8; SAL28F28 28mm f/2.8; SAL135F28 135mm f/2.8; and SAL500F80 500mm f/8 mirror lens. If you're using third-party lenses, check with your vendor.) The camera will automatically change from ADI to Pre-Flash TTL when a non-compatible lens is mounted.
- Manual. You set the intensity of the built-in flash, but not accessory flash units; you must use the external flash's controls for that. Intensity of the pop-up flash is set using the Power Ratio option, described next.

Power Ratio

Options: 1/1, 1/2, 1/4, 1/8, 1/16

Default: 1/1

My preference: Depends on situation

This is the first entry in the Camera Settings 3 menu. (See Figure 3.9.) Available only when Manual is selected in the Flash Control entry. It is an easy menu entry to use; simply highlight one of the five intensity levels using the directional buttons and press the center button to confirm. There are many reasons why you might want to use manual flash. Perhaps you want to balance your flash with another unit that can't be controlled automatically. Or, you might want a specific amount of fill flash outdoors, say, to brighten shadows just a little.

Red Eye Reduction

Options: On, Off

Default: Off

My preference: Off

When flash is used in a dark location, red-eye is common in pictures of people, and especially of animals. Unfortunately, your camera is unable, on its own, to *eliminate* the red-eye effects that occur when an electronic flash bounces off the retinas of your subject's eyes and into the camera lens. The effect is worst under low-light conditions (exactly when you might be using a flash) as the pupils expand to allow more light to reach the retinas. The best you can hope for is to *reduce* or minimize the red-eye effect.

It's fairly easy to remove red-eye effects in an image editor (some image importing programs will do it for you automatically as the pictures are transferred from your camera or memory card to your computer). But, it's better not to have glowing red eyes in your photos in the first place.

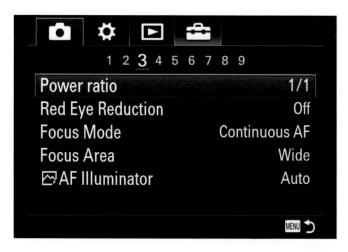

Figure 3.9
Power Ratio is the first entry in the Camera Settings 3 menu.

To use this feature, you first have to pop up the flash to its active position or attach an external flash to the multi interface shoe. When Red Eye Reduction is turned on through this menu item, the flash issues a few brief bursts prior to taking the photo, theoretically causing your subjects' pupils to contract, reducing the red-eye syndrome. Like any such system, its success ratio is not great.

Focus Mode

Options: Single-shot AF (AF-S), Automatic AF (AF-A), Continuous AF (AF-C)

Default: Automatic AF (AF-A)

My preference: Automatic AF (AF-A)

This menu item can be used to set the way in which the camera focuses. I'll discuss focus options in detail in Chapter 6.

- Single-shot AF (AF-S). With this setting, the camera will set focus and it will keep that focus locked as long as you maintain slight pressure on the shutter release button; even if the subject moves before you take the photo, the focus will stay where it was set. If you use this setting for still photos and then switch to Movie mode, the camera switches temporarily to AF-C.
- Automatic AF (AF-A). This default setting begins to focus using AF-S, but will switch to continuous autofocus (AF-C) if your subject is moving. This is a good all-purpose setting when you aren't sure whether your subject will suddenly begin moving around as you shoot.
- Continuous AF (AF-C). The camera will continue to adjust the focus if the camera-to-subject distance changes, as when a cyclist approaches your shooting position. The camera will constantly adjust focus to keep the subject sharply rendered. It uses predictive AF to predict the moving subject's position at the time you'll take the next shot and focusing at that distance. This option is useful when you're photographing sports, active children, animals, or other moving subjects, making it possible to get a series of sharply focused shots.
- Manual Focus (MF). This entry appears among the menu choices, but is grayed out. You must select manual focus using the focus mode switch on the camera or on your lens (if it has such a switch).

Focus Area

Options: Wide, Zone, Center, Flexible Spot, Expand Flexible Spot, Lock-On AF

Default: Wide

My preference: Wide for general use; Lock-On AF Wide for sports and action.

When the camera is set to Autofocus, use this menu option to specify where in the frame the camera will focus when you compose a scene in still photo mode, using the focus area selection you specify. I'll explain these options, the special requirements, and include illustrations of the focusing areas in Chapter 6 in more detail.

Your options are:

- Wide. The camera uses its own electronic intelligence to determine what part of the scene should be in sharpest focus, providing automatic focus point selection. A green frame is displayed around the area that is in focus. Even if you set one of the other options, Wide is automatically selected in certain shooting modes, including both Auto and all SCN modes.
- **Zone.** Select one of nine focus areas (described in Chapter 6), and the a68 chooses which section of that zone to use to calculate sharp focus.
- Center. Choose this option if you want the camera to always focus on the subject in the center of the frame. Center the primary subject (like a friend's face in a wide-angle landscape composition); allow the camera to focus on it; maintain slight pressure on the shutter release button to keep focus locked; and re-frame the scene for a more effective, off-center, composition. Take the photo at any time and your friend (who is now off-center) will be in the sharpest focus. Use this option instead of manually selecting a focus point to quickly lock focus on the center of the frame, then press the defined AF lock button to fix the focus at that point so you can recompose the image as you prefer.
- Flexible Spot. This mode allows you to move the camera's focus detection point (focus area) around the scene to any one of multiple locations using the directional buttons. This mode can be useful when the a68 is mounted on a tripod and you'll be taking photos of the same scene for a long time, while the light is changing, for example. Move the focus area to cover the most important subject, and it will always focus on that point when you later take a photo.
- Expand Flexible Spot. If the camera is unable to lock in focus using the selected focus point, it will also use the eight adjacent points to try to achieve focus.
- Lock-On AF. In this mode, the camera locks focus onto the subject area that is under the selected focus spot when the shutter button is depressed halfway. Then, if the subject moves (or you change the framing in the camera), the camera will continue to refocus *on that subject*. You can select this mode only when Continuous AF is active.
 - This option is especially powerful, because you can activate it for any of the five focus area options described above. That is, once you've highlighted Lock-On AF on the selection screen, you can then press the left-right directional button and choose Wide, Zone, Center, Flexible Spot, or Expand Flexible Spot.

AF Illuminator (Stills)

Options: Auto, Off

Default: Auto

My preference: Off

With previous cameras, the AF illuminator was a red light projector that was activated when there was insufficient light for the camera's autofocus mechanism to zero in on the subject. This light emanated from the same lamp on the front of the camera that provides the indicator for the self-timer and the Smile Shutter feature.

However, Sony determined that the AF illuminator was not powerful enough to be especially useful, so Sony has removed that function from the lamp. Instead, if you elevate the built-in flash, it will emit a brief burst as required to aid in achieving sharp focus. You can also attach an accessory flash unit, which has LEDs that supply a pattern that is bright enough to be useful. In either case, your subject will need to be less than a dozen feet from the camera.

The default setting, Auto, allows the AF illuminator to work any time the camera judges that it is necessary. The a68's AF system is so good that I generally disable this feature, especially when I don't want to disturb the people around me or call attention to my photographic endeavors. The AF illuminator doesn't work when the camera is set for manual focus or to AF-C (Continuous autofocus), when shooting movies or panoramas, or in certain other shooting modes, including the Landscape, Night Scene, Pet, Fireworks, or Sports Action varieties of SCN mode.

AF Drive Speed (Stills)

Options: Fast, Slow

Default: Fast

My preference: Slow for normal shooting, Fast for sports and action

This first entry on the Camera Settings 4 menu (see Figure 3.10) is a still-photos-only setting used to adjust how quickly the a68 focuses. It's used in conjunction with AF Track Sensitivity, described next. Your two options are as follows:

- **Fast.** The a68 focuses as quickly as possible, but with slightly less precision. This setting is good for sports, action, photojournalism, and street photography, and any situation where it's important to get the shot as soon as you press the shutter release down all the way, even if it is slightly out of focus.
- Slow. Focusing is much less speedy, but significantly more accurate. If your subjects are moving at a constant rate of speed and direction, this setting will allow the a68 to smoothly follow focus, even if there is a slight delay in achieving the sharpest image. Choose Slow to be on the safe side, particularly when using older lenses that are themselves somewhat pokey in achieving focus.

Figure 3.10
AF Drive Speed is the first entry in the Camera Settings 4 menu.

AF Track Sensitivity (Stills)

Options: 5 (High), 4, 3 (Mid), 2, 1 (Low)

Default: 3 (Mid)

My preference: 5 (High) most of the time, with lower settings for subjects prone to "distractions."

This is another stills-only setting (a movie version is also available), which works hand-in-hand with AF Drive Speed just described. The previous option determines how quickly the camera locks in focus; this one determines how quickly the a68 unlocks focus from the subject it is currently tracking, and focuses instead on another subject that intervenes. For example, if you're shooting a football game as a running back is breaking through the line and a referee bolts along the sideline in front of you. With this feature set to 5 (High), the camera will very quickly switch to the ref, and then should return its attention to the running back—but often, not quickly enough. A better choice would be to use a lower setting, such as 2 or 1 (Low), so that the a68 more or less ignores the referee, who is likely to have moved on in a second or two. Tracking will remain on your running back.

- 5 (High). The a68 quickly responds to new subjects that cross the frame. This is the best setting to use for fast-moving subjects, such as sports or frenetic children as long as you don't expect intervening subjects. The camera will smoothly follow your subjects, especially if AF Drive Speed has been set to Fast, too.
- 4. This speed is halfway between High and Mid.

- 3 (Mid). Response to movement is a bit slower, so that the a68 doesn't constantly refocus as subjects move about the frame. This is the default, and should be used when there is only moderate movement, and especially if the movement is across the width or height of the frame (rather than coming toward you or away from you); and when you're using a small f/stop, because the increased depth-of-field will eliminate the need for most re-focusing.
- 2. This speed is halfway between Mid and Low.
- 1 (Low). This is the slowest tracking setting, used when you don't want autofocus to change focus quickly.

AF Track Sensitivity (Movies)

Options: 5 (High), 4, 3 (Mid), 2, 1 (Low)

Default: 3 (Mid)

My preference: 5 (High)

This is a movies-only setting and operates exactly the same as the stills version. Separating the two options gives you the choice of using one type of tracking for stills, and another for movies, without the need to switch back and forth.

Exposure Compensation

Options: From +5 to -5

Default: 0.0

My preference: 0.0, adjusted as needed.

The fastest way to adjust exposure compensation is to press the EV compensation (+/-) button on the top right shoulder of the camera when in Program, Shutter Priority, or Aperture Priority, and adjust using the up/down directional buttons or control dials. The next fastest way is through the Fn menu, followed by this Camera Settings 4 menu entry. If you decide to access this item from this menu instead of using the other available access methods, go into the exposure compensation screen and scroll up/down using the control dial or the control wheel or the up/down direction buttons. Scroll until you reach the value for the amount of compensation you want to set to make your shots lighter (with positive values) or darker (with negative values). I'll discuss exposure compensation in more detail in Chapter 5.

Remember that any compensation you set will stay in place until you change it, even if the camera has been powered off in the meantime. It's worth developing a habit of checking your display to see if any positive or negative exposure compensation is still in effect; return to 0.0 before you start shooting. Exposure compensation cannot be used when the camera is set to Intelligent Auto, Superior Auto, or one of the SCN modes.

Exposure Step

Options: 1/3, 1/2 EV

Default: 1/3

My preference: 1/3

This setting specifies the size of the exposure change for both exposure compensation and flash exposure compensation. The 1/3 stop default allows fine-tuning exposure more precisely, while selecting 1/2 EV lets you make larger adjustments more quickly, which is useful when you are trying to capture more dramatic exposure changes.

180

Options: ISO Auto (with upper/lower limits); Settings from 100 to 25600; Multi Frame Noise Reduction

Default: ISO Auto

My preference: ISO Auto, set to ISO 100 Minimum/ISO 1600 Maximum

This menu item is the first on the Camera Settings 5 page (see Figure 3.11). It can also be accessed by pressing the ISO button on the top of the camera. This entry can be used to specify the ISO (sensor sensitivity) in one of three ways:

■ ISO Auto. The true Auto ISO setting is the second entry from the top. You can press the right button and choose a minimum ISO to be used as well as the maximum ISO applied (which prevents the a68 from taking a clutch of pictures at, say, ISO 25600, unbeknownst to you). For general shooting, I use ISO 100 and ISO 1600 for my limits, and raise the upper end to ISO 3200 or 6400 for indoor subjects (especially sports, which can benefit from faster shutter speeds and/or smaller f/stops). (See Figure 3.13.)

Figure 3.11
ISO is the first entry in the Camera
Settings 5 menu.

- **Fixed ISO settings.** You can Select ISO settings from 100 to 25600, and the camera will take all its shots at that sensitivity.
- Multi Frame NR. The camera takes multiple shots and aligns them (because, hand-held, there is probably some camera movement between shots) and sorts out the image pixels that are common to all the shots (and which remain more or less the same in each individual shot) from the random visual noise pixels (which will be different in each shot, because they are *random*). It then creates an image that (in theory) uses only the image pixels, with much less visual noise. The processing takes a few seconds, so you wouldn't want to use it when you plan to take multiple shots within a short period of time.

Highlight the entry (which is confusingly labeled with the current ISO speed or ISO Auto, rather than Multi Frame Noise Reduction; see the top listing in the left column in Figure 3.12). You can then press the right button to highlight the option at the bottom of the figure (the maximum ISO setting you want to use).

Multi frame NR can only be used when Image Quality is set to JPEG, and is unavailable when D-Range Optimizer or Auto HDR are activated. Note: the a68 also offers a Hand-Held Twilight scene mode, which doesn't let you choose shutter speed, ISO setting, white balance, and other parameters, but produces comparable (or sometimes even better) images. If your image suits the automated settings of the Hand-Held Twilight mode, it's certainly faster and requires fewer decisions from you.

Your choices are restricted when you're using Panorama mode or fully automatic and scene modes since the camera always uses ISO Auto. Note too that ISO Auto is not available in M mode; you must set a numerical value. Settings up to 25600 are available in still mode, and up to 12800 in movie mode. (If you've selected a higher sensitivity when you switch to movie mode, the a68 will automatically change to 12800.)

Figure 3.12 Select Multi Frame Noise Reduction ISO maximum speed.

Figure 3.13 You can specify a minimum and maximum value for Auto ISO.

Metering Mode

Options: Multi, Center, Spot

Default: Multi

My preference: Multi

The metering mode determines how the camera will calculate the exposure for any scene. The a68 is set by default to Multi, which is a multi-zone or multi-segment metering approach. No other options are available in either Auto mode or in SCN modes or when you're using digital zoom or the Smile Shutter.

- Multi. Evaluates many segments of the scene using advanced algorithms; often, it will be able to ignore a very bright area or a very dark area that would affect the overall exposure. It's also likely to produce a decent (if not ideal) exposure with a light-toned scene such as a snowy land-scape, especially on a sunny day. While it's not foolproof, Multi is the most suitable when you must shoot quickly and don't have time for serious exposure considerations.
- Center. Center-weighted metering primarily considers the brightness in a large central area of the scene; this ensures that a bright sky that's high in the frame, for example, will not severely affect the exposure. However, if the central area is very light or very dark in tone, your photo is likely to be too dark or too bright (unless you use exposure compensation).
- **Spot.** When using Spot metering, the camera measures only the brightness in a very small central area of the scene. Again, if that area is very light or very dark in tone, your exposure will not be satisfactory; it's important to spot meter an area of a medium tone. You'll learn how metering mode affects exposure in Chapter 5, which covers exposure topics in detail.

White Balance

Options: Auto WB, Daylight, Shade, Cloudy, Incandescent, Fluorescent (4 options), Flash, C.Temp, Filter, Custom, Custom Setup

Default: Auto (AWB) **My preference:** AWB

The various light sources that can illuminate a scene have light that's of different colors. A house-hold lamp using an old-type (not Daylight Balanced) bulb, for example, produces light that's quite amber in color. Sunlight around noon is close to white but it's quite red at sunrise and sunset; on cloudy days, the light has a bluish bias. The light from fluorescents can vary widely, depending on the type of tube or bulb you're using. Some lamps, including sodium vapor and mercury vapor, produce light of unusual colors.

The Auto White Balance feature works well with the a68, particularly outdoors and under artificial lighting that's daylight balanced. Even under lamps that produce light with a slight color cast such as green or blue, you should often get a pleasing overall color balance. One advantage of using AWB

is that you don't have to worry about changing it for your next shooting session; there's no risk of having the camera set for, say, incandescent light, when you're shooting outdoors on a sunny day.

The a68 also lets you choose a specific white balance option—often called a preset—that's appropriate for various typical lighting conditions, because the AWB feature does not always succeed in providing an accurate or the most pleasing overall color balance. Your choices include:

- Daylight. Sets white balance for average daylight.
- **Shade.** Compensates for the slightly bluer tones encountered in open shade conditions.
- Cloudy. Adjusts for the colder tones of a cloudy day.
- Incandescent. Indoor illumination is typically much warmer than daylight, so this setting compensates for the excessive red bias.
- Fluorescent (four types). You can choose from Warm White, Cool White, Day White, and Daylight fluorescent lighting.
- Flash. Suitable for shooting with the a68's electronic flash unit.
- C.Temp/Filter/Custom/Custom Setup. These advanced features provide even better results once you've learned how to fine-tune color balance settings, which I'll explain in Chapter 7.

When any of the presets are selected, you can press the right button to produce a screen that allows you to adjust the color along the amber (yellow)/blue axis, the green/magenta axis, or both, to fine-tune color rendition even more precisely. The screen shown in Figure 3.14 will appear, and you can use the up/down and left/right buttons to move the origin point in the chart shown at lower right to any bias you want. The amount of your amber/blue and/or green/magenta bias is shown numerically above the chart.

Figure 3.14
Fine-tune the color bias of your images using this screen.

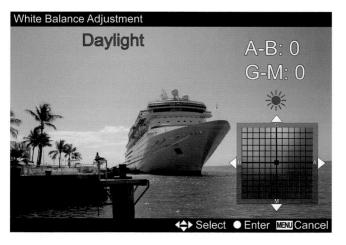

If you shoot in RAW capture, though, you don't have to be quite as concerned about white balance, because you can easily adjust it in your software after the fact. Here again, as with ISO and exposure compensation, the white balance item is not available in either Auto mode or in SCN modes; when you use any of those, the camera defaults to Auto White Balance.

DRO/Auto HDR

Options: DRO Off, DRO Auto, DRO Levels 1–5, AUTO HDR (1–6 EV interval)

Default: DRO Off

My preference: DRO Auto

The brightness/darkness range of many images is so broad that the sensor has difficulty capturing detail in both bright highlight areas and dark shadow areas. That's because a sensor has a limited dynamic range. However, the a68 is able to expand its dynamic range using extra processing when dynamic range optimization (DRO) is active. It's on by default at the Auto level where the camera evaluates the scene contrast and decides how much extra processing to apply; this is the only available setting in certain automatic camera modes. In other modes, you can turn DRO off, or set it manually to one of five intensity levels. There's also an Auto HDR feature discussed in a moment.

When the DRO Auto option is highlighted, you can press the left/right keys to set the DRO to a specific level of processing, from 1 (weakest) to 5 (strongest). You'll find that DRO can lighten shadow areas; it may darken bright highlight areas too, but not to the same extent. By level 3, the photos you take will exhibit much lighter shadow areas for an obviously wide dynamic range; DRO Auto will never provide such an intense increase in shadow detail.

In addition, you'll find the Auto HDR (High Dynamic Range) feature, available only in the P, A, S, M shooting modes (Program, Aperture Priority, Shutter Priority, and Manual). If you select this option instead of DRO, the camera will take three photos, each at a different exposure level, and it will combine them into one HDR photo with lighter shadow areas and darker highlight areas than in a conventional shot. You can control the intensity of this feature. After scrolling to Auto HDR, press the left/right buttons to choose an exposure increment between shots, from 1.0 to 6.0 EV. The one you select will specify the difference in exposure among the three photos it will shoot: 1 EV (minor exposure difference) for a slight HDR effect to 6 EV (a huge exposure difference) for a dramatic high dynamic range effect. If you don't choose a level, the camera selects an HDR level for you. I'll provide tips and examples of DRO and HDR in Chapter 5.

Creative Style

Options: Standard, Vivid, Neutral, Clear, Deep, Light, Portrait, Landscape, Sunset, Night Scene, Autumn Leaves, Black & White, Sepia

Default: Standard

My preference: Standard

This option allows you to apply to JPEGs any of thirteen different combinations of contrast, saturation, and sharpness: Standard, Vivid, Neutral, Clear, Deep, Light, Portrait, Landscape, Sunset, Night Scene, Autumn Leaves, Black & White, and Sepia. They are a quick way of using preset "looks," both those created for you by Sony as well as customized sets you develop yourself. I generally stick to Standard and do required image manipulation in Photoshop, but I like the Black & White style for switching quickly to monochrome shooting.

You can apply Creative Styles when you are using any shooting mode except Superior Auto, Intelligent Auto, or any of the scene modes. You can customize your Creative Styles, and save your own versions in any of six different memory slots. I discuss the use of this option and explain what all the styles do in Chapter 5.

Picture Effect

Options: Off, Toy Camera, Pop Color, Posterization, Retro Photo, Soft High-key, Partial Color, High Contrast Monochrome, Soft Focus, HDR Painting, Rich Tone Monochrome, Miniature, Watercolor, Illustration

Default: Off

My preference: Off

This camera feature allows you to create JPEG photos with special effects provided by the camera's processor in JPEG capture mode (but not in RAW or RAW & JPEG) when the camera is in P, A, S, or M mode. It's not available for use when shooting movies. Scroll through the options in this item and watch the change in the preview image display that reflects the effect that each option can provide if you activate it; if you find one that looks interesting, press the center button or touch the shutter release button to confirm your choice and return to shooting mode.

When some effects are highlighted, left/right triangles will appear next to their label, indicating you can press the left/right keys to select an option available for that effect. Not all provide this extra benefit.

- Toy Camera. Produces images like you might get with a Diana or Holga "plastic" camera, with vignetted corners, image blurring, and bright, saturated colors. It's at Normal by default but when you press the left/right buttons you can select Normal, Cool, Warm, Green, or Magenta.
- **Pop Color.** This setting adds a lot of saturation to the colors, making them especially vivid and rich looking. When used with subjects that have a lot of bright colors, the effect can be dramatic. Duller subjects gain a more "normal" appearance; try using this setting on an overcast day to see what I mean.
- **Posterization.** This option produces a vivid, high-contrast image that emphasizes the primary colors (as shown in Figure 3.15, upper left) or in black-and-white, with a reduced number of tones, creating a poster effect. The default rendition is Color, but a monochrome option also appears if you press the left/right keys.
- **Retro Photo.** Adds a faded photo look to the image, with sepia overtones.
- **Soft High-key.** Produces bright images.

Figure 3.15 Clockwise, from upper left: Posterization, Partial Color, High Contrast Monochrome, Miniature.

- Partial Color. Attempts to retain the selected color of an image, while converting other hues to black-and-white. (See Figure 3.15, upper right.) It's set at Red by default, indicating that photos will retain red tones, but you can also choose Blue, Green, or Yellow.
- **High Contrast Monochrome.** Converts the image to black-and-white and boosts the contrast to give a stark look to the image. (See Figure 3.15, lower left.)
- **Soft Focus.** Creates a soft, blurry effect. It's at Mid by default (for a medium intensity); press the left/right buttons to specify Lo or Hi intensity.
- HDR Painting. Produces a painted look by taking three pictures consecutively and then using HDR techniques to enhance color and details. It's at Mid by default (for a medium intensity); press the left/right buttons to specify Lo or Hi intensity. The camera will quickly shoot three photos, at varying exposures, and combine them into one. (This is most suitable for static subjects; do not move the camera until all three shots have been fired.)
- **Rich-tone Monochrome.** Uses the same concept as the one above but creates a long-gradation black-and-white image (by darkening bright areas but keeping dark tones rich) from three consecutive exposures.
- Miniature. You select the area to be rendered in sharp focus using the Option button. The effect is similar to the tilt-shift look used to photograph craft models. (See Figure 3.15, lower right.) Press the left/right keys to position the blurry area to the left, right, top, bottom, or middle of the image; watch the preview display while scrolling among them to get a feel for the effect that each one can provide.
- Watercolor. Creates a look with blurring and runny colors, as if the image were painted using watercolors.
- Illustration. Emphasizes the edges of an image to show the outlines more dramatically. The left/right buttons can be used to adjust the effect from Low, to Mid, or High levels.

Zoom

Options: Optical Zoom Range, Smart Zoom Range, Clear Image Zoom Range, Digital Zoom Range

Default: None

My preference: None

This feature, the first listed on the Camera Settings 6 menu, adds an ersatz "power zoom" control to the a68, which otherwise lacks one. (See Figure 3.16.) Of course, if you want to avoid accessing this menu entry every time you want to use it, you'll have to define a button to activate Zoom, as I'll describe in Chapter 4 under the Custom Keys Settings entry in the Custom Settings 6 menu.

It's useful once you understand what it does and how it works, especially when shooting movies. That's because anything other than optical zoom (zooming using your lens only) crops the image and wastes pixels in still mode, but when capturing video, the a68 does that anyway to end up with

Figure 3.16

Zoom is the first entry on the Camera Settings 6 page.

a (maximum) 1920×1080 video format. The downside is that the technology used to zoom digitally makes it necessary to use a slower contrast detect autofocus method (described in Chapter 6) rather than the fast phase detect system located above the semi translucent mirror.

Still, Sony has done its best to make the feature as confusing as possible, including tucking it away here in the Camera Settings 6 menu, while hiding the Zoom Setting entry (which controls how it works) in the Custom 3 menu. In fact, if you have the Zoom Setting set to Optical Zoom Only, this entry is grayed out and unavailable. Fortunately, you don't need to jump back and forth between menus often, even though *descriptions* of the two relevant entries are necessarily in separate sections of this book.

Some cameras in the Sony E-mount digital lineup either have a zoom lever built into the camera body or can use one of the power zoom lenses offered in that mount. We A-mount users have no such luck. However, you still have *four* different ways to zoom manually while you're taking still photographs or movies. This list will sort out the options for you:

- Optical Zoom with Zoom Ring. Zoom lenses always have a ring around their barrel that can be rotated back and forth to zoom in or out on your subject.
- Smart Zoom. This is one of three zoom options that take you beyond the true optical zoom range of your lens into the realm of digitized zooming, which produces a zoom *effect* by taking the pixels in the center of the original image and filling the frame with them.

Smart Zoom is available only when you have set the camera to M (medium) or S (small) image size. It provides a limited amount of zooming, but, technically, requires no quality-reducing interpolation. The a68 simply produces each "zoomed" image by cropping the photo to the zoomed size. The resolution of your final image corresponds to the resolution of the Medium or Small image size. When using Smart Zoom, an S label appears in the viewfinder or LCD monitor zoom scale to indicate that the feature is in effect.

- ClearImage Zoom. When using this option, some quality is lost, as this kind of zooming doesn't produce any actual additional information; it just *interpolates* the pixels captured optically to simulate a zoomed-in perspective. Pixels are created to fill the frame at the resolution of the given Image Size setting (Large, Medium, or Small). ClearImage Zoom has many options, and I'll explain them later in this chapter. When a zoom scale is shown in the view-finder or on the LCD monitor, a C label appears whenever you leave optical zooming behind and enter the ClearImage realm. When ClearImage Zoom is used alone, you'll typically achieve 1x to 2.0x magnifications *over and above* whatever optical zoom setting you've used.
- **Digital Zoom.** This option gives you even higher magnifications than ClearImage Zoom, with an additional decrease in image quality. When a zoom scale is shown in the viewfinder or on the LCD monitor, a D label appears when you are using digital zoom. I'll explain the options later in the chapter. When Digital Zoom is active, it takes up where ClearImage Zoom leaves off, giving you up to 4.0x magnification *beyond* the optical zoom focal length you've selected when using Large Image Size. At Medium Image Size, you can zoom up to 5.7x; with Small Image Size, up to 8x.

Using Zoom

My basic recommendation is to use optical zoom only most of the time, and this feature might not be available. If you've set the a68 for Optical Zoom Only in the Zoom Settings entry of the Custom Settings 3 menu, then this Zoom feature is not available at all if Image Size is set to Large. If ClearImage Zoom is set to On, you can use ClearImage zooming; if Digital Zoom is set to On, you can use both, as described in Chapter 4. When Image Size is set to Medium or Small, then Smart Zoom is also available for all three Zoom Settings options. After you've sorted out which of the zoom methods you want to use, using the Zoom feature while shooting is fairly easy. Just follow these steps:

- 1. Navigate to the Camera Settings 6 menu. Select Zoom, and press the center button. (You can also define a camera button to take you directly to the zoom screen, as I'll show you in Chapter 4.)
- 2. **Preview image.** A live view of your sensor image appears, with a zoom scale at lower right, as shown in Figure 3.17.
- 3. **Zoom in or out.** You can rotate the control wheel or control dial, or use the left/right directional keys to zoom in or out.
- 4. **Change zoom steps.** Press the up/down keys to change the size of the zoom increment, from 1x to 1.4x to 2x.
- Confirm or cancel. When you're satisfied with the zoom level, press the center button to confirm, or the MENU button to cancel. You can then continue to shoot at the new zoomed magnification.

Figure 3.17
The zoom scale shows the amount of magnification, and type of zoom in use.

Focus Magnifier

Options: Activate

My preference: Assign this function to a button.

The focus magnifier is a feature that enlarges the LCD image so you can focus more easily on an enlarged portion of the image to view the subject you are trying to bring into focus. Activate the magnifier, and the screen image will look something like Figure 3.18 (left). The image is enlarged, and a navigation window appears at lower left showing an orange rectangle that represents the current location of the magnified portion of the frame. The center button magnifies the image either 5.9x or 11.7x.

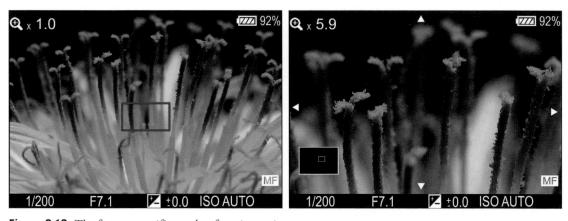

Figure 3.18 The focus magnifier makes focusing easier.

That part is easy. The complication comes from the need, by default, to make the trip to menuland to access this feature, and the three additional menu entries needed to configure it. If you'll follow the steps that I outline next, your focus magnifier usage will be greatly simplified.

- 1. **Select activation time.** When you summon the focus magnifier, it will zoom in on your image for the amount of time you specify, then automatically return to full-screen view when you're done manually focusing. You can select 2 seconds, 5 seconds, or No Limit (the default). If No Limit is selected, the image remains zoomed until you take a picture or press the shutter release halfway. Visit the Custom Settings 1 menu and select the Focus Magnif. Time entry.
- 2. Choose an activation button. The annoying thing about this feature is the need to visit the Camera Settings 6 menu each time you want to activate it. It's easy to fix that by assigning focus magnifier to a custom key. Visit the Custom Settings 6 menu, select Custom Key Settings, highlight the C Button (Custom Button) entry, and choose Focus Magnifier as its definition. You can assign the focus magnifier to a different button instead, but the Custom button at lower right on the back panel makes the most sense. Even if you've redefined the button to summon the focus magnifier, it still functions as a Trash button in playback mode, so you've lost virtually nothing.
- 3. **Use the focus magnifier.** Once you've switched to your preferred focusing mode, set activation time, and define a button, just press your defined button. There's no need to visit the menu. You'll *still* need to press the center button to zoom in. (Sony should change the camera so that the defined Focus Magnifier button also zooms.) The focus magnifier is released after the specified activation time has elapsed, or when the shutter button is pressed halfway, and after you've taken a shot.

Long Exposure NR/High ISO NR (Stills)

Long Exposure NR: Options: On/Off; Default: On

High ISO NR: Options: Normal, Low, Off; Default: Normal

My preference: On/Normal

I've grouped these two menu options together because they work together, each under slightly different circumstances. Moreover, the causes and cures for noise involve some overlapping processes. Digital noise is that awful graininess that shows up as multicolored specks in images, and these menu items help you manage it. In some ways, noise is like the excessive grain found in some high-speed photographic films. However, while photographic grain is sometimes used as a special effect, it's rarely desirable in a digital photograph.

The visual noise-producing process is something like listening to a CD in your car, and then rolling down all the windows. You're adding sonic noise to the audio signal, and while increasing the CD player's volume may help a bit, you're still contending with an unfavorable signal-to-noise ratio that probably mutes tones (especially higher treble notes) that you really want to hear.

The same thing happens when the analog signal is amplified: You're increasing the image information in the signal, but boosting the background fuzziness at the same time. Tune in a very faint or distant AM radio station on your car stereo. Then turn up the volume. After a certain point, turning up the volume further no longer helps you hear better. There's a similar point of diminishing returns for digital sensor ISO increases and signal amplification, as well.

Your a68 can reduce the amount of grainy visual noise in your photo with noise reduction processing. That's useful for a smoother look, but NR processing does blur some of the very fine detail in an image along with blurring the digital noise pattern. These two menu items let you choose whether or not to apply noise reduction to exposures of longer than one second and how much noise reduction to apply (Normal or Low) when shooting at a high ISO level (at roughly ISO 1600 and above).

High ISO NR is grayed out when the camera is set to shoot only RAW-format photos. The camera does not use this feature on RAW-format photos since noise reduction—at the optimum level for any photo—can be applied in the software you'll use to modify and convert the RAW file to JPEG or another file format. (If you shoot in RAW & JPEG, the JPEG images, but not the RAW files, will be affected by this camera feature.) As well, high ISO Noise Reduction is never applied when the camera is set to Sweep Panorama, or continuous shooting, bracketing, Sports Action or Handheld Twilight or Anti Motion Blur Scene mode, or when the ISO is set to Multi Frame Noise Reduction.

Digital noise is also created during very long exposures. Extended exposure times allow more photons to reach the sensor, but increase the likelihood that some photosites will react randomly even though not struck by a particle of light. Moreover, as the sensor remains switched on for the longer exposure, it heats up, and this heat can be mistakenly recorded as if it were a barrage of photons. To minimize the digital noise that can occur during long exposures, the a68 uses a process called "dark frame subtraction." After you take the photo, the camera fires another shot, at the same shutter speed, with the shutter closed to make the so-called dark frame. The processor compares the original photo and the dark frame photo and identifies the colorful noise speckles and "hot" pixels. It then removes (subtracts) them so the final image saved to the memory card will be quite "clean."

Context-Sensitive

The a68 has a novel "context-sensitive" noise reduction algorithm that examines the image to identify smooth tones, subject edges, and textures, and apply different NR to each. This processing works best with areas with continuous tones and subtle gradations, and does a good job of reducing noise while preserving detail. Because the BIONZ X digital processing chip is doing so much work, you may see a message on the screen while NR is underway. You cannot take another photo until the processing is done and the message disappears. If you want to give greater priority to shooting, set Long Exposure NR and High ISO NR to Off.

Long Exposure NR works well but it causes a delay; roughly the same amount of time as the exposure itself, as the camera takes a second "control" exposure with the shutter closed, and then subtracts the "noise" in that additional shot from the first exposure. That would be a long ten seconds after a 10-second exposure. During this delay, the camera locks up, so you cannot take another shot. You may want to turn this feature off to eliminate that delay when you need to be able to take a shot at any time. This feature is Off by default in continuous shooting, bracketing, Panorama mode, and two Scene modes—Sports Action and Hand-held Twilight.

You might want to turn off noise reduction for long exposures and set it to a weak level for high ISO photos in order to preserve image detail. (NR processing blurs the digital noise pattern, but it can also blur fine details in your images.) Or, you simply may not need NR in some situations. For example, you might be shooting waves crashing into the shore at ISO 200 with the camera mounted on a tripod, using a neutral-density filter and long exposure to cause the pounding water to blur slightly. To maximize detail in the non-moving portions of your photos, you can switch off long exposure noise reduction.

Center Lock-on AF

Options: On, Off

Default: Off

My preference: Use as required

This item, the first in the Camera Settings 7 menu (see Figure 3.19) tells the a68 to track a moving subject nearest to the camera. When you select this feature from the menu, a white box appears on the LCD. Move the camera to center the box on the subject you want to track and press the center button. The camera will then track that object as you reframe, or the subject moves, until you take a picture. Center Lock-on AF is not available at all when focus is set to Manual Focus, or you've activated Eye-Start AF (which starts autofocus as soon as you bring the camera up to your eye).

Figure 3.19
The Camera
Settings 7 menu.

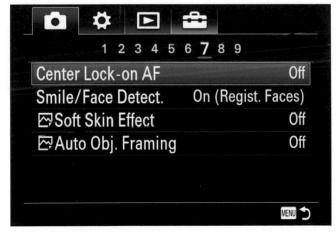

Like the Focus Magnifier function, this feature isn't "live" all the time once you've set it. It requires a trip to the Camera Settings 7 menu each time you want to use it, unless you define a custom key to summon it. You can use a Custom button. Alternatively, choose another button that you don't use much while shooting.

Smile/Face Detect.

Options: Face Detection Off, Face Detection On (Registered Faces), Face Detection, Smile Shutter (Normal Smile, Slight Smile, Big Smile)

Default: Off

My preference: Face Detection On; Forget Smile Shutter

Your camera can detect faces and zero in its focusing and exposure prowess on them. You can also tell the camera to use face detection to identify a face and look for a smile; it takes a photo each time it sees a smile (actually, just an array of pearly white teeth). This is potentially an interesting high-tech feature, because the subject's smile acts as a sort of remote control. I haven't had much success with Smile Shutter, however.

Most of us take so many photos of people that it's easy to justify leaving Face Detection on all the time. With the feature activated, the camera will survey the subjects before it and try to determine if it is looking at any human faces. If it decides that it is, it sets focus, flash, exposure, and white balance settings for you. The ability to zero in those parameters on a human face is a powerful feature!

When a face is detected, the camera will select a main subject and place a white frame around that face. Press the shutter release halfway, and the frame around the priority face will turn green as the settings lock in. Other faces in the picture will be framed in gray. With the a68, there is no special indicator when registered faces are detected; previous models highlighted them with a magenta frame. Your options include:

- Face Detection Off. Disables all face detection.
- Face Detection On (Registered Faces). When set to On (Registered Faces), any faces previously logged will be given priority. As you press the shutter button to take the picture, the camera will attempt to set the exposure and white balance using the face it has selected as the main subject. If that result is not what you want, you can start over, or you may want to take control back from the camera by choosing Flexible Spot or Center for the Autofocus Area and placing the focus spot exactly where you want it.

You'll need to register faces you want to recognize separately using a Face Registration option, and even assign a priority for up to eight faces (ranking them 1 to 8 on your face recognition speed dial). Sony has hidden the registration feature, as you might guess by now, in a completely different menu, specifically the Custom Settings 6 menu. Happy hunting! I'll describe the process in Chapter 4.

- Face Detection. In this mode, the a68 diligently looks for any human face it can find, and doesn't care who it belongs to. Use this option if you have few friends, or, more than eight that you don't want to offend.
- Smile Shutter. First, activate this feature, which is disabled if you are using Manual Focus. When you turn the camera off, it reverts to Face Detection On (Registered Faces) until you re-activate the Smile Shutter. Then, press the left/right buttons to specify Normal Smile (the default), Big Smile, and Slight Smile. Set Big Smile, for example, and the camera won't take a photo when the detected face smiles only slightly; it will wait for a serious toothy grin. You will need to experiment to find out which level to use. The sensitivity of this fcature depends on factors such as whether the subject shows his or her teeth when smiling, whether the eyes are covered by sunglasses, and others. I suggest leaving it at Normal Smile, changing it only if that does not work as you had expected.

A vertical scale appears on the left side of the screen showing you that the feature has been activated by a potentially smiling face. Keep in mind that if multiple faces are found, only one (and any one) of them will trigger the shutter.

There is no limit to the number of smiles and images you can take with this feature; you, or whoever is in front of the camera, can keep smiling repeatedly, and the camera will keep taking more pictures until it runs out of memory storage or battery power. Of course, the main purpose of this feature is not to act as a remote control; it's really intended to make sure your subject is smiling before the photo is taken.

Soft Skin Effect (Stills)

Options: Off/On (Lo, Mid, Hi)

Default: Off

My preference: Use as needed

This item can be used to instruct the camera's processor to minimize blemishes and wrinkles in the detected face, which usually helps produce a more flattering picture. I find it more suitable for photos of women than of men. If you choose On, press the left/right buttons and select the low, middle, or high intensity for skin softening. This effect does not work when shooting movies or in any continuous shooting mode, including bracketing and continuous self-timer, nor when using the Sports Action scene mode, Sweep Panorama, or RAW capture mode.

Auto Object Framing (Stills)

Options: Off/Auto

Default: Auto

My preference: Off

When this feature is active, the a68 analyzes three types of images: close-up shots, images taken using Center Lock-On AF (discussed earlier), and images containing faces (only when Face

Detection is activated). When it's On and the camera detects a close-up subject, tracked object, or face, it takes the photo as you composed it but also makes another image and saves that to the memory card, as well. This second photo is made after cropping the photo you had composed into one that the camera thinks is a more pleasing composition. If you have Setting Effect On specified in the Live View Display entry of the Custom Settings 2 menu, a frame appears to show the cropped area before it is stored. The camera's processor uses the Rule of Thirds compositional technique when making its cropping decision so the eyes will not be in the center of the image area, for example. Note that if you've activated Eye-Start AF, this setting cannot be used.

Since cropping makes the image smaller, the processor adds pixels to ensure that the photo will be full size. It uses Sony's By Pixel Super Resolution Technology for the "up sampling"; this technology maintains very good image quality. Sure, Auto Object Framing is a feature intended to attract novices and inveterate snap shooters, but I find it useful at parties when taking quick shots of friends; in most cases, the photo with automatic cropping is preferable to the original (sloppily composed) shot. Of course, both photos are available on the memory card so you can use either of them.

Auto Mode

Options: Intelligent Auto, Superior Auto

Default: Intelligent Auto

My preference: Intelligent Auto

This entry allows you to specify which of the a68's two fully auto modes (Intelligent Auto and Superior Auto) is activated when the Mode dial is moved to the Auto position. Most users of a camera as sophisticated as the a68 won't use either one very often, so Sony has uncluttered the Mode dial by allowing you to specify which of these two Auto modes you'd like to activate by default. This entry is grayed out (unavailable) if the mode dial is not set to the Auto position. This is the first entry in the Camera Settings 8 menu, shown in Figure 3.20.

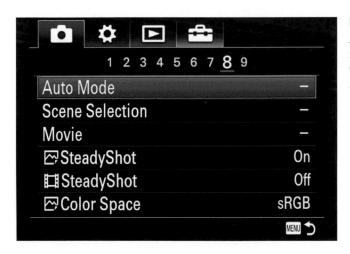

Figure 3.20
Auto Mode is the first entry in the Camera Settings 8 menu.

Scene Selection

Options: Select Scene Modes

Default: None

My preference: None

This entry is available *only* when the mode dial is set to SCN. It provides an alternate method for choosing among the available Scene modes. It would have been brilliant if Sony had made Scene Selection one of the definable actions for a custom key (at least for those who use Scene modes a lot), but no such luck. However, it's here if you want to use it. You'll find descriptions of Scene modes in Chapter 5.

Movie

Options: Program Auto, Aperture Priority, Shutter Priority, Manual Exposure

Default: Program Auto

My preference: Shutter Priority

This setting, available only when the mode dial is set to the Movie position, allows you to specify which exposure mode is used when shooting movies; the mode you select can be different from the one set for still photography mode. As it happens, only Program Auto can be used with autofocus; you must use Manual focus to select Shutter Priority, Aperture Priority, or Manual Exposure.

I happen to prefer Shutter Priority (and thus, by default, manual focus) for much of my work, because there are excellent reasons you might want to lock in a particular shutter speed for movies. For example, you *can't* use a shutter speed that's longer than 1/4 second, and any shutter speed longer than the frame rate (i.e., 1/8th second when shooting 30 frames per second isn't the best idea, as well). Nor are shutter speeds much *shorter* than twice the frame rate wise (for example, 1/60th second is OK for 30 fps shooting, but 1/160th second can yield weird results), as I'll explain in Chapter 8.

SteadyShot (Stills)

Options: On, Off

Default: On

My preference: On

The a68 has in-camera image stabilization, using slight shifts of the sensor platform to compensate for camera motion. You can use this menu item to turn the SteadyShot system off. It's on by default to help counteract image blur that is caused by camera shake, but you should turn it off when the camera is mounted on a good tripod, as the additional anti-shake feature is not needed, and slight movements of the tripod can sometimes "confuse" the system. In other situations, including when you're using one of those \$49.95 big box tripods (with the leg braces because they need them), I recommend leaving SteadyShot turned on at all times.

SteadyShot (Movies)

Options: On, Off

Default: On

My preference: On

Your a68's movie-mode SteadyShot system is an entirely different kettle of fish. Rather than using sensor plane shifts, movie SteadyShot uses an electronic system (actually similar to the type of image stabilization found in video cameras).

Remember that the a68's sensor captures an area that's larger than the pixels used for each individual movie frame. That gives the camera the flexibility to crop what the sensor sees and record a slightly smaller frame that can be shifted left or right, up or down, or even rotated to compensate for camera motion. Instead of the sensor being physically shifted, the picture area is adjusted instead. Because movies are shot frame-by-frame on a continual basis, they are less prone to interference from slight tripod movement, so you usually don't have to turn the feature off, whether using a tripod or not.

Color Space (Stills)

Options: sRGB, Adobe RGB

Default: sRGB

My preference: sRGB

This menu item gives you the choice of two different color spaces (also called color gamuts). One is named Adobe RGB, an abbreviation for Adobe RGB (1998), so named because it was developed by Adobe Systems in 1998, and the other is sRGB, supposedly because it is the *standard* RGB color space. These two color gamuts define a specific set of colors that can be applied to the images your Alpha captures.

You're probably surprised that the a68 doesn't automatically capture all the colors we see. Unfortunately, that's impossible because of the limitations of the sensor and the filters used to capture the fundamental red, green, and blue colors, as well as that of the LEDs used to display those colors on your camera and computer monitors. Nor is it possible to print every color our eyes detect, because the inks or pigments used don't absorb and reflect colors perfectly.

Instead, the colors that can be reproduced by a given device are represented as a color space that exists within the full range of colors we can see. That full range is represented by the odd-shaped splotch of color shown in Figure 3.21 as defined by scientists at an international organization back in 1931. The colors possible with the camera's Adobe RGB option are represented by the larger, black triangle in the figure, while the sRGB gamut is represented by the smaller white triangle. As the illustration indicates, Adobe RGB (1998) is an expanded color space, because it can reproduce a range of colors that is spread over a wider range of the visual spectrum.

Figure 3.21
The outer figure shows all the colors we can see; the two inner outlines show the boundaries of Adobe RGB (black triangle) and sRGB (white triangle).

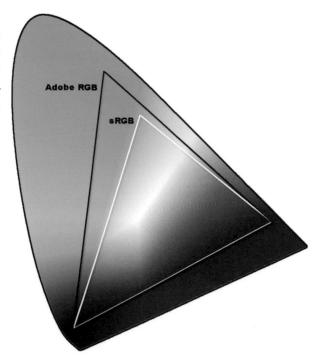

ADOBE RGB vs. sRGB

You might want to use sRGB, which is the default for the Sony camera, as it is well suited for the colors displayed on a computer screen and viewed over the Internet.

(It is possible to buy a specialized and very expensive computer monitor that's specifically designed to display nearly the entire Adobe RGB (1998) color gamut, such as the Eizo FlexScan EV2736WFS, which sells for about \$870 in the U.S., but I doubt that many readers own a monitor of that type.) As well, images made in sRGB color space are fine for use with inexpensive inkjet printers that use three ink colors in a single cartridge. Note too that most mass market print-making services (including kiosks and online photofinishers) have standardized on sRGB because that is the color space that 95 percent of their customers use.

Adobe RGB's expanded color space is preferable only for professional printing. Because it can reproduce a wider range of colors than sRGB, it's possibly a better choice if you own a high-end inkjet photo printer that employs five or more color ink cartridges. Since pro and custom printing labs also use machines of this type, they'll provide the best results in prints made from images in the Adobe color space. You'll get slightly richer cyan-green mid tones, a bit more detail in dark green tones, and more pleasing orange-magenta highlights (as in a sunset photo).

So, if you often make inkjet prints using a high-end machine, or order prints from custom or pro labs, it makes sense to set the camera to Adobe RGB. Later, if you decide to use some of the photos on a website, you can convert them to sRGB in your image-editing software.

Regardless of which triangle—or color space—is used by the Sony a68, you end up with 16.8 million possible different colors that can be used in your photograph. (No one image will contain all 16.8 million!) But, as you can see from the figure, the colors available will be different.

Auto Slow Shutter (Movies)

Options: On, Off
Default: On

My preference: On

This is the first entry on the Camera Settings 9 page. (See Figure 3.22.) When shooting movies in very dark locations, the best way to ensure that the video clips are bright is to use a slow shutter speed. It operates when ISO is set to Auto and the exposure mode is Aperture Priority, and enables the camera to use 1/30th second instead of the default 1/60th second, to avoid the need to increase ISO instead (and thus boost noise levels). This is a useful feature, since it works in any camera operating mode; there's no need to use Shutter Priority mode and set a slow shutter speed yourself in dark locations.

Audio Recording

Options: On, Off

Default: On

My preference: On

Use this item to turn off sound recording when you're shooting videos, if desired. In most cases you'll want to leave the setting to On, in order to capture as much information as possible; the audio track can be deleted later, if desired, within your video-editing software. However, there could be occasions when it's useful to disable sound recording for movies; for example, if you know ahead of

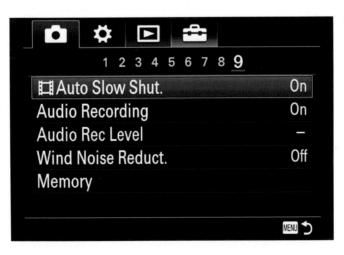

Figure 3.22
The Camera
Settings 9 page.

time that you will be dubbing in other sound, or if you have absolutely no need for sound, such as when panning over a vista of the Grand Canyon. At any rate, this option is there if you want to use it.

Audio Recording Level

Options: On, Off

Default: On

My preference: On

You can adjust the recording level of the camera's built-in or external microphones using this entry, which also enables/disables the audio level overlay on the screen while movies are captured. To use this feature, just follow these steps:

- 1. Rotate the mode dial to the Movie position.
- 2. Navigate to the Camera Settings 9 menu, highlight Audio Rec Level, and press the center button.
- 3. The screen shown in Figure 3.23 appears. Rotate the front control dial or rear control wheel or use the left/right directional controls to adjust the volume level up or down.
- 4. Press the center button to confirm and exit the screen.
- 5. Alternatively, you can use the up/down buttons to highlight Reset to return the recording level to the default value. Then press MENU to exit.
- 6. If Audio Recording and Audio Level Display are set to On, an overlay appears at the lower left of the EVF or LCD monitor showing the current audio levels for the left/right channels (Ch1/Ch2).

Figure 3.23
As long as all the boxes aren't yellow, the audio is not too high.

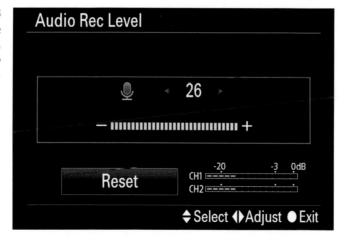

Wind Noise Reduction

Options: On, Off
Default: Off

My preference: Off

Designed to muffle the howling sound produced by a loud wind passing over the a68's built-in condenser microphones, this item (when On) is for use when recording video. It's off by default because Wind Noise Reduction (provided by the camera's processor) does degrade sound quality, especially bass tones. As well, it's off because the recording volume is reduced when it's on in a situation where wind noise is not actually present. I would recommend setting it to On only when shooting in a location with loud wind noises.

Memory

Options: Select register to store settings

Default: None

My preference: None

The a68 gives you the option of storing up to three different groups of settings in separate registers, and then recalling those settings for use later. This item is a powerful and useful tool. It enables you to save almost all of the settings that you use for a particular shooting situation, and then recall them quickly. This function lets you save three distinct sets of camera settings. Each will be a custom-crafted set that you can activate at any time. Simply activate the set that fits your current needs. For example, you might set up register 1 with the settings you use while shooting volleyball in an indoor arena, register 2 for use in landscape photography outdoors at sunrise or sunset, and register 3 for use while shooting portraits in a shady spot under a tree. Whenever you encounter any of those three types of scenes, activate the memory channel with the suitable settings for that situation. You can then begin shooting immediately.

The power of this camera feature stems from the fact that so many shooting settings can be saved for instant recall in any memory channel. Before you access the Memory item in the menu, make the desired settings in terms of camera operating mode, drive mode, ISO, white balance, exposure compensation, metering mode, focus mode, the position of the Local AF area, or any other items in the Function menu or in the camera's Still Shooting menus.

These are the steps to follow to create a custom shooting setup:

- **Set up your shooting options.** The first order of business is to set up the a68 with all of its shooting options, exactly the way you want them to be when you call up the register.
- Register these options. Leaving the camera set up just as you have it, press the MENU button to enter the menu system, then navigate to the Memory item in the Camera Settings 9 menu. You will see the screen shown in Figure 3.24. This display shows the settings currently set; the number 1 is highlighted at the top of the screen.

You can use the control wheel to scroll down through several more screens that display the other settings that are currently in effect for items such as aspect ratio, autofocus setup, flash control, and others. (If you're not satisfied with all your settings, press the MENU button to switch back to Shooting mode and make any changes; then return to the Memory item in the menu.) Select a channel to register—in this example, that's Channel 1. Scroll to it and press the control wheel to confirm your choice. Your settings are now registered to Channel 1.

- Recall your settings whenever you want to. Just rotate the mode dial to the 1, 2, or 3 position.
- Register settings for other Memory channels. Later, when you're shooting in another common situation, such as landscape photography at sunset, make your preferred settings for that type of scene. Register those to Channel 2, using the same procedure. Later, when shooting, say, portraits in a shady spot, register the settings you made to Channel 3.

Figure 3.24
View your current settings to be stored.

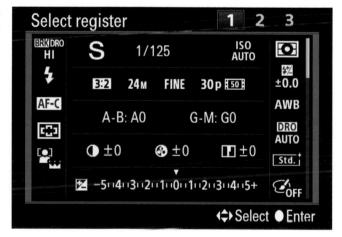

Custom Settings, Playback, and Setup Menus

Additional options are available from the Sony a68's Custom Settings, Playback, and Setup menus, which allow you to tailor how your camera operates; view, print, and protect images; and adjust important camera settings, such as monitor brightness or audio volume.

Custom Settings Menu

Custom Settings are adjustments that you generally don't make during a particular shooting session, but need to tweak more often than those in the Setup menu. The Custom Settings 1 menu is shown in Figure 4.1.

Figure 4.1

Zebra is the first entry in the Custom Settings 1 menu.

1 2 3 4 5 6 7	
Zebra	Off
Focus Magnif. Time	No Limit
Grid Line	Off
Audio Level Display	On
Auto Review	2 Sec
	MENU 5

The Custom Settings are as follows:

- Zebra
- Focus Magnifier Time
- Grid Line
- Audio Level Display
- Auto Review
- DISP Button
- Peaking Level
- Peaking Color
- Exposure Settings Guide
- Live View Display
- AF Range Control Assist
- AF Area Auto Clear
- AF Area Points

- Flexible Spot Points
- Wide AF Area Display
- Zoom Setting
- Eye-Start AF
- FINDER/MONITOR
- Release w/o Lens
- Priority Setup
- AF w/ shutter
- AEL w/ shutter
- SteadyShot w/ shutter
- e-Front Curtain Shutter
- Superior Auto

- Exposure Compensation Set
- Bracket Order
- Face Registration
- AF Micro Adjust
- Lens Compensation
- Function Menu Settings
- Custom Key Settings
- Dial/Wheel Setup
- Dial/Wheel Ev Compensation
- MOVIE Button
- Dial Wheel Lock

Zebra

Options: OFF, IRE 70, 75, 80, 85, 90, 95, 100, 100+

Default: OFF

My preference: 100

This feature, the first entry in the Custom Settings 1 menu (shown in Figure 4.1), warns you when highlight levels in your image are brighter than a setting you specify in this menu option. It's somewhat comparable to the flashing "blinkies" that digital cameras have long used during image review to tell us, after the fact, which highlight areas of the image we just took are blown out.

As you learn more about correct exposure (see Chapter 5), you'll discover that *over*exposure is your worst enemy. It is often possible to extract information from areas that are *under*exposed, as those inky shadows are rarely pure black and may still contain some detail that can be coaxed out with image-editing tools. But once your sensor's photosites have been flooded with photons and register pure white, the detail is lost forever. So, your a68 gives you multiple tools capable of alerting you to overexposure.

Your camera's live histogram, if you bother to activate and use it, is your first line of defense. When the histogram chart shows that a significant number of pixels are hugging the right side (as I'll explain in Chapter 5), that's your warning to reduce exposure. But, unfortunately, a histogram only tells us that some areas are overexposed; it doesn't let us know *where*. Perhaps the washed-out area of an image is the white seamless background in a studio shot, which we *want* portrayed as a featureless area. But if the overexposure involves, say, a human face, it's a different story.

The a68's highlight "blinkie" feature, which can display both over and underexposure, is more area-oriented, but provides its information only on picture review. You must retake your picture using a corrected exposure setting. Zebra patterns, on the other hand, are a much more useful tool, because you are given an overexposure alert *before* you take the picture, and can actually specify exactly how bright *too bright* is.

The Zebra feature has been a staple of professional video shooting for a long time, as you might guess from the moniker assigned to the unit used to specify brightness: IRE, a measure of video signal level, which stands for *Institute of Radio Engineers*. The Zebra pattern warnings manifest themselves as a real-time display of diagonal stripes in overexposed areas, as seen in Figure 4.2. You can immediately adjust exposure to correct the problem—if it applies to your shot.

Figure 4.2
The Zebra stripes in this example show that the white seamless background behind the model is "overexposed," and, in this case, is not a problem.

When you want to use Zebra pattern warnings, access this menu entry and specify an IRE value from 70 to 100, plus 100+. Once you've been notified, you can adjust your exposure settings (using, say, exposure compensation) to reduce the brightness of the highlights, as I'll describe in Chapter 5.

So, exactly how bright *is* too bright? A value of 100 IRE indicates pure white, so any Zebra pattern visible when using this setting (or 100+) indicates that your image is extremely overexposed. Any details in the highlights are gone, and cannot be retrieved. Settings from 70 to 90 can be used to make sure facial tones are not overexposed. As a general rule of thumb, Caucasian skin generally falls in the 80 IRE range, with darker skin tones registering as low as 70, and very fair skin or lighter areas of your subject edging closer to 90 IRE. Once you've decided the approximate range of tones that you want to make sure do *not* blow out, you can set the a68's Zebra pattern sensitivity appropriately and receive the flashing striped warning on the LCD of your camera. The pattern does not appear in your final image (nor in previews using an HDMI-connected external monitor), of course—it's just an aid to keep you from blowing it, so to speak.

Focus Magnifier Time

Options: 2 sec., 5 sec., No Limit

Default: 2 sec.

My preference: 2 sec.

This entry can be used to specify the length of time that the feature will magnify the image during focusing using the lens focusing ring. If you find that it takes you longer than two seconds to focus, you can change the time to five seconds, or to No Limit. If you choose No Limit, focus magnification is canceled until you press the shutter release halfway or all the way.

Grid Line

Options: Rule of 3rds Grid, Square Grid, Diag.+Square Grid, Off

Default: Off

My preference: Off

This feature allows you to activate one of three optional grids, so it's superimposed on the LCD monitor or EVF display. The grid pattern can help you with composition while you are shooting. I sometimes use the Rule of Thirds grid to help with composition, but you might want to activate another option when composing images of scenes that include diagonal, horizontal, and perpendicular lines. (See Figure 4.3 for the LCD version.)

Figure 4.3 Grid lines can help you align your images on the display.

Audio Level Display

Options: On, Off

Default: Off

My preference: On

When this item is set to On, the Sony a68 displays a moderately helpful pair of scales that show the relative volume level of the sound being recorded. Unless you have an add-on device (such as a video recorder connected to the camera's HDMI port) with a headphone jack (as the a68 has no headphone connector of its own), you really can't monitor the quality of your sound, but this feature, at least, gives you a feeling for whether the sound level is too low, too high, or just about right.

Auto Review

Options: Off, 2 sec., 5 sec., 10 sec.

Default: 2 sec.

My preference: 5 sec.

When this item is set to an option other than Off, the Sony a68 can display an image on the LCD or viewfinder for your review immediately after the photo is taken. (When you shoot a continuous or bracketed series of images, only the last picture that's been recorded will be shown.) During this display, you can delete a disappointing shot by pressing the Delete button, or cancel picture review by tapping the shutter release or performing another function. (You'll never be prevented from taking another picture because you were reviewing images.) This option can be used to specify whether the review image appears on the LCD for 2, 5, or 10 seconds, or not at all.

Depending on how you're working, you might want a brief display or you might prefer to have time for a more leisurely examination (when you're carefully checking compositions). Other times, you might not want to have the review image displayed at all, such as when you're taking photos in a darkened theater or concert venue, and the constant flashing of images might be distracting to others. Turning off picture review or keeping the duration short also saves battery power. You can always review the last picture you took at any time by pressing the Playback button.

For most of what I shoot, 2 seconds is too short, and 5 seconds is about right. If you select 10 seconds as your default value, remember that you can stop the review display and return to shooting mode at any time by tapping the shutter release button.

DISP Button

Options (Monitor): Graphic Display, Display All Info., No Disp. Info., Histogram, For Viewfinder

Options (Viewfinder): Graphic Display, Display All Info., No Disp. Info., Histogram

Default: Graphic Display, Display All Info., No Disp. Info.

My preference: Deactivate Graphic Display Only

Use this item, the first on the Custom Settings 2 page (see Figure 4.4), to specify which of the available display options will—and will not—be available in shooting mode when you use the LCD or viewfinder and press the DISP button to cycle through the various displays. All of the options except for Histogram are on by default. If you want to add the Histogram as one of the display options, you can do so in this menu item. Scroll to Histogram and press the center button to add a checkmark beside this option.

Choose from Monitor or Viewfinder and mark or unmark the screens you want to be able to view (see Figure 4.5). The Monitor selection includes a For Viewfinder option that displays a text/graphic display of your current settings.

You can use this menu item to deselect one or more of the display options so it/they will never appear on the LCD when your press the DISP button. To change which screens are shown, scroll to an option and press the center button to remove the checkmark beside it. Naturally, at least one display option must remain selected. If you de-select all of them, the camera will warn you about this and it will not return to shooting mode until you add a checkmark to one of the options. If you turn the a68 off while none are selected, the camera will interpret this as a Cancel command and return to your most recent display settings. Here's a recap of the available display options for the monitor.

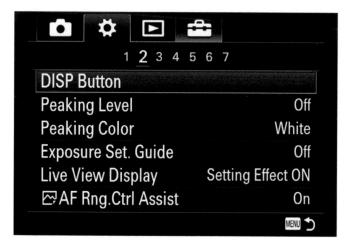

Figure 4.4
The Custom
Settings 2 menu.

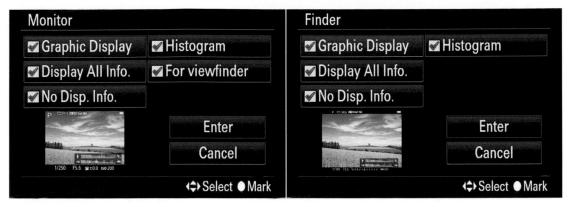

Figure 4.5 Scleet which display screens are shown on the LCD monitor (left) or viewfinder (right).

All five of the display screen options were illustrated in Chapter 2.

- **Graphic Display.** When selected, this display shows basic shooting information, plus a graphic display of shutter speed and aperture (except when Sweep Panorama is the mode in use). If you learn how to interpret it, you'll note that it indicates that a fast shutter speed will freeze motion, and that a small aperture (large f/number) will provide a great range of acceptably sharp focus and other information of this type. It's a useful screen for beginners, but once you become adept with your a68, you'll probably want to deactivate it.
- **Display All Info.** The default screen when you first turn the camera on, this option displays many items of data about current settings for a complete overview of recording information.
- No Disp. Info. In spite of its name, this display option provides the basic shooting information as to settings, in a conventional size.
- **Histogram.** Activate this option if you want to be able to view a live luminance histogram to assist you in evaluating the exposure before taking a still photo, a feature to be discussed in Chapter 5. The basic shooting data will appear in addition to the histogram. The histogram cannot be displayed when using Movie mode.
- For Viewfinder. This display can be shown only on the LCD monitor. When visible, you can press the Fn button to produce the Quick Navi screen, which I explained in Chapter 2.

Peaking Level

Options: High, Mid, Low, Off

Default: Off

My preference: High

This is a useful manual focusing aid (available only when focusing in Manual and Direct Manual modes) that's difficult to describe and to illustrate. You're going to have to try this feature for yourself to see exactly what it does. *Focus peaking* is a technique that outlines the area in sharpest focus

with a color; as discussed below, that can be red, white, or yellow. The colored area shows you at a glance the edges of what will be very sharp if you take the photo at that moment. If you're not satisfied, simply change the focused distance (with manual focus). As the focus gets closer to ideal for a specific part of the image, the color outline develops around hard edges that are in focus. You can choose how much peaking is applied (High, Medium, and Low), or turn the feature off. I use this feature a lot, and like to set the intensity on High.

Peaking Color

Options: White, Red, Yellow

Default: White

My preference: Yellow

Peaking Color allows you to specify *which* color is used to indicate peaking when you use manual focus. White is the default value, but if that color doesn't provide enough contrast with a similarly hued subject (which I find to be the case frequently), you can switch to a more contrasting color, such as red or yellow. (See Figure 4.6.)

Figure 4.6
You can choose any of three colors for peaking color (for manual focus), but only if you have activated the Peaking

Level item.

Exposure Settings Guide

Options: On, Off

Default: On

My preference: Off

This mystery feature (Sony's manual provides nary a clue as to what sort of "guide" appears when it's enabled) is of most use to those with poor eyesight, but it is a convenience for all. All it does is show a scrolling scale on the LCD or viewfinder with the current shutter speed or aperture highlighted in orange. It more or less duplicates the display of both that already appears on the bottom line of the screen, but in a larger font and with the next/previous setting flanking the current value. In Aperture Priority, the scale shows f/stops. In Shutter Priority, you see shutter speeds. The display can be somewhat distracting, and interferes with your view of your subject. However, when using Manual exposure, the down key alternates between f/stop and shutter speed display. In that case, I like to leave this feature switched on, as the display is a reminder of which parameter I'm fooling with at the moment.

Live View Display

Options: Setting Effect ON, Setting Effect OFF

Default: Setting Effect ON

My preference: Setting Effect ON

Here's another poorly named feature. The a68 is always in "live view" mode, showing you what the sensor sees. Sony uses the term in a more precise sense, here: when activated (the default setting), the live preview display in the EVF or the LCD reflects the *exact* effects of any camera features that you're using to modify the view, such as exposure compensation and white balance. This allows for an accurate evaluation of what the photo will look like and enables you to determine whether the current settings will provide the effects you want.

It's virtually mandatory to turn this feature OFF when using studio flash, because the camera has no idea that you're using flash illumination and assumes the picture will be taken using ambient light. So, at the typical flash sync speed of 1/160th second, a small f/stop appropriate for high-intensity flash illumination, and a low ISO sensitivity setting, the camera thinks you are seriously underexposing the image, and the screen may look very dark, or even completely black. With Setting Effect OFF, the screen remains bright. Unfortunately, this setting has caused more than a few minutes of head-scratching among new users who switch to Manual exposure mode and find themselves with a completely black (or utterly white) screen. The black screen, especially, may fool you into thinking your camera has malfunctioned.

On the other hand, the On option can be especially helpful when you're using any of the Picture Effects, because you can preview the exact rendition that the selected effect and its overrides will provide. It's also very useful when you're setting some exposure compensation, as you can visually determine how much lighter or darker each adjustment makes the image. And when you're trying to achieve correct color balance, it's useful to be able to preview the effect of your white balance setting.

AF Range Control Assist

Options: Off, On Default: Off

My preference: On

This setting does nothing more than turn the focus points yellow when your subject is within the range during the AF Range Control Function. At this point, you're probably wondering what the AF Range Control Function is. It's one of several Sony "secret" functions (another being Eye Autofocus), and lets you tell the a68 the specified minimum and maximum distance that should be used when calculating autofocus; subjects closer than or farther than the range you define will be ignored.

As a secret function, AF Range Control isn't activated as the default function of any button, and, in fact, can't be used at *all* unless you take the time to assign a button yourself in order to enable that function. This particular menu entry is the only vestigial reflection of the function's existence.

Using AF Range Control

Before the AF Range Control Assist can be used, you must turn on AF Range Control. In my case, I assigned the function to the C2 button, located just southwest of the Fn button on the back of the camera. Here's how to define a button (you'll find a more complete discussion of defining custom keys later in this chapter):

- 1. **Access Custom Key Settings.** Visit the Custom Key Settings entry in the Custom Settings 6 menu.
- 2. **Select button to define.** Scroll down the list of definable buttons and select the one you want to use. Press the center button.
- 3. **Select function.** A list of available functions appears. Scroll down to AF Range Control and press the center button.
- 4. Exit. Press the MENU button to exit Custom Key setup.

Once you've specified a button to summon the AF Range Control function, to use it all you need to do is follow these steps:

- 1. **Autofocus on your subject.** The AF Range Control feature does not work in Manual focus mode or Movie mode.
- 2. **Press the defined button.** A screen like the one shown in Figure 4.7 appears, with a scale at the bottom.
- 3. **Evaluate current AF plane.** The scale has a flower icon at its left end, indicating the closest possible focusing distance; a mountain at the other end of the scale represents the most distant focus position. A white triangle shows the current autofocus plane, and will be used to set the nearest/farthest points of your range.
- 4. **Set near point.** Use the control wheel to set the near point of the focus range, to the left of the white triangle.
- 5. **Set far point.** Use the control dial to set the farthest point of the focus range, located to the right of the white triangle. The orange area in the scale shows the current autofocusing area.
- 6. **Monitor changes.** As you set the focusing range, the focusing points that represent the area that will be used to autofocus appear. Use the yellow highlighted focus points as a guideline for setting your range.
- 7. **Exit range setting.** Press the defined button a second time, or tap the shutter release button. AF Range Control is now activated. The orange range bar turns white, and the yellow focus points continue to illuminate in yellow.
- 8. **Reset when finished.** The easiest way to turn off your current AF range is to simply power down the camera and then turn it on again. **Note:** If, for some reason, you don't want those yellow-illuminated focus points, you can turn off their display using this menu entry.

Figure 4.7 Setting autofocus range.

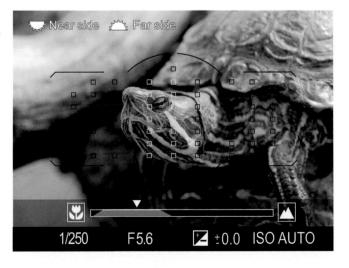

AF Area Auto Clear

Options: Off, On Default: Off

My preference: Off

When activated, this setting declutters your viewing screen by turning off the green AF points a second or two after the a68 achieves autofocus. If you find the illuminated points distracting, set this option to On; if you'd rather the points were illuminated as long as focus is achieved, set to Off. I like the reassurance that my subject is still sharply focused, so I disable this setting most of the time. This is the first entry in the Custom Settings 3 menu. (See Figure 4.8.)

AF Area Points

Options: Auto, 61 Points

Default: Auto

My preference: Auto

This setting allows you to deactivate the outermost focus points within the a68's 79-point focus grid when using the AF Area: Wide focus option, leaving "only" 61 points to collect focus information. Of course, most of the time you selected Wide because you knew your main subject was going to reside in an unpredictable position in the frame, so Wide gave you a better chance to lock in focus on that subject than Zone or Spot modes. Even so, there are cases when you want to narrow the search for perfect focus down just a tad.

Figure 4.9 shows an example of such a situation at a basketball game. You're stationed along the baseline, and the players are usually clustered around the area under the hoop, with a few located farther out. The top image shows the positions of the focus points using the full 71 points. The player on the left is too far away to attract the attention of the focus system, but the other player on the right is close enough to, possibly, cause problems.

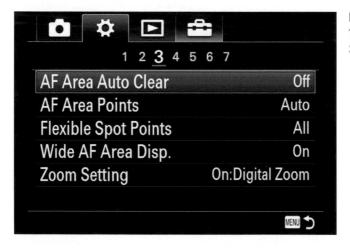

Figure 4.8
The Custom
Settings 3 menu.

With the AF area points set to 61, both players are more or less out of the picture (figuratively), and the autofocus system can concentrate on the most important action.

Most of the time you'll want to use Auto when working with Wide Area AF, and let the a68 decide which set of area points to use. But, as you gain experience you may find a few instances where you'll find the 61-point option handy.

Figure 4.9
All 79 focus points
can be active in
Auto mode (top);
select 61 Points
instead, and the 18
points along the
periphery are disabled (bottom).

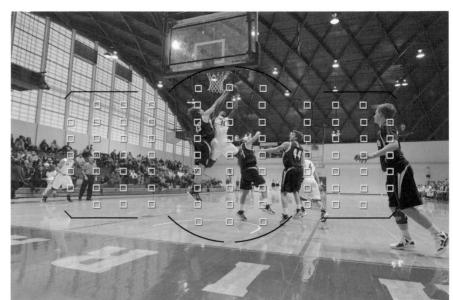

Flexible Spot Points

Options: All, 15 Points

Default: All

My preference: All

Spot focus allows you to choose which focus point to use exclusively. When you select All in this menu entry, it's possible to use the control wheel to locate the spot focus point at any of the 79 available points. That can make for a lot of finger action, which might not be practical if you want to use spot focus with subjects that may roam around the frame.

This entry lets you switch from 79 AF points to just 15 spaced within roughly the same area of the frame. You can combine either 79 point or 15 point modes with Expanded Flexible Spot option for additional flexibility. There are enough permutations involved in choosing the correct focus point that I'm going to save the in-depth discussion (and illustrations of the locations of the focus points) for Chapter 6.

Wide AF Area Display

Options: On, Off

Default: On

My preference: On

The focus points are illuminated in green singly or in combination when you are selecting an AF point, or the a68 is choosing one for you. The rest of the time they are displayed as small black rectangles. They aren't really distracting once you've become accustomed to them. But, you can set this entry to Off, rendering the focus points invisible when not being actively used for focus, which can be helpful when you want to frame your image with a decluttered screen.

Zoom Setting

Options: Optical Zoom Only, Clear Image Zoom, Digital Zoom

Default: Optical Zoom Only

My preference: Optical Zoom Only

As I mentioned in Chapter 3 under the Camera Settings 1 menu's Zoom entry, the a68 has three different types of zoom settings: Optical Zoom, Clear Image Zoom, and Digital Zoom, and you can choose any one of them. The last two are not available when using Sweep Panorama, Smile Shutter, or when Image Quality is set to RAW or RAW & JPEG; Metering Mode is locked at Multi, and Focus Area setting is disabled (the focus area frame in the zoomed image is shown by a dotted line). Descriptions of each type of zoom follow.

Optical Zoom Only

This is what you get when you select Optical Zoom Only. Simply turn the zoom ring on the lens. Your zooming is limited to the focal length range(s) provided by the lens mounted on your camera. With the 18-55mm kit lens, you'll get only the field of view offered by the lens, and nothing more. If you have a fixed focal length lens mounted, you get no zooming at all.

This mode provides the best image quality, because the full 24 megapixels of the a68's sensor are used (when Large Image Size is selected in the Camera 1 menu) to record the photo. The magnification range is determined by the lens itself. For example, the 18-55mm kit lens allows a roughly 1X to 3X zoom range.

You should always use the optical zoom to magnify your image first, before resorting to one of the "fake" zoom options, because optical zoom produces the least amount of image degradation. Indeed, with a good-quality zoom lens, you may notice little, if any, loss in sharpness as you zoom in and out. Note that if you have selected Optical Zoom Only and set Image Size to Medium or Small, the Smart Zoom version (described next) is available.

Clear Image Zoom

This digital zoom mode varies its magnification effect depending on the Image Size you select in the Camera Settings 1 menu:

Large Image Size. When Clear Image Zoom is activated, rotate the zoom ring on any A-mount zoom lens you have mounted. The a68 will use image processing to magnify the image, if required. A scale on the LCD is divided into two parts. The left-hand portion shows the amount of optical zoom applied using the actual zooming characteristics of a zoom lens; the focal length (say, 18-55mm) appears under the scale. When the indicator crosses the center portion of the scale, the focal length readout freezes at the maximum focal length of the lens (say, 50mm), and Clear Image Zoom kicks in, and the magnifying glass icon has a "C" next to it to show that additional magnification is being applied using image processing.

Medium/Small Image Size. However, if you choose Medium or Small Image Size, the zooming begins as before with the left-hand portion of the scale showing the optical zoom range. Once the indicator crosses the center point, the camera will first simply crop the image (without any processing) from 1X to 1.5X (Medium) or 1.1X to 2.1X (Small). Sony calls this Smart Zoom, and the magnifying glass shows an "S" label. If you continue zooming, then image processing will be used to provide additional zooming from 1.4X to 2.8X (Medium) or 2X to 4X (Small). The magnifying glass icon will then display a "C" to show the processing mode being used.

Clear Image Zoom provides a *simulated* zoom effect that operates even if you don't have a zoom lens! However, you could simply shoot Large JPEGs and later crop them with image-editing software in your computer to make the subject larger in the frame. This automated feature is useful if you do not own a sufficiently long telephoto lens, since it's possible to make a subject larger in the frame.

Digital Zoom

With this variation, the camera gives you even higher magnifications, up to 4X in Large JPEG photos creating more impressive simulated zooming effects to fill the frame with a distant subject. However, the higher the level of digital zoom that you use, the greater the loss of image quality. That's because the camera crops the photo to simulate the use of a longer lens, discarding millions of pixels; the processor then uses interpolation (adding pixels) to restore the image to its original full size. That works well with Clear Image Zoom but above 2X magnification, the camera's processor no longer uses the most sophisticated technology (which Sony calls Bi-pixel Super Resolution), so the image quality suffers; it gets worse at each higher magnification level.

That's why I recommend leaving the Digital Zoom item at Off and using only Clear Image Zoom unless you absolutely must have greater magnification of a distant subject. If you often need telephoto focal lengths, you might want to save up and add such a long lens to your arsenal.

Large Image Size. When Large is selected, Clear Image Zoom magnification, a high-quality image processing algorithm, will be used from 1.1X to 2X, while from 2.1X to 4X, the reduced image-quality process, Digital Zoom, will be activated.

Medium Image Size. Select Medium resolution, and the highest quality Smart Zoom trimming will be applied from 1.1X to 1.4X, and Clear Image Zoom from 1.5X to 2.9X, and Digital Zoom from 3X to 5.7X.

Small Image Size. Select Small, and Smart Zoom will be applied from 1.1X to 2.0X, and Clear Image Zoom will be applied from 2.1X to 3.8 X, and Digital Zoom from 4.1X to 8.0X.

Eye-Start AF

Options: On, Off

Default: Off

My preference: Off

This setting is the first in the Custom Settings 4 menu. (See Figure 4.10.) It is Off by default, but when turned On, the a68 will start autofocusing the instant you move the viewfinder to your eye. The display on the LCD vanishes, the camera adjusts autofocus, and, if you're using any operating mode other than Manual, it sets the shutter speed and/or aperture so you're ready to take the shot. You don't even need to touch the shutter release button. Of course, it's not magic. There is a sensor just above the viewfinder window that detects when your face (or anything else) approaches the finder.

This is useful because it increases the odds of capturing a fleeting moment. On the other hand, some people find this feature annoying. When it's On, the camera will begin to autofocus every time a stray hand or other object passes near the viewfinder. Also, if you're wearing the camera

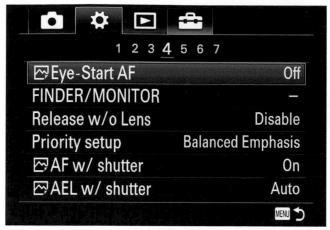

around your neck, you may hear a continuous clicking as the camera rubs against your body, triggering the focusing mechanism. When this happens frequently, it will consume a significant amount of battery power.

After experimenting with this feature, you may decide to turn Eye-Start AF off. After you do so, the a68 reverts to its boring old behavior of not initiating focus until you partially depress the shutter button. Naturally, the electronic viewfinder will still activate when your eye (or anything else) is near the sensors, but you won't get autofocus until you're certain you want AF to start. Note that this feature is disabled when you use Center Lock-On AF mode.

FINDER/MONITOR

Options: Auto, Viewfinder, Monitor

Default: Auto

My preference: Auto

This item is somewhat similar to the Eye-Start AF item, but it controls only whether the camera turns off the LCD and switches the view to the viewfinder when your eye comes near the EVF. With the default setting of Auto, the screen goes blank and the viewfinder activates when your eye (or any other object) approaches the Eye-Start sensors.

Switch to the Viewfinder or Monitor and the Eye-Starr sensors are disabled. The display is *always* sent to the viewing device you selected, and the other one is turned off. You might want to use the Monitor option if you are doing work involving critical focusing using the LCD, and as you examine the screen closely, your face will frequently be close to the back of the camera where the Eye-Start sensor might detect it. Or, perhaps, you are shooting at a concert or other venue where the bright LCD can be distracting to others. Choose Viewfinder, and the shooting preview, menus, photos displayed for review during playback, and so forth will be shown only in the EVF.

Release w/o Lens

Options: Disable, Enable

Default: Disable

My preference: Enable

By default, the a68 will refuse to try to take a photo when a lens is not mounted on the camera; this is a logical setting. If you chose Enable, however, the a68 will activate its shutter when you depress the shutter release button even when no lens is mounted. This option will be useful if you attach the camera to some accessory such as a telescope or third-party optic that's not recognized as a lens (perhaps a Lensbaby distortion lens). I happen to use a few Nikon lenses with my a68 with an adapter, so I leave this option set to Enable.

Priority Setup

Options: AF, Release, Balanced Emphasis

Default: Balanced Emphasis

My preference: Release

Lets you specify whether the camera waits to actually take the picture until it has achieved sharp focus (when using an autofocus mode, not Manual focus mode); whether it takes the picture immediately, even if sharp focus is not guaranteed; or using a balanced approach somewhere between the two. For most kinds of candid photography, sports, or photojournalism, most of us would rather get the shot rather than lose a fleeting moment, and so Release is often your best choice. If you have a little more time, and the shot won't be affected by a short delay (perhaps half a second, on average), Balanced Emphasis, the default, will do the job. If you're looking for the best sharpness your 24-megapixel shooter can provide, AF might be your best option. The three choices are as follows:

- AF. The shutter is not activated until sharp focus is achieved. This is best for subjects that are not moving rapidly. In Continuous Focus mode, the a68 will continue to track your subjects' movement, but the camera won't take a picture until focus is locked in. An indicator in the viewing screen will flash green until focus can be achieved. You might miss a few shots, but you will have fewer out-of-focus images.
- Release. When this option is selected, the shutter is activated when the release button is pushed down all the way, even if sharp focus has not yet been achieved. Because Continuous Focus focuses and refocuses constantly when autofocus is active, you may find that an image is not quite in sharpest focus. Use this option when taking a picture is more important than absolute best focus, such as fast action or photojournalism applications. (You don't want to miss that

record-setting home run, or the protestor's pie smashing into the governor's face.) Using this setting doesn't mean that your image won't be sharply focused; it just means that you'll get a picture even if autofocusing isn't *quite* complete. If you've been poised with the shutter release pressed halfway, the camera probably has been tracking the focus of your image.

■ Balanced Emphasis. As I said, the shutter is released when the button is pressed, with a slight pause if autofocus has not yet been achieved. You would not want to use this setting if the highest possible continuous shooting rates are important to you.

AF w/ Shutter

Options: On, Off

Default: On

My preference: On

As you know, a gentle touch on the shutter release button causes the camera to begin focusing when using an autofocus mode. There may be some situations in which you prefer that the camera *not* re-focus every time you touch the shutter release button. Let's say you are taking multiple pictures in a laboratory or studio with the subject at the same distance; you have no need to refocus constantly, and there is no need to put an extra burden on the autofocus mechanism and on the battery. But, you don't want to switch to manual focus. Instead, you can set AF w/Shutter to Off. From then on, the camera will never begin to autofocus, or to change the focus. You can still initiate autofocus by pressing a key that you've assigned the AF-On function (as I'll describe later under Custom Keys). The user-defined AF-On button will start autofocus at any point, independent of the shutter release, giving you the "back button focus" capability. This setting works only in still photography mode.

AEL w/ Shutter

Options: Auto, On, Off

Default: Auto

My preference: Auto

This item is Auto by default so the a68 can lock the exposure (as well as the focus in AF-S or DMF mode) when you apply light pressure to the shutter release button. Point the camera at your primary subject, and maintain contact with the button while re-framing for a better composition. This technique will ensure that both focus and exposure are optimized for the primary subject. You can also select On, in which case exposure is always locked with a half-press of the shutter release button, regardless of focus mode.

However, if you set this item to Off, light pressure on the shutter release button will lock only focus, and *not* the exposure. After choosing Off, you'll need to depress the AEL button when you want to lock the exposure. (Light pressure on the shutter release button will still lock focus, unless you've disabled that using the AF w/Shutter feature described above.) Then, the only method for locking the exposure will be to press the AEL button you have set up.

You might want to choose the Off option because this will allow you to lock focus on one subject in the scene while locking the exposure for an entirely different part of the scene. To use this technique, focus on the most important subject and keep the focus locked by keeping your finger on the shutter release button while you recompose. You can then point the lens at an entirely different area of the scene to read the exposure, and lock in the exposure with pressure on the AEL button you've defined using the Custom Key Settings option in the Custom Settings 6 menu. Finally, reframe for the most pleasing composition and take the photo.

In your image, the primary subject will be in sharpest focus while the exposure will be optimized for the area that you metered. This technique makes most sense when your primary subject is very light in tone like a snowman or very dark in tone like a black Lab dog. Subjects of that type can lead to exposure errors, so you might want to expose for an area that's a middle tone, such as grass. I'll discuss exposure in detail in Chapter 5; then, the value of this menu option will be more apparent. This is another stills-only setting that does not operate in Movie mode.

SteadyShot w/ Shutter

Options: On/Off
Default: On

My preference: Off

This setting, the first in the Custom Settings 5 menu (see Figure 4.11) enables or disables activation of the a68's in-body image stabilization when you press the shutter button *halfway* while shooting still images. I usually disable it to save battery power, in which case SteadyShot, if active (see below), will wait to activate until you press the shutter release down all the way to actually take a picture. The important factors to keep in mind:

- You must have SteadyShot for still photos enabled using the entry in the Camera Settings 8 menu described in Chapter 3.
- Choose On if you want image stabilization to begin as soon as you half-press the shutter release. In this case, you'll be able to see the shake correction on your LCD monitor/viewfinder screen as you compose the image.
- Choose Off, and image stabilization won't be activated until you take the photo.
- Remember that, as I explained earlier in Chapter 3, still photography SteadyShot corrects for motion by shifting the sensor, while its movie-shooting counterpart uses electronic correction. So this entry has no effect on SteadyShot when shooting movies.

e-Front Curtain Shutter

Options: On, Off

Default: On

My preference: On

This feature reduces the lag time between when you press the shutter, and when the picture is actually taken. It can also reduce a certain type of blurring due to slight camera motion when the physical shutter "clunks" open. When set to On, the electronic front shutter curtain is used by the camera at the start of the exposure, rather than the mechanical shutter. (The physical rear shutter curtain is still used to conclude the exposure.) I'll explain the use of front curtain versus rear curtain shutters as they relate to flash exposures in detail in Chapter 10.

For now, you just need to keep in mind that the a68 has *three* shutters. There is a physical front curtain shutter, which first closes to allow the live view image to be "dumped" and the sensor readied to take a picture, and then opens again to start the exposure. It also has an *electronic* front-curtain shutter (enabled with this menu entry), which doesn't require the physical shutter to close; the live view image is discarded electronically and the camera immediately starts recording the new image. In either case, a physical rear curtain shutter closes and blocks the sensor to conclude the capture, and then opens again to restore your live view image.

The electronic front curtain shutter is both faster and quieter. However, while the e-front curtain shutter usually works very well when you are using an unusually wide aperture, such as f/1.8, and a very fast shutter speed, areas of the photo may exhibit a secondary (ghost) image. The aperture of an affected lens requires the diaphragm components to travel a greater distance, and there may simply not be enough time. An overexposure may result.

When that happens, set this menu item to Off and the camera will use only its mechanical shutter mechanism, and the problem will not occur. Sony also recommends turning the e-curtain Off when you are using a lens made by another manufacturer, as exposure may be uneven or incorrect.

The problems pop up because the e-curtain is, in effect, *too* fast. It reduces the shutter lag to the point that the iris may not have sufficient time to close completely before the exposure begins. So, the f/stop used at the beginning of the exposure can be different from the one used for the rest of the exposure (after the iris closes down to the correct aperture completely). The overall exposure will thus be incorrect, regardless of shutter speed. In addition, at higher shutter speeds, *exposure grading*, can occur. At those higher speeds, the "slit" (the gap between the front and rear curtains) is increasingly small as the shutter speed becomes faster, and parts of the image exposed initially will receive more exposure than those exposed later.

Exposure grading is worse with lenses that need a longer time to close their irises, and so is more likely with non-Sony lenses, older Sony lenses, and Sony/Minolta/third-party A-mount lenses. The irises of those lenses aren't designed to respond at the speeds demanded by an electronic front curtain shutter. In addition, even theoretically compatible lenses may have slower iris response due to dust/grit infiltration. You'll want to use newer, good-condition A-mount lenses, or adapted lenses that are manually stopped down to the "taking" aperture prior to exposure.

Superior Auto

Options: Continuous Shooting Auto, Off; Image Extraction Auto, Off

Default: Continuous Shooting Auto; Image Extraction Auto

My preference: Auto for both

Thank Sony for splitting up two paired menu entries. As I mentioned in Chapter 3, you can specify whether the green Auto position on the mode dial yields Intelligent Auto or Superior Auto exposure behavior. This entry is available *only* when you have selected Superior Auto using the Auto Mode entry in the Camera Settings 8 menu. This entry, on the other hand, controls two options that you have for how Superior Auto operates.

■ Continuous Shooting. As you know, Superior Auto is much smarter than plain old Intelligent Auto! As you shoot, the a68 evaluates a scene and selects a relevant SCN mode. If appropriate (as deemed by the camera; it's not up to you), when this setting is set to Auto, the camera can snap off multiple shots for as long as you hold down the shutter release, upping your odds of getting at least one good one. You can partially disable this behavior by selecting Off instead. Disabling the feature can reduce the inevitable lag time that results while the camera is busy shooting multiple images unbidden.

However, you can't totally disable Superior Auto's proclivity for snapping off multiple shots. If the SCN mode it selects is HDR or Hand-Held Twilight, the a68 will go ahead and take three consecutive shots when the shutter button is pressed, and then choose one or create a composite that has a higher dynamic range or improved digital noise than you'd get with Intelligent Auto alone.

■ Image Extraction. With the default Auto setting for this feature, only the final image is saved to the memory card, which makes a lot of sense. But if you want the camera to record all three of the photos it fired, as well as the final photo, choose the Off option. Note: No composite image can be saved if Image Quality is set to RAW or RAW & JPEG. When HDR or Hand-Held Twilight modes are selected, only one image is saved, even if this entry is set to Off. With Auto Object Framing active, two images are always saved, even if you select Auto here.

Exp. Comp. Set

Options: Ambient & Flash, Ambient Only

Default: Ambient & Flash

My preference: Ambient Only

Your a68 has separate exposure compensation, Flash Comp. and Exposure Comp., available from the Fn menu, and also from the Camera Settings 2 and 4 menus (respectively). When this item is at the default setting, any exposure compensation value that you set will apply to *both* the ambient light exposure and to the flash exposure when using flash. You'd want to stick to this option in flash photography when you find that both the available-light exposure and the flash exposure produce an image that's too dark or too light. Setting plus or minus exposure compensation will affect both. However, most of the time you'll want to set each independently, so I recommend choosing Ambient Only, so you can control only the brightness of the ambient light exposure and not mess with the flash exposure.

For example, the Ambient Only option allows you to control only the brightness of the background such as a city skyline behind a friend when you're taking flash photos at night in a scene of this type. Setting exposure compensation will now allow you to get a brighter or a darker background (at a + and – setting, respectively) without affecting the brightness of your primary subject who will be exposed by the light from the flash. (Any exposure compensation you set will have no effect on the flash intensity.) You can then tone down the flash output, if you choose to, by adjusting the separate Flash Compensation setting.

Bracket Order

Options: $0 \rightarrow - \rightarrow +, - \rightarrow 0 \rightarrow +$

Default: $0 \rightarrow - \rightarrow +$

My preference: $0 \rightarrow - \rightarrow +$

This option sets the order of your shots when using exposure bracketing. With the default setting, the first photo is made at the metered setting, the second with minus exposure compensation (darker), and the third with plus exposure compensation (lighter). With the other option, the first exposure is darker, the second as metered, and the third lighter. I like the default value because I trust my camera, and would prefer to take the metered (and probably correct) exposure first to make sure I get the shot. Those who shoot and manually merge HDR images may prefer to have the exposures taken in order of increasing exposure instead.

Face Registration

Options: New Registration, Order Exchanging, Delete, Delete All

Default: None

My preference: None

This menu entry, the first in the Custom Settings 6 menu (see Figure 4.12), is used to log into your camera's Face Detection memory the visages of those you photograph often. New Registration allows you to log up to eight different faces. Line up your victim (subject) against a brightly lit background, to allow easier detection of the face. A white box appears that you can use to frame the face. Press the shutter button. A confirmation message appears (or a Shoot Again warning suggests you try another time). When Register Face? appears, choose Enter or Cancel, and press the MENU button to confirm.

Figure 4.12
The Custom
Settings 6 menu.

The Order Exchanging option allows you to review and change the priority in which the faces appear, from 1 to 8. The a68 will use your priority setting to determine which face to focus on if several registered faces are detected in a scene. You can also select a specific face and delete it from the registry (say, you broke up with your significant other!) or delete *all* faces from the registry (your SO got custody of the camera). Face data remains in the camera when you delete individual faces, but is totally erased when you select Delete All.

AF Micro Adjustment

Options: AF Adjustment Setting, Amount, Clear

Default: None

My preference: None

From time to time, you may find that some slight autofocus adjustment is necessary to fine-tune your lens. This menu item allows choosing a value from -20 (to focus closer to the camera) to +20 (to change the focus point to farther away). You can enable/disable the feature, and clear the value set for each lens. The camera stores the value you dial in for the lens currently mounted on the camera, and can log up to 30 different lenses (but each lens must be different; you can't register two copies of the same lens). Once you've "used up" the available slots, you'll need to mount a lesser-used lens and clear the value for that lens to free up a memory slot. This adjustment works reliably only with Sony, Minolta, and Konica-Minolta A-mount lenses. I'll show you how to use this feature in Chapter 9.

Lens Compensation

Options: Shading, Chromatic Aberration, Lens Distortion: Auto, Off

Default: Lens Distortion: Off; Shading: Auto; Chromatic Aberration: Auto

My preference: Auto

This trio of menu entries optimizes lens performance by compensating for optical defects; they're useful because very few lenses in the world are even close to perfect in all aspects. While each of these requires the a68 to perform additional processing on your images before saving them to your memory card, unless you're shooting at high continuous rates, the actual time penalty is negligible.

■ Shading compensation. This is an anti-vignetting correction feature, which can fully or partially compensate for darkened corners produced by some types of lenses, as illustrated in Figure 4.13. Because the default setting is Auto, you may never know that this feature is at work until you turn it off. This setting works with both JPEG and RAW files, while the next two apply only to JPEGs.

- Chromatic aberration compensation. This is a type of distortion caused by a lens's failure to focus all colors of light on the same plane. That can cause reduced sharpness or colored fringes along distinct edges in an image. By default, the camera corrects for this aberration, a useful feature in my opinion. (See Figure 4.14.)
- Lens distortion compensation feature. This feature corrects the inward (pincushion) or outward (barrel) bowing of lines at the edges of images, caused by telephoto and wide-angle lenses (respectively). Both forms of distortion can also be fixed (somewhat) in an image editor like Photoshop, but allowing the camera to do so can save a lot of extra work. If the Distortion feature is grayed out with the lens you're using, you'll need to update the camera's firmware. (Newer lenses may not be compatible with Distortion Compensation without a firmware update.)

Figure 4.13

No shading (vignetting) correction (top); shading corrected (bottom).

Figure 4.14
Chromatic aberration displayed as green fringe (top); chromatic aberration corrected (bottom).

Function Menu Settings

Options: Function menu settings

Default: Drive Mode, Flash Mode, Flash Comp., Focus Area, Exposure Comp., ISO, Metering Mode, White Balance, DRO/Auto HDR, Creative Style, Picture Effect, Shooting Mode

My preference: None

When you press the Fn button, a screen like the one shown in Figure 4.15 pops up, with a total of 12 settings in two rows arrayed along the bottom. The default options are illustrated. This entry allows you to change the function of any of the 12 positions in the Function menu, so you can display only those you use most, and arrange them in the order that best suits you.

Figure 4.15 Function menu default settings.

For example, the last three default settings in the second row may be of little interest to some a68 owners. Perhaps you shoot only RAW and don't need to change Creative Styles frequently; or you find the canned Picture Effects too gimmicky. Shooting modes can be selected using the mode dial, so it's unlikely you'll be using the Function menu to change modes. Instead, you might want to put White Balance and Metering Mode on the top line next to Drive Mode, and would like the Quality settings to be available from the Function menu. The seemingly infinitely adjustable a68 lets you arrange things your preferred way.

Just highlight Function Menu Set., and press the center button to produce the first of two screens, shown in Figure 4.16. The screen has an entry for each of the positions in the top row, along with the current function (the second screen shows the positions in the bottom row). Highlight the position you want to modify, and press OK. You can then select from among these options:

- Drive Mode
- Flash Mode
- Flash Comp.
- Focus Mode
- Focus Area
- Exposure Comp.
- ISO
- Metering Mode
- White Balance
- DRO/Auto HDR

- Creative Style
- Shoot Mode
- Picture Effect
- Center Lock-On AF
- Smile/Face Detect
- Soft Skin Effect
- Auto Obj. Framing
- Image Size
- Aspect Ratio
- Quality

- SteadyShot (Stills)
- SteadyShot (Movies)
- Auto Recording Level
- Zebra
- Grid Line
- Auto Level Display
- Peaking Level
- Peaking Color
- Not Set

Note that you can select Not Set to leave a position blank if you want to unclutter your screen, and you can even duplicate an entry in multiple positions, accidentally or on purpose.

Function Menu Set.		Function Menu Set.	
Function Upper2	Flash Mode	Function Lower2	Metering Mode
Function Upper3	Flash Comp.	Function Lower3	White Balance
Function Upper4	Focus Mode	Function Lower4	DRO/Auto HDR
Function Upper5	Focus Area	Function Lower5	Creative Style
Function Upper6	Exposure Comp.	Function Lower6	Shoot Mode
	MENU 🗢		MENU 5

Figure 4.16 Function menu settings.

Custom Key Settings

Options: Definitions for Custom 1, Custom 2, Center, AEL, ISO, Exposure Comp., White Balance, Drive Mode, Preview, and Focus Hold Buttons

Default: Various **My preference:** None

This entry is an essential one, as it allows you to define 10 different buttons to summon any of 51 functions that you prefer to have available with a dedicated key, plus Not Set (to disable a button entirely). Your custom key definitions override any default definitions for those buttons when in shooting mode; they retain their original functions in playback mode. The definable buttons and their *default* values are shown in Figure 4.17.

Custom Key Settings 1 2		Custom Key Settings	
Custom Button 2	AF Range Control	Drive Mode Button	Drive Mode
Center Button	Standard	Preview Button	Aperture Preview
AEL Button	AEL hold	Focus Hold Button	Focus Hold
ISO Button	ISO		
Exp. Comp. Button	Exposure Comp.		
	MENU 5		MENU 🔿

Figure 4.17 Custom Key Settings.

That's quite a large number of definable controls. Indeed, the following is a list of the key buttons on the camera that you *cannot* redefine to perform some other function:

- **Shutter release.** It is always used to take a picture and will initiate autofocus (although you can assign AF-ON and other AF functions to a different key).
- Mode dial lock release. This is a mechanical button in the center of the mode dial that unlocks the mode dial, and has no electronic functions at all.
- **Up directional button.** It is used to change your information display in shooting and playback modes, and as a directional button in menus.
- Playback button. Activates picture review.
- Fn (Function) button. Always summons the Function menu, and in playback mode rotates the current image.
- Movie button. Starts/stops movies. However, you can specify whether you want the button to commence video capture always, or only when the mode dial is set to the Movie position. I'll explain that in the description of the entries in the Custom Settings 7 menu later in this chapter.

Most of the functions available for assignment, which are listed below, simply provide faster access to a function that is available from the Fn or regular menus. When assigning definitions to keys, keep in mind that certain behaviors, such as Eye AF, can be used *only after* you have made them available using a custom key definition. They are more or less self explanatory. Some exceptions include:

- **Standard.** Available only for the center button, this option leaves the control wheel at its standard behavior as an OK/Enter button.
- In-Camera Guide. The defined button provides a tip that reminds you what a menu item or function does.
- AEL Hold/AEL Toggle/Center AEL Hold/Center AEL Toggle. *Hold* options lock exposure while the button is held down; *Toggle* options turn lock on when pressed, off when pressed again.
- Flash Exposure Lock Hold/Flash Exposure Lock Toggle. Same as above, but for flash exposure.
- Flash Exposure Lock/AEL Hold. Both flash and ambient light exposure locked when button held down.
- Flash Exposure Lock/AEL Toggle. Both flash and ambient light exposure locked when button is pressed, unlocked when pressed again.
- **Eye AF.** This function is available *only* when you assign it to a button. It tells the a68 to focus on the subject's eyes when a face is detected.
- **AF Range Control.** Another function available only when assigned to a button, as described in Chapter 3.

- Focus Hold. Deactivates further autofocus while the button is held down.
- Aperture Preview. Creates a depth-of-field preview button.
- Shot Result Preview. Includes depth-of-field preview, and adds in preview of any lens corrections and Dynamic Range Optimizer adjustments.
- Focus Magnifier. Zooms in on the live view image to enhance manual focusing.
- **Deactivate Monitor.** Turns off display of preview image on the LCD monitor. Useful, say, at a concert or other dark venue where you want to reduce the distraction of the monitor while you shoot.

The full list of the functions you can assign include:

- Standard (assignable only to center button)
- Drive Mode
- Flash Mode
- Flash Compensation
- Focus Area
- Exposure Compensation
- ISO
- Metering Mode
- White Balance
- DRO/Auto HDR
- Creative Style
- Picture Effect
- Smile/Face Detect.
- Soft Skin Effect
- Auto Object Framing
- SteadyShot (Stills)
- SteadyShot (Movies)
- Auto Recording Level
- Image Size
- Aspect Ratio
- Quality
- In-Camera Guide
- AEL Hold
- AEL Toggle
- Center Point AEL Hold
- Center Point AEL Toggle

- Flash Exposure Lock Hold
- Flash Exposure Lock Toggle
- Flash Exposure Lock/AEL Hold
- Flash Exposure Lock/AEL Toggle
- AF/MF Control Hold
- AF/MF Ctrl Toggle
- Center Lock-on AF
- Eye AF
- AF Lock
- AF-On
- AF Range Control
- Focus Hold
- Aperture Preview
- Shot. Result Preview
- Smart Teleconverter
- Zoom
- Focus Magnifier
- Deactivate Monitor
- Zebra
- Grid Line
- Audio Level Display
- Peaking Level
- Peaking Color
- Monitor Brightness
- Not Set

VARIATIONS ON A THEME

You have several options for assigning the very useful autoexposure lock (AEL) functions to one of the definable keys.

- **AEL hold.** Exposure is locked while the button is held down.
- **AEL toggle.** The AEL button can be pressed and released, and the exposure remains locked until the button is pressed again.
- Center Point AEL hold. Exposure is locked on the center point of the frame while the button is held down.
- Center Point AEL toggle. Toggles exposure lock on/off using the center point of the frame.

Dial/Wheel Setup

Options: Reverse functions

Default: Control Dial: f/stop, Control Wheel: Shutter speed

My preference: Control Dial: f/stop, Control Wheel: Shutter speed

By default, the control dial adjusts the aperture, and the control wheel controls the shutter speed in Manual exposure mode. This feature allows you to reverse those functions for Manual exposure only if you prefer. Either the control dial *or* control wheel can be used to adjust shutter speed (in Shutter Priority mode) and aperture (in Aperture Priority mode), unless you activate Dial/Wheel Ev Comp, described next.

Dial/Wheel Ev Comp

Options: Off, Control Dial, Control Wheel

Default: Off

My preference: Control Wheel

This is the first entry in the Custom Settings 7 menu (see Figure 4.18). If you like, you can use the front control dial or rear control dial to set exposure compensation. When you do that, the other control retains its original function. That is, if you choose the control dial to set EV, then the control wheel can still be used to adjust shutter speed in Shutter Priority mode, and the control wheel to select aperture in Aperture Priority mode. Select the control wheel for EV instead, and the control dial retains its shutter speed or aperture function, respectively.

MOVIE Button

Options: Always, Movie Mode Only

Default: Always

My preference: Always

Movie recording can be started in any operating mode by pressing the Movie record button. This feature is set for Always by default, but if you find that you occasionally press the button inadvertently, you might want to choose the Movie Mode Only option. After you do so, pressing the button will have no effect; when you want to record a movie you'll need to rotate the mode dial to the Movie position.

Dial/Wheel Lock

Options: Lock, Unlock

Default: Unlock

My preference: Unlock

If you want to avoid accidentally changing settings by inadvertently rotating the control wheel or control dial, you can implement this locking option. Choose Lock and both dials are frozen whenever the Fn button is pressed and held down for approximately 2 seconds. A "Locked" indicator appears on the screen. You can unlock the dials by pressing the Fn button again for 2 seconds. If the default Unlock option is selected, pressing the Fn button has no effect on the dials.

Playback Menu

This menu controls functions for deleting, protecting, displaying, and printing images. You can bring it up on your screen more quickly by pressing the Playback button first, then the MENU button, which causes the Playback icon to be highlighted on the main menu screen. The first set of items that are visible on the screen when you activate the Playback menu are shown in Figure 4.19.

■ Delete

■ Slide Show

■ Protect

■ View Mode

■ Rotate

■ Specify Printing

■ Image Index

■ Display Rotation

■ Enlarge Image

■ 4K Still Image Playback

Delete

Options: Multiple Img., All in Movie or Still Folder, by AVCHD, or by Date

Default: Multiple Img.

My preference: Multiple Img.

Sometimes we take pictures or video clips that we know should never see the light of day. Maybe you were looking into the lens and accidentally tripped the shutter. Perhaps you really goofed up your settings. You want to erase that photo *now*, before it does permanent damage to your reputation as a good photographer. Unless you have turned Auto Review off through the Setup menu, you can delete a photo immediately after you take it by pressing the Trash key (Delete button), which is marked with a trash can icon next to it. Also, you can use that method to delete any individual image that's being displayed on the screen in playback mode.

However, sometimes you need to wait for an idle moment to erase all pictures that are obviously not "keepers." This menu item makes it easy to remove selected photos or video clips (Multiple

Figure 4.19 Playback 1 menu.

Images), or to erase all the photos or video clips taken, sorted by your currently active view mode (such as folder, or date). (Change the type of view using the View Mode option, described next.) Note that there is no delete method that will remove images tagged as Protected (as described below in the section on "Protect").

To remove one or more images (or movie files), select the Delete menu item, and use the up/down direction controls or the control dial to choose the Multiple Images option. Press the center button, and the most recent image *using your currently active view* will be displayed on the LCD.

Scroll left/right through your images and press the center button when you reach the image you want to tag for deletion; a checkmark then appears beside it and an orange check mark appears to the left of the image. You can press the DISP button to see more information about a particular image.

The number of images marked for deletion is incremented in the indicator at the lower-right corner of the LCD, next to a trash can icon. When you're satisfied (or have expressed your dissatisfaction with the really bad images), press the MENU button, and you will be asked if you're sure you want to proceed. To confirm your decision, press the center button. The images (or video clips) you had tagged will now be deleted. If you want to delete *everything* on the memory card, it's quicker to do so by using the Format item in the Setup menu, as discussed later in this chapter.

View Mode

Options: Date View, Folder View (Still), Folder View (MP4), AVCHD, XAVC S View

Default: Date View (Still) **My preference:** Date View

Adjusts the way the a68 displays image/movie files, which is useful for reviewing only certain types of file, or for deleting only particular types, as described above. You can elect to display files by Date View, Folder View (still photos only), Folder View (MP4 clips only), or AVCHD and XAVC S View (just AVCHD or XAVC S movies).

Image Index

Options: 9, 25

Default: 9

My preference: 9

You can view an index screen of your images on the camera's LCD by pressing the AEL/Index button while in playback mode. By default, that screen shows up to 9 thumbnails of photos or movies; you can change that value to 25 using this menu item. Remember to use the View Mode menu item first, to identify the folder (stills, MP4, or AVCHD) that the index display should access; by default, it will show thumbnails of still photos but you might want to view thumbnails of your movie clips instead.

Display Rotation

Options: Auto, Manual, Off

Default: Auto

My preference: Off

You can use this function to determine whether a vertical image is rotated automatically during picture review. The options are somewhat confusingly named, as the Off setting actually means that vertical images *are* automatically rotated:

- **Auto.** The a68 rotates images shot in vertical orientation, as shown at top in Figure 4.20. The image will be smaller in size, but the camera does not have to be tilted to view it. Landscape images are always displayed in landscape mode. When you rotate the camera, the image is rotated at the same time.
- Manual. With this setting, the image is always displayed on the LCD in the same orientation it was taken. You can manually rotate either type of image using the Rotate option discussed later in this section.
- Off. With this setting, both vertical and horizontal images are displayed in landscape mode, filling the screen as much as possible with the image. Vertical shots are larger, as shown at bottom in Figure 4.20, but the camera must be rotated to view them as shot.

Figure 4.20 Vertical images can be displayed in their normal orientation (top), or rotated to fill more of the screen (bottom).

Slide Show

Options: Repeat: On, Off; Interval: 1 second, 3 seconds, 5 seconds, 10 seconds, 30 seconds

Default: 3 seconds **My preference:** None

Use this menu option when you want to display all the still images on your memory card in a continuous show. You have your choice of viewing on the a68's screens or on an HDTV screen through an HDMI cable connection. If you have a Sony Bravia-compatible set, you have additional options (see HDMI Settings in the "Setup Menu" section later in this chapter).

Using this command, you can display still images in a continuous series. You'll need to have View Mode (described earlier in this section) set to Date View (to display images in reverse chronological order), or Folder View (Still) (to view all images in a folder on your memory card). Each "slide" is displayed for the amount of time that you set. Choose the Repeat option to make the show repeat in a continuous loop. After making your settings, press the center button and the slide show will begin. You can scroll left or right to go back to a previous image or go forward to the next image immediately, but that will stop the slide show. The show cannot be paused, but you can exit by pressing the MENU button. If your show is a long one, it's a good idea to set Power Save Start Time in the Setup menu 2 (described later in this chapter) to the maximum delay, 30 minutes.

Rotate

Options: None

When you select this menu item, you are immediately presented with a new screen showing the current or most recently reviewed image along with an indication that the center button can be used to rotate the image. (This feature does not work with movies.) Scroll left/right to reach the image you want to rotate. Successive presses of the center button will now rotate the image 90 degrees at a time. The camera will remember whatever rotation setting you apply here. You can use this function to rotate an image that was taken with the camera held vertically, when you have set Display Rotation to Manual. Press the MENU button to exit. If you have set Display Rotation to Auto, you cannot access this feature.

Enlarge Image

Options: None **Default:** N/A

This is the first entry on the second page of the Playback menu (see Figure 4.21). Whenever you are playing back still images (not movies), you can use this menu entry to magnify the image. Use the rear control dial to zoom in and out, and you can scroll around inside the enlarged image using the control wheel. In playback mode, the Zoom In button does the same thing. The Zoom Out (AEL) button reduces the image size.

Figure 4.21
The second page of the Playback menu.

4K Still Image Playback

Options: None Default: N/A

This menu choice sends JPEG images in 4K format to a compatible 4K television connected using an HDMI cable. It does not work with non-4K HDTV equipment. If you send a RAW image, it will be displayed in HD quality, rather than 4K resolution.

Protect

Options: Multiple Images, All with Current View Mode, Cancel All Images

Default: None

You might want to protect certain images or movie clips on your memory card from accidental erasure, either by you or by others who may use your camera from time to time. This menu item enables you to tag one or more images or movies for protection so a delete command will not delete it. (Formatting a memory card deletes everything, including protected content.) This menu item also enables you to cancel the protection from all tagged photos or movies.

To use this feature, make sure to specify whether you want to do so for stills or movies; use the View Mode item in the Playback menu to designate the desired view mode, as described earlier. Then, access the Protect menu item, choose Multiple Images, and press the center button. An image (or thumbnail of a movie) will appear. Scroll among the photos or videos to reach the photo you want to tag for protection; press the center button to tag it. (If it's already tagged, pressing the button will remove the tag, eliminating the protection you had previously provided.) An orange checkmark at the left of the image indicates it is tagged.

After you have marked all the items you want to protect, press the MENU button to confirm your choice. A screen will appear asking you to confirm that you want to protect the marked images; press the center button to do so. Later, if you want, you can go back and select the Cancel All Images option to unprotect all of the tagged photos or movies.

Specify Printing

Options: Multiple Images, Cancel All, Print Setting

Default: N/A

Most digital cameras are compatible with the DPOF (Digital Print Order Format) protocol, which enables you to tag JPEG images on the memory card (but not RAW files or movies) with an orange red checkmark, designating them for printing with a DPOF-compliant printer; you can also specify whether you want the date imprinted, as well. Afterward, you can transport your memory card to a retailer's digital photo lab or do-it-yourself kiosk, or use your own DPOF-compatible printer to print out the tagged images in the quantities you've specified.

Choose multiple images using the View Mode filters described earlier to select to view either by Date or by Folder. Press the center button to mark an image for printing, and the MENU button to confirm when you're finished. The Print Setting entry lets you choose to superimpose the date onto the print. The date will be added during printing by the output device, which controls its location on the final print. The camera displays a message asking if you want to create the DPOF set and number of images. Select OK to confirm, or choose Cancel to quit.

Setup Menu

Use the lengthy Setup menu to adjust infrequently changed settings, such as language, date/time, and power-saving options. The first five items in the Setup menu are shown in Figure 4.22.

- Monitor Brightness
- Viewfinder Brightness
- Finder Color Temperature
- Volume Settings
- Audio Signals
- Tile Menu
- Mode Dial Guide
- Delete Confirm.
- Power Save Start Time

- Cleaning Mode
- Demo Mode
- HDMI Settings
- USB Connection
- USB LUN Setting
- Language
- Date/Time Setup
- Area Setting
- Format

- File Number
- Select REC Folder
- New Folder
- Folder Name
- Recover Image Database
- Display Media Information
- Version
- Setting Reset

Figure 4.22 The Setup menu.

Monitor Brightness

Options: Auto, Sunny Weather, Manual

Default: Manual

My preference: Manual

When you access this menu item, one of three screens appears, depending on how you have this option currently set:

- Auto. At this setting, the a68 will adjust the brightness of the LCD screen according to the ambient light levels. You cannot make any changes, except pressing the center button to display a screen that allows you to switch between Auto, Manual, and Sunny Weather modes. (Figure 4.23, top.)
- Sunny Weather. If you set Sunny Weather, the LCD brightness will automatically increase, making the display easier to view in very bright light. This makes the display unusually bright so use it only when it's really necessary. Remember too that it will consume a lot more battery power, so have a spare battery available. Use this setting while on the ski slopes, or when shooting at a beach. You might resort to this setting if you're shooting outdoors in bright sun and find it hard to view the LCD even when shading it with your hand.

Again, you cannot adjust the screen brightness, but you can press the center button to display a screen that allows you to switch to one of the other modes. (Figure 4.23, middle.)

■ Manual. In this mode, two controls appear on the screen (see Figure 4.23, bottom). The first is a Brightness bar (shown just above the grayscale/color patches). The grayscale steps and color patches can be used as a reference while you manually adjust the screen brightness using the control wheel left/right controls or rear control dial. Scroll to the right to make the LCD display brighter or scroll to the left to make the LCD display darker, in a range of plus and minus 2 (arbitrary) increments.

As you change the brightness, keep an eye on the grayscale and color chart in order to visualize the effect your setting will have on various tones and hues. The zero setting is the default and it provides the most accurate display in terms of exposure, but you might want to dim it when the bright display is distracting while shooting in a dark theater, perhaps. A minus setting also reduces battery consumption but makes your photos appear to be underexposed (too dark) during picture review.

I prefer to choose Manual but then to leave the display at the zero setting. This ensures the most accurate view of scene brightness on the LCD for the best evaluation of exposure while previewing the scene before taking a photo.

Figure 4.23
Adjust monitor brightness (top to bottom): Auto, Sunny Weather, Manual.

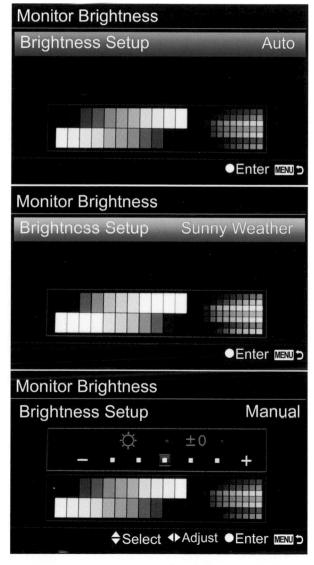

Viewfinder Brightness

Options: Manual, Auto

Default: Manual

My preference: Manual

This entry operates exactly the same as the Monitor Brightness option just described, but without the Sunny Weather option. A notice will appear on the LCD monitor advising you to look through the viewfinder and make your adjustments.

Finder Color Temperature

Options: +2 to -2

Default: 0

My preference: None

While looking through the viewfinder, press the left/right directional buttons or control wheel to adjust the color balance of the finder to make it appear warmer (using the left button) or colder/bluer (using the right button), according to your preference. Use this if you find that the image you see in the viewfinder is slightly different from what you see on the LCD monitor.

Volume Settings

Options: 0–15

Default: 7

My preference: None

This menu item affects only the audio volume of movies that are being played back in the camera, rather than the camera's other sounds, such as the beeping you hear when the self-timer counts down. When you select Volume Settings, the camera displays a scale of loudness from 0 to 15; change the setting using the left/right controls or rear control dial. Your setting will remain in effect until changed. You might want to use this menu item to pre-set a volume level that you generally prefer.

Audio Signals

Options: On, Off

Default: On

My preference: Off

This is the menu entry to use when you want to turn off (or enable) the self-timer beep and other feedback provided by the a68 as you shoot. I usually switch those sounds off, as I find them distracting, and, sometimes, so do my human or non-human subjects. Playback sounds, such as movie audio, are not affected.

Upload Settings

Options: On, Off

Default: On

My preference: Off

The Upload Settings for Eye-Fi cards (not shown in Figure 4.24) appears as the very last entry of the Setup 1 menu, but only when you have inserted an Eye-Fi card into the camera's memory card slot. An Eye-Fi card is a special type of SD card that connects to an available wireless network and uploads the images from your memory card to a computer on that network. The Upload Settings option on the Setup menu lets you either enable or disable the use of the Eye-Fi card's transmitting capability. So, if you want to use an Eye-Fi card just as an ordinary SD card, simply set this item to Off, which saves a bit of power drawn by the card's Wi-Fi circuitry. I usually leave it Off until I am ready to work with the Eye-Fi card's Wi-Fi features.

Tile Menu

Options: On, Off

Default: On

My preference: Off

This is the first entry on the second page of the Setup menu. The Tile menu is a holdover from the NEX era, and features icons representing the six main menu tabs. While it might be marginally useful when you first begin working with your a68, it's really an unnecessary intermediate step. Turn it Off, and when you press the MENU button, you'll be whisked to the conventional menu system, where you can quickly navigate to the tab you want. (See Figure 4.24.)

Figure 4.24 The Setup 2 menu.

Mode Dial Guide

Options: On, Off

Default: On

My preference: Off

The On setting activates an on-screen description of the current shooting mode as you rotate the mode dial. You might want to enable this extra help when you first begin using your a68, and turn it off after you're comfortable with the various mode dial settings.

Delete Confirm

Options: Delete First, Cancel First

Default: Cancel First

My preference: Delete First

Determines which choice is highlighted when you press the trash button to delete an image. The default Cancel First is the safer option, as Cancel is highlighted when the trash button is pressed, and you must deliberately select Delete and then press the center button to actually remove an image. Delete First is faster, and, for most people, makes more sense. Just press the trash button, and a screen appears with Delete highlighted. Press the center button, and the unwanted image is gone. You'd have to scroll to Cancel if you happened to have changed your mind or pressed the trash button by mistake.

Power Save Start Time

Options: 30 minutes, 5 minutes, 2 minutes, 1 minute, 10 seconds

Default: 1 minute

My preference: 1 minute; 5 minutes for photojournalism or sports

This item lets you specify the exact amount of time that should pass before the camera goes to "sleep" when not being used. The default of 1 minute is a short time, useful to minimize battery consumption. You can select a much longer time before the camera will power down, or a much shorter time. Don't worry about interrupting long downloads from your camera to your computer over a cable or Eye-Fi Wi-Fi link; the a68 will always wait until the download is finished before powering down.

I always set this parameter to five minutes when I'm doing street photography or sports. There may be periods when nothing is happening, but I'm closely following the activities or action and want to be able to snap off a picture at a moment's notice. I find the five-minute setting to be perfect; if I forget to turn off the camera at half-time, the a68 powers down automatically and battery power isn't wasted for the 15-minute interval.

If you're using the Slide Show capability described earlier in this chapter and have connected to an external TV or monitor, there's no need to change this setting. The a68 is smart enough to temporarily switch to a 30-minute power-down cycle while you're linked, and then return to the setting you've made here when you resume operations.

Cleaning Mode

Options: None Default: None

My preference: None

This is the first item on the third page of the Setup menu. (See Figure 4.25.) Use this entry when you want to use the a68's auto image sensor cleaning feature. Highlight Enter and press the center button. The sensor vibrates rapidly to shake off any accumulated artifacts.

Demo Mode

Options: On, Off
Default: Off

My preference: None

This is a semi-cool feature that allows your camera to be used as a demonstration tool, say, when giving lectures or showing off at a trade show. When activated, if the camera is idle for about one minute it will begin showing a protected AVCHD movie, which is not impressive on the camera's built-in LCD, but can have a lot more impact if the a68 is connected to a large-screen HDTV through the HDMI port.

Figure 4.25 The Setup 3 menu.

Just follow these steps:

- 1. Use the File Format entry in the Camera Settings 2 menu and select AVCHD as the movie format, as explained in Chapter 3. Demo Mode works only with AVCHD files.
- 2. Shoot the clip that you want to use as your demonstration, in AVCHD format.
- 3. In the Playback 1 menu, access the View Mode and select AVCHD View so that only AVCHD videos will appear.
- 4. In the Playback 2 menu, choose Protect and select the demo clip, which should be the movie file with the oldest recorded date and time.
- 5. Connect the a68 to the optional AC-PW10 AC adapter. Because Demo Mode uses a lot of juice, *it operates only when the external power source is connected*.
- 6. Demo Mode will no longer be grayed out in the Setup 2 menu. Select it and choose On.
- 7. After about one minute of idling, the demo clip will begin playing. Note that, because the AC adapter is connected, your automatic power saving setting is ignored, and that Demo Mode will not operate if no movie file is stored on your memory card.

HDMI Settings

Options: HDMI Resolution: Auto, 1080p, 1080i; HDMI Info. Display: On, Off; Control for HDMI: On, Off

Default: Auto, On, On (respectively)

My preference: Auto, Off, Off (respectively)

This entry allows adjusting three HDMI parameters:

- **HDMI Resolution.** The camera can adjust its output for display on a high-definition television when at the Auto setting. This usually works well with any HDTV. If you have trouble getting the image to display correctly, you can set the resolution manually here to 1080p or to 1080i; the latter should work fine with any HDTV.
- HDMI Info. The parameter controls whether on-screen information overlays are shown while you're shooting movies when the a68 is connected to an HDTV television/monitor using an HDMI cable. Select Off if you don't want to show the shooting information on the display as you capture your video, or (especially) if you are routing the video from your camera to an external video recorder and want only the raw uncompressed video to be captured.

■ Ctrl for HDMI. You can view the display output of your camera on a high-definition television (HDTV) when you connect it to the a68 if you make the investment in an HDMI cable (which Sony does not supply); get the Type C with a mini-HDMI connector on the camera end. When connecting HDMI-to-HDMI, the camera automatically makes the correct settings. If you're lucky enough to own a TV that supports the Sony Bravia synchronization protocol (Sony brand or otherwise), you can operate the camera using that TV's remote control when this item is On. Just press the Link Menu button on the remote, and then use the device's controls to delete images, display an image index of photos in the camera, display a slide show, protect/unprotect images in the camera, specify printing options, and play back single images on the TV screen.

The CTRL for HDMI option on the Setup menu can also be useful when you have connected the camera to a non-Sony HDTV that is supposedly Bravia-sync compatible and find that the TV's remote control produces unintended results with the camera. If that happens, try turning this option Off, and see if the problem is resolved. If you later connect the camera to a Sony Bravia sync-compliant HDTV, set this menu item back to On.

The RMT-DSLR-2 remote discussed earlier can also be used to control display on an HDTV screen.

USB Connection

Options: Auto, Mass Storage, MTP, PC Remote

Default: Auto

My preference: Mass Storage

This entry allows you to select the type of USB connection protocol between your camera and computer.

- **Auto.** Connects your a68 to your computer or other device automatically, choosing either Mass Storage or MTP connection as appropriate.
- Mass Storage. In this mode, your camera appears to the computer as just another storage device, like a disk drive. You can drag and drop files between them.
- MTP. This mode, short for Media Transfer Protocol is a newer version of the PTP (Picture Transfer Protocol) that was standard in earlier cameras. It allows better two-way communication between the camera and the computer and is useful for both image transfer and printing with PictBridge-compatible printers.
- **PC Remote.** This setting is used with Sony's Remote Camera Control software to adjust shooting functions and take pictures from a linked computer.

USB LUN Setting

Options: Multi, Single

Default: Multi

My preference: Multi

This setting specifies how the a68 selects a Logical Unit Number when connecting to a computer through the USB port. Normally, you'd use Multi, which allows the camera to adjust the LUN as necessary, and is compatible with the PlayMemories Home software. Use Single to lock in a LUN if you have trouble making a connection between your camera and a particular computer. PlayMemories Home software will usually not work when this setting is active. But don't worry; Single is rarely necessary.

Language

Options: English, French, Spanish, Italian, Japanese, Chinese languages

Default: Language of country where camera is sold

My preference: English

If you accidentally set a language you cannot read and find yourself with incomprehensible menus, don't panic. Just find the Setup menu, the one with the red tool box for its icon, and scroll down to the line that has a symbol that looks like an alphabet block "A" to the left of the item's heading. No matter which language has been selected, you can recognize this menu item by the "A." Scroll to it, press the center button to select this item, and scroll up/down among the options until you see a language you can read.

Date/Time Setup

Options: Year, Month, Day, Hour, Minute, Date Format, Daylight Savings Time

Default: None

My preference: None

This is the first entry on the Setup 4 menu. (See Figure 4.26.) Use this option to specify the date and time that will be embedded in the image file along with exposure information and other data. Having the date set accurately also is important for selecting movies for viewing by date. Use the left/right directional buttons to navigate through the choices of Daylight Savings Time: On/Off; year; month; day; hour; minute; and date format. You can't directly change the AM/PM setting; you need to scroll the hours past midnight or noon to change that setting. Use the up/down directional buttons or rotate the control dial to change each value as needed.

Area Setting

Options: World time zones

Default: None

My preference: None

When you select this option, you are presented with a world map on the LCD. Use the left/right directional buttons to scroll until you have highlighted the time zone that you are in. Once the camera is set up with the correct date and time in your home time zone, you can use this setting to change your time zone during a trip, so you will record the local time with your images without disrupting your original date and time settings. Just scroll back to your normal time zone once you return home. Because Daylight Savings Time is activated on different dates in different countries, this setting also helps your a68 make the switchover on the correct weekend.

Format

Options: Enter, Cancel

Default: None

My preference: Format after images are copied

As you'd guess, you'll use Format to re-format your memory card while it's in your a68. To proceed with this process, choose the Format menu item and select "OK" and press the center button to confirm, or Cancel to chicken out.

Use the Format command to erase everything on your memory card and to set up a fresh file system ready for use. This procedure removes all data that was on the memory card, and reinitializes the card's file system by defining anew the areas of the card available for image storage, locking out defective areas, and creating a new folder in which to deposit your images. The camera will

recognize SDXC cards and install the proper exFAT file system on them. It's usually a good idea to reformat your memory card in the camera (not in your camera's card reader using your computer's operating system) before each use. Formatting is generally much quicker than deleting images one by one. Before formatting the card, however, make sure that you have saved all your images and videos to another device; formatting will delete everything, including images that were protected.

File Number

Options: Series, Reset

Default: Series

My preference: Series

The default for the File Number item is Series, indicating that the a68 will automatically apply a file number to each picture and video clip that you make, using consecutive numbering; this will continue over a long period of time, spanning many different memory cards, and even if you reformat a card. Numbers are applied from 0001 to 9999; when you reach the limit, the camera starts back at 0001. The camera keeps track of the last number used in its internal memory. So, you could take pictures numbered as high as 100-0240 on one card, remove the card and insert another, and the next picture will be numbered 100-0241 on the new card. Reformat either card, take a picture, and the next image will be numbered 100-0242. Use the Series option when you want all the photos you take to have consecutive numbers (at least, until your camera exceeds 9999 shots taken).

If you want to restart numbering back at 0001 frequently, use the Reset option. In that case, the file number will be reset to 0001 *each* time you format a memory card or delete all the images in a folder, insert a different memory card, or change the folder name format (as described in the next menu entry). I do not recommend this since you will soon have several images with exactly the same file number.

Select REC Folder

Options: Folder **Default:** None

My preference: None

This entry allows you to create a new storage folder. Although your a68 will create new folders automatically as needed, you can create a new folder at any time, and switch among available folders already created on your memory card. (Of course, a memory card must be installed in the camera.) This is an easy way to segregate photos by folder. For example, if you're on vacation, you can change the Folder Name convention to Date Form (described next). Then, each day, create a new folder (with that date as its name), and then deposit that day's photos and video clips into it. A highlighted bar appears; press the up/down buttons to select the folder you want to use, and press the center button.

New Folder

Options: N/A

Default: None

My preference: None

This item will enable you to create a brand-new folder. Press the center button, and a message like "10100905 folder created" or "102MSDCF folder created" appears on the LCD. The alphanumeric format will be determined by the Folder Name option you've selected (and described next), either Standard Form or Date Form.

Folder Name

Options: Standard Form, Date Form

Default: Standard Form

My preference: Standard Form

This is the first entry in the Setup 5 menu (see Figure 4.27). If you have viewed one of your memory card's contents on a computer, you noticed that the top-level folder on the card is always named DCIM. Inside it, there's another folder created by your camera. Different cameras use different folder names, and they can co-exist on the same card. For example, if your memory card is removed from your Sony camera and used in, say, a camera from another vendor that also accepts Secure Digital or Memory Stick cards, the other camera will create a new folder using a different folder name within the DCIM directory.

Figure 4.27 The Setup 5 menu.

By default, the a68 creates its folders using a three-number prefix (starting with 100), followed by MSDCF. As each folder fills up with 999 images, a new folder with a prefix that's one higher (say, 101) is used. So, with the "Standard Form," the folders on your memory card will be named 100MSDCF, 101MSDCF, and so forth.

You can select Date Form instead, and the Alpha will use a xxxymmdd format, such as 10070904, where the 100 is the folder number, 7 is the last digit of the year (2017), 09 is the month, and 04 is the day of that month. If you want the folder names to be date-oriented, rather than generic, use the Date Form option instead of Standard Form. This entry allows you to switch back and forth between them, both for folder creation (using the New Folder entry described above) and REC folder preference (also described above).

Tip

Whoa! Sony has thrown you a curveball in this folder switching business. Note that if you are using Date Form naming, you can *create* folders using the date convention, but you can't switch among them when Date Form is active. If you *do* want to switch among folders named using the date convention, you can do it. But you have to switch from Date Form back to Standard Form. *Then* you can change to any of the available folders (of either naming format). So, if you're on that vacation, you can select Date Form, and then choose New Folder each day of your trip, if you like. But if, for some reason, you want to put some additional pictures in a different folder (say, you're revisiting a city and want the new shots to go in the same folder as those taken a few days earlier), you'll need to change to Standard Form, switch folders, and then resume shooting. Sony probably did this to preserve the "integrity" of the date/folder system, but it can be annoying.

Recover Image Database

Options: OK, Cancel

Default: None

My preference: None

The Recover Image DB function is provided in case errors crop up in the camera's database that records information about your movies. According to Sony, this situation may develop if you have processed or edited movies on a computer and then re-saved them to the memory card that's in your camera. I have never had this problem, so I'm not sure exactly what it would look like. But, if you find that your movies are not playing correctly in the camera, try this operation. Highlight this menu option and press the center button, and the camera will prompt you, "Check Image Database File?". Press the center button to confirm, or the MENU button to cancel.

Display Media Information

Options: None Default: None

My preference: None

This entry gives you a report of how many still images and how many movies can be recorded on the memory card that's in the camera, given the current shooting settings. This can be useful, but that information is already displayed on the screen when the camera is being used to shoot still photos (unless you have cycled to a display with less information), and the information about minutes remaining for movie recording is displayed on the screen as soon as you press the Record button. But, if you want confirmation of this information, this menu option is available.

Version

Options: None **Default:** None

My preference: None

Select this menu option to display the version number of the firmware (internal operating software) installed in your camera. From time to time, Sony updates the original firmware with a newer version that adds or enhances features or corrects operational bugs. When a new version is released, it will be accompanied by instructions, which generally involve downloading the update to your computer and then connecting your camera to the computer with the USB cable to apply the update. It's a good idea to check occasionally at the Sony website, esupport.sony.com (don't preface the URL with www), to see if a new version of the camera's firmware is available for download. (You can also go to that site to download updates to the software that came with the camera, and to get general support information.)

Setting Reset

Options: Camera Settings Reset, Initialize

Default: Camera Settings Reset

If you've made a lot of changes to your a68's settings, you may want to return their features to their defaults so you can start over without manually going back through the menus and restoring everything. This menu item lets you do that. Your choices are as follows:

- Camera Settings Reset. Resets the main shooting settings to their default values.
- Initialize. Resets *all* camera settings to their default settings, including the time/date and downloaded applications, but *not* including any AF Micro Adjustments you may have dialed in.

Shooting Modes and Exposure Control

When you bought your Sony a68, you probably thought your days of worrying about getting the correct exposure were over. To paraphrase an old Kodak tagline dating back to the 19th Century—the goal is, "you press the button, and the camera does the rest." For the most part, that's a realistic objective. The a68 is one of the smartest cameras available when it comes to calculating the right exposure for most situations. You can generally choose one of the Auto or Scene modes, or spin the mode dial to Program (P), Aperture Priority (A), or Shutter Priority (S) and shoot away.

So, why am I including an entire chapter on exposure? As you learn to use your a68 creatively, you're going to find that the right settings—as determined by the camera's exposure meter and intelligence—need to be *adjusted* to account for your creative decisions or special situations.

But even a camera as smart as the a68 can frequently benefit from additional intelligent input. For example, when you shoot with the main light source behind the subject, you end up with *backlighting*, which can result in an overexposed background and/or an underexposed subject. The Sony a68 recognizes backlit situations nicely, and, in most cases, can properly base exposure on the main subject using the default Multi metering mode, producing a decent photo. Features like D-Range Optimizer can further fine-tune exposure to preserve detail in the highlights and shadows.

But what if you *want* to underexpose the subject, to produce a silhouette effect? Or, perhaps, you might want to flip up the a68's built-in flash unit to fill in the shadows on your subject. The more you know about how to use your a68, the more you'll run into situations where you want to creatively tweak the exposure to provide a different look than you'd get with a straight shot.

This chapter shows you the fundamentals of exposure, so you'll be better equipped to override the Sony a68's default settings when you want to, or need to. After all, correct exposure is one of the foundations of good photography, along with accurate focus and sharpness, appropriate color balance, freedom from unwanted noise and excessive contrast, as well as pleasing composition.

The Sony a68 gives you a great deal of control over all of these, although composition is entirely up to you. You must still frame the photograph to create an interesting arrangement of subject matter, but all the other parameters are basic functions of the camera. You can let your a68 set them for you automatically, you can fine-tune how the camera applies its automatic settings, or you can make them yourself, manually. The amount of control you have over exposure, sensitivity (ISO settings), color balance, focus, and image parameters like sharpness and contrast make the a68 a versatile tool for creating images.

In the next few pages, I'm going to give you a grounding in one of those foundations, and explain the basics of exposure, either as an introduction or as a refresher course, depending on your current level of expertise. When you finish this chapter, you'll understand most of what you need to know to take well-exposed photographs creatively in a broad range of situations.

Getting a Handle on Exposure

In the most basic sense, exposure is all about light. Exposure can make or break your photo. Correct exposure brings out the detail in the areas you want to picture, providing the range of tones and colors you need to create the desired image. Poor exposure can cloak important details in shadow, or wash them out in glare-filled featureless expanses of white. However, getting the perfect exposure requires some intelligence—either that built into the camera or the smarts in your head—because digital sensors can't capture all the tones we are able to see. If the range of tones in an image is extensive, embracing both inky black shadows and bright highlights, we often must settle for an exposure that renders most of those tones—but not all—in a way that best suits the photo we want to produce.

As the owner of an advanced camera like the a68, you're probably well aware of the traditional "exposure triangle" of aperture (quantity of light/light passed by the lens), shutter speed (the amount of time the shutter is open), and the ISO sensitivity of the sensor—all working proportionately and reciprocally to produce an exposure. The trio is itself affected by the amount of illumination that is available to work with. So, if you double the amount of light, increase the aperture by one stop, make the shutter speed twice as long, or boost the ISO setting 2X, you'll get twice as much exposure. Similarly, you can increase any of these factors while decreasing one of the others by a similar amount to keep the *same* exposure.

Working with any of the three controls always involves trade-offs. Larger f/stops provide less depth-of-field, while smaller f/stops increase depth-of-field and can decrease sharpness through a phenomenon called diffraction, as discussed in Chapter 9. Shorter shutter speeds do a better job of reducing the effects of camera/subject motion, while longer shutter speeds make that motion blur more likely. Higher ISO settings increase the amount of visual noise and artifacts in your image, while lower ISO settings reduce the effects of noise. (See Figure 5.1.)

For example, look at two exposures presented at top in Figure 5.2. For the image at the left, the highlight areas (chiefly the clouds at upper left and the top-left edge of the skyscraper) are well exposed, but everything else in the shot is seriously underexposed. The version at right, taken an instant later with the tripod-mounted camera, shows detail in the shadow areas of the buildings, but the highlights are completely washed out. The camera's sensor simply can't capture detail in both dark areas and bright areas in a single shot.

With digital camera sensors, it's often tricky to capture detail in both highlights and shadows in a single image, because the number of tones, the *dynamic range* of the sensor, is limited. The solution, in this particular case, was to resort to a technique called High Dynamic Range (HDR) photography, in which the two exposures were combined in an image editor such as Photoshop, or a specialized HDR tool like Photomatix (about \$100 from www.hdrsoft.com). The resulting shot is shown

Figure 5.1
The traditional exposure triangle includes aperture, shutter speed, and ISO sensitivity.

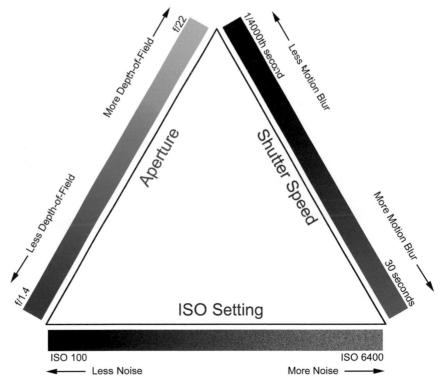

in Figure 5.2, bottom. The Auto HDR feature of your a68, found in the DRO/Auto HDR entry of the Camera Settings 5 menu, lets you accomplish a decent approximation of HDR processing right in the camera. For now, though, I'm going to concentrate on showing you how to get the best exposures possible without resorting to such tools, using only the ordinary exposure-related features of your a68.

Figure 5.2 At top left, the image is exposed for the highlights, losing shadow detail. At top right, the exposure captures detail in the shadows, but the highlights are washed out. Combining the two exposures in HDR software produces the best compromise image. (Bottom.)

To understand exposure, you need to appreciate the aspects of light that combine to produce an image. Start with a light source—the sun, a household lamp, or the glow from a campfire—and trace its path to your camera, through the lens, and finally to the sensor that captures the illumination. Here's a brief review of the things within our control that affect exposure, listed in "chronological" order (that is, as the light moves from the subject to the sensor):

- Light at its source. Our eyes and our cameras—film or digital—are most sensitive to that portion of the electromagnetic spectrum we call visible light. That light has several important aspects that are relevant to photography, such as color and harshness (which is determined primarily by the apparent size of the light source as it illuminates a subject). But, in terms of exposure, the important attribute of a light source is its intensity. We may have direct control over intensity, which might be the case with an interior light that can be brightened or dimmed. Or, we might have only indirect control over intensity, as with sunlight, which can be made to appear dimmer by introducing translucent light-absorbing or reflective materials in its path.
- **Light's duration.** We tend to think of most light sources as continuous. But, as you'll learn in Chapter 10, the duration of light can change quickly enough to modify the exposure, as when the main illumination in a photograph comes from an intermittent source, such as an electronic flash.
- Light reflected, transmitted, or emitted. Once light is produced by its source, either continuously or in a brief burst, we are able to see and photograph objects by the light that is reflected from our subjects toward the camera lens; transmitted (say, from translucent objects that are lit from behind); or emitted (by a candle or television screen). When more or less light reaches the lens from the subject, we need to adjust the exposure. This part of the equation is under our control to the extent we can increase the amount of light falling on or passing through the subject (by adding extra light sources or using reflectors), or by pumping up the light that's emitted (by increasing the brightness of the glowing object).
- Light passed by the lens. Not all the illumination that reaches the front of the lens makes it all the way through. Filters can remove some of the light before it enters the lens. Inside the lens barrel is a variable-sized diaphragm that dilates and contracts to produce an aperture that controls the amount of light that enters the lens. You, or the a68's autoexposure system, can vary the size of the aperture to control the amount of light that will reach the sensor. The relative size of the aperture is called the f/stop.
- Light passing through the shutter. Once light passes through the lens, the amount of time the sensor receives it is determined by the a68's shutter; this mechanism can remain open for as long as 30 seconds (or even longer if you use the camera's Bulb setting) or as briefly as 1/4,000th second.

■ Light captured by the sensor. Not all the light falling onto the sensor is captured. If the number of photons reaching a particular photosite doesn't pass a set threshold, no information is recorded. Similarly, if too much light illuminates a pixel in the sensor, then the excess isn't recorded or, worse, spills over to contaminate adjacent pixels. We can modify the minimum and maximum number of pixels that contribute to image detail by adjusting the ISO setting. At higher ISO levels, the incoming light is amplified to boost the effective sensitivity of the sensor.

F/STOPS AND SHUTTER SPEEDS

Especially if you're new to advanced cameras, it's worth quickly reviewing some essential concepts. For example, the lens aperture, or f/stop, is a ratio, much like a fraction, which is why f/2 is larger than f/4, just as 1/2 is larger than 1/4. However, f/2 is actually four times as large as f/4. (Think back to high school geometry where we learned that to double the area of a circle, you multiply its diameter by the square root of two: 1.4.) (See Figure 5.3.)

The full f/stops available with an f/2 lens are f/2, f/2.8, f/4, f/5.6, f/8, f/11, f/16, and f/22. Each higher number indicates an aperture that's half the size of the previous number. Of course, you can also set intermediate apertures with the a68, such as f/6.3 and f/7.1, which fall between f/5.6 and f/8.

Shutter speeds are actual fractions (of a second), so that 1/60, 1/125, 1/160, 1/500, 1/1000, and so forth represent 1/60th, 1/125th, 1/160th, 1/500th, and 1/1000th second. Each higher number indicates a shutter speed that's half as long as the one before. (And yes, intermediate shutter speeds can also be used, such as 1/640th or 1/800th second.) To avoid confusion, Sony uses quotation marks to signify long exposures: 0.8", 2", 2.5", 4", and so forth; these examples represent 0.8-second, 2-second, 2.5-second, and 4-second exposures, respectively.

Figure 5.3
Top row (left to right): f/2, f/2.8, f/4, f/5.6; bottom row: f/8, f/11, f/16, f/22.

Quantity of light, light passed by the lens, the amount of time the shutter is open, and the sensitivity of the sensor all work proportionately and reciprocally to produce an exposure. That is, if you double the amount of light, increase the aperture size by one stop, make the shutter speed twice as long, or double the ISO sensitivity, you'll get twice as much exposure. Similarly, you can reduce any of these and reduce the exposure when that is preferable.

As we'll see, however, changing any of those aspects in P, A, or S mode does not change the exposure; that's because the camera also makes changes when you do so, in order to maintain the same exposure. That's why Sony provides other methods for modifying the exposure in those modes.

Equivalent Exposure

One of the most important aspects in this discussion is the concept of "equivalent exposure." This term means that exactly the same amount of light will reach the sensor at various combinations of aperture and shutter speed. Whether we use a small aperture (large f/number) with a long shutter speed or a wide aperture (small f/number) with a fast shutter speed, the amount of light reaching the sensor can be exactly the same. Table 5.1 shows equivalent exposure settings using various shutter speeds and f/stops; in other words, any of the combination of settings listed will produce exactly the same exposure.

When you set the a68 to P mode, the camera sets both the aperture and the shutter speed that should provide a correct exposure, based on guidance from the light metering system. In P mode, you cannot change the aperture or the shutter speed individually, but you can shift among various aperture/shutter speed combinations by rotating either control dial. And if you change the ISO, the camera will set a different combination automatically. As the concept of equivalent exposure indicates, the image brightness will be exactly the same in every photo you shoot with the various combinations because they all provide the same exposure.

In Aperture Priority (A) and Shutter Priority (S) modes, you can change the aperture or the shutter speed, respectively. The camera will then change the other factor to maintain the same exposure. I'll cover all of the operating modes and the important aspects of exposure with each mode in this chapter.

Table 5.1 Equivalent Exposures			
Shutter speed	f/stop	Shutter speed	f/stop
1/30th second	f/22	1/160th second	f/8
1/60th second	f/16	1/500th second	f/5.6
1/125th second	f/11	1/1000th second	f/4

How the a68 Calculates Exposure

Your camera calculates exposure by measuring the light that passes through the lens and reaches the sensor, based on the assumption that each area being measured reflects about the same amount of light as a neutral gray card that reflects a "middle" gray of about 12- to 18-percent reflectance. (The photographic "gray cards" you buy at a camera store have an 18-percent gray tone; your camera is calibrated to interpret a somewhat darker 12-percent gray. I'll explain more about this later.) That "average" 12- to 18-percent gray assumption is necessary, because different subjects reflect different amounts of light. In a photo containing, say, a white cat and a dark gray cat, the white cat might reflect five times as much light as the gray cat. An exposure based on the white cat will cause the gray cat to appear to be black, while an exposure based only on the gray cat will make the white cat look washed out.

This is more easily understood if you look at some photos of subjects that are dark (they reflect little light), those that have predominantly middle tones, and subjects that are highly reflective. The next few figures show some images of actual cats (actually, the same off-white cat rendered in black, gray, and white varieties through the magic of Photoshop), with each of the three strips exposed using a different cat for reference.

Correctly Exposed

The three pictures shown in Figure 5.4 represent how the black, gray, and white cats would appear if the exposure were calculated by measuring the light reflecting from the middle, gray cat, which, for the sake of illustration, we'll assume reflects approximately 12 to 18 percent of the light that strikes it. The exposure meter sees an object that it thinks is a middle gray, calculates an exposure based on that, and the feline in the center of the strip is rendered at its proper tonal value. Best of all, because the resulting exposure is correct, the black cat at left and white cat at right are rendered properly as well.

Note

The examples in Figure 5.4 were made using Center metering, which works exactly as discussed in the previous paragraph. The a68 also offers Multi metering which applies artificial intelligence when calculating the exposure, as discussed shortly. That system applies algorithms that can produce a good exposure even when part of a scene is white or another light tone. Since Center metering does not use such "trickery," the results you get are more predictable, making this type of metering useful when learning the concepts of exposure. Later in this chapter, I'll describe the three metering modes, each employing a different "strategy," as well as the various a68 features you can use to get a good exposure in difficult situations.

Overexposed

The strip of three images in Figure 5.5 shows what happens if the exposure were calculated based on metering the leftmost, black cat. The light meter sees less light reflecting from the black cat than it would see from a gray middle-tone subject, and so figures, "Aha! I need to add exposure to brighten this subject up to a middle gray!" That lightens the black cat, so it now appears to be gray.

But now the cat in the middle that was *originally* middle gray is overexposed and becomes light gray. And the white cat at right is now seriously overexposed, and loses detail in the highlights, which have become a featureless white.

Underexposed

The third possibility in this simplified scenario is that the light meter might measure the illumination bouncing off the white cat, and try to render that feline as a middle gray. A lot of light is reflected by the white kitty, so the exposure is *reduced*, bringing that cat closer to a middle gray tone. The cats that were originally gray and black are now rendered too dark. Clearly, measuring the gray cat—or a substitute that reflects about the same amount of light—is the only way to ensure that the exposure is precisely correct. (See Figure 5.6.)

Figure 5.4
When exposure is calculated based on the middle-gray cat in the center, the black and white cats are rendered accurately, too.

Figure 5.5

When exposure is calculated based on the black cat at the left, the black cat looks gray, the gray cat appears to be a light gray, and the white cat is seriously overexposed.

Figure 5.6
When exposure is calculated based on the white cat on the right, the other two cats are underexposed.

Metering Mid-Tones

As you can see from the examples using felines, the best way to guarantee a perfect exposure is to measure the light reflected by a mid-tone subject. That need not be gray like our furry friend in the center of the three strips of photos. Any mid-tone subject—including green grass or a rich, mediumblue sky—also reflects about 12 to 18 percent of the light. Metering such an area should ensure that the exposure for the entire scene will be correct or close to correct.

In some scenes (like a snowy landscape or a lava field) you won't have a mid-tone to meter. Unless the gray cat has come along for the ride, you might want to use the evenly illuminated gray card mentioned earlier. But, the standard Kodak gray card reflects 18 percent of the light while your camera is calibrated for a somewhat darker 12-percent tone. If you insisted on getting a perfect exposure, you would need to add about one-half stop more exposure than the value provided by taking the light meter reading from the card.

WHY THE GRAY CARD CONFUSION?

Why are so many photographers under the impression that cameras and meters are calibrated to the 18-percent "standard," rather than the true value, which may be 12 to 14 percent, depending on the vendor? You'll find this misinformation in an alarming number of places. I've seen the 18-percent "myth" taught in camera classes; I've found it in books, and even been given this wrong information from the technical staff of camera vendors. (They should know better—the same vendors' engineers who design and calibrate the cameras have the right figure.)

A gray value of 18 percent derives from the *printing* industry, and it's thought that Kodak originally decided to use that gray reference because such cards could be produced cheaply and consistently. When the company began marketing gray cards, they were accompanied by instructions to meter from the card, and then open up an extra half stop to compensate.

Unfortunately, during a revision of Kodak's instructions for its gray cards in the 1970s, the advice to open up an extra half stop was omitted, and a whole generation of shooters grew up thinking that a measurement off a gray card could be used as-is. The proviso returned to the instructions a decade later, but by then it was too late. Using the latest version of the KODAK Gray Cards, Publication R-27Q (which is still available for purchase from vendors who took over from Kodak), the current directions read (with a bit of paraphrasing from me in italics):

- For subjects of normal reflectance increase the indicated exposure by 1/2 stop.
- For light subjects use the indicated exposure; for very light subjects, decrease the exposure by 1/2 stop. (*That is, you're measuring a cat that's lighter than middle gray.*)
- If the subject is dark to very dark, increase the indicated exposure by 1 to 1-1/2 stops. (You're shooting a black cat.)

Another substitute for a gray card is the palm of a human hand (the backside of the hand is too variable). But a human palm, regardless of ethnic group, is even brighter than a standard gray card, so instead of one-half stop more exposure, you need to add one additional stop. Let's say you're using the camera's M mode. If the meter reading (based on your palm) is 1/500th of a second at f/8, switch to a shutter speed of 1/250th second. If you prefer, switch to f/5.6 instead, while continuing to use 1/500th second shutter speed. Whether you set a one step longer shutter speed or a one stop wider aperture, the photo will be brighter by exactly the same amount. (Both exposures are equivalent.)

If you actually wanted to use a gray card, place it in your frame near your main subject, facing the camera, and with the exact same even illumination falling on it that is falling on your subject. Then, use the Spot metering function (described in the next section) to take a light meter reading only from the card. Of course, in most situations, it's not necessary to do this. Your camera's light meter will do a good job of calculating the right exposure, especially if you use the exposure tips in the next section. But, I felt that explaining exactly what is going on during exposure calculation would help you understand how your a68's metering system works.

To meter properly you'll want to choose both the *metering method* (how light is evaluated) and *exposure method* (how the appropriate shutter speeds and apertures are chosen). I'll describe both in the following sections.

EXTERNAL METERS CAN BE CALIBRATED

The light meters built into your a68 are calibrated at the factory and cannot be adjusted. But if you use a hand-held incident or reflective light meter, you *can* calibrate it, using the instructions supplied with your meter. Because a hand-held meter can be calibrated to the 18-percent gray standard (or any other value you choose), my rant about the myth of the 18-percent gray card doesn't apply.

MODES, MODES, AND MORE MODES

Call them modes or methods, the Sony a68 seems to have a lot of different sets of options that are described using similar terms. Here's how to sort them out:

- Metering method. These modes determine the *parts of the image* on the sensor that are examined in order to calculate exposure. The a68 may look at many different points within the image, segregate them by zone (Multi metering); examine the same number of points, but give greater weight to those located in the middle of the frame (Center metering); or evaluate only a limited number of points in a limited area (Spot metering).
- Exposure method. These modes determine *which* of the available settings are used to expose the image. The a68 may adjust the shutter speed, the aperture, or both, or even ISO setting (if Auto ISO is active), depending on the method you choose.

The Importance of ISO

Another essential concept when discussing exposure, ISO control allows you to change the sensitivity of the camera's imaging sensor. (Actually, the sensitivity isn't being changed; selecting a higher ISO causes the camera to *amplify* the signal to produce the same effect.) Sometimes photographers forget about this option, because the common practice is to set the ISO once for a particular shooting session (say, at ISO 100 or 200 for bright sunlight outdoors, or ISO 800 or 1600 when shooting indoors) and then forget about it. Or some shooters simply leave the camera set to ISO Auto. That enables the camera to change the ISO it deems necessary, setting a low ISO in bright conditions or a higher ISO in a darker location. That's fine but sometimes you'll want to set a specific ISO yourself. That will be essential sometimes, since ISO Auto cannot set the highest ISO levels that are available when you use manual ISO selection.

TIP

When shooting in the Program (P), Aperture Priority (A), and Shutter Priority (S) modes, all discussed soon, changing the ISO does not change the exposure. If you switch from using ISO 100 to ISO 1600 in A mode, for example, the camera will simply set a different shutter speed. If you change the ISO in S mode, the camera will set a different aperture, and in P mode, it will set a different aperture and/or shutter speed. In all of these examples, the camera will maintain the same exposure. If you want to make a brighter or a darker photo in P, A, or S mode, you would need to set + or – exposure compensation, as discussed later.

However, when you use the Manual (M) mode, changing the ISO also changes the exposure, as discussed shortly.

While any camera provides the best possible image quality in the ISO 100 to 800 range, we use higher ISO levels such as ISO 1600 in low light and ISO 6400 in a very dark location because it allows us to shoot at a faster shutter speed. That's often useful for minimizing the risk of blurring caused by camera shake or by the movement of the subject. Or, we may want the higher sensitivity to let us use a smaller aperture for increased sharpness or depth-of-field. Sometimes, we boost ISO in order to let us do both.

Although you can set a desired ISO level yourself, the a68 also offers an ISO Auto option. When set, the camera will select an ISO that should be suitable for the conditions: a low ISO on a sunny day and a high ISO in a dark location. In fully automatic operating modes, ISO Auto is the only available option. As I explained in Chapter 3, you can use the Camera Settings 5 menu's ISO setting to specify both minimum and maximum ISO settings that will limit the range used by the a68 in ISO Auto mode.

You can select a minimum value from ISO 100 to ISO 25600, and a maximum within the same range, except, of course, that the maximum can't be *lower* than the minimum. You could, however, choose a seemingly ridiculous combination, such as a minimum ISO of 12800, and a maximum of 25600 (it must be *very* dark!), or even have *both* minimum and maximum set to, say, 25600, which would be the same as selecting a fixed ISO 25600 setting.

Over the past few years, there has been something of a competition among the manufacturers of digital cameras to achieve the highest ISO ratings—sort of a non-military version of the "missile gap" of years gone by. The highest announced ISO numbers have been rising annually; a few cameras even allow you to set an ISO higher than 200,000. Sony is a bit more conservative but the a68 offers all of the ISO options you're ever likely to need, up to ISO 25600. You can even use Auto ISO in Manual exposure mode, as I'll explain later.

Choosing a Metering Method

The Sony a68 has three different schemes for evaluating the light received by its exposure sensors. The quickest way to choose among them is to assign Metering Mode to a key using the Custom Key settings in the Custom Settings 4 menu, as described in Chapter 4. Then, you can press the defined key to produce the Metering Mode screen; then scroll up/down among the options. Without a custom key, the default method for choosing a metering mode is to use the Camera Settings 6 menu entry (see Figure 5.7), the Function menu, or the Quick Navi menu.

Figure 5.7
The a68 provides three options for metering mode (left, top to bottom):
Multi (the default),
Center, and Spot.

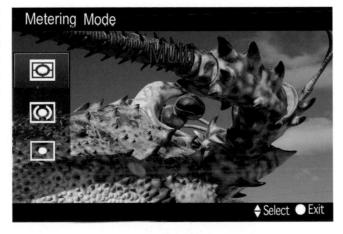

Here are your options:

■ Multi. In this "intelligent" (multi-segment) metering mode, the a68 slices up the frame into 1,200 different zones, as shown in Figure 5.8. The camera evaluates the measurements to make an educated guess about what kind of picture you're taking, based on examination of exposure data derived from thousands of different real-world photos. For example, if the top section of a picture is much lighter than the bottom portions, the algorithm can assume that the scene is a landscape photo with lots of sky. This mode is the best all-purpose metering method for most pictures. A typical scene suitable for Multi metering is shown in Figure 5.9.

The Multi system can recognize a very bright scene and it can automatically increase the exposure to reduce the risk of a dark photo. This will be useful when your subject is a snow-covered landscape or a close-up of a bride in white. Granted, you may occasionally need to use a bit of exposure compensation, but often, the exposure will be close to accurate even without it. (In my experience, the Multi system is most successful with light-toned scenes on bright days. When shooting in dark, overcast conditions, it's more likely to underexpose a scene of that type.)

■ Center. Mentioned earlier, this (center-weighted) metering was the only available option with cameras some decades ago. In this mode you get conventional metering without any "intelligent" scene evaluation. The light meter considers brightness in the entire frame but places the greatest emphasis on a large area in the center of the frame, as shown in Figure 5.10, on the theory that, for most pictures, the main subject will not be located far off-center.

Of course, Center metering is most effective when the subject in the central area is a mid-tone. Even then, if your main subject is surrounded by large, extremely bright or very dark areas, the exposure might not be exactly right. (You might need to use exposure compensation, a feature discussed shortly.) However, this scheme works well in many situations if you don't want to use one of the other modes, for scenes like the one shown in Figure 5.11.

Figure 5.8 Multi metering uses 1,200 zones.

Figure 5.9 Multi metering is suitable for complex scenes like this one.

Figure 5.10 Center metering calculates exposure based on the full frame, but emphasizes the center area.

Figure 5.11 Scenes with the important tones in the center of the frame lend themselves to Center metering.

■ **Spot.** This mode confines the reading to a very small area in the center of the image, as shown in Figure 5.12. (When you use Flexible Spot autofocus however, the spot metering will be at the area where the camera sets focus.) The Spot meter does not apply any "intelligent" scene evaluation. Because the camera considers only a small target area, and completely ignores its surroundings, Spot metering is most useful when the subject is a small mid-tone area. For example, the "target" might be a tanned face, a medium red blossom, or a gray rock in a wideangle photo; each of these is a mid-tone. And that is important as you will recall from our example involving the cats.

The Spot metering technique is simple if you want to Spot meter a small area that's dead center in the frame. If the "target" is off-center, you would need to point the lens at it and use the AE Lock technique discussed later in this chapter. (Lock exposure on your target before re-framing for a better composition so the exposure does not change.) For Figure 5.13, Spot metering was used to base the exposure on the musician's face.

If you Spot meter a light-toned area or a dark-toned area, you will get underexposure or over-exposure respectively; you would need to use an override for more accurate results. On the other hand, you can Spot meter a small mid-tone subject surrounded by a sky with big white clouds or by an indigo blue wall and get a good exposure. (The light meter ignores the subject's surroundings so they do not affect the exposure.) That would not be possible with Center metering, which considers brightness in a much larger area.

Figure 5.12 Spot metering calculates exposure based on a spot that's only a small percentage of the image area.

Figure 5.13 Meter from precise areas in an image, such as facial features, using Spot metering.

Choosing an Exposure Mode

After you set a desired metering mode, you have several methods for choosing the appropriate shutter speed and aperture semi-automatically or manually. Just press the center button of the mode dial and spin the dial to the exposure mode that you want to use. If the Mode Dial Guide is activated in the Setup 2 menu (as described in Chapter 4), you'll see a display like the one shown in Figure 5.14. Your choice of which is best for a given shooting situation will depend on aspects like your need for extensive or shallow depth-of-field (the range of acceptably sharp focus in a photo) or the desire to freeze action or to allow motion blur. The semi-automatic Aperture Priority and Shutter Priority modes discussed in the next section emphasize one aspect of image capture or another, but the following sections introduce you to all four of the modes that photographers often call "creative."

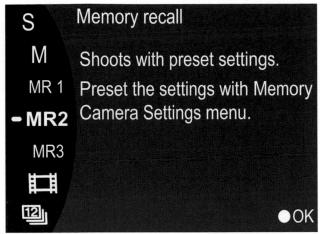

Aperture Priority (A) Mode

When using the A mode, you specify the lens opening (aperture or f/stop) with either control dial. After you do so, the a68 (guided by its light meter) will set a suitable shutter speed considering the aperture and the ISO in use. If you change the aperture, from f/5.6 to f/11 for example, the camera will automatically set a longer shutter speed to maintain the same exposure, using guidance from the built-in light meter. (I discussed the concept of equivalent exposure earlier and provided the equivalent exposure chart.)

Aperture Priority is especially useful when you want to use a particular lens opening to achieve a desired effect. Perhaps you'd like to use the smallest aperture (such as f/22) to maximize depth-of-field (DOF), to keep the entire subject sharp in a close-up picture. Or, you might want to use a large aperture (small f/number like f/4) to throw everything except your main subject out of focus, as in Figure 5.15. Maybe you'd just like to "lock in" a particular f/stop, such as f/8, because it allows your lens to provide the best optical quality. Or, you might prefer to use f/2.8 with a lens that has a maximum aperture of f/1.4, because you want the best compromise between shutter speed and optical quality.

Aperture Priority can even be used to specify a *range* of shutter speeds you want to use under varying lighting conditions, which seems almost contradictory. But think about it. You're shooting a soccer game outdoors with a telephoto and want a relatively fast shutter speed, but you don't care if the speed changes a little should the sun duck behind a cloud. Set your a68's shooting mode to A, and adjust the aperture using either control dial until a shutter speed of, say, 1/1000th second is selected at the ISO level that you're using. (In bright sunlight at ISO 400, that aperture is likely to be around f/11.) Then, go ahead and shoot, knowing that your a68 will maintain that f/11 aperture (for sufficient DOF as the soccer players move about the field), but will drop down to 1/800th or 1/500th second if necessary should a light cloud cover part of the sun.

Figure 5.15 Use Aperture Priority mode to "lock in" a wide aperture (denoted by a large f/number) when you want to blur the background.

When the camera cannot provide a good exposure at the aperture you have set, the +/- symbol and the shutter speed numeral will blink in the LCD or viewfinder display. The blinking warns that the a68 is unable to find an appropriate shutter speed at the aperture you have set, considering the ISO level in use, and over- or underexposure will occur. That's the major pitfall of using Aperture Priority: you might select an f/stop that is too small or too large to allow an optimal exposure with the available shutter speeds.

Here are a couple of examples where you might encounter a problem. Let's say you set an aperture of f/2.8 while using ISO 400 on an extremely bright day (perhaps at the beach or in snow); in this situation, even your camera's fastest shutter speed might not be able to cut down the amount of light reaching the sensor to provide the right exposure. (The solution here is to set a lower ISO or a smaller aperture, or both, until the blinking stops.) Or, let's say you have set f/16 in a dark arena while using ISO 100; the camera cannot find a shutter speed long enough to provide a correct exposure so your photo will be underexposed. (In low light, the solution is to set a higher ISO or a wider aperture, or both, until the blinking stops.) Aperture Priority is best used by those with a bit of experience in choosing settings. Many seasoned photographers leave their a68 set on Aperture Priority all the time.

Shutter Priority (S) Mode

Shutter Priority is the inverse of Aperture Priority. You set the shutter speed you'd like, using either control dial, and the camera sets an appropriate f/stop considering the ISO that's in use. When you change the shutter speed, the camera will change the aperture to maintain the same (equivalent) exposure using guidance from the built-in light meter. Shutter Priority mode gives you some control over how much action-freezing capability your digital camera brings to bear in a particular situation. In other cases, you might want to use a slow shutter speed to add some blur to a sports photo that would be mundane if the action were completely frozen (see Figure 5.16).

Take care when using a slow shutter speed such as 1/8th second, because you'll get blurring from camera shake unless you're using a tripod or other firm support. Of course, this applies to any mode but in most modes the camera displays a camera shake warning icon when the shutter speed is long. That does not appear in S mode however, perhaps because Sony assumes that users of Shutter Priority are aware of the potential problem caused by camera shake. The SteadyShot stabilizer in OSS (Optical SteadyShot)-designated lenses is useful but it cannot work miracles.

Figure 5.16 Set a slow shutter speed when you want to introduce blur into an action shot, as with this panned image of a cyclist.

As in Aperture Priority, you can encounter a problem in Shutter Priority mode; this happens when you select a shutter speed that's too long or too short for correct exposure under certain conditions. I've shot outdoor soccer games on sunny fall evenings and used Shutter Priority mode to lock in a 1/1000th second shutter speed, only to find that my a68 refused to produce the correct exposure when the sun dipped behind some trees and there was no longer enough light to shoot at that speed, even with the lens wide open.

In cases where you have set an inappropriate shutter speed, the aperture numeral and the +/- symbol will blink on the LCD. When might this happen? Let's say you set 1/15th second shutter speed while using ISO 400 on that extremely bright day; in this situation, even the smallest aperture available with your lens might not be able to cut down the amount of light reaching the sensor to provide a correct exposure. (The solution here is to set a lower ISO or a faster shutter speed, or both, until the blinking stops.) Or, let's say you have set 1/160th second in the arena while using ISO 100; your lens does not offer an aperture that's wide enough to enable the camera to provide a good exposure so you'll get the blinking and your photo will be underexposed. (In low light, the solution is to set a higher ISO or a longer shutter speed, or both, until the blinking stops.)

Program Auto (P) Mode

The Program mode uses the camera's built-in smarts to set an aperture/shutter speed combination, based on information provided by the light meter. If you're using Multi metering, the combination will often provide a good exposure. Rotate the control dial and you can switch to other aperture/shutter speed combinations, all providing the same (equivalent) exposure. This is called Program Shift, and when you use it to depart from the setting chosen by the a68, an asterisk appears next to the P on viewing screens.

In the unlikely event that the correct exposure cannot be achieved with the wide range of shutter speeds and apertures available, the shutter speed and aperture will both blink. (The solution is to set a lower ISO in bright light and a higher ISO in dark locations until the blinking stops.) The P mode is the one to use when you want to rely on the camera to make reasonable basic settings of shutter speed and aperture, but you want to retain the ability to adjust many of the camera's settings yourself. All overrides and important functions are available, including ISO, white balance, metering mode, exposure compensation, and others.

Making Exposure Value Changes

Sometimes you'll want a brighter or darker photo (more or less exposure) than you got when relying on the camera's metering system. Perhaps you want to underexpose to create a silhouette effect, or overexpose to produce a high-key (very light) effect. It's easy to do so by using the a68's exposure compensation control. This feature is available only in P, A, S, and Panorama mode; you cannot modify exposure in fully automatic modes and there are different methods for doing so in the fully manual M mode.

Press the +/- button (located between the WB and ISO buttons on top of the camera) and a scale appears (see Figure 5.17). Using the left/right controls or either control dial, scroll toward the + end of the scale if you want to take photos that will be brighter. Or scroll down to set minus compensation when you want to take photos that will be darker.

In my experience, adding exposure compensation is the option that's most often necessary. I'll often set +2/3 when using Multi metering if the camera underexposed my first photo of a light-toned scene. With Center or Spot metering, +1.3 or an even higher level of plus compensation is almost always necessary with a light-toned subject. Since the a68 provides a live preview of the scene, it's easy to predict when the photo you'll take is likely to be obviously over- or underexposed. When the histogram display is on, you can make a more accurate prediction about the exposure; I'll discuss this feature shortly. Of course, you can also use plus compensation when you want to intentionally overexpose a scene for a creative effect.

You won't often need to use minus compensation. This feature is most likely to be useful when metering a dark-toned subject, such as close-ups of black animals or dark blue buildings. Since these dark-toned subjects lead the camera to overexpose, set -2/3 or -1 compensation (when using Multi metering) for a more accurate exposure. (The amount of minus compensation that you need to set may be quite different when using the other two metering modes.) Minus compensation can also be useful for intentionally underexposing a scene for a creative effect, such as a silhouette of a sailboat or a group of friends on a beach.

Any exposure compensation you set will remain active for all photos you take afterward. The camera provides a reminder as to what value is currently set in some display modes. Turning the a68 off and then back on does not set compensation back to zero; when you no longer need to use it, be sure to do so yourself. If you inadvertently leave it set for +1 or -1, for example, your photos taken under other circumstances will be over- or underexposed.

Figure 5.17 Adjusting Exposure Compensation.

Manual Exposure (M) Mode

Part of being an experienced photographer comes from knowing when to rely on your a68's automation (including Intelligent Auto, Superior Auto, P mode, and SCN mode settings), when to go semi-automatic (with Shutter Priority or Aperture Priority), and when to set exposure manually (using M). Some photographers actually prefer to set their exposure manually. This is quite convenient since the camera is happy to provide an indication of when your settings will produce over-or underexposure, based on its metering system's judgment. It can even indicate how far off the "correct" (recommended) exposure your photo will be, at the settings you have made.

I often hear comments from novices first learning serious photography claiming that they must use Manual mode in order to take over control from the camera. That's really not necessary. For example, you can control all important aspects when using semi-automatic A or S mode as discussed in the previous sections. This allows you to control depth-of-field (the range of acceptable sharpness) or the rendition of motion (as blurred or as frozen). You can set a desired ISO level; that will not change the exposure. You would use exposure compensation when you want a brighter or a darker photo.

Manual mode provides an alternative that allows you to control the aperture and the shutter speed and the exposure simultaneously. For example, when I shot the windmill in Figure 5.18, I was not getting exactly the desired effect with A or S mode while experimenting with various levels of exposure compensation. So, I switched to M mode, set ISO 100 and then set an aperture/shutter speed that might provide the intended exposure. After taking a test shot, I changed the aperture slightly and the next photo provided the exposure for the interpretation of the scene that I wanted.

Manual mode is also useful when working in a studio environment using multiple flash units. The additional flash units are triggered by slave devices (gadgets that set off the flash when they sense the light from another flash, or, perhaps from a radio or infrared remote control). Your camera's exposure meter doesn't compensate for the extra illumination, and can't interpret the flash exposure at all, so you need to set the aperture and shutter speed manually.

The Basic M Mode Technique

Depending on your proclivities, you might not need to use M mode very often, but it's still worth understanding how it works. Here are your considerations:

- Rotate the mode dial to M.
- Use the front control dial to adjust aperture and the rear control dial to adjust shutter speed (unless you've swapped their functions, as described in Chapter 4). The setting that is currently active will be highlighted in orange.
- If you have Exposure Set Guide in the Custom Settings 2 menu set to On, enlarged labels showing the changing shutter speed or aperture will be displayed near the bottom of the screen, unless you choose the Graphic display mode with the DISP button. In that case, scales will show the current shutter speed and aperture at the same time.

Figure 5.18 Manual mode allowed setting the exact exposure for this silhouette shot, by metering the subject and then underexposing.

- Any change you make to either factor affects the exposure, of course, so if you have Live View Display in the Custom Settings 2 menu set to Setting Effect ON, you'll see the display getting darker or brighter as you change settings.
- If the display you're viewing includes the histogram graph, that will provide an even better indication of the exposure you'll get as you set different apertures or shutter speeds. I'll explain histograms later in this chapter.

Adjusting Exposure with ISO Control in M Mode

As mentioned in the previous section, changing the ISO level is another method of changing the exposure in M mode. Most photographers control the aperture and/or shutter speed for this purpose, sometimes forgetting about the option to adjust ISO. The common practice is to set the ISO once for a particular shooting session (say, at ISO 100 outdoors on a bright day or ISO 1600 when shooting indoors). There is also a tendency to use the lowest ISO level possible because of a concern that high ISO levels produce images with obvious digital noise (such as a grainy effect). However, changing the ISO is a valid way of adjusting exposure in M mode, particularly with the a68, which produces good results at high ISO levels that create grainy, unusable pictures with some other camera models.

Indeed, I find myself using ISO adjustment as a convenient alternate way of adding or subtracting EV (exposure values) when shooting in Manual mode, and as a quick way of choosing equivalent exposures when in automatic or semi-automatic modes. For example, I've selected a manual exposure with both f/stop and shutter speed suitable for my image using, say, ISO 400. I can change the exposure in full stop increments by pressing the ISO button on top of the camera, and spinning either control dial one click at a time. The difference in image quality/noise is not much different at ISO 200 or ISO 800 than at ISO 400, and this method of exposure control allows me to shoot at my preferred f/stop and shutter speed while retaining control of the exposure.

Or, perhaps, I am using Shutter Priority mode and the metered exposure at ISO 400 is 1/500th second at f/11. If I decide on the spur of the moment I'd rather use 1/500th second at f/8, I can press the ISO button and quickly switch to ISO 200. Of course, it's a good idea to monitor your ISO changes, so you don't end up at ISO 6400 or above accidentally; a setting like that will result in more digital noise (graininess) in your image than you would like. In M mode, Auto ISO is not available. (If you are shooting with ISO Auto in another mode and then switch to M mode, the ISO will be set at 100 by the camera.) You can set any ISO level as high as 25600 but I rarely need to go above 6400. The higher ISO levels are necessary only when shooting in a very dark location where a fast shutter speed is important; this might happen during a sports event in a dark arena, for example.

As I mentioned in Chapter 3, if you have a situation in which you want to nail down a specific shutter speed *and* aperture, you can configure the a68 to lock in those values and automatically change the ISO setting as appropriate to achieve a good exposure. Oddly enough, this behavior is carried out in so-called Manual exposure mode! Just follow these steps:

- 1. **Switch to Manual exposure mode.** Rotate the mode dial to M.
- 2. **Make settings.** Adjust the shutter speed and aperture to the settings you want to use. Perhaps you'd like to set a slow shutter speed for an indoor shot to provide some image blur, and work with a relatively wide aperture to give you limited depth-of-field. That was my goal for Figure 5.19, which I shot at 1/15th second and f/4, while panning the camera along with the dribbling basketball player.
- 3. Activate Auto ISO. If you haven't already turned on Auto ISO, use the Fn menu or visit the Camera Settings 5 menu and enable it, selecting a minimum ISO of 100 and maximum of 25600, as described in Chapter 3.
- 4. **Take your shot.** Your shutter speed and f/stop are fixed at the settings you make in Manual exposure mode, but the a68 will change the ISO setting to provide an appropriate exposure.

Figure 5.19 A shutter speed of 1/15th second and an f/4 aperture produced this image in Manual exposure mode, with the a68's Auto ISO feature providing the correct exposure.

Exposure Bracketing

The exposure compensation feature works well, as discussed earlier, but sometimes you'll want to quickly shoot a series of photos at various exposures in a single burst. Doing so increases the odds of getting one photo that will be exactly right for your needs, and is particularly useful when assembling high dynamic range (HDR) composite images manually. This technique is called bracketing.

Years ago, before high-tech cameras became the norm, it was common to bracket exposures when shooting color slide film especially, taking three (or more) photos at different exposures in Manual mode. Eventually, exposure compensation became a common feature as cameras gained semi-automatic modes; it was then possible to bracket exposures by setting a different compensation level for each shot in a series, such as 0, -1, and +1 or 0, -1/3, and +2/3.

Today, cameras like the a68 give you a lot of options for automatically bracketing exposures. When Bracket is active, you can take three consecutive photos: one at the metered ("correct") exposure, one with less exposure, and one with more exposure. Figure 5.20 shows an image with the metered exposure (center), flanked by exposures of 2/3 stop more (left), and 2/3 stop less (right).

Bracketing cannot be performed when using Auto mode, any SCN mode, Panorama mode, or when using the Smile Shutter or Auto HDR features. If the flash is popped up, it will be forced off and will not fire while bracketing is active. Exposure bracketing can be used with both RAW and JPG capture. When it's set, the camera will fire the three shots in a sequence if you keep the shutter release button depressed; you can also decide to shoot the photos one at a time.

Figure 5.20 Metered exposure (center) accompanied by bracketed exposures of 2/3 stop more (left) and 2/3 stop less (right).

To take a bracketed series, follow these steps:

- 1. **Drive, he said.** You'll find the bracketing choices on the Drive mode menu. Press the Drive mode button (on top of the camera). Use the up/down directional buttons or *front* control dial to scroll down to Bracket: Cont. (to shoot all the images continuously) or Single Bracket (to fire them off one shot at a time).
- 2. **Select Number of Images and Increment.** When your Continuous or Single Bracket mode is highlighted, use the left/right directional buttons or *rear* control dial to choose either 3 or 5 shot sets, with increments of 0.3, 0.7, 1.0, 2.0, or 3.0 EV.
- 3. Confirm. Press the center button to confirm your choice and exit.
- 4. **Shoot your set.** For Continuous bracketing, press and hold the shutter release once, and all 3 or 5 shots will be exposed; for Single bracketing, you must press the shutter release 3 or 5 times, and between shots the a68 will preview how your images will look, either lighter or darker as the set progresses.
- 5. **Turn off when finished.** Remember to turn bracketing off when finished. If you don't, you may find yourself wondering why the camera is behaving oddly because you expect single, non-bracketed exposures.

Here are some points to keep in mind about bracketing:

- HDR isn't hard. The 1.0 EV option is the one you might try first when bracketing if you plan to perform High Dynamic Range magic later on in Photoshop (with Merge to HDR), Elements (with Photomerge), or with another image editor or utility that provides an HDR feature. That will allow you to combine images with different exposures into one photo with an amazing amount of detail in both highlights and shadows. To get the best results, mount your camera on a tripod, shoot in RAW format, and use BRK C3.0EV to get three shots each with a 3 EV of difference in exposure. Of course, with this camera, you also have the option of using the Auto HDR feature in the Fn menu as well; this can provide very good results in the camera without the need to use any special HDR software.
- Adjust the base value. You can bracket your exposures based on something other than the base (metered) exposure value. Set any desired exposure compensation, either a plus or a minus value. Then set the bracketing level you want to use. The camera will bracket exposures as over, under, and equal to the *compensated* value.
- What changes? In Aperture Priority mode, exposure bracketing will be achieved by changing the shutter speed if possible, and then by changing the ISO if necessary. In Shutter Priority mode, bracketing will be done using different f/stops if possible, and then by using different ISO levels if that's necessary. When you're using Manual mode, bracketing is applied by changing the shutter speed. In Program mode, the camera will vary shutter speed and aperture, and sometimes the ISO. Choose your shooting mode before you set bracketing based on your creative intention: whether you want to keep a particular aperture for all of the photos (say, for selective focus), or keep a certain shutter speed (to blur or stop action).

Using Dynamic Range Optimizer

Dynamic Range Optimizer (DRO) is a feature you can select from the Camera Settings 5 menu or the Function menu, as explained in Chapter 3. When enabled, the a68 will examine your images as they are exposed, and if the shadows appear to have detail even though they are too dark, will attempt to process the image so the shadows are lighter, with additional detail, without overexposing detailed highlights. The processed image is always saved as a JPEG, so if you are shooting RAW you won't notice a difference.

When you activate DRO, you have your choice of specifying the aggressiveness of the processing (from Level 1 through Level 5), in which case it will *always* be applied at the level you specify. Or, you can set the feature to Auto and let the a68 decide on the optimum amount of optimization (or even when to apply it at all). Auto is usually your best choice, because the camera is pretty smart about choosing which images to process, and which to leave alone. Indeed, the camera's programming usually does a better job than a similar feature available in the Image Data Converter SR software you may have installed on your computer.

Figure 5.21 shows an image with DRO turned off, and using Level 1, Level 3, and Level 5 optimization. (The differences between, say Level 1 and 2, or 2 and 3 are subtle and wouldn't show up well on the printed page, so I skipped the even-numbered levels.) The printed page also doesn't show that DRO tends to increase the amount of noise in an image as it works more aggressively; it's usually a good idea to avoid using the feature at high ISO levels where noise tends to be a real problem under any conditions.

Working with HDR

High dynamic range (HDR) photography is quite the rage these days, and entire books have been written on the subject. It's not really a new technique—film photographers have been combining multiple exposures for ages to produce a single image of, say, an interior room while maintaining detail in the scene visible through the windows.

It's the same deal in the digital age. Suppose you wanted to photograph a dimly lit room that had a bright window showing an outdoors scene. Proper exposure for the room might be on the order of 1/60th second at f/2.8 at ISO 200, while the outdoors scene probably would require f/11 at 1/400th second. That's almost a 7 EV step difference (approximately 7 f/stops) and well beyond the dynamic range of any digital camera, including the Sony a68.

Until camera sensors gain much higher dynamic ranges (which may not be as far into the distant future as we think), special tricks like DRO and HDR photography will remain basic tools. With the Sony a68, you can create in-camera HDR exposures, or shoot HDR the old-fashioned way—with separate bracketed exposures that are later combined in a tool like Photomatix or Adobe's Merge to HDR image-editing feature. I'm going to show you how to use both.

Figure 5.21 The shadow areas under the ledge show the differences among DRO Off (upper left), Level 1 (upper right), Level 3 (lower left), and Level 5 (lower right).

Auto HDR

The a68's in-camera Auto HDR feature is simple and surprisingly effective in creating high dynamic range images. It's also remarkably easy to use. Although it combines only three images to create a single HDR photograph, in some ways it's as good as the manual HDR method I'll describe in the section after this one. For example, it allows you to specify an exposure differential of six stops/EV between the three shots, whereas the a68 shooting bracketed exposures is limited to no more than three EV between shots. (I'll show you how to overcome that limitation easily.)

Figure 5.22 illustrates how the three shots that the a68's Auto HDR feature merges might look. There is a one-stop differential between each of the images, from the underexposed image at top,

Figure 5.22
The three images can be automatically combined...

Figure 5.23 ...to produce this merged high dynamic range (HDR) image.

the intermediate exposure in the middle, and the overexposed image at the bottom. The in-camera HDR processing is able to combine the three to derive an image similar to the one shown in Figure 5.23, which has a much fuller range of tones.

To use the a68's HDR feature, select it in the Camera Scttings 5 menu's DRO/Auto HDR entry, or from the Fn menu. You can manually specify an increment from 1 to 6 EV, or choose Auto and allow the camera to select the appropriate differential. When you press the shutter release, the a68 will take all three shots consecutively, align the images (because, if the camera is hand-held, there is likely to be a small amount of movement between shots), and then save one JPEG image to your memory card. The feature does not work if you have selected RAW or RAW+JPEG formats.

Bracketing and Merge to HDR

If your credo is "If you want something done right, do it yourself," you can also shoot HDR manually, without resorting to the a68's HDR mode. Instead, you can shoot individual images either by manually bracketing or using the a68's auto bracketing modes, described earlier in this chapter.

While my goal in this book is to show you how to take great photos *in the camera* rather than how to fix your errors in Photoshop, the Merge to HDR Pro feature in Adobe's flagship image editor is too cool to ignore. The ability to have a bracketed set of exposures that are identical except for exposure is key to getting good results with this Photoshop feature, which allows you to produce images with a full, rich dynamic range that includes a level of detail in the highlights and shadows that is almost impossible to achieve with digital cameras.

When you're using Merge to HDR Pro, you'd take several pictures, some exposed for the shadows, some for the middle tones, and some for the highlights. The exact number of images to combine is up to you. Four to seven is a good number. Then, you'd use the Merge to HDR Pro command to combine all of the images into one HDR image that integrates the well-exposed sections of each version. Here's how.

The images should be as identical as possible, except for exposure. So, it's a good idea to mount the a68 on a tripod, use a remote release, and take all the exposures in one burst. Just follow these steps:

- 1. **Set up the camera.** Mount the a68 on a tripod.
- 2. Set the camera to shoot a bracketed burst of five images with an increment of at least 2 EV. The description of how to do this will be found earlier in this chapter. As I noted there, you can set the a68 to shoot up to five exposures, each one increment apart, and use all five for your HDR merger.

TIP

If you want to use more than five exposures, you can skip the a68's auto bracketing feature and switch to Manual exposure and take as many exposures as you want, at any increment you desire. In Manual mode, make sure Auto ISO is off, and you adjust exposures *only* by changing the shutter speed. You should be very careful when you make the adjustment to avoid jostling the camera.

- 3. **Choose an f/stop.** Set the camera for Aperture Priority and select an aperture that will provide a correct exposure at your initial settings for the series of manually bracketed shots. *And then leave this adjustment alone!* You don't want the aperture to change for your series, as that would change the depth-of-field. You want the a68 to adjust exposure *only* using the shutter speed.
- 4. **Choose manual focus.** You don't want the focus to change between shots, so set the a68 to manual focus, and carefully focus your shot.
- 5. **Choose RAW exposures.** Set the camera to take RAW files, which will give you the widest range of tones in your images. (This is an advantage of manually creating HDR files; the a68's Auto HDR feature can't be used when RAW or RAW+JPEG is active.)
- 6. **Take your bracketed set.** Press the button on the remote (or carefully press the shutter release or use the self-timer) and take the set of bracketed exposures.
- 7. **Continue with the Merge to HDR Pro steps listed next.** You can also use a different program, such as Photomatix or Nik software, if you know how to use it.

DETERMINING THE BEST EXPOSURE DIFFERENTIAL

How do you choose the number of EV/stops to separate your exposures? You can use histograms, described at the end of this chapter, to determine the correct bracketing range. Take a test shot and examine the histogram. Reduce the exposure until dark tones are clipped off at the left of the resulting histogram. Then, increase the exposure until the lighter tones are clipped off at the right of the histogram. The number of stops between the two is the range that should be covered using your bracketed exposures.

The next steps show you how to combine the scparate exposures into one merged high dynamic range image. The sample images in Figures 5.24 and 5.25 show the results you can get from a three-shot bracketed sequence.

- 1. Copy your images to your computer. If you use an application to transfer the files to your computer, make sure it does not make any adjustments to brightness, contrast, or exposure. You want the real raw information for Merge to HDR Pro to work with.
- Activate Merge to HDR Pro. Choose File > Automate > Merge to HDR Pro.
- 3 Select the photos to be merged. Use the Browse feature to locate and select your photos to be merged. You'll note a checkbox that can be used to automatically align the images if they were not taken with the camera mounted on a rock-steady support. This will adjust for any slight movement of the camera that might have occurred when you changed exposure settings.
- 4. Choose parameters (optional). The first time you use Merge to HDR Pro, you can let the program work with its default parameters. Once you've played with the feature a few times, you can read the Adobe Help files and learn more about the options than I can present in this non-software-oriented camera guide.
- 5. Click OK. The merger begins.
- 6. **Save.** Once HDR merge has done its thing, save the file to your computer.

Figure 5.24 Three bracketed photos should look like this.

Figure 5.25 You'll end up with an extended dynamic range photo like this one.

If you do everything correctly, you'll end up with a photo like the one shown in Figure 5.25.

What if you don't have the opportunity, inclination, or skills to create several images at different exposures, as described? If you shoot in RAW format, you can still use Merge to HDR, working with a *single* original image file. What you do is import the image into Photoshop several times, using Adobe Camera Raw to create multiple copies of the file at different exposure levels.

For example, you'd create one copy that's too dark, so the shadows lose detail, but the highlights are preserved. Create another copy with the shadows intact and allow the highlights to wash out. Then, you can use Merge to HDR to combine the two and end up with a finished image that has the extended dynamic range you're looking for. (This concludes the image-editing portion of the chapter. We now return you to our alternate sponsor: photography.)

Exposure Evaluation with Histograms

While you may be able to improve poorly exposed photos in your image-editing software or with DRO or HDR techniques, it's definitely preferable to get the exposure close to correct in the camera. This will minimize the modifications you'll need to make in post-processing, which can be very time-consuming and will degrade image quality, especially with JPEGs. A RAW photo can tolerate more significant changes with less adverse effects, but for optimum quality, it's still important to have an exposure that's close to correct.

Instead, you can use a histogram, which is a chart displayed on the a68's screen that shows the number of tones that have been captured at each brightness level. Two types of histograms are available, a "live" histogram that appears at the lower-right corner of the screen in shooting mode, and a larger, more detailed version that appears in Histogram mode during playback. The live version can help you make exposure decisions as you shoot, while the playback version is useful in determining corrections to be made before you take your next shot. I'll explain both versions, but first it's useful to understand exactly what you're seeing when you view a histogram.

Tonal Range

Histograms help you adjust the tonal range of an image, the span of dark to light tones, from a complete absence of brightness (black) to the brightest possible tone (white), and all the middle tones in between. Because all values for tones fall into a continuous spectrum between black and white, it's easiest to think of a photo's tonality in terms of a black-and-white or grayscale image, even though you're capturing tones in three separate color layers of red, green, and blue.

Because your images are digital, the tonal "spectrum" isn't really continuous: it's divided into discrete steps that represent the different tones that can be captured. Figure 5.26 may help you understand this concept. The gray steps shown range from 100-percent gray (black) at the left, to 0-percent gray (white) at the right, with 20 gray steps in all (plus white).

Along the bottom of the chart are the digital values from 0 to 255 recorded by your sensor for an image with 8 bits per channel. (8 bits of red, 8 bits of green, and 8 bits of blue equal a 24-bit, full-color image.) Any black captured would be represented by a value of 0, the brightest white by 255, and the midtones would be clustered around the 128 marker.

Grayscale images (which we call black-and-white photos) are easy to understand. Or, at least, that's what we think. When we look at a black-and-white image, we think we're seeing a continuous range of tones from black to white, and all the grays in between. But, that's not exactly true. The blackest black in any photo isn't a true black, because *some* light is always reflected from the surface of the print, and if viewed on a screen, the deepest black is only as dark as the least-reflective area a computer monitor can produce. The whitest white isn't a true white, either, because even the lightest areas of a print absorb some light (only a mirror reflects close to all the light that strikes it), and, when viewing on a computer monitor, the whites are limited by the brightness of the display's LCD or LEDs picture elements. Lacking darker blacks and brighter, whiter whites, that continuous set of tones doesn't cover the full grayscale tonal range.

The full scale of tones becomes useful when you have an image that has large expanses of shades that change gradually from one level to the next, such as areas of sky, water, or walls. Think of a picture taken of a group of campers around a campfire. Since the light from the fire is striking them directly in the face, there aren't many shadows on the campers' faces. All the tones that make up the *features* of the people around the fire are compressed into one end of the brightness spectrum—the lighter end.

Yet, there's more to this scene than faces. Behind the campers are trees, rocks, and perhaps a few animals that have emerged from the shadows to see what is going on. These are illuminated by the softer light that bounces off the surrounding surfaces. If your eyes become accustomed to the reduced illumination, you'll find that there is a wealth of detail in these shadow images.

This campfire scene would be a nightmare to reproduce faithfully under any circumstances. If you are an experienced photographer, you are probably already wincing at what is called a *high-contrast* lighting situation. Some photos may be high in contrast when there are fewer tones and they are all bunched up at limited points in the scale. In a low-contrast image, there are more tones, but they are spread out so widely that the image looks flat. Your digital camera can show you the relationship between these tones using a *histogram*.

Histogram Basics

Your a68's histograms are a simplified display of the numbers of pixels at each of 256 brightness levels, producing an interesting mountain range effect. Although separate charts may be provided for brightness and the red, green, and blue channels, when you first start using histograms, you'll want to concentrate on the brightness histogram.

Each vertical line in the graph represents the number of pixels in the image for each brightness value, from 0 (black) on the left to 255 (white) on the right. The vertical axis measures that number of pixels at each level.

Although histograms are most often used to fine-tune exposure, you can glean other information from them, such as the relative contrast of the image. Figure 5.27 shows a generic histogram captured from an image-editing program, accompanied by an image at left having normal contrast. In such an image, most of the pixels are spread across the image, with a healthy distribution of tones throughout the midtone section of the graph. That large peak at the right side of the graph represents all those light tones in the sky. A normal-contrast image you shoot may have less sky area, and less of a peak at the right side, but notice that very few pixels hug the right edge of the histogram, indicating that the lightest tones are not being clipped because they are off the chart.

Figure 5.27
This image has fairly normal contrast, even though there is a peak of light tones at the right side representing the sky.

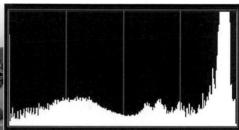

Figure 5.28
This low-contrast image has all the tones squished into one section of the grayscale.

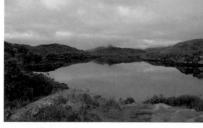

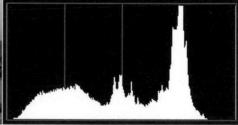

Figure 5.29
A high-contrast image produces a histogram in which the tones are spread out.

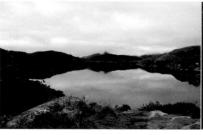

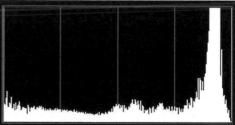

With a lower-contrast image, like the one shown in Figure 5.28, the basic shape of the previous histogram will remain recognizable, but gradually will be compressed together to cover a smaller area of the gray spectrum. The squished shape of the histogram is caused by all the grays in the original image being represented by a limited number of gray tones in a smaller range of the scale.

Instead of the darkest tones of the image reaching into the black end of the spectrum and the whitest tones extending to the lightest end, the blackest areas of the scene are now represented by a light gray, and the whites by a somewhat lighter gray. The overall contrast of the image is reduced. Because all the darker tones are actually a middle gray or lighter, the scene in this version of the photo appears lighter as well.

Going in the other direction, increasing the contrast of an image produces a histogram like the one shown in Figure 5.29. In this case, the tonal range is now spread over the entire width of the chart, but, except for the bright sky, there is not much variation in the middle tones; the mountain "peaks" are not very high. When you stretch the grayscale in both directions like this, the darkest tones become darker (that may not be possible) and the lightest tones become lighter (ditto). In fact, shades that might have been gray before can change to black or white as they are moved toward either end of the scale.

The effect of increasing contrast may be to move some tones off either end of the scale altogether, while spreading the remaining grays over a smaller number of locations on the spectrum. That's exactly the case in the example shown. The number of possible tones is smaller and the image appears harsher.

Understanding Histograms

Although the histograms I just showed you show how these charts change depending on the contrast of an image, an important thing to remember when working with the histogram display in your a68 is that changing the exposure does *not* change the contrast of an image. The curves illustrated in the previous three examples remain exactly the same shape when you increase or decrease exposure. I repeat: The proportional distribution of grays shown in the histogram doesn't change when exposure changes; it is neither stretched nor compressed. However, the tones as *a whole* are moved toward one end of the scale or the other, depending on whether you're increasing or decreasing exposure. You'll be able to see that in some illustrations that follow.

So, as you reduce exposure, tones gradually move to the black end (and off the scale), while the reverse is true when you increase exposure. The contrast within the image is changed only to the extent that some of the tones can no longer be represented when they are moved off the scale.

To change the contrast of an image, you must do one of four things:

- Change the a68's contrast setting using one of the Creative Styles, which each have a contrast adjustment. I explain Creative Styles at the end of this chapter.
- Use your camera's shadow-tone "boosters." As previously discussed, both DRO and Auto HDR processing can adjust the contrast of your final image.
- Alter the contrast of the scene itself, for example, by using a fill light or reflectors to add illumination to shadows that are too dark, when that is possible.
- Attempt to adjust contrast in post-processing using your image editor or RAW file converter. You may use features such as Levels or Curves (in Photoshop, Photoshop Elements, and many other image editors), or work with HDR software to cherry-pick the best values in shadows and highlights from multiple images.

Of the four of these, the third—changing the contrast of the scene—is the most desirable, because attempting to fix contrast by fiddling with the tonal values is unlikely to be a perfect remedy. However, adding a little contrast can be successful because you can discard some tones to make the image more contrasty. However, the opposite is much more difficult. An overly contrasty image rarely can be fixed, because you can't add information that isn't there in the first place.

What you can do is adjust the exposure so that the tones that are already present in the scene are captured correctly, even if the contrast itself remains the same. Figure 5.30 shows the histogram for an image that is badly underexposed. You can guess from the shape of the histogram that many of the dark tones to the left of the graph have been clipped off. There's plenty of room on the right side for additional pixels to reside without having them become overexposed. So, you can increase the exposure (either by changing the f/stop or shutter speed, or by adding an EV value) to produce the corrected histogram shown in Figure 5.31.

Conversely, if your histogram looks like the one shown in Figure 5.32, with bright tones pushed off the right edge of the chart, you have an overexposed image, and you can correct it by reducing exposure. In addition to the histogram, the a68 has its Highlights and Zebra options, which, when activated, shows areas that are overexposed with flashing tones (often called "blinkies") in the picture review screen, or, with Zebra, by stripes in the overexposed areas in your live view image. Depending on the importance of this "clipped" detail, you can adjust exposure or leave it alone. For example, if all the dark-coded areas in the review are in a background that you care little about, you can forget about them and not change the exposure, but if such areas appear in facial details of your subject, you may want to make some adjustments.

In working with histograms, your goal should be to have all the tones in an image spread out between the edges, with none clipped off at the left and right sides. Underexposing (to preserve highlights) should be done only as a last resort, because retrieving the underexposed shadows in your image editor will frequently increase the noise, even if you're working with RAW files. A better

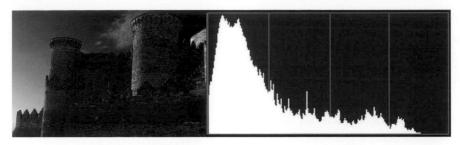

Figure 5.30 A histogram of an underexposed image may look like this.

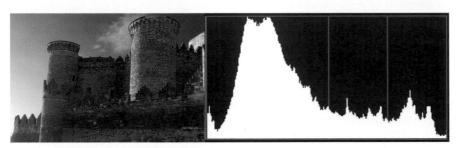

Figure 5.31Adding exposure will produce a histogram like this one.

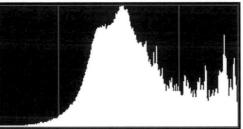

Figure 5.32 A histogram of an overexposed image will show clipping at the right side.

course of action is to expose for the highlights ("exposing to the right"), but, when the subject matter makes it practical, fill in the shadows with additional light, using reflectors, fill flash, or other techniques rather than allowing them to be seriously underexposed.

A histogram graph includes a *representation* of up to 256 vertical lines on a horizontal axis (but not 256 actual lines; only the general shape of the resulting curve is shown). The graph shows the number of pixels in the image at each brightness level, from 0 (black) on the left side to 255 (white) on the right. The 2.7-inch LCD doesn't have enough pixels to show each and every one of the 256 lines; instead, it provides a representation of the shape of the curve, often resembling a mountain range. The more pixels at a given level, the higher the "peak" will be at that position. If no bar appears at a particular position along the scale in the graph, there are no pixels at that particular brightness level.

A typical histogram produces a mountain-like shape, with most of the pixels bunched in the middle tones, with fewer pixels at the dark and light ends of the scale. Ideally, though, there will be at least some pixels at either extreme, so that your image has both a true black and a true white representing some details. Learn to spot histograms that represent over- and underexposure, and add or subtract exposure using exposure compensation as described earlier. (The D-Range Optimizer is also a useful feature when you want to get more detail in shadow areas; it can also slightly increase the amount of detail in highlight areas.)

The key is to make settings that will produce a histogram with a more even distribution of tones. A corrected histogram exhibits a mountain-like shape with a tall wide peak in the center of the scale (denoting the many mid-tone areas), and a good distribution of tones overall. This histogram indicates that the image exhibits detail in both the dark and the light tones since there's no spike at either end of the graph. Typically, this is the type of histogram you want for an accurate exposure. Of course, you'll sometimes want to create a special effect like a silhouette or a high-key look (mostly light tones); then your histogram will look entirely different.

As noted earlier, the histogram can also warn you of very high or very low contrast in an image. If all the tones are bunched up in one area of the graph (usually around the center), the photo will be low in contrast. You can increase the contrast level with the Creative Style item as discussed at the end of this chapter, or do so later with software.

The more you work with histograms, the more useful they become. One of the first things that histogram veterans notice is that it's possible to overexpose one channel even if the overall exposure appears to be correct. The a68's playback histogram screen shows separate histograms for both brightness (luminance) at top right, and for red, green, and blue channels underneath.

For example, flower photographers soon discover that it's really, really difficult to get a good picture of a red rose, like the one shown in Figure 5.33. The exposure looks okay—but there's no detail in the rose's petals. Looking at the histogram (see Figure 5.34) shows why: the red channel is blown out. If you look at the red histogram, there's a peak at the right edge that indicates that highlight information has been lost. In fact, the green channel has been blown, too, and so the green parts of the flower also lack detail. Only the blue channel's histogram is entirely contained within the boundaries of the chart, and, on first glance, the white luminance histogram at top of the column of graphs seems fairly normal.

Any of the primary channels—red, green, or blue—can blow out all by themselves, although bright reds seem to be the most common problem area. More difficult to diagnose are overexposed tones in one of the "in-between" hues on the color wheel. Overexposed yellows (which are very common) will be shown by blowouts in *both* the red and green channels. Too-bright cyans will manifest as excessive blue and green highlights, while overexposure in the red and blue channels reduces detail in magenta colors. As you gain experience, you'll be able to see exactly how anomalies in the RGB channels translate into poor highlights and murky shadows.

Figure 5.33 It's common to lose detail in bright red flowers because the red channel becomes overexposed even when the other channels are properly exposed.

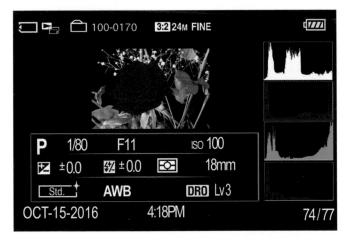

Figure 5.34
The RGB histograms show that both the red and green channels are overexposed.

The only way to correct for color channel blowouts is to reduce exposure. As I mentioned earlier, you might want to consider filling in the shadows with additional light to keep them from becoming too dark when you decrease exposure. In practice, you'll want to monitor the red channel most closely, followed by the blue channel, and slightly decrease exposure to see if that helps. Because of the way our eyes perceive color, we are more sensitive to variations in green, so green channel blowouts are less of a problem, unless your main subject is heavily colored in that hue. If you plan on photographing a frog hopping around on your front lawn, you'll want to be extra careful to preserve detail in the green channel, using bracketing or other exposure techniques outlined in this chapter.

The Live Histogram

The a68's live histogram offers the most reliable method for judging the exposure as you shoot (although the Zebra feature can be used to isolate specific problems involving blown highlights). A pair of live histograms are also available for display for both the viewfinder and monitor. You can activate both with the DISP Button (Monitor/Finder) item in the Custom Settings 4 menu, as discussed in Chapter 4. After doing so, press the DISP button a few times to reach the display that includes the histogram, which will be shown at lower right in the viewfinder and LCD monitor screens.

In Shooting mode, you'll get a luminance (brightness) histogram that shows the distribution of tones and brightness levels across the image given the current camera settings, including exposure compensation, Dynamic Range Optimizer (DRO) level in use, or the aperture, shutter speed, and ISO that you have set if using Manual mode. This live histogram (displayed before taking a photo) is useful for judging whether the exposure is likely to be satisfactory or whether you should use a camera feature to modify the exposure. When the histogram looks better, take the photo.

The Playback Histograms

You can view histograms in Playback mode, too; press the DISP button until the display shown in Figure 5.34 appears. The top graph, called the luminance or brightness histogram, is conventional, showing the distribution of tones across the image. Each of the other three histograms is in a specific color: red, green, and blue. That indicates the color channel you're viewing in that histogram: red, green, or blue. These additional graphs allow you to see the distribution of tones in the three individual channels. It takes a lot of expertise to interpret those extra histograms and, frankly, the conventional luminance histogram is the only one that many photographers use.

As a bonus in Playback mode, another feature is available when the histograms are visible: any areas of the displayed image that are excessively bright, or excessively dark, will blink. This feature, often called "blinkies," warns that you may need to change your settings to avoid loss of detail in highlight areas (such as a white wedding gown) or in shadow areas (such as a black animal's fur).

The a68 also includes the Zebra feature to indicate overexposure, as discussed in Chapter 4. You can use the histogram information along with the flashing blinkie and Zebra alerts to guide you in modifying the exposure, and/or setting the DRO feature (discussed earlier), before taking the photo again.

Automatic and Specialized Shooting Modes

After the long discussion of exposure control and other issues, let's get back to the remaining shooting modes. When you set the Intelligent Auto or the Superior Auto mode, the camera will use its programmed intelligence to try to identify the type of scene and set itself accordingly. These "autopilot" modes are useful when you suddenly encounter a picture-taking opportunity and don't have time to decide exactly what settings you might want to make in a semi-automatic or manual mode. Instead, you can spin the mode dial to one of the Auto modes, or, if you have a little more time, to the most appropriate scene mode, and fire away, knowing that you have a fighting chance of getting a usable or very good photo.

The a68 also offers more specialized modes, for use in particular situations: Sweep Panorama and two special scene modes that provide surprisingly fine quality at high ISO levels—Hand-held Twilight and Anti Motion Blur.

Auto and Scene Modes

The two Auto modes and the scene modes are especially helpful when you're just learning to use your a68, because they let you get used to composing and shooting, and obtaining excellent results, without having to struggle with unfamiliar controls to adjust things like shutter speed, aperture, ISO, and white balance. Once you've learned how to make those settings, you'll probably prefer to use P, A, S, and M modes since they provide more control over shooting options.

The fully automatic modes may give you few options for overrides, or none at all. For example, the AF mode, AF area, ISO, white balance, Dynamic Range Optimizer, and metering mode are all set for you. In most modes, you can select the drive setting and the flash mode, though not all settings for those options are available. You cannot adjust exposure compensation or Creative Styles in any of these modes. Here are some essential points to note about the Intelligent Auto, Superior Auto, and SCN modes:

■ Intelligent Auto. This is the setting to use when you hand your camera to a total stranger and ask him or her to take your picture posing in front of the Eiffel Tower. All the photographer has to do is press the shutter release button. Almost every other decision is made by the camera's electronics, and many settings, such as ISO, white balance, metering mode, and autofocus mode, are not available to you for adjustment.

However, you can press the Fn button and use the Function menu to set the drive mode to Single or Continuous shooting, or either self-timer modes, choose from Wide or Lock-On AF: Wide focus areas, and you can set the flash mode to Auto Flash, Fill Flash, or Flash Off.

- Superior Auto. This mode is similar to Intelligent Auto (with the same Fn menu limitations), but provides an extra benefit. In scenes that include extremely bright areas as well as shadow areas, the camera can choose (on its own) to activate various scene modes or even resort to its Auto HDR (high dynamic range) feature to provide more shadow detail. And in dark locations, when an extremely high ISO will be used, the camera can activate a special mode (Multi Frame Noise Reduction—MFNR) that fires several shots and composites them into one after discarding the digital noise data.
- SCN Modes. You can select from the following Scene modes:
 - Portrait. The first of the scene modes that you'll encounter, this one tends to use wide apertures (large f/numbers) and faster shutter speeds. This is intended to try to provide shallow depth-of-field to blur the background while minimizing the risk of blurry photos caused by camera shake or subject movement. It's also optimized to provide "soft" skin tones. The drive mode cannot be set to Continuous shooting, though you can set the self-timer to take three shots. You can use the Remote Commander; you can set AF, MF, or DMF in the Function sub-menu; and you can set the flash mode to Auto Flash, Fill Flash, or forced off.
 - **Sports Action.** In this mode, the a68 favors fast shutter speeds to freeze action and it switches to Continuous drive mode to let you take a quick sequence of pictures with one press of the shutter release button. Continuous Autofocus is activated to continually refocus as a subject approaches the camera or moves away from your shooting position. You can find more information on autofocus options in Chapter 6.
 - Macro. This mode is similar to the Portrait setting, favoring wider apertures to isolate your close-up subjects, and fast shutter speeds to eliminate the camera shake that's accentuated at close focusing distances. However, if your camera is mounted on a tripod or if you're using a lens with SteadyShot, you might want to use Aperture Priority mode instead. That will allow you to specify a smaller aperture (larger f/number) for additional depth-of-field to keep an entire three-dimensional subject within the range of acceptably sharp focus.
 - Landscape. The a68 tries to use smaller apertures for more depth-of-field to try to render the entire scene sharply; it also boosts saturation slightly for richer colors. You have some control over flash and can use the self-timer; most other settings are not available in this mode.
 - **Sunset.** Increases saturation to emphasize the red tones of a sunrise or sunset. You can use the Fill Flash or Flash Off settings, but most other adjustments are unavailable to you.

- **Night Scene.** This is another mode for low-light photography. Similar to Night Portrait, but the flash is forced off. Use a tripod if at all possible or set the camera on a solid object, because the shutter speed will be long in low light. Most settings are not available, other than the Self-timer and Remote Commander.
- Hand-held Twilight. This is one of the two special modes designed for use in low light when hand-holding the a68. The camera will set a high ISO (sensitivity) level to enable it to use a fast shutter speed to minimize the risk of blurring caused by camera shake. (In extremely dark conditions, however, the shutter speed may still be quite long.) When you press the shutter release button, the camera takes six shots in a quick series. The processor then composites them into one after discarding most of the digital noise data for a "cleaner" image than you'd get in a conventional high ISO photo. You'll get one image that's of surprisingly fine quality. (See Figure 5.35.) Flash is never fired in this mode and you have access to virtually no camera options.
- Night Portrait. This mode is intended for taking people pictures in dark locations with flash using a long shutter speed. The Flash mode is set to Slow Sync. A nearby subject will be illuminated by flash while a distant background (such as a city skyline) will be exposed by the available light during the long exposure. Because the shutter speed will be long, it's necessary to use a tripod or set the camera on something solid like the roof of a car. If using an OSS-designated lens with a SteadyShot stabilizer, make sure it's on, unless the camera is mounted on a tripod; in that case, turn the stabilizer off using the SteadyShot item in the Setup menu. You can use the Self-timer or the Remote Commander in Night Portrait mode.
- Sweep Panorama. When you turn the dial to this next setting, marked by the icon of a stretched rectangle, the camera presents a brief menu at the left side of the screen or viewfinder. This special mode lets you "sweep" the camera across a scene that is too wide for a single image. The camera takes multiple pictures and combines them in the camera into a single, wide panoramic final product.
- Continuous Advance Priority AE. This shooting mode, the last of the automatic or specialized modes, is marked on the mode dial by a stack of rectangles containing the number 8, indicating the maximum number of continuous shots per second that the camera will take in this mode. The camera initially sets itself to optimize continuous shooting by choosing a high ISO setting and other options, but you can change most of the settings if you want to, as I'll discuss later.
- Movie. Choose this mode when you want to shoot video clips. You can also shoot video when using any other mode simply by pressing the red Movie button located to the immediate right of the optical viewfinder window, as long as you've selected Always in the Custom Settings 7's Movie Button entry. (If not, you must indeed rotate to the Movie slot on the mode dial.)
- MR 1, 2, 3 (Memory Recall). This isn't a shooting mode, as such, but a set of three storage positions you can use to memorize sets of camera settings, and then recall them quickly.

Figure 5.35 The Hand-held Twilight scene mode is very useful in dark locations when you cannot use a tripod and must shoot at a high ISO for a fast shutter speed. The image quality is surprisingly fine as indicated in the bottom photo, a small portion of the full ISO 6400 image (top).

Sweep Panorama Mode

A conventional panorama mode has been available for several years with many other cameras, especially those with a built-in lens. That allows you to shoot a series of photos, with framing guided by an on-screen display; make sure they overlap correctly and you can then "stitch" them together in special software to make a single, very wide, panoramic image. Some cameras can even do this for you with in-camera processing but most (though not all) require you to use a tripod. Your Sony camera offers the most convenient type of panorama mode; it's automatic (but allows you to use some overrides), and it can produce very good results without a tripod. Of course, it's easier to keep the camera perfectly level while shooting the series when using a tripod, but that's not always practical. Here are a few tips to consider:

- Choose a direction. You can select one of four directions for your panorama: right, left, up, or down. Select any of these options in the Shooting 1 menu, using the Panorama Direction item. It's only available when the camera is set to Sweep Panorama mode. The default setting, right, is probably the most natural for many people; it requires you to pan the camera from the left to the right across a wide vista. Occasionally, you might want to use one of the other options. The up or down motion is the one you'll need to make a panoramic photo of very tall subjects, such as skyscrapers and nearby mountains.
- Change settings while in Panorama mode. When you select this shooting mode, the camera presents you with a large arrow and urgent-sounding instructions to press the shutter button and move the camera in the direction of the arrow. Don't let the camera intimidate you with this demand; what it is neglecting to tell you is that you can take all the time you want, and that you are free to change certain settings before you shoot.
 - Press the MENU button and you can set the focus mode, white balance, and metering mode. Other useful functions include exposure compensation, Image Size in the Image Size menu (which lets you set either the Standard or the Wide panorama option), and the Creative Style modes in the Brightness/Color menu. Once you have those settings fine-tuned to your satisfaction, *then* go ahead and press the shutter release button.
- Smooth and steady does it. After pressing the shutter release button to start the exposure, immediately begin moving the camera smoothly and steadily in an arc; pivot your feet or the camera on a tripod head and keep going until the shutter stops clicking. If you moved the camera at a speed that was too fast or too slow, you'll get an error message and the camera will prompt you to start over.
- Beware of moving objects. The Sweep Panorama mode is intended for stationary subjects, such as mountain ranges, city skylines, or expansive gardens. There's nothing to stop you from shooting a scene that contains moving cars, people, or other objects, but be aware of problems that can arise in that situation. Because you're taking multiple overlapping shots that are then stitched into a single image, the camera may capture the same car or person two or more times in slightly different positions; this can result in a truncated or otherwise distorted picture of that particular subject. Press the Playback button to view your just-completed panorama; press the center button to view a moving playback of the image.

Dealing with Digital Noise

Visual noise is that random grainy look with colorful speckles that some like to use as a visual effect, but most consider to be objectionable. That's because it robs your image of detail even as it adds that "interesting" texture.

The a68's Multi-Frame Noise Reduction feature, which can be set in the ISO menu (it's the ISO Auto setting located above the plain old Auto setting in the menu), captures multiple frames, aligns them, and then creates a merged image with the visual noise averaged out. As mentioned in Chapter 3, it will shoot 12 images if you've set this feature to Normal, and 4 images if you've specified Low. The actual image pixels remain the same between frames, so those that change—caused by noise—can be averaged out to produce a more noise-free image.

Noise can also be handled in your image editor, using the software tools available, or in the camera using NR settings in the Camera Settings 6 menu, discussed in Chapter 3. Noise is caused by two different phenomena: high ISO levels and long exposures. The a68 offers a menu item to minimize high ISO noise. In Chapter 3, I discussed the Camera Settings 6 menu item that you can use to modify the noise reduction processing; you might want to review the sections about High ISO NR and Long Exposure NR as a refresher.

High ISO Noise

Digital noise commonly appears when you set an ISO above ISO 400 with some cameras or above ISO 1600 with the a68; with this camera it's not really problematic until much higher ISO levels. High ISO noise appears as a result of the amplification needed to increase the sensitivity of the sensor. While higher ISOs do pull details out of dark areas, they also amplify non-signal information randomly, creating noise.

This makes High ISO Noise Reduction very useful, although at default, it also tends to make images slightly softer; blurring the noise pattern also blurs some intricate details. The higher the ISO, the more aggressive the processing will be. The Low level for NR provides images that are more grainy but with better resolution of fine detail.

High ISO NR is grayed out when the camera is set to shoot only RAW-format photos. The camera does not use this feature on RAW-format photos since noise reduction—at the optimum level for any photo—can be applied in the software you'll use to modify and convert the RAW file to JPEG or TIFF. (If you shoot in RAW & JPEG, the JPEG images, but not the RAW files, will be affected by this camera feature.) I'll discuss Noise Reduction with software in more detail in the next section.

Figure 5.36 shows two pictures that I shot at ISO 12800. For the first, I used the default (Normal) High ISO NR and for the second shot, I set the NR to Low. (I've exaggerated the differences between the two so the grainy/less grainy images are more evident on the printed page. The half-tone screen applied to printed photos tends to mask these differences.)

Figure 5.36 The Normal level for High ISO NR (left) produces a smoother (less grainy) image than one made with Low NR (right).

Long Exposure Noise

A similar digital noise phenomenon occurs during long time exposures, which allow more photons to reach the sensor, increasing your ability to capture a picture under low-light conditions. However, the longer exposures also increase the likelihood that some pixels will register as random "phantom" photons, often because the longer an imager is "hot," the more likely that heat can be mistaken by the sensor as actual photons. The a68 tries to minimize this type of noise automatically; there is no separate control you can adjust to add more or less noise reduction for long exposures.

CMOS imagers, like the one in the a68, contain millions of individual amplifiers and A/D (analog to digital) converters, all working in unison though the BIONZ X digital image processor chip. Because these circuits don't necessarily all process in precisely the same way all the time, they can introduce something called fixed-pattern noise into the image data.

Long exposure noise reduction is used with JPEG exposures longer than one full second. (This feature is not used on RAW photos and in continuous shooting, bracketing, Panorama, and Sports Action and Hand-held Twilight Scene modes.) When it's active, long exposure noise reduction processing removes random pixels from your photo, but some of the image-making pixels are unavoidably vanquished at the same time.

It's possible that you prefer the version made without NR, and you can achieve that simply by shooting RAW. Indeed, noise reduction can be applied with most image-editing programs. You might get even better results with an industrial-strength product like Nik Dfine, part of Google's Nik collection or Topaz DNoise or Enhance (www.topazlabs.com). You can apply noise reduction to RAW photos with Sony's Image Data Converter or any other versatile converter software. Some products are optimized for NR with unusually sophisticated processing, such as Photo Ninja (www.picturecode.com) and recent versions of DXO Optics Pro (www.dxo.com).

Using Creative Styles

This option, found in the Function menu, gives you 13 different combinations of contrast, saturation, and sharpness, listed below. Those are useful enough that you should make them a part of your everyday toolkit. You can apply Creative Styles *only* when you are not using one of the a68's Auto or Scene modes. (That is, you're shooting in Program, Aperture Priority, Shutter Priority, or Manual exposure mode.) But wait, as they say, there's more. When working with Creative Styles, you can *adjust* those parameters within each preset option to fine-tune the rendition, and select an entirely different style to be registered in a particular slot.

The process can be confusing for the new user, so I'll explain it simply. Just follow these steps:

- 1. Access Creative Style menu. Press the Fn button and navigate to the Creative Style entry that's fifth from the left in the bottom row of options. (See Figure 5.37, left.) Press the center button to access the Creative Style screen. (Figure 5.37, right.)
- 2. **Choose a style to apply.** In the Creative Style screen, the styles are shown in the left-hand column. (You must scroll down to see all of them.) If you want to use one of the existing styles shown, press up/down to highlight that style and press the center button to activate it.

Figure 5.37 The Creative Style screens.

- 3. **Select a style to modify.** You can adjust the contrast, saturation, and sharpness of any of the styles in the left column, or replace that style with another style of your choice. Highlight the style you want to adjust/replace, and press the right button.
- 4. **Select an attribute to change.** The icons at the bottom of the image area represent (left to right): Image Style, Contrast, Saturation, and Sharpness. Press left/right to highlight the attribute you'd like to modify.
- 5. **Enter your adjustments.** To change the style that appears in the box you selected at left, highlight the Image Style icon and press up/down to choose one of the 13 styles (described below).
- 6. **Make other adjustments.** To modify the currently selected style, press left/right to highlight Contrast, Saturation, or Sharpness, then press up/down to add/subtract from the default zero values:
 - **Sharpness.** Increases or decreases the contrast of the edge outlines in your image, making the photo appear more or less sharp, depending on whether you've selected 0 (no sharpening), +3 (extra sharpening), to -3 (softening). Remember that boosting sharpness also increases the overall contrast of an image, so you'll want to use this parameter in conjunction with the contrast parameter with caution.
 - **Contrast.** Compresses the range of tones in an image (increase contrast from 0 to +3) or expands the range of tones (from 0 to -3) to decrease contrast. Higher-contrast images tend to lose detail in both shadows and highlights, while lower-contrast images retain the detail but appear more flat and have less snap.
 - **Saturation.** You can adjust the richness of the color from low saturation (0 to -3) to high saturation (0 to +3). Lower saturation produces a muted look that can be more realistic for certain kinds of subjects, such as humans. Higher saturation produces a more vibrant appearance, but can be garish and unrealistic if carried too far. Boost your saturation if you want a vivid image, or to brighten up pictures taken on overcast days. This setting cannot be changed for the B/W Creative Style.
- 7. **Confirm and exit.** Press the center button to confirm your changes. If you redefined one of the six slots, that style will appear in the listing in the left column henceforth and can be selected quickly by following Steps 1–2 above and pressing the center button.

Here's a description of the 13 different Creative Styles I've been tantalizing you with:

- **Standard.** This is, as you might expect, your default setting, with a good compromise of sharpness, color saturation, and contrast. Choose this, and your photos will have excellent colors, a broad range of tonal values, and standard sharpness that avoids the "oversharpened" look that some digital pictures acquire.
- Vivid. If you want more punch in your images, with richer colors, heightened contrast that makes those colors stand out, and moderate sharpness, this setting is for you. It's good for flowers, seaside photos, any picture with expanses of blue sky, and on overcast days where a punchier image can relieve the dullness.
- **Neutral.** Provides a more balanced look, with muted colors and less sharpness emphasis.
- Clear. Sony recommends this style for "clear tones" and "limpid colors" in the highlights, especially when you're capturing "radiant light." The description is a bit artsy, but I've found this style useful for foggy mornings and other low-contrast scenes.
- **Deep.** Good for low key, moody representations.
- **Light.** Recommended for bright, uncomplicated color expressions. I like it for high-key images with lots of illumination and few shadows.
- **Portrait.** Unless you're photographing a clown, you don't want overly vivid colors in your portraits. Nor do you need lots of contrast to emphasize facial flaws and defects. This setting provides realistic, muted skin tones, and a softer look that flatters your subjects.
- Landscape. As with the Vivid setting, this option boosts saturation and contrast to give you rich scenery and purple mountain majesties, even when your subject matter is located far enough from your camera that distant haze might otherwise be a problem. There's extra sharpness, too, to give you added crispness when you're shooting Fall colors.
- Sunset. Accentuates the red tones found in sunrise and sunset pictures.
- **Night Scene.** Contrast is adjusted to provide a more realistic night-time effect.
- Autumn Leaves. Boosts the saturation of reds and yellows for vivid Fall colors.
- **B/W.** If you're shooting black-and-white photos in the camera, this setting allows you to change the contrast and sharpness (only).
- Sepia. Provides a warm brownish, old-timey tone to images.

Mastering the Mysteries of Autofocus

One of the most useful and powerful features of modern digital cameras is their ability to lock in sharp focus faster than the blink of an eye. Sometimes. Although autofocus has been with us for roughly 20 years, it continues to be problematic. While vendors like Sony are giving us faster and more precise autofocus systems—like the full-time autofocus possible with the A-mount series' translucent mirror technology—it's common for the sheer number of options to confuse even the most advanced photographers.

One key problem is that the camera doesn't really know, for certain, what subject you want to be in sharp focus. It may select an object and lock in focus with lightning speed—even though the subject is not the one that's the center of interest of *your* photograph. Or, the camera may lock focus too soon, or too late. This chapter will help you choose the options available with your Sony a68 to achieve sharp focus.

Prior to the introduction of dSLR autofocus capabilities in the 1980s, back in the day of film cameras, focusing was always done manually. Honest. Even though viewfinders were bigger and brighter than they are today, special focusing screens, magnifiers, and other gadgets were often used to help the photographer achieve correct focus. Imagine what it must have been like to focus manually under demanding, fast-moving conditions such as sports photography. Minolta, which pioneered the technology now used in Sony a68 cameras and lenses, led the way in developing autofocus systems.

Manual focusing is problematic because our eyes and brains have poor memory for correct focus, which is why your eye doctor must shift back and forth between sets of lenses and ask "Does that look sharper—or was it sharper before?" in determining your correct prescription. Similarly, manual focusing involves jogging the focus ring back and forth as you go from almost in focus, to sharp focus, to almost focused again. The little clockwise and counterclockwise arcs decrease in size until you've zeroed in on the point of correct focus. What you're looking for is the image with the most contrast between the edges of elements in the image.

The Sony a68's autofocus mechanism, like all such systems found in modern cameras, also evaluates these increases and decreases in sharpness, but it is able to remember the progression perfectly, so that autofocus can lock in much more quickly and, with an image that has sufficient contrast, more precisely. Unfortunately, while the Sony a68's focus system finds it easy to measure degrees of apparent focus at each of the focus points in the viewfinder, it doesn't really know with any certainty which object should be in sharpest focus. Is it the closest object? The subject in the center? Something lurking behind the closest subject? A person standing over at the side of the picture? Using autofocus effectively involves telling the Sony a68 exactly what it should be focusing on.

Getting into Focus

Learning to use the a68's modern autofocus system is easy, but you do need to fully understand how the system works to get the most benefit from it. Once you're comfortable with autofocus, you'll know when it's appropriate to use the manual focus option, too. The important thing to remember is that focus isn't absolute. For example, some things that look in sharp focus at a given viewing size and distance might not be in focus at a larger size and/or closer distance. In addition, the goal of optimum focus isn't always to make things look sharp. Not all of an image will be or should be sharp. Controlling exactly what is sharp and what is not is part of your creative palette. Use of depth-of-field characteristics to throw part of an image out of focus while other parts are sharply focused is one of the most valuable tools available to a photographer. But selective focus works only when the desired areas of an image are in focus properly. For the digital SLR (or SLT) photographer, correct focus can be one of the trickiest parts of the technical and creative process.

To make your job easier, the Sony a68 has a precision 79-point autofocus system located above the semitransparent mirror (see Figure 6.1). It interprets the 30 percent of the light that is reflected up to a separate autofocus sensor. When the contrast is highest at the active autofocus point(s), that part of the image is in sharp focus. The active focus points are actually 79 sets of pixels represented by boxes visible in the display (see Figure 6.2), and can be selected automatically by the camera, or manually by you, the photographer. A total of 64 of those focus points are arranged horizontally, while 15 centrally located points are of the advanced "cross" type (that is, they interpret contrast in both horizontal and vertical directions). I'll explain cross-type focus sensors, and show you their locations later in this chapter.

The camera also looks for these contrast differences among pixels to determine relative sharpness. There are two ways that sharp focus can be determined: phase detection and contrast detection. The primary method used by the a68 is phase detection, so I'll discuss it first; then I'll explain how contrast detection differs and when it is used with this camera.

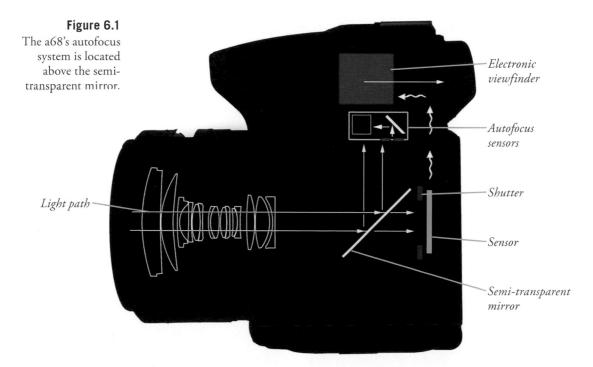

Figure 6.2
Any of the 79 autofocus points can be selected by the photographer manually or by the camera automatically.

Phase Detection

In this mode, the autofocus sampling area is divided into two halves by a lens in the focus sensor. The two halves are compared, much like (actually, exactly like) a two-window rangefinder used in surveying, weaponry, and non-SLR cameras like the venerable Leica M film models. The contrast between the two images changes as focus is moved in or out, until sharp focus is achieved when the images are "in phase," or lined up.

You can visualize how phase detection autofocus works if you look at Figures 6.3 and 6.4. (However, your camera's actual autofocus sensors don't look *anything* like this; I'm providing a greatly simplified graphical representation just for illustration.) In Figure 6.3, a typical horizontally oriented focus sensor is looking at a series of parallel vertical lines in a weathered piece of wood. The lines are broken into two halves by the AF sensor's rangefinder prism, and you can see that they don't line up exactly; the image is slightly out of focus.

Fortunately, the rangefinder approach of phase detection tells the a68 exactly how badly out of focus the image is, and in which direction (focus is too near, or too far) thanks to the amount and direction of the displacement of the split image. The camera can quickly and precisely snap the image into sharp focus and line up the vertical lines, as shown in Figure 6.4. Of course, this scenario—vertical lines being interpreted by a horizontally oriented sensor—is ideal. When the same sensor is asked to measure focus for, say, horizontal lines that don't split up quite so conveniently,

Figure 6.3 When an image is out of focus, the split lines don't align precisely.

Figure 6.4 Using phase detection, the a68 is able to align the features of the image and achieve sharp focus quickly.

or, in the worst case, subjects such as the sky (which may have neither vertical or horizontal lines), focus can slow down drastically, or even become impossible. Figure 6.5 might help you visualize how phase detection aligns images in rangefinder-fashion.

Phase detection is the focusing mode used at all times by the a68 for autofocus, no matter whether you are viewing the live view in the electronic viewfinder or on the LCD. As with any rangefinder-like function, accuracy is better when the "base length" between the two images is larger. (Think back to your high school trigonometry; you could calculate a distance more accurately when the separation between the two points where the angles were measured was greater.) For that reason, phase detection autofocus is more accurate with larger (wider) lens openings—especially those with maximum f/stops of f/2.8 or better—than with smaller lens openings, and may not work at all when the f/stop is smaller than f/5.6. As I noted, the camera is able to perform these comparisons very quickly.

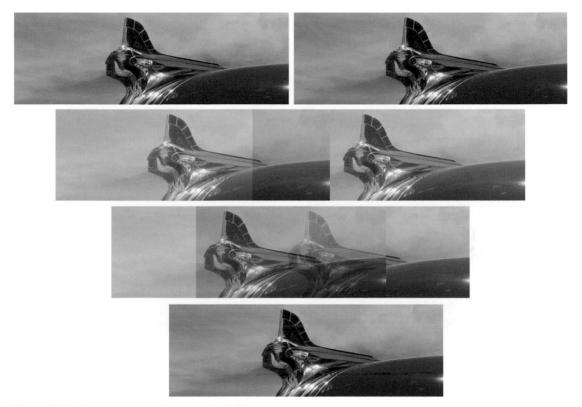

Figure 6.5 Phase detection's "rangefinder" aligns image elements.

Improved Cross-Type Focus Points

Besides the camera's ability to use phase detection autofocus at all times, another important feature of the a68 is the use of cross-type focus points at fifteen positions. Why is this important? It helps to take a closer look at the phase detection system when presented with a non-ideal subject.

Figure 6.6 shows the same weathered wood pictured shown earlier, except in this case we've chosen to rotate the camera 90 degrees (say, because we want a vertically oriented composition). In the illustration, the image within the focus sensor's area is split in two and displaced slightly side-to-side, but the amount and direction of the misalignment is far from obvious. A horizontally oriented focus sensor will be forced to look for less obvious vertical lines to match up. Our best-case subject has been transformed into a *worst*-case subject for a horizontal focus sensor.

The value of the cross-type focus sensors, which can interpret contrast in both horizontal and vertical directions, can be seen in Figure 6.7. The horizontal lines are still giving the horizontal portion of the cross sensor fits, but the vertical bar can easily split and align the subject to achieve optimum focus. Cross-type sensors can handle horizontal and vertical lines with equal aplomb and, if you think about it, lines at any diagonal angle as well. In lower light levels, with subjects that were moving, or with subjects that have no pattern and less contrast to begin with, the cross-type sensor not only works faster but can focus subjects that a horizontal- or vertical-only sensor can't handle at all.

Figure 6.6 A horizontal focus sensor doesn't handle horizontal lines very well.

Figure 6.7 Cross-type sensors can evaluate contrast in both horizontal and vertical directions, as well as diagonally.

So, you can see that having a cross-type focus sensor that is extra-sensitive with faster lenses is a definite advantage. Having fifteen of these sensors, when many digital cameras have only one, if any, is a great leap forward for the a68. Figure 6.8 shows the location of the horizontal and cross-type focus sensors with the a68's focus array. The center point, outlined in red, is a special high-sensitivity point with enhanced performance with lenses having a maximum aperture of f/2.8 or larger.

Figure 6.8
Location of the horizontal and cross sensors.

Contrast Detection

This is a slower mode, suitable for static subjects, which comes into play with the a68 *primarily* when the camera is set to manual focus mode. That's because contrast detection is the system your eye uses to focus on the image on the LCD or in the electronic viewfinder, when you're focusing manually. It's a bit easier to understand than phase detection, and is illustrated by Figure 6.9. At top in the figure, the transitions between the edges found in the image are soft and blurred because of the low contrast between them. Although the illustration uses the same vertical lines used with the phase detection example, the orientation of the features doesn't matter. The focus system looks only for contrast between edges, and those edges can run in any direction.

At the bottom of Figure 6.9, the image has been brought into sharp focus, and the edges have much more contrast; the transitions are sharp and clear. Although this example is a bit exaggerated so you can see the results on the printed page, it's easy to understand that when maximum contrast in a subject is achieved, it can be deemed to be in sharp focus.

Figure 6.9
Manual focus in contrast detection mode allows you to evaluate the increase in contrast in the edges of subjects, starting with a blurry image (top) and producing a sharp, contrasty image (bottom).

Although achieving focus with contrast detection is generally quite a bit slower, because you're doing it manually, there are several advantages to this method:

- Works with more image types. Contrast detection doesn't require subject matter rotated 90 degrees from the sensor's orientation for you to use it to focus manually. Any subject that has edges will work.
- **Focus on any point.** While phase detection focus can be achieved *only* at the points that fall under one of the 79 autofocus sensors, with contrast detection, any portion of the image can be used as you view the image. Focus is achieved with the actual sensor image, so focus point selection is simply a matter of choosing which part of the sensor image to use.
- Potentially more accurate. Phase detection can fall prey to the vagaries of uncooperative subject matter: if suitable lines aren't available, the system may have to hunt for focus or achieve less than optimal focus. Contrast detection is more clear-cut. Your eye can clearly see when the highest contrast has been achieved.

The a68's autofocus mechanism, like all such phase detection systems found in digital cameras, evaluates the degree of focus, but, unlike the human eye, it is able to remember the progression perfectly, so that autofocus can lock in much more quickly and, with an image that has sufficient contrast, more precisely. Many of the techniques for using autofocus effectively involve telling the Sony a68 exactly what it should be focusing on, by choosing a focus zone or by allowing the camera to choose a focus zone for you. I'll address that topic shortly.

As the camera collects focus information from the sensors, it then evaluates it to determine whether the desired sharp focus has been achieved. The calculations may include whether the subject is moving, and whether the camera needs to "predict" where the subject will be when the shutter release button is fully depressed and the picture is taken. (The a68 actually resorts to

contrast detection by monitoring the live view image to help it decide which direction your subject is moving.) The speed with which the camera is able to evaluate focus and then move the lens elements into the proper position to achieve the sharpest focus determines how fast the autofocus mechanism is.

Adding Circles of Confusion

But there are other factors in play, as well. You know that increased depth-of-field brings more of your subject into focus. But more depth-of-field also makes autofocusing (or manual focusing) more difficult because the contrast is lower between objects at different distances. So, autofocus with a 200mm lens (or zoom setting) may be easier than at a 28mm focal length (or zoom setting) because the longer lens has less apparent depth-of-field. By the same token, a lens with a maximum aperture of f/1.8 will be easier to autofocus (or manually focus) than one of the same focal length with an f/4 maximum aperture, because the f/4 lens has more depth-of-field *and* a dimmer view. That's why lenses with a maximum aperture smaller than f/5.6 can give your Sony a68's autofocus system fits, because the largest f/stop is the lens opening the camera uses to focus.

To make things even more complicated, many subjects aren't polite enough to remain still. They move around in the frame, so that even if the a68 is sharply focused on your main subject, it may change position and require refocusing. An intervening subject may pop into the frame and pass between you and the subject you meant to photograph. You (or the a68) have to decide whether to lock focus on this new subject, or remain focused on the original subject. Finally, there are some kinds of subjects that are difficult to bring into sharp focus because they lack enough contrast to allow the Sony a68's AF system (or our eyes) to lock in. Blank walls, a clear blue sky, or other subject matter may make focusing difficult.

If you find all these focus factors confusing, you're on the right track. Focus is, in fact, measured using something called a *circle of confusion*. An ideal image consists of zillions of tiny little points, which, like all points, theoretically have no height or width. There is perfect contrast between the point and its surroundings. You can think of each point as a pinpoint of light in a darkened room. When a given point is out of focus, its edges decrease in contrast and it changes from a perfect point to a tiny disc with blurry edges (remember, blur is the lack of contrast between boundaries in an image). (See Figure 6.10.)

Figure 6.10
When a pinpoint of light (left) goes out of focus, its blurry edges form a circle of confusion (center and right).

If this blurry disc—the circle of confusion—is small enough, our eyes still perceives it as a point. It's only when the disc grows large enough that we can see it as a blur rather than a sharp point that a given point is viewed as out of focus. You can see, then, that enlarging an image, either by displaying it larger on your computer monitor or by making a large print, also enlarges the size of each circle of confusion. Moving closer to the image does the same thing. So, parts of an image that may look perfectly sharp in a 5×7 —inch print viewed at arm's length, might appear blurry when blown up to 11×14 and examined at the same distance. Take a few steps back, however, and it may look sharp again.

To a lesser extent, the viewer also affects the apparent size of these circles of confusion. Some people see details better at a given distance and may perceive smaller circles of confusion than someone standing next to them. For the most part, however, such differences are small. Truly blurry images will look blurry to just about everyone under the same conditions.

Technically, there is just one plane within your picture area, parallel to the back of the camera (or sensor, in the case of a digital camera) that is in sharp focus. That's the plane in which the points of the image are rendered as precise points. At every other plane in front of or behind the focus plane, the points show up as discs that range from slightly blurry to extremely blurry. In practice, the discs in many of these planes will still be so small that we see them as points, and that's where we get depth-of-field. Depth-of-field is just the range of planes that include discs that we perceive as points rather than blurred splotches. The size of this range increases as the aperture is reduced in size and is allocated roughly one-third in front of the plane of sharpest focus, and two-thirds behind it. The range of sharp focus is always greater behind your subject than in front of it—although in many cases, depth-of-field will be very shallow, as shown in Figure 6.11.

Components of Autofocus

To achieve correct focus, your a68 needs to know three things from you:

- When to begin focusing. You need to tell the a68 when it should start attempting to bring your image into focus. There are several ways to accomplish that. The most common way of activating the AF system is to press the shutter release halfway prior to taking a picture, but another button can be defined as an AF-ON button instead. The a68 can even be told to begin its autofocus efforts as soon as you bring the viewfinder up to your eye (using Eye Start AF, discussed in Chapter 4).
- When to stop focusing. Would you like AF to stop as soon as the subject is sharply focused? You might want that option so that you can reframe your image without needing to refocus on the same subject. Or would you prefer that the AF system continue focusing until you press the shutter release down all the way to take the picture? That would be a good choice if your subject is moving. Again, there are several ways you can tell the a68 which way to proceed, using focus modes (described next), or a button that performs a *focus lock* function.

Figure 6.11 Only the deer's eyes are in sharp focus; other areas of the image appear blurry because the depth-of-field is limited.

■ The area of the frame you want to focus on. Left to their own devices, cameras tend to like to focus on the closest object in the frame. You, however, may have other ideas and may, in fact, want to use selective focus techniques to focus on some specific subject, rather than the closest, or largest object in the picture. The a68 gives you *lots* of choices in selecting the focus area, and I'll explain all of those in this chapter, as well.

Focus Modes—Begin/Stop

Starting and stopping focus is determined primarily by the focus mode you select—AF-S, AF-A, or AF-C using the default Focus Mode behavior of the C1 button (and also available from the Function and Camera Settings 3 menus). Some lenses also have their own AF/MF switch to quickly change from automatic to manual focus, and the AF/MF button on the back of the camera can perform the same function. However, selecting the Focus Mode can only be done with that dial.

Choosing the right focus mode is one of your keys to success. Using the wrong mode for a particular type of photography can lead to a series of pictures that are all sharply focused—on the wrong subject. When I first started shooting sports with an autofocus SLR (back in the film camera days), I covered one baseball game alternating between shots of base runners and outfielders with pictures of a promising young pitcher, all from a position next to the third base dugout. The base runner and outfielder photos were great, because their backgrounds didn't distract the autofocus mechanism. But all my photos of the pitcher had the focus tightly zeroed in on the fans in the stands behind him. Because I was shooting film instead of a digital camera, I didn't know about my gaffe until the film was developed. A simple change, such as locking in focus or focus zone manually, or even manually focusing, would have done the trick.

To save battery power, your Sony a68 doesn't start to focus the lens until you partially depress the shutter release (or other AF-ON button you've defined), or your face approaches the Eye-Start sensors (if you have that feature switched on). But, autofocus isn't some mindless beast out there snapping your pictures in and out of focus with no feedback from you after you press that button. There are several settings you can modify that return at least a modicum of control to you. In order to make these settings, you have to be shooting in Program, Aperture Priority, Shutter Priority, Manual, or Continuous Advance Priority AE exposure mode. (In the latter mode, you can only select either Continuous AF or Single-shot AF.) If you're shooting in Auto, or one of the Scene or Panorama modes, the camera will make all focus settings for you.

If you're shooting in one of the modes that gives you these focusing options, your first decision should be whether to set the Sony a68 to Single-shot AF (AF-S), Continuous AF (AF-C), or Automatic AF (AF-A). The fastest way is to press the C1 button to select the AF mode (unless you've redefined it to some other behavior). If the lens you are using has an AF/MF switch, you must set that switch to AF; the switch on the camera will have no effect. If the lens does not have a switch, then you must set the switch on the camera.

When the image under the current focus area (described later) is in sharp focus, the focus confirmation indicator in the viewfinder or on the LCD will glow a steady green; the camera is ready to shoot. You can take a picture at any time. When only the green brackets are illuminated, the a68 is still seeking focus, and the shutter is locked. A flashing green indicator dot indicates that the a68 is unable to focus. The shutter is locked. You may need to switch to manual focus to get this shot. Your four focus modes are discussed next.

Single-Shot AF

In this mode, also called *single autofocus*, focus is set once and remains at that setting until the button is fully depressed, taking the picture, or until you release the shutter button without taking a shot. In effect, the a68 starts focusing when you press the shutter release halfway (or press another AF-ON button you've defined), and then stops—at least until you release the shutter button or other autofocus activating control, and then press it again.

For non-action photography, this setting is usually your best choice, as it minimizes out-of-focus pictures (at the expense of spontaneity). The drawback here is that you might not be able to take a picture at all while the camera is seeking focus; you're locked out until the autofocus mechanism is happy with the current setting. Single autofocus is sometimes referred to as *focus priority* for that reason. Because of the small delay while the camera zeroes in on correct focus, you might experience slightly more shutter lag. This mode uses less battery power. When sharp focus is achieved, the selected focus point(s) will turn green in the viewfinder or on the LCD, and the focus confirmation light at the lower left will glow green.

Continuous AF

This mode is the one to use for sports and other fast-moving subjects. With Continuous AF, once the shutter release (or other AF-ON button) is partially depressed, the camera sets the focus but continues to monitor the subject, so that if it moves or you move, the lens will be refocused to suit. Focus and exposure aren't really locked until you press the shutter release down all the way to take the picture, *or* press an autofocus lock (AF lock) button that you may have defined.

If the focus confirmation indicator in the viewfinder or on the LCD is flanked by parentheses-like brackets, which indicates that you are using AF-C focus mode, the image is in focus, but the a68 will change focus as your subject moves. Continuous AF uses the most battery power, because the autofocus system operates as long as the shutter release button is partially depressed. (It also operates when your eye or another object approaches the viewfinder, if you're using the viewfinder and have the Eye-Start AF option turned on. In that case, there's even more risk of battery drain.)

Continuous AF uses a technology called *predictive AF*, which allows the camera to calculate the correct focus if the subject is moving toward or away from the camera at a constant rate. It uses either the automatically selected AF point or the point you select manually to set focus.

Automatic AF

This setting is actually a combination of the first two. When AF-A is selected, the camera focuses using Single-shot AF and locks in the focus setting. But, if the subject begins moving, it will switch automatically to Continuous AF and change the focus to keep the subject sharp. Automatic AF is a good choice when you're shooting a mixture of action pictures and less dynamic shots and want to use Single-shot AF when possible. The camera will default to that mode, yet switch automatically to Continuous AF when it would be useful for subjects that might begin moving unexpectedly.

Manual Focus

I'll discuss your manual focus options in greater detail in a special section later in this chapter.

AF AREA AUTO CLEAR

If you find that having the selected focus area is distracting, you can tell the a68 to clear the focus indicator from the frame automatically after a few seconds. In Custom Settings 3, set AF Area Auto Clear to Off.

Area to Focus On

The third parameter you need to pass along to your a68's autofocus system is the area of the frame you want to focus on. In some ways, the focus area is the most important aspect of all. You can tell the camera to use all of its 79 AF points, work with a reduced set of 61 points, look only in specific zones, concentrate on the center area of the frame, *track* a moving object as it roams around the frame, or even to switch focus to or ignore intervening objects (such as a referee at a football game) that cross in front of your desired main subject. All these choices are made using the AF area specifications you select.

You can specify which of the 79 focus points the Sony a68 uses to calculate correct focus, or allow the camera to select the point for you. Note that the a68 camera has its autofocus points clustered, which means that you (or the camera) can focus only on subjects that fall under one of the autofocus marks shown earlier in Figure 6.2. To focus somewhere else in the frame, you'll need to place your subject under the appropriate autofocus area or move the focus area to your subject, focus, and then lock focus by pressing the shutter release button halfway or locking focus with a defined AF Lock button. You can then reframe your photo with the focus locked in.

To choose the AF area mode, press the Fn button and navigate to the Focus Area option, located by default in the top row of the Function menu. Press the center button. The screen shown in Figure 6.12 appears, with four of the six basic AF area options. You must scroll down to access the last two. (Additional options, not available from this screen, include Face Detection and Object Tracking, which I'll discuss shortly.) Make your selection, and press the center button again to confirm. **Note:** If you're using Auto, Sweep Panorama, Scene Selection, Smile Shutter, or Object Tracking, AF Area is locked at Wide.

I'll explain each of these choices, and their options, in the sections that follow:

- Wide. The a68 chooses the appropriate focus point or points on your behalf from the 79 or 61 AF areas on the screen. You cannot manually select the focus points.
- **Zone.** A cluster of focus points are active, and you can move the zone containing those points around within the focus frame. The camera selects the focus point to use within the zone you specify.
- Center. Only the center focus area is used to achieve autofocus.
- Flexible Spot. You select which of the 79 or 61 focus points to use, using the control wheel.
- Expand Flexible Spot. You select the focus point, but the a68 also considers the eight surrounding points.
- Lock-On AF. This option lets you *track* moving subjects, and can be set to use Wide, Zone, Center, Flexible Spot, or Expand Flexible Spot focus areas. I'll describe this feature in a separate section that follows.

Figure 6.12
Press the Fn button and choose AF Area.

Wide

When you select Wide from the Focus Area screen in the Function menu, the a68 goes into full auto AF point selection mode, and chooses which of the focus points to use. Ordinarily, that will be the full array of 79 points, shown at top in Figure 6.13. However, you can eliminate some points on the periphery of the array by visiting the Customs Settings 3 menu, and switching the Area Points entry from Auto to 61 points. In that case, the points used will include those represented in black in Figure 6.13 (middle). I've colored the "ignored" points in light magenta in the illustration so you can see which ones are deleted.

Figure 6.13
With the Wide setting, the a68
chooses from among
79 (top) or 61 (middle) focus points.
The focus point
array can be displayed all the time,
or hidden (bottom).

Sony's manual implies that 61 points can be used only with certain SAL lenses; however, I've been able to use the 61-point array with other lenses, including third-party optics from Sigma. Whether you choose 79 or 61 points, you can show or hide the display of the available points by using the Custom Settings 3 entry Wide AF Area Disp. Select On, and the points appear as shown in the upper two screens of Figure 6.13. Choose Off, and only the focus point frame is shown, as in Figure 6.13 (bottom). In all three cases, though, when the a68 selects points and focuses, the chosen point(s) will be illuminated in green.

Wide is usually your best choice for most subjects, and does particularly well when Face Detection is activated and you're photographing humans (not animals) who are facing the camera.

Zone

This focus area mode gives you a little more control over the focus point selected by the a68. When activated, the camera groups a cluster of focus points into a zone, and you can move the zone around within the focus frame using the control wheel. Figure 6.14 shows you the zones you can select. At the left and right sides of the array they overlap, so I've color coded the points and highlighted each of them with a yellow or orange rectangle.

The a68 will still choose focus points on its own, but will stick to the zone you specify, and illuminate the selected point(s) in green. This is a good choice when you know that your subject will generally remain in a certain portion of the frame, and want the camera to ignore subjects elsewhere.

Center

With this selection, neither the a68 nor you can choose a focus point; the camera *always* uses the center spot, as shown in Figure 6.15, top. Use this setting if you know your subject will always be in the exact center of the frame or, more likely, you're shooting and find that some intervening objects may be located between you and your subject (as in Figure 6.16), and want to focus on the more distant subject.

Figure 6.14
Chose Zone and you can limit the a68's focus point search to the zone you select, from among those marked with yellow and orange rectangles in this figure.

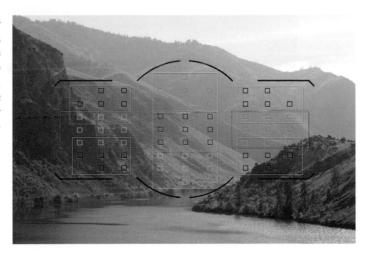

Flexible Spot

Flexible spot allows you to use the control wheel to choose the focus point, either the center point, as shown in Figure 6.15 (middle), or any of the other points in the 79- or 61-point array (depending on how you've set the Area Points entry in the Custom Settings 3 menu). You're free to move the active point anywhere you like within the array. Use this choice, and Expand Flexible Spot (described next), when you want to select a specific focus point *and have the time to do so.* Unless you have a fast finger, it might not be your best choice for sports and fast-moving action, but could work well when shooting active kids, as well as cavorting pets (a turtle would be a perfect subject).

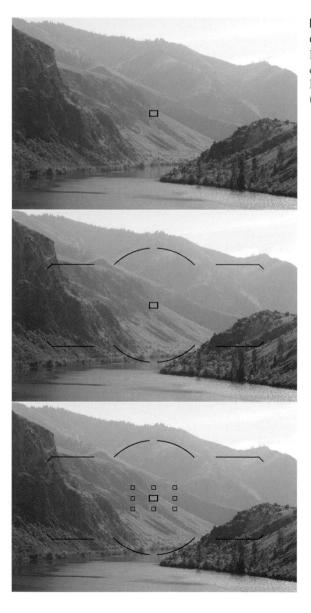

Figure 6.15
Center Spot (top),
Flexible Spot (middle), and Expand
Flexible Spot (bottom).

Figure 6.16 Center focus is a good choice when you want to ignore distracting objects that are closer to you than your main subject.

Expand Flexible Spot

This is a variation on Flexible Spot. You still select the focus point from the 79/61 available locations, but the a68 also takes into account up to eight surrounding points, if needed, to lock in focus. Figure 6.15 (bottom) shows the center focus point selected, surrounded by eight auxiliary points; but you can move the main point around within the array. The addition of the extra focus points may make it possible for you to use this setting with sports—you don't have to nail the exact position of your subject with any precision.

Lock-On, Object Detection, and Tracking

The Sony a68 has several other tricks up its sleeve in the autofocus area. It can lock focus, detect objects, recognize faces, and track moving subjects to make sure they remain sharply focused. Your subjects may leave the frame, and the camera will notice when they come back, and resume focusing as before. This section will introduce you to those features.

Lock-On AF

Lock-On AF and Center Lock-On AF are two tools for tracking a moving subject. They are activated and operate in slightly different ways. Lock-On AF is the easier of the two, because you can turn it on and forget it, so I'll describe it first. It does, however, only work in still photography mode; you can't use it when shooting movies. To use Lock-On AF, just follow these steps:

- 1. **Choose AF-C.** This feature works only when you are using continuous autofocus because, well, it refocuses continually.
- 2. **Deactivate Center Lock-On.** You can't use Lock-On and Center Lock-On (described next) at the same time.
- 3. **Activate Lock-On AF.** Use the Function menu and choose Focus Area. Scroll down past the Expand Flexible Spot entry and highlight Lock-On AF.
- 4. **Choose Focus Area.** Surprise! Using Lock-On AF does *not* mean you lose access to the four AF area modes. With Lock-On AF highlighted, use the left/right controls to select Wide, Zone, Center, Flexible Spot, or Expand Flexible Spot. That will give you both Lock-On AF *and* the area mode you prefer. If you switch from AF-C to AF-S, you lose the lock on capabilities, and the camera just reverts to whatever focus area mode you select here.
- 5. **Start tracking.** When you activate focus by pressing the shutter release halfway, the camera will use your selected focus area option to lock in focus, as always. However, now, once focus has been locked, the a68 will *track* your subject as it roams around the screen. You'll see the green focus area rectangles moving as your subject moves (or you reframe the image with the camera). If a face is detected, a tracking rectangle around the face will be shown. (You'll learn more about face detection in an upcoming section.)

Center Lock-On AF

This is a similar feature, with a couple differences. First, it allows you to choose the subject to track, rather than rely on the camera to track whatever object focus is originally locked on. In addition, it can also be used in Movie mode, which can be very handy when you want to track a moving subject as you capture video. It cannot be used when Lock-On AF is active. To use Center Lock-On AF, just follow these steps:

- Deactivate Lock-On AF. You won't be able to activate Center Lock-On AF if its Lock-On AF
 cousin is enabled. Visit the Function menu and choose Wide, Zone, Center, Flexible Spot, or
 Expand Flexible Spot.
- Activate Center Lock-On AF. Next, stop by the Camera Settings 7 menu and enable Center Lock-On AF.
- 3. Activate. Press the center button to activate.
- 4. **Choose subject.** A screen like the one at left in Figure 6.17 appears. Align the camera so the subject you want to track is within the selection box. Press the center button again to select that subject.
- 5. **Start tracking.** Once the camera figures out which areas of the image under the selection box include your subject, it will outline the subject with a double white border. The camera will now use the live view image to track the subject and its phase detection AF system to keep that subject in focus.
- 6. **Don't panic.** If your subject moves out of the frame, the a68 will remember what it was tracking for several seconds, and relock on it if it appears in the frame again within that time. If tracking is totally lost, the camera resumes its normal AF behavior until you select another subject to track.
- 7. Stop tracking. You can press the center button again to stop tracking your subject.

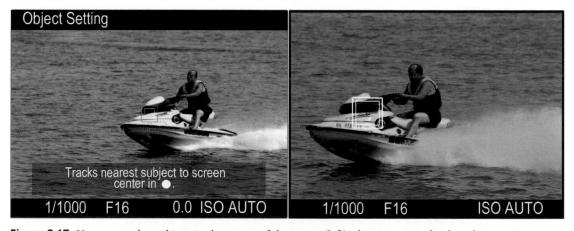

Figure 6.17 You can track a subject in the center of the screen (left); the camera tracks the subject as it moves (right).

There are some special considerations when using this feature if the target subject is a human face. The a68 "remembers" the face selected, so if the subject disappears from the frame and then returns, the camera locks in on that face again. If you're using the Smile Shutter function, then the a68 will not only track the individual's face, but release the shutter and take a picture if your subject smiles!

Center Lock-On may not work if the subject is moving too quickly, is too small or too large to be isolated effectively, has only reduced contrast against its background, or if the ambient light is too dark or changes dramatically while you're tracking.

Face Detection

If you activate Face Detection mode in the Camera Settings 7 menu, the camera will try to identify any faces in the scene. In Chapter 4, I explained each of the options in the Smile/Face Detection entry:

- Face Detection Off. Disables face detection.
- Face Detection On (Registered Faces). When set to On (Registered Faces), any faces *previously logged* will be given priority. As you press the shutter button to take the picture, the camera will attempt to set the exposure and white balance using the face it has selected as the main subject.
- Face Detection. The a68 looks for any human face it can find, and doesn't care who it belongs to. (See Figure 6.18.)
- Smile Shutter. You must activate this feature each time you use it. When you power down the camera, it reverts to Face Detection On (Registered Faces) until you re-activate the Smile Shutter. Press the control wheel buttons to specify Normal Smile, Big Smile, and Slight Smile. A vertical scale appears on the left side of the screen showing you that the feature has been activated. The sensitivity depends on whether the subject has a toothy grin or is wearing sunglasses. If multiple faces are found, only one (and any one) of them will trigger the shutter.

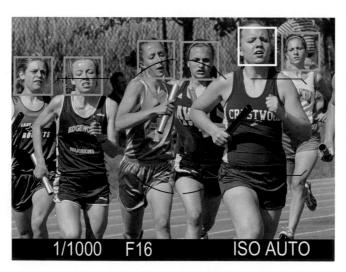

Figure 6.18
In Face Detection mode, the camera will attempt to identify as many as eight human faces in a scene, and focus on the one nearest the camera.

You'll need to register faces you want to recognize separately using the Face Registration option, which Sony has hidden in the Customs Settings 6 menu, as described in Chapter 4. You can assign a priority for up to eight faces (ranking them 1 to 8).

Once activated, the a68 will surround each face detected (up to eight in all) with a frame that is initially gray. If it judges that autofocus is possible for one or more faces, it highlights the frames around those faces in white. Then, when you press the shutter halfway down to autofocus, the frames will turn green once they are in focus. The camera will also attempt to adjust white balance, exposure, including using the pop-up flash, as appropriate for the scene. If no faces are detected, the camera will choose a focus point using whichever of the basic AF areas has been set.

Face Detection is available at all times, except when you are using either the Sweep Panorama or the Continuous Priority AE shooting mode, Picture Effect is set to Posterization, Scene Selection is set to Landscape, Night Scene, or Sunset, when you are using the Focus Magnifier, or shooting a movie. While you may prefer to exercise your own control over what parts of a scene to focus on, this feature comes in handy when photographing kids, or people in general, or if you need to hand the camera to a stranger to photograph you and your family or friends at an outing in the park.

As I explained in Chapter 4, you can refine the a68's Face Detection operation by registering familiar faces so they'll be easier for the camera to detect. This Custom Settings 6 menu entry has several options. New Registration allows you to log up to eight different faces. Line up your subject against a brightly lit background, to allow easier detection of the face. Use the directional buttons to align the green frame that appears with the face, and press the shutter button. A confirmation message appears; press the center button to confirm.

Also available is the Order Exchanging Option, which allows you to review and change the priority in which the faces will be recognized, from 1 (your youngest child) to 8 (your brother-in-law). The a68 will use your priority setting to determine which face to focus on if several registered faces are detected in a scene. You can also select a specific face and delete it from memory or delete *all* faces from the registry.

EYE AF

As long as you're detecting faces, don't forget the "secret" Eye AF feature, which tells the a68 to focus on your subject's eyes. This feature is available *only* when you've defined a key to activate it, using the Custom Keys entry in the Custom Settings 6 menu, as described in Chapter 4.

Manual Focus

Although the autofocus capabilities of modern digital cameras at times seem to border on the miraculous in their features, such as deciding where to focus, focusing in low light, detecting faces, and tracking moving subjects, there are times when manual focus is your best option for getting the picture made the way you want it. For example, when shooting through glass, shooting a complex scene with many possible focus points, or shooting extreme close-ups (macro photography), there may be no viable substitute for adjusting the focus by hand.

Here's a brief reminder of the basic procedure for using manual focus, after which I'll discuss a couple of specific options that can help you achieve sharp focus manually in particular situations. In focusing manually with the Sony a68, you first have to consider what lens you are using. If you're using a SAM lens (see Chapter 9 for a discussion of the differences among SAM, SSM, and other autofocus lenses), you will see an AF/MF switch on the lens itself. In order to use manual focus mode in that case, you have to set the switch on the lens to MF; if you leave it set to AF and set the switch on the camera to MF, the camera will still autofocus with the lens. In other words, when the lens has an AF/MF switch, always use the switch on the lens to change focus modes, and leave the switch on the camera set to AF at all times. If you're using a lens that does not have an AF/MF switch, such as the Sony SAL 100mm f/2.8 macro lens, then you need to use the switch on the camera to switch between manual focus and autofocus.

Once you have selected manual focus using the proper switch, just turn the focusing ring on the lens until the image appears sharp. The camera will give you confirmation as you focus: As you view the image in the electronic viewfinder or on the LCD, the green focus circle will appear to confirm focus, once the camera has determined that the image is sharp. If you're having difficulty getting the image into the best possible focus, there are a couple of techniques you can use to improve your results:

- **Zoom in.** If you're using a zoom lens, but are not composing the shot at the longest zoom setting, zoom all the way in before focusing so you can see the focus point on your subject more clearly. If the focus is sharp at the longest focal length, it will also be sharp when you zoom back out to the focal length at which the picture is taken.
- Use the Focus Magnifier. If you're finding it difficult to achieve a sharp image using manual focus, you can use the Focus Magnifier option, which can be activated from the Camera Settings 6 menu (not recommended), or via a button that you define to perform that function much more quickly. Press the button once to activate the feature, and move the small orange block over the area of most critical focus. Then press the button again to enlarge the image to about 5.9 times normal and once more to about 11.7 times. Press it a final time to return to the normal view. (See Figure 6.19.)
- Activate Focus Peaking. This is an invaluable aid to achieving sharp manual focus, and is revisited in the next section.

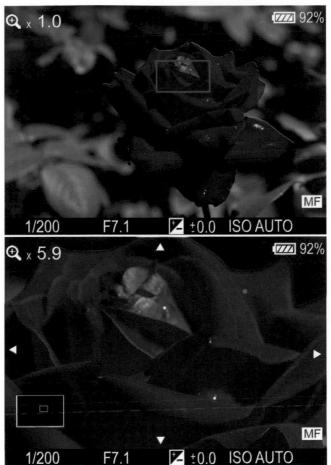

Focus Peaking

This is a sensational manual focusing enhancer that you can use in Manual and Direct Manual modes. *Focus peaking*, enabled in the Custom Settings 2 menu as described in Chapter 4, outlines the area in sharpest focus with red, white, or yellow (see Figure 6.20). The highlight color area shows you instantly the edges of what will be very sharp if you take the photo at that moment. As the focus gets closer to ideal for a specific part of the image, the color outline develops around hard edges that are in focus. You can choose how much peaking is applied (High, Medium, and Low), or turn the feature off. Select a color that contrasts with your subject's surroundings. I use yellow or red the most, and set the intensity on High for maximum effect.

Figure 6.20 This simulated image illustrates the focus peaking effect.

Autofocus Summary

Here's a summary of autofocus considerations that were discussed elsewhere in this book, primarily here and in Chapters 3 and 4 under the explanations of the various autofocus settings. I'll recap the most important aspects here, as a quick guide to help you locate the longer discussions. Table 6.1 provides some guidelines for particular types of subjects.

- AF-A Setup (Camera Settings 3). Whether AF-A mode activates DMF when autofocus is achieved.
- Focus Area (Camera Settings 3). Select the number and location of autofocus points used.
- AF Illuminator (Camera Settings 3). Enables/disables use of built-in or external flash as an autofocus aid.
- AF Drive Speed (Camera Settings 4). Choose between slow and accurate AF, or fast and slightly less accurate.
- AF Track Sensitivity (Stills) (Camera Settings 4). Adjust how long the a68 waits to refocus on intervening objects when shooting still photos.
- AF Track Sensitivity (Movie) (Camera Settings 4). Adjust how long the a68 waits to refocus on intervening objects when shooting movies.

- Focus Magnifier (Camera Settings 6). Assign to button to enlarge 5.9X or 11.7X during manual focus.
- Focus Magnifier Time (Custom Settings 1). Length of time focus magnifier remains active.
- Lock-On AF (Focus Area setting). When activated (Camera Settings 3 menu), automatically tracks focused subject when shooting stills. Mutually exclusive with Center Lock-On AF.
- Priority Setup (Custom Settings 4). Select whether focus is *release priority* (take picture immediately, even if sharp focus is not achieved) or *focus priority* (don't take picture until sharp focus is locked in). You can also choose *balanced emphasis* as a compromise between the two.

Table 6.1	Focus Guidelines							
Subject	Focus Mode	Focus Area	Priority Setup	Lock-On AF	Tracking Drive Speed	Tracking Duration	Smile/ Face Detection	Eye AF
Portraits	AF-S	Flexible Spot	AF	Off	Fast	3	On	Yes
Street photo- graphy	AF-C	Wide	Balanced Emphasis	On	Fast	3	On	As needed
General sports action	AF-C	Expanded Flexible Spot	Release	On	Fast	1	Off	No
Birds in flight	AF-C	Expanded Flexible Spot	Balanced Emphasis	On	Fast	5	Off	No
Football, soccer, basketball	AF-C	Expanded Flexible Spot	Release	On	Fast	1	Off	Off
Kids, pets	AF-C	Zone	Balanced Emphasis	On	Fast	2	On	Yes
Track events, auto racing	AF-C	Wide	Release	On	Fast	3	Off	No
Landscapes	AF-S	Wide	AF	Off	Slow	3	Off	No
Concerts, perfor- mances	AF-S	Flexible Spot	AF	Off	Fast	3	On	Yes

- Center Lock-On AF (Camera Settings 7). For stills and movies, allows you to choose a subject to track.
- Smile/Face Detection (Camera Settings 7). Sets focus, exposure, and white balance for detected faces, both registered and unregistered.
- Face Registration (Custom Settings 6). Allows you to register up to eight faces.
- Eye AF. Define a button to search for and lock focus on eyes, as described in Chapter 4.
- Peaking Level/Color (Custom Settings 2). Color outline of manually focused sharp areas.
- AF Range Control Assist (Custom Settings 2). Displays indicators of areas within range of focus you select.
- AF Area Auto Clear (Custom Settings 3). Allows AF areas to disappear after a few seconds.
- **AF Area Points (Custom Settings 3).** Activate 61 central AF points, or choose Auto for 61 or 79 focus points.
- Flexible Spot Points (Custom Settings 3). Activate all focus points for Flexible Spot focusing, or limit to 15.
- Wide AF Area Display (Custom Settings 3). Enable/Disable display of Wide Area AF points.
- Eye-Start AF (Custom Settings 4). AF begins when the a68 viewfinder window is brought up to your eye.
- **AF w/Shutter (Custom Settings 4).** Choose On to start AF when the shutter is pressed halfway, or Off to start AF only when the shutter release is pressed all the way to take picture.
- **AF Micro Adjustment (Custom Settings 6).** Fine-tune autofocus for specific lenses. Discussed in Chapter 9.

Focus Stacking

If you are doing macro (close-up) photography of insects, flowers, or other small objects at short distances, the depth-of-field often will be extremely narrow. In some cases, it will be so narrow that it will be impossible to keep the entire subject in focus in one photograph. Although having part of the image out of focus can be a pleasing effect for a portrait of a person, it is likely to be a hindrance when you are trying to make an accurate photographic record of a flower, insect, or small piece of precision equipment. One solution to this problem is focus stacking, a procedure that can be considered like HDR translated for the world of focus—taking multiple shots with different settings, and, using software as explained below, combining the best parts from each image in order to make a whole that is better than the sum of the parts.

For example, see Figures 6.21 through 6.23, in which I took photographs of three colorful crayons using a Sony a68 with the Sony SAL f/2.8 100mm macro lens, which has an effective focal length of 150mm when used with the camera's APS-C-sized sensor. As you can see from these images, the depth-of-field was extremely narrow, and only a small part of the subject was in focus for each shot.

Now look at Figure 6.24, in which the entire subject is in reasonably sharp focus. This image is a composite, made up of the three shots above, as well as 10 others, each one focused on the same scene, but at very gradually increasing distances from the camera's lens. All 13 images were then combined in Adobe Photoshop using the focus stacking procedure.

Figure 6.21 Figure 6.22 Figure 6.23

These three shots were all focused on different distances within the same scene. No single shot could bring the entire subject into sharp focus.

Figure 6.24 Three partially out-of-focus shots have been merged, along with ten others, through a focus stacking procedure in Adobe Photoshop, to produce a single image with the entire subject in focus.

Here are the steps you can take to combine shots for the purpose of achieving sharp focus in this sort of situation:

- 1. Set the camera firmly on a solid tripod. A tripod or other equally firm support is absolutely essential for this procedure.
- 2. Connect a wired remote control or use an infrared remote control if possible. If not, consider using the self-timer to avoid any movement of the camera when images are captured.
- 3. Set the camera to manual focus mode.
- 4. Set the exposure, ISO, and white balance manually, using test shots if necessary to determine the best values. This step will help prevent visible variations from arising among the multiple shots that you'll be taking.
- 5. Set the quality of the images to RAW & JPEG or FINE.
- 6. Focus manually on the very closest point of the subject to the lens. Trip the shutter, using the remote control or self-timer.
- 7. Gently refocus on a point slightly farther away from the lens and trip the shutter again.
- 8. Continue taking photographs in this way until you have covered the entire subject with in-focus shots.
- 9. In Photoshop, select Files > Scripts > Load Files into Stack. In the dialog box that then appears, navigate on your computer to find the files for the photographs you have taken, and highlight them all.
- 10. At the bottom of the next dialog box that appears, check the box that says, "Attempt to Automatically Align Source Images," then click OK. The images will load; it may take several minutes for the program to load the images and attempt to arrange them into layers that are aligned based on their content.
- 11. Once the program has finished processing the images, go to the Layers panel and select all of the layers. You can do this by clicking on the top layer and then Shift-clicking on the bottom one.
- 12. While the layers are all selected, in Photoshop go to Edit > Auto-Blend Layers. In the dialog box that appears, select the two options, Stack Images and Seamless Tones and Colors, then click OK. The program will process the images, possibly for a considerable length of time.
- 13. If the procedure worked well, the result will be a single image made up of numerous layers that have been processed to produce a sharply focused rendering of your subject. If it did not work well, you may have to take additional images the next time, focusing very carefully on small slices of the subject as you move progressively farther away from the lens.

Although this procedure can work very well in Photoshop, you also may want to try it with programs that were developed more specifically for focus stacking and related procedures, such as Helicon Focus (www.heliconsoft.com) or PhotoAcute (www.photoacute.com).

Advanced Techniques for Your Sony a68

Of the primary foundations of great photography, only one of them—the ability to capture a compelling image with a pleasing composition—takes a lifetime (or longer) to master. The art of *making* a photograph, rather than just *taking* a photograph, requires an aesthetic eye that sees the right angle for the shot, as well as a sense of what should be included or excluded in the frame; a knowledge of what has been done in the medium before (and where photography can be taken in the future); and a willingness to explore new areas. The more you pursue photography, the more you will learn about visualization and composition. When all is said and done, this is what photography is all about.

The other basics of photography—equally essential—involve more technical aspects: the ability to use your camera's features to produce an image with good tonal and color values; to achieve sharpness (where required) or unsharpness (when you're using selective focus); and to master appropriate white/color balance. It's practical to learn these technical skills in a timeframe that's much less than a lifetime, although most of us find there is always room for improvement. You'll find the basic information you need to become proficient in each of these technical areas in this book.

You've probably already spent a lot of time learning your Sony's basic features, and setting it up to take decent pictures automatically, with little input from you. It probably felt great to gain the confidence to snap off picture after picture, knowing that a large percentage of them were going to be well exposed, in sharp focus, and rich with color. The Sony a68 is designed to produce good, basic images right out of the box.

But after you were comfortable with your camera, you began looking for ways to add your own creativity to your shots. You explored ways of tweaking the exposure, using selective focus, and, perhaps, experimenting with the different looks that various lens zoom settings (*focal lengths*) could offer.

The final, and most rewarding, stage comes when you begin exploring advanced techniques that enable you to get stunning shots that will have your family, friends, and colleagues asking you, "How did you do that?" These more advanced techniques deserve an entire book of their own (and I have written several), but there is plenty of room in this chapter to introduce you to some clever things you can do with your Sony a68.

Exploring Ultra-Fast Exposures

Fast shutter speeds stop action, because they capture only a tiny slice of time. Electronic flash also freezes motion by virtue of its extremely short duration—as brief as 1/50000th second or less. The Sony a68 has a top shutter speed of 1/4000th second and its built-in flash unit fires off brief bursts that can give you more of these ultra-quick glimpses of moving subjects. An external flash, such as one of the Sony HVL-series strobes, offers even more versatility. You can read more about using electronic flash to stop action in Chapter 10.

In this section, I'm going to emphasize the use of short exposures to capture a moment in time. The Sony a68 is fully capable of immobilizing all but the fastest movement using only its shutter speeds, which range all the way up to that impressive 1/4000th second. But those ultra-fast shutters are generally overkill when it comes to stopping action, and are rarely needed for achieving the exposure you desire. For example, the image shown in Figure 7.1 required a shutter speed of just 1/2000th second to freeze the high jumper clearing the bar.

When it comes to stopping action, most sports can be frozen at 1/2000th second or slower, and for many sports a slower shutter speed is actually preferable—for example, to allow the wheels of a racing automobile or motorcycle, or the propeller on a helicopter, to blur realistically.

In practice, shutter speeds faster than 1/2000th second are rarely required. If you wanted to use an aperture of f/1.8 at ISO 200 outdoors in bright sunlight, say to throw a background out of focus with a wide aperture's shallow depth-of-field, a shutter speed of 1/2000th second would more than do the job. You'd need a faster shutter speed only if you moved the ISO setting to a higher sensitivity, and you probably wouldn't do that if your goal were to use the widest f/stop possible. Under less than full sunlight, 1/4000th second is more than fast enough for any conditions you're likely to encounter. That's why electronic flash units work so well for high-speed photography when used as the only source of illumination: they provide both the effect of a very brief shutter speed and the high levels of light needed for an exposure.

Of course, as you'll see, the tiny slices of time extracted by the millisecond duration of an electronic flash exact a penalty. To use flash at its full power setting, you have to use a shutter speed equal to or slower than the maximum sync speed of your camera. With the a68, the top speed usable for flash is 1/160th second (unless you're using the special High-speed sync mode I'll describe in Chapter 10). The sync speed is the fastest speed at which the camera's focal plane shutter is completely open. At shorter speeds, the camera uses a "slit" passed in front of the sensor to make an exposure. The flash will illuminate only the portion of the slit exposed during the duration of the flash.

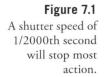

Indoors, that shutter speed limitation may cause problems: at 1/160th second, there may be enough existing ("ambient") light to cause ghost images. Outdoors, you may find it difficult to achieve a correct exposure. In bright sunlight at the lowest ISO settings available with the cameras, an exposure of 1/160th second at f/13 might be required. So, even if you want to use daylight as your main light source, and work with flash only as a fill for shadows, you can have problems. I'll explain the vagaries of electronic flash in more detail in Chapter 10.

You can have a lot of fun exploring the kinds of pictures you can take using very brief exposure times, whether you decide to take advantage of the action-stopping capabilities of your built-in or external electronic flash or work with the motion-freezing capabilities of the Sony a68's faster shutter speeds (between 1/1000th and 1/4000th second).

Here are a few ideas to get you started:

■ Take revealing images. Fast shutter speeds can help you reveal the real subject behind the façade, by freezing constant motion to capture an enlightening moment in time. Legendary fashion/portrait photographer Philippe Halsman used leaping photos of famous people, such as the Duke and Duchess of Windsor, Richard Nixon, and Salvador Dali, to illuminate their real selves. Halsman said, "When you ask a person to jump, his attention is mostly directed toward the act of jumping and the mask falls so that the real person appears." Try some high-speed portraits of people you know in motion to see how they appear when concentrating on something other than the portrait. (See Figure 7.2.)

Figure 7.2 Shoot your subjects leaping and see what they look like when they're not preoccupied with posing.

■ Create unreal images. High-speed photography can also produce photographs that show your subjects in ways that are quite unreal. A helicopter in mid-air with its rotors frozen or a motocross cyclist leaping over a ramp, but with all motion stopped so that the rider and machine look as if they were frozen in mid-air, makes for an unusual picture. (See the frozen rotors at top in Figure 7.3.) When we're accustomed to seeing subjects in motion, seeing them stopped in time can verge on the surreal.

Figure 7.3
Freezing a helicopter's rotors with a fast shutter speed makes for an image that doesn't look natural (top); a little blur helps convey a feeling of motion (bottom).

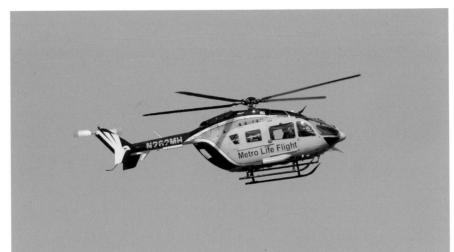

244

■ Capture unseen perspectives. Some things are *never* seen in real life, except when viewed in a stop-action photograph. M.I.T. professor Dr. Harold Edgerton's famous balloon burst photographs were only a starting point for the inventor of the electronic flash unit. Freeze a hummingbird in flight for a view of wings that never seem to stop. Or, capture the splashes as liquid falls into a bowl, as shown in Figure 7.4. No electronic flash was required for this image (and wouldn't have illuminated the water in the bowl as evenly). Instead, a clutch of high-intensity lamps bounced off a green card and an ISO setting of 1600 allowed the a68 to capture this image at 1/2000th second.

Figure 7.4 A large amount of artificial illumination and an ISO 1600 sensitivity setting allowed capturing this shot at 1/2000th second without use of an electronic flash.

Long Exposures

Longer exposures are a doorway into another world, showing us how even familiar scenes can look much different when photographed over periods measured in seconds. At night, long exposures produce streaks of light from moving, illuminated subjects like automobiles or amusement park rides, such as the Ferris wheel shown in Figure 7.5. Extra-long exposures of seemingly pitch-dark subjects can reveal interesting views using light levels barely bright enough to see by. At any time of day, including daytime (in which case you'll often need the help of neutral-density filters to make the long exposure practical), long exposures can cause moving objects to vanish entirely, because they don't remain stationary long enough to register in a photograph.

Three Ways to Take Long Exposures

There are actually three common types of lengthy exposures: *timed exposures*, *bulb exposures*, and *time exposures*. The Sony a68 offers only the first two, but once you understand all three, you'll see why Sony made the choices it did.

Figure 7.5 Long exposures can produce interesting streaks of light.

Because of the length of the exposure, all of the following techniques should be used with a tripod to hold the camera steady.

- Timed exposures. These are long exposures from 1 second to 30 seconds, measured by the camera itself. To take a picture in this range, simply use Manual or Shutter Priority mode and use the front control dial to set the shutter speed to the length of time you want, choosing from several preset speeds ranging from 1.0 to 30.0 seconds. The advantage of timed exposures is that the camera does all the calculating for you. There's no need for a stopwatch. If you review your image on the EVF or LCD and decide to try again with the exposure doubled or halved, you can dial in the correct exposure with precision. The disadvantage of timed exposures is that you can't take a photo for longer than 30 seconds.
- Bulb exposures. This type of exposure is so-called because in the olden days the photographer squeezed and held an air bulb attached to a tube that provided the force necessary to keep the shutter open. Traditionally, a bulb exposure is one that lasts as long as the shutter release button is pressed; when you release the button, the exposure ends. To make a bulb exposure with the Sony a68, set the camera on Manual mode, and rotate the rear control dial to the left to select the shutter speed immediately after 30 seconds. BULB will be displayed on the LCD and in the viewfinder. (You can't set the shutter speed to BULB when using the Smile Shutter, Auto HDR, or Multi Frame Noise Reduction ISO settings.)
 - Then, press the shutter to start the exposure, and release it to close the shutter. If you'd like to minimize camera shake, you can use the self-timer or the Sony wired or infrared remote control. With the wired remote, RM-S1AM, you can press and hold the release button to open the shutter, and then release it to close the shutter. Or, you can lock the release button in place to open the shutter, and press it again later to end the exposure.
- Time exposures. This is a setting found on some cameras to produce longer exposures. With cameras that implement this option, the shutter opens when you press the shutter release button, and remains open until you press the button again. Usually, you'll be able to close the shutter using a mechanical cable release or, more commonly, an electronic release cable. The advantage of this approach is that you can take an exposure of virtually any duration without the need for special equipment. You can press the shutter release button, go off for a few minutes, and come back to close the shutter (assuming your camera is still there). The disadvantages of this mode are exposures must be timed manually, and with shorter exposures it's possible for the vibration of manually opening and closing the shutter to register in the photo. For longer exposures, the period of vibration is relatively brief and not usually a problem—and there is always the release cable option to eliminate photographer-caused camera shake entirely.

Working with Long Exposures

Because the Sony a68 produces such good images at longer exposures, and there are so many creative things you can do with long-exposure techniques, you'll want to do some experimenting. Get yourself a tripod or another firm support and take some test shots with long exposure noise reduction both enabled and disabled (to see whether you prefer low noise or high detail) and get started.

Here are some things to try:

■ Create streaks. If you aren't shooting for total invisibility, long exposures with the camera on a tripod can produce some interesting streaky effects. Even a single 8X ND filter will let you shoot at f/22 and 1/6th second in daylight. Indoors, you can achieve interesting streaks with slow shutter speeds, as shown in Figure 7.6. I shot the dancers using a 1/2-second exposure, triggering the shot at the beginning of a movement.

Figure 7.6 The shutter opened as the dancers began their movement from a standing position, and finished when they had bent over and paused.

■ Make people invisible. One very cool thing about long exposures is that objects that move rapidly enough won't register at all in a photograph, while the subjects that remain stationary are portrayed in the normal way. That makes it easy to produce people-free landscape photos and architectural photos at night or, even, in full daylight if you use a neutral-density filter (or two or three) to allow an exposure of at least a few seconds. At ISO 100, f/22, and a pair of 8X (three-stop) neutral-density filters, you can use exposures of nearly four seconds; overcast days and/or even more neutral-density filtration would work even better if daylight people-vanishing is your goal. They'll have to be walking *very* briskly and across the field of view (rather than directly toward the camera) for this to work. At night, it's much easier to achieve this effect with the 20- to 30-second exposures that are possible.

Tip

Neutral-density filters are gray (non-colored) filters that reduce the amount of light passing through the lens, without adding any color or other effect of their own.

- Produce light trails. At night, car headlights, taillights, and other moving sources of illumination can generate interesting light trails. Your camera doesn't even need to be mounted on a tripod; hand-holding the Sony a68 for longer exposures adds movement and patterns to your trails. If you're shooting fireworks, a longer exposure—with a tripod—may allow you to combine several bursts into one picture, as shown in Figure 7.7.
- Blur waterfalls, etc. You'll find that waterfalls and other sources of moving liquid produce a special type of long-exposure blur, because the water merges into a fantasy-like veil that looks different at different exposure times, and with different waterfalls. Cascades with turbulent flow produce a rougher look at a given longer exposure than falls that flow smoothly. Although blurred waterfalls have become almost a cliché, there are still plenty of variations for a creative photographer to explore, as you can see in Figure 7.8. For that shot, I incorporated the flowing stream in the background.
- Show total darkness in new ways. Even on the darkest, moonless nights, there is enough starlight or glow from distant illumination sources to see by, and, if you use a long exposure, there is enough light to take a picture, too. I was visiting a Great Lakes park hours after sunset, but found that a several-second exposure revealed the skyline scene shown in Figure 7.9, even though in real life, there was barely enough light to make out the boats in the distance. Although the photo appears as if it were taken at twilight or sunset, in fact the shot was made at 10 p.m.

Figure 7.7
I caught the fireworks after a baseball game from a half-mile away, using a four-second exposure to capture several bursts in one shot.

Figure 7.8 Long exposures can transform a stream into a display of flowing silk.

Figure 7.9 A long exposure transformed this night scene into a picture apparently taken at dusk.

Continuous Shooting

The Sony a68's continuous shooting modes remind me how far digital photography has brought us. The first accessory I purchased when I worked as a sports photographer some years ago was a motor drive for my film SLR. It enabled me to snap off a series of shots at a three-frames-per-second rate, which came in very handy when a fullback broke through the line and headed for the end zone. Even a seasoned action photographer can miss the decisive instant when a crucial block is made, or a baseball superstar's bat shatters and pieces of cork fly out. Continuous shooting simplifies taking a series of pictures, either to ensure that one has more or less the exact moment you want to capture or to capture a sequence that is interesting as a collection of successive images.

The Sony a68's "motor drive" capabilities are, in many ways, much superior to what you get with a film camera. For one thing, a motor-driven film camera can eat up film at an incredible pace, which is why many of them are used with cassettes that hold hundreds of feet of film stock. At three frames per second (typical of film cameras), a short burst of a few seconds can burn up as much as half of an ordinary 36-exposure roll of film. Digital cameras like the a68, in contrast, have reusable "film," so if you waste a few dozen shots on non-decisive moments, you can erase them and shoot more.

The increased capacity of digital memory cards gives you a prodigious number of frames to work with. At a baseball game I covered a while back, I took more than 1,000 images in a couple hours. Yet, even with my a68's 24-megapixel resolution I was able to cram more than 500 JPEG Fine images on a single memory card. That's a lot of shooting. Given an average burst of about eight frames per sequence (nobody really takes 15–20 shots or more of one play in a baseball game), I was

able to capture more than 60 different sequences before I needed to swap cards. Figure 7.10 shows a typical short burst of three shots taken at another kind of event, an air show.

On the other hand, for some activities (such as football) the longer bursts came in handy, because running and passing plays often last 5 to 10 seconds, and change in character as the action switches from the quarterback dropping back to pass or hand off the ball, to the receiver or running back trying to gain as much yardage as possible.

Because of the special capabilities made possible by its fixed-mirror internal construction, the a68 is especially adept at snapping rapid sequences of full-resolution shots. To take full advantage of these capabilities, Sony has equipped the cameras with a special shooting mode that is optimized for super-fast shooting, which I'll discuss in a moment. First, though, I'll discuss the standard continuous shooting feature of the cameras.

Figure 7.10 Continuous shooting allows you to capture an entire sequence of exciting moments as they unfold.

To use the Sony a68's normal continuous shooting option, press the drive button on top of the camera. Then navigate down the list with the up/down controls until the Continuous Adv. (continuous advance) mode is selected, and navigate left or right with the control wheel to choose between Lo and Hi speeds. The maximum output at Lo speed is about 3 images per second; the maximum for Hi speed is about 5 images per second. (For even faster frame rates, see Continuous Advance Priority AE, described below.) These speeds will be reduced by various conditions, such as dim ambient light that requires slow shutter speeds, the use of flash, and the size of your images. When you choose the Hi speed, the camera does not display the Live View between shots; instead, it displays the last recorded image. So, if it's important to you to keep viewing the live scene before you while you're shooting, you may want to set the continuous shooting speed to Lo. You can't use continuous advance when using Scene modes, other than Sports Action.

Once you have decided on a continuous shooting mode and speed, press the center button to confirm your choice. As long as you hold down the shutter button, the a68 will fire continuously until it reaches the limit of its capacity to store images, given the image size you have selected.

You can considerably increase the number of continuous shots by reducing the image-quality setting to JPEG Standard, or even to Fine. The reason the size of your bursts is limited is that continuous images are first shuttled into the a68's internal memory buffer, then doled out to the memory card as quickly as they can be written to the card. Technically, the camera takes the RAW data received from the digital image processor and converts it to the output format you've selected—either JPEG or RAW—and deposits it in the buffer ready to store on the card.

This internal "smart" buffer can suck up photos much more quickly than the memory card and, indeed, some memory cards are significantly faster or slower than others. When the buffer fills, you can't take any more continuous shots until the a68 has written some of them to the card, making more room in the buffer. Keep an eye on the red memory card access light at the bottom of the camera's back, and wait until it turns off before trying for another stream of speedy shots. (You should keep in mind that faster memory cards, rated at least Class 10, write images more quickly, freeing up buffer space faster.) The camera does not provide any display showing how many images can be shot in continuous mode.

Tele-Zoom Continuous AE

Sony has paid extra attention to the aptitude of the SLT models to fire off rapid bursts of images. The a68 is equipped with a special shooting mode that occupies its own slot on the mode dial, called Tele-Zoom Continuous AE. When you turn the dial to this position, the camera is optimized for the greatest speed of shooting possible, cropping the image and reducing resolution while still letting you capture your images at rates of up to 8 frames per second. There are some tradeoffs in return for achieving maximum speed, but they still leave you with an extremely powerful photographic tool in your hands.

In the Tele-Zoom Continuous AE mode, the a68 can fire at a rate of up to 8 images per second, rivaling the capability of professional-level dSLRs. You can set the Autofocus mode to AF-C, and the camera will focus continuously while shooting, but in that case you cannot adjust the aperture or ISO; the camera locks the aperture at its widest value in order to achieve the increased shooting speed, and adjusts the exposure automatically. If you set the focus mode to manual or AF-S, the camera will fix the focus with the first image, and not vary it for later images. However, in that case you are free to set the aperture (using the front control dial) and the ISO (using the ISO button or Function menu).

In this mode, features like Multi-Frame Noise Reduction, Smile/Face Detection, Long Exposure/ High ISO noise reduction, Auto Object Framing, Picture Effect, Center Lock-On autofocus, and Eye AF are not available. Image Size is fixed at Small, and RAW and RAW & JPEG image quality settings are disabled. Lens compensation features, including Shading, Chromatic Aberration, and Distortion compensation are also disabled.

The Sony a68's continuous shooting abilities, particularly the Tele-Zoom Continuous AE mode, give you a phenomenal tool for expanding your capacity for making stunning images. Take some time to experiment with these features. You will find that they can be of great use not just for stopping action in sports and other action shots, but for capturing fleeting expressions on your subjects' faces or for recording a scene at the "decisive moment" immortalized by the great French photographer Henri Cartier-Bresson (who used his reflexes and impeccable instinct, rather than a motor drive, of course).

Setting Image Parameters

You can fine-tune the appearance of the images that you take in several different ways. For example, if you don't want to choose a predefined white balance (see Chapter 3) or use white balance bracketing, you can set a custom white balance based on the illumination of the site where you'll be taking photos, or choose a white balance based on color temperature. With the Creative Style options, you can set up customized saturation, contrast, and sharpness for various types of pictures. This section shows you how to use the available image parameters.

Customizing White Balance

Back in the film days, color films were standardized, or balanced, for a particular "color" of light. Digital cameras like the Sony a68 use a "white balance" that is, ideally, correctly matched to the color of light used to expose your photograph. The proper white balance is measured using a scale called *color temperature*. Color temperatures were assigned by heating a theoretical "black body radiator" and recording the spectrum of light it emitted at a given temperature in degrees Kelvin. So, daylight at noon has a color temperature in the 5,500 to 6,000 degree range. Indoor illumination is around 3,400 degrees. Hotter temperatures produce bluer images (think blue-white hot) while cooler temperatures produce redder images (think of a dull-red glowing ember). Because of

human nature, though, bluer images are actually called "cool" (think wintry day) and redder images are called "warm" (think ruddy sunset), even though their color temperatures are reversed.

If a photograph is exposed indoors under warm illumination with a digital camera sensor balanced for cooler daylight, the image will appear much too reddish. An image exposed outdoors with the white balance set for incandescent illumination will seem much too blue. These color casts may be too strong to remove in an image editor from JPEG files, although if you shoot RAW, you can change the WB setting to the correct value when you import the image into your editor.

Mismatched white balance settings are easier to achieve accidentally than you might think, even for experienced photographers. I'd just arrived at a concert after shooting some photos indoors with electronic flash and had manually set WB for flash. Then, as the concert began, I resumed shooting using the incandescent stage lighting—which looked white to the eye—and ended up with a few shots like Figure 7.11. Eventually, I caught the error during picture review, and changed my white balance. Another time, I was shooting outdoors, but had the camera white balance still set for incandescent illumination. The excessively blue image shown in Figure 7.12 resulted. (I suppose I should salvage my reputation as a photo guru by admitting that both these images were taken "incorrectly" deliberately, as illustrations for this book; in real life, I'm excessively attentive to how my white balance is set. You do believe me, don't you?)

Figure 7.11
An image exposed indoors with the WB set for daylight or electronic flash will appear too reddish.

Figure 7.12
An image exposed under daylight illumination with the WB set for tungsten illumination will appear too blue.

The Auto White Balance (AWB) setting, available by pressing the WB button on the top panel of the a68, or by using the Fn key and navigating to the White Balance menu, examines your scene and chooses an appropriate value based on your scene and the colors it contains. However, the Sony a68's selection process is not foolproof. Under bright lighting conditions, it may evaluate the colors in the image and still assume the light source is daylight and balance the picture accordingly, even though, in fact, you may be shooting under extremely bright incandescent illumination. In dimmer light, the camera's electronics may assume that the illumination is tungsten, and if there are lots of reddish colors present, set color balance for that type of lighting. Sony notes that with mercury vapor or sodium lamps, correct white balance is virtually impossible to achieve; in that case, you should use flash instead, or shoot in RAW and make your corrections when importing the file into your image editor.

Of course, flash isn't completely consistent in white balance, either. However, some electronic flash units, such as the Sony HVL-series dedicated flash units, can report to the camera the particular white balance that they are outputting, since a flash's color temperature can vary depending on how brief the flash exposure is. The a68 can adjust its own white balance setting automatically, based on the information it receives from the flash.

The other presets in the WB list apply to specific lighting conditions. You can choose from Daylight, Shade, Cloudy, Incandescent, four types of Fluorescent (Warm White, Cool White, Day White, and Daylight), plus Flash, Color Temperature/Filter, and Custom. When any is selected, you can

fine-tune the white balance by pressing the right control to reveal the Fine Adjustment screen, shown in Figure 7.13.

Then, use the left/right controls to change the bias of the color. Pressing the right control makes the image more red/amber; the left control makes the image bluer. The up control produces a greener bias, and the down control more magenta balance. Use all four to place the center balance indicator anywhere in the grid for a customized white balance. You can choose plus/minus 7 increments (although Sony doesn't reveal exactly what those increments are) in any of the four directions. A readout just above the color grid shows the current Amber-Blue and Green-Magenta bias. (Yes, I know the Amber-Blue readout is opposite the Blue-Amber scale on the grid.)

The Daylight setting puts WB at 5,200K, while the Shade setting uses a much bluer 7,000K. The chief difference between direct daylight and shade or even incandescent light sources is nothing more than the proportions of red and blue light. The spectrum of colors used by the a68 is continuous, but it is biased toward one end or the other.

However, some types of fluorescent lights produce illumination that has a severe deficit in certain colors, such as only *particular* shades of red. If you looked at the spectrum or rainbow of colors encompassed by such a light source, it would have black bands in it, representing particular wavelengths of light that are absent. You can't compensate for this deficiency by adding all tones of red. That's why the fluorescent setting of your Sony a68 may provide less than satisfactory results with some kinds of fluorescent bulbs. If you take many photographs under a particular kind of noncompatible fluorescent light, you might want to investigate specialized fluorescent light filters for your lenses, available from camera stores, or learn how to adjust for various sources in your image editor. However, you might also get acceptable results using the four choices on the WB list.

If you find that none of the presets fits your lighting conditions, and the Automatic setting is not able to set the white balance adequately, you have two other options—using the color temperature option, or setting a custom white balance.

Figure 7.13
Adjust the white balance in the Fine
Adjustment screen.

Setting White Balance by Color Temperature

If you want to set your white balance by color temperature, you have the option of setting it anywhere from 2,500K (resulting in bluish images) to 9,900K (resulting in reddish images). Of course, if you have instrumentation or reliable information that gives you a precise reading of the color temperature of your lighting, this option is likely to be your best bet. Even if you don't have that information, you may want to experiment with this setting, especially if you are trying to achieve creative effects with color casts along the spectrum from blue to red. To use this setting, just highlight it on the white balance menu and use the left/right directional buttons to scroll through the numerical color temperature scale.

Sony has had a sub-option to this setting called Color Filter, which corresponds to the use of CC (Color Compensation) filters that are used to compensate for various types of lighting when shooting with film. It has been folded into the fine adjustment screen, and now has adjustments in both the green/magenta and blue/amber directions. When you use this option, as with any fine adjustment, the color filter value you set takes effect in conjunction with the color temperature you have set. In other words, both of these settings work together to give you very precise control over the degree of color correction you are using.

Setting a Custom White Balance

Setting a custom white balance expressly for the scene you want to shoot may be the most accurate way of getting the right color balance, short of having a special meter that gives you a precise reading of color temperature. It's easy to do with the Sony a68. Just follow these steps:

- 1. Access menu. Press the WB button to produce the White Balance menu. Or, press the Fn button, and then use the control wheel up/down/left/right keys to navigate to the White Balance menu selection, and press the center button to produce the White Balance menu.
- 2. **Select Custom.** Scroll down the list of white balance options until the Custom entry is highlighted. Press the right control wheel button to bring up the "Custom setup" screen, select a register number, and then press the center button.
- 3. **Aim at neutral target.** The camera will prompt you to "Use spot focus area data. Press shutter to load." Point the camera at a neutral white object large enough to fill the small frame in the center of the viewfinder.
- 4. **Press the shutter release.** The picture you took, as well as the custom white balance calculated, appears on the LCD.
- 5. **Exit.** Press the center button or press the shutter button halfway to return to the recording information display.

The a68 will retain the custom setting you just captured until you repeat the process to replace the setting with a new one. Thereafter, you can activate this custom setting by scrolling down to Custom in the White Balance menu and pressing the center button to confirm your choice.

Image Processing

As I mentioned in Chapter 3, the Sony a68 camera offers two more very powerful ways of customizing the rendition of your images, Creative Styles and Picture Effects.

Using Creative Styles

As previously mentioned, this option, found in the Function menu and Camera Settings 5 menu, gives you six different combinations of contrast, saturation, and sharpness with names like Standard, Vivid, Portrait, Landscape, Sunset, and B/W (black-and-white). Those are useful enough that you should make them a part of your everyday toolkit. You can apply Creative Styles *only* when you are not using one of the a68's Auto or Scene modes. (That is, you're shooting in Program, Aperture Priority, Shutter Priority, or Manual exposure mode.) But, when working with Creative Styles, you can *adjust* those parameters within each preset option to fine-tune the rendition, and select an entirely different style to be registered in a particular slot.

You can have a total of 19 different Creative Styles:

- Six numbered "base" styles. The basic six styles include Standard, Vivid, Neutral, Portrait, Landscape, and B/W, and they are assigned numbers from 1 to 6, in that order. You can adjust the settings for any of those six, but I recommend leaving them alone so that you'll always have the six basic default styles available.
- Thirteen additional styles. Six of the additional 13 styles are duplicates of the default styles, and their settings are based on them. That allows you to have, say, both the Standard Vivid numbered style, plus a second Vivid that you have customized. That gives you, in effect, two possible Standard, Vivid, Neutral, Portrait, Landscape, and B/W styles. An additional seven customizable styles are available, with settings suitable for effects labeled Clear, Deep, Light, Sunset, Night, Autumn, and Sepia. I'll explain the "looks" of all the Creative Styles later in this chapter.

Just follow these steps:

- Access the Creative Style menu. Press the Fn button and navigate to the Creative Style entry
 that's second from the right in the bottom row of function options. Press the center button to
 access the Creative Style screen.
- 2. **Choose a style to apply.** In the Creative Style screen, the styles are shown in the left-hand column. (You must scroll down to see all of them.) If you want to modify one of the styles shown, press up/down to highlight that style, and press the center button to activate it.
- 3. **Select a parameter to modify.** You can adjust the contrast, saturation, and sharpness of any of the styles in the left column. Highlight the style you want to adjust/replace, and press the control wheel right. The screen shown in Figure 7.14 appears.

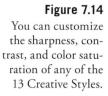

- 4. **Select an attribute to change.** The icons at the bottom of the image area represent (left to right): Image Style, Contrast, Saturation, and Sharpness. Press left/right to highlight the attribute you'd like to modify.
- 5. **Enter your adjustments.** To change the style that appears in the box you selected at left, highlight the Image Style icon and press up/down to choose one of the 13 styles (described below).
- 6. **Make other adjustments.** To modify the currently selected style, press left/right to highlight Contrast, Saturation, or Sharpness, then press up/down to add/subtract from the default zero values:
 - **Sharpness.** Increases or decreases the contrast of the edge outlines in your image, making the photo appear more or less sharp, depending on whether you've selected 0 (no sharpening), +3 (extra sharpening), to -3 (softening). Remember that boosting sharpness also increases the overall contrast of an image, so you'll want to use this parameter in conjunction with the contrast parameter with caution.
 - **Contrast.** Compresses the range of tones in an image (increase contrast from 0 to +3) or expands the range of tones (from 0 to -3) to decrease contrast. Higher-contrast images tend to lose detail in both shadows and highlights, while lower-contrast images retain the detail but appear more flat and have less snap.
 - **Saturation.** You can adjust the richness of the color from low saturation (0 to −3) to high saturation (0 to +3). Lower saturation produces a muted look that can be more realistic for certain kinds of subjects, such as humans. Higher saturation produces a more vibrant appearance, but can be garish and unrealistic if carried too far. Boost your saturation if you want a vivid image, or to brighten up pictures taken on overcast days. This setting cannot be changed for the B/W Creative Style.
- 7. **Confirm and exit.** Press the center button to confirm your changes. If you redefined one of the six slots, that style will appear in the listing in the left column henceforth and can be selected quickly by following Steps 1 and 2 above and pressing the center button.

Here's a description of the 13 unique Creative Styles (remember, six are duplicated) that I've been tantalizing you with:

- **Standard.** This is, as you might expect, your default setting, with a good compromise of sharpness, color saturation, and contrast. Choose this, and your photos will have excellent colors, a broad range of tonal values, and standard sharpness that avoids the "oversharpened" look that some digital pictures acquire.
- Vivid. If you want more punch in your images, with richer colors, heightened contrast that makes those colors stand out, and moderate sharpness, this setting is for you. It's good for flowers, seaside photos, any picture with expanses of blue sky, and on overcast days where a punchier image can relieve the dullness.
- Neutral. Provides a more balanced look, with muted colors and less sharpness emphasis.
- Clear. Sony recommends this style for "clear tones" and "limpid colors" in the highlights, especially when you're capturing "radiant light." The description is a bit artsy, but I've found this style useful for foggy mornings and other low-contrast scenes.
- Deep. Darker and more somber images result from this style.
- **Light.** Recommended for bright, uncomplicated color expressions. I like it for high-key images with lots of illumination and few shadows.
- **Portrait.** Unless you're photographing a clown, you don't want overly vivid colors in your portraits. Nor do you need lots of contrast to emphasize facial flaws and defects. This setting provides realistic, muted skin tones, and a softer look that flatters your subjects.
- Landscape. As with the Vivid setting, this option boosts saturation and contrast to give you rich scenery and purple mountain majesties, even when your subject matter is located far enough from your camera that distant haze might otherwise be a problem. There's extra sharpness, too, to give you added crispness when you're shooting Fall colors.
- Sunset. Accentuates the red tones found in sunrise and sunset pictures.
- **Night Scene.** Contrast is adjusted to provide a more realistic night-time effect.
- Autumn Leaves. Boosts the saturation of reds and yellows for vivid Fall colors.
- **B/W.** If you're shooting black-and-white photos in the camera, this setting allows you to change the contrast and sharpness (only).
- **Sepia.** Provides a warm brownish, old-timey tone to images.

Picture Effects

All the Picture Effects modes perform significant image processing on your photos before saving them to the memory card. Picture Effects cannot be used when shooting RAW or RAW & JPEG; Soft Focus, HDR Painting, Rich-Tone Monochrome, and Miniature cannot be used when shooting movies. Picture Effects can be found in the Camera Settings 5 menu. Your choices include:

- Toy Camera. Produces images like you might get with a Diana or Holga "plastic" camera, with vignetted corners, image blurring, and bright, saturated colors. Not available when using the Smart Teleconverter option.
- Pop Color. This setting adds a lot of saturation to the colors, making them especially vivid and rich looking. When used with subjects that have a lot of bright colors, the effect can be dramatic. Duller subjects gain a more "normal" appearance (try using this setting on an overcast day to see what I mean).
- **Posterization.** This option produces a vivid, high-contrast image that emphasizes the primary colors (as shown in Figure 7.15), or in black-and-white, with a reduced number of tones, creating a poster effect.

Figure 7.15 Posterization effect.

- Retro Photo. Adds a faded photo look to the image, with sepia overtones.
- **Soft High Key.** Produces bright images.
- Partial Color. Attempts to retain the selected color of an image, while converting other hues to black-and-white. Use the left/right controls to select a color, from red, green, blue, or yellow. (See Figure 7.16.)
- **High Contrast Monochrome.** Converts the image to black-and-white and boosts the contrast to give a stark look to the image.
- **Soft Focus.** Creates a soft, blurry effect. Use the left/right controls to choose low, mid, or high intensity.
- HDR Painting. Produces a painted look by taking three pictures consecutively and then using HDR techniques to enhance color and details. The Option button allows specifying the intensity of the effect—low, mid, high.
- **Rich-tone Monochrome.** Also uses HDR processes to create a long-gradation image from three consecutive exposures.
- Miniature. You select the area to be rendered in sharp focus using the left/right controls. You can select from horizontal areas (top, middle, bottom) or vertical sections (left, middle, right) or choose Auto. The effect is similar to the tilt-shift look used to photograph craft models. Not available when using the Smart Teleconverter option.
- Watercolor. Produces a painterly effect with soft colors.
- Illustration. Mimics an illustrator's rendition, with Lo, Mid, and High choices available with the left/right controls.

Figure 7.16Partial Color effect.

Shooting Movies

As we've seen in our exploration of its features so far, the Sony a68 is superbly equipped for taking still photographs of very high quality in a wide variety of shooting environments. But this camera's superior level of performance is not limited to stills. The a68 camera is capable in the movie-making arena as well. So, even though you may have bought your a68 primarily for shooting stationary scenes, you acquired a device that is equipped with a cutting-edge set of features for recording high-quality video clips. It can record high-definition (HD) video with stereo sound, and it is quite versatile in its feature set. Whether you're looking to record informal clips of the family on vacation, the latest viral video for YouTube, or a set of scenes that will be painstakingly crafted into a cinematic masterpiece using editing software, the a68 will perform admirably.

When you set out to record video with the a68, remember that, although a large memory card, such as a 64GB SDXC card, can hold about two hours of the highest-quality (AVCHD or XAVC S) video, the camera is limited in its ability to record continuous movie sequences. With the SteadyShot feature turned on, the a68 can record for about 9 minutes. With SteadyShot turned off, the camera can record about 29 minutes of video continuously. The maximum movie file size is 2GB, though, and the camera will stop if that limit is reached while recording an MP4 file. If the camera is recording an AVCHD or XAVC S file, it will create a new file automatically when the 2GB limit is reached.

OKAY, WHAT ARE AVCHD AND XAVC S?

Even if you're not new to movie making, the video formats known as AVCHD (Advanced Video Coding High Definition) and XAVC S may be unknown to you. They were developed by Sony for use in producing high-definition video for professional and consumer use. Both use the MPEG-4 AVC/H.264 (AVC) standard for video compression, which may be familiar to those with some video-shooting experience. They support a variety of resolutions and scanning methods, with XAVC able to support 4K resolution (4096×2160 and 3840×2160) at up to 60 frames per second (fps)—although the a68 itself does not offer either of those Ultra High Definition (UHD) formats. These can be used to produce Blu-ray, AVCHD, XAVC S, and DVD-Video discs using the Sony Play Memories Home software, assuming you have compatible recording and playback equipment, as described in a later section.

Basic Settings

Before you start, you'll want to review the special movie settings first discussed in Chapters 3 and 4. These options are recapped in the following sections. These two settings are the basic parameters you should adjust before starting to capture video. You'll want to choose a file format (the type of movie file), and the frame rate/resolution.

File Format

The file format is the type of video file you capture and store on your memory card. Your choice of file format affects image quality, image characteristics, and, potentially, your editing and output options. Your choices in the Camera Settings 2 menu's File Format listings include XAVC S, AVCHD (the default), or MP4. The AVCHD format is the highest quality option available with the a68, and produces movies recorded at 1920×1080 pixels, with five additional choices of size/quality selected in the Record Setting menu entry, described next. If you select MP4, you have two choices of image size, 1440×1080 and 640×510 pixels, both of lower image quality.

Record Setting

Here you'll select the image quality of your 60i/60p and MP4 movies, and, with XAVC S and AVCHD video, the type of scanning used—either progressive scan or interlaced scan. (See the sections that follow for an explanation of the difference between the two.)

For XAVC S, your choices for 1920 × 1080 (full HD movies) include:

- **60p 50M.** This setting produces the highest quality video supported by the a68, at a 50 Mbps recording rate, and uses *progressive scan*, which captures all the horizontal lines in an image in the correct order, 60 times per second.
- **30p 50M.** This setting also uses the 50 Mbps recording rate with progressive scan, but at a 30 fps rate.
- 24p 50M. This setting captures high-quality video at a rate of 24 fields/frames per second, captured progressively at the fast 50 Mbps capture rate, and is said to produce the most cinemalike appearance in the final movie image. I'll explain why this is important shortly.

For AVCHD video, there are five choices for 1920 × 1080 (full HD movies):

- 60i 24M (FX). This setting produces high-quality video, but also puts the stiffest demands on your memory card and, when editing, on your computer equipment. It records movies at a 24 megabits per second rate with 60 interlaced fields recorded per second (30 odd-numbered fields alternating with 30 even-numbered fields). (The section which follows explains interlacing and fields.) You can use this setting if you have a fast SD card, preferably Class 10 or better.
- **60i 17M** (**FH**). This default setting produces standard image quality video at a slightly less demanding 17 Mbps recording rate, with 60 interlaced fields recorded per second. You'll want to use this setting most of the time.
- **60p 28M (PS).** This setting produces the highest quality video at a 28 Mbps recording rate, and uses *progressive scan*, which captures all the horizontal lines in an image in the correct order, 60 times per second.
- 24p 24M (FX). This setting captures high-quality video at a rate of 24 fields/frames per second, captured progressively at a 24 Mbps capture rate, and is said to produce the most cinemalike appearance in the final movie image. I'll explain why this is important shortly.
- 24p 17M (FH). This setting captures standard-quality cinema-style video at 24 fps with a 17 Mbps capture rate.

You might elect to use the MP4 file format instead to produce movies if your video requirements are not as demanding, and you don't plan on creating a playable disc using the Play Memories Home software. You can select either of two image qualities, both of which use progressive scanning:

- 1440 × 1080 12M. This option provides medium-quality video that may be good enough for many applications, such as display on a laptop or other small screen. Its 12 Mbps average bit rate is compatible with virtually all memory cards.
- 640 × 510 3M (VGA). If you're planning on sending your video by e-mail, displaying your movie on a web page, or uploading to YouTube, this image quality setting may be ideal.

Understanding Interlacing and Progressive Scan

TECH ALERT

The a68 is aimed at still photographers who are upgrading their equipment and goals, and at more advanced photographers who want to shoot stills and video without making too many compromises feature-wise. That's why the a68 offers the resolution and frame rate options it has. This next section is aimed at more advanced movie makers who want to understand some of the nuts and bolts behind their choices. To understand which resolution and frame rate you might want to use, it's necessary to understand the difference between interlaced and progressive scans. I'll make the explanation as painless as possible. Those of you who just want to shoot movies can opt to choose 60i 17M in the Record Setting section of the Camera Settings 2 menu, and jump to the next section.

As you probably know, video images as you see them on your TV or monitor consist of a series of lines which are displayed, or *scanned*, at a fixed rate. When captured by your a68, the images are also grabbed, using what is called a *rolling shutter*, which simply means that the image is grabbed one line at a time at the same fixed rate that will be used during playback. (There is a more expensive option, not used in the a68, called a *global shutter* that captures all the lines at one time, which eliminates the possible distortion that can result with moving subjects that are recorded only one line at a time.)

Line-by-line scanning during capture and playback can be done in one of two ways. With *interlaced scanning*, odd-numbered lines (lines 1, 3, 5, 7... and so forth) are captured with one pass, and then the even-numbered lines (2, 4, 6, 8...and so forth) are grabbed. With the AVCHD 60i format, roughly 60 pairs of odd/even line scans, or 60 *fields* are captured each second. (The actual number is 59.94 fields per second.) Interlaced scanning was developed for and works best with analog display systems such as older television sets. It was originally created as a way to reduce the amount of bandwidth required to transmit television pictures over the air. Modern LCD, LED, and plasmabased HDTV displays must de-interlace a 1080i image to display it. (See Figure 8.1.)

Newer displays work better with a second method, called *progressive scanning* or *sequential scanning*. Instead of two interlaced fields, the entire image is scanned as consecutive lines (lines 1, 2, 3, 4... and so forth). This happens at a rate of about 60 frames per second (not fields). (All these numbers apply to the NTSC television system used in the United States, Canada, Japan, and some other countries; other places use systems like PAL, where the nominal scanning figures are 50.)

One problem with interlaced scanning appears when capturing video of moving subjects. Half of the image (one set of interlaced lines) will change to keep up with the movement of the subject while the other interlaced half retains the "old" image as it waits to be refreshed. Flicker or *interline twitter* results. That makes your progressive scan options of 60p or 24p a better choice for action photography.

Figure 8.1
The inset shows how lines of the image alternate between odd and even in an interlaced video capture.

Which to Choose?

If you're shooting a relatively static image, you can choose XAVC S 60p 50M for the best combination of resolution and image quality, if you can accept the high demands of a 50 Mbps transfer rate, and have a TV that can display 60p video (otherwise the video will be converted before output to the television). AVCHD provides a less demanding 60p 28M option that provides slightly less quality, but is less demanding in terms of memory card speed.

Use 60i 24M or 60i 17M if you know you'll be mixing your video with existing 60i footage, or if you happen to be shooting for NBC, CBS, or The CW (Ha!). Keep in mind that if you use the Picture Motion Browser (PMB) software available for download from the Sony website instead of another movie-editing package, your 60p, 60i, or 24p video will be converted before it can be written to an XAVC or AVCHD disc, and that can take a long time and reduce image quality. To preserve all the detail you shot, you must write your movie to a Blu-ray disc (and most of us don't have Blu-ray disc writers). For action shooting, choose 24p M or 24P 17 to get the smoothest-looking image, one that's more film-like.

The quality provided by the default (FH) in AVCHD is very good, but you can get even higher quality with some of the other options, and you'll get a "cinematic" feel with a framing rate of 24 fps (or 25 fps). If you use the MP4 format instead, you'll get 30p (30 fps) in NTSC countries and 25p (25 fps) in PAL countries when recording with the high-resolution option; the VGA option is always at 30p (30 fps).

ONLY 50p AND 50i IN SOME COUNTRIES

In countries where the PAL video format is the standard (including Europe), the a68 is limited to 50p and 50i instead of the 60p and 60i in countries where NTSC is standard, including North America. (In truth, NTSC is an analog format so most countries now use the digital ATSC for broadcasting, but this is only of academic interest.) As well, instead of 24p for a cinematic effect, cameras sold in PAL countries provide 25p. I doubt that you'd be able to see a difference in the quality of the video clips made by an a68 purchased in Paris or Rio de Janeiro versus one you bought in Los Angeles or Toronto, for example.

Exposure Settings

Good exposure is especially important when capturing video because, unlike still photos, it's not practical to make extensive adjustments after the movie has been captured. You'll want to get it right the first time. The two parameters that follow give you the kind of exposure control you need.

Movie

This setting, available in the Camera Settings 8 menu only when the mode dial is set to the Movie position, allows selecting a specific exposure mode for capturing video, and can be different from the one chosen for still photography.

If you're using the a68's autofocus features, your exposure mode is chosen for you: Program Auto is automatically selected when AF is active. However, in movie shooting there are some good reasons for choosing manual focus. Basic cinema focus techniques include shallow focus (also known as selective focus) to emphasize a subject; focus in/focus out, in which a subject gradually goes into or out of focus; and rack/pull focus, which can be used to direct the viewer's attention forcibly from one subject to another.

If you elect to use manual focus, you can select Shutter Priority, Aperture Priority, or Manual exposure. Shutter Priority is often your best choice, because you might want to lock in a particular shutter speed. For example, you *can't* use a shutter speed that's longer than 1/4th second, and any shutter speed longer than the frame rate (i.e., 1/8th second when shooting 30 frames per second) isn't the best idea, as well. Nor are shutter speeds much *shorter* than twice the frame rate (for example, 1/60th second is OK for 30 fps shooting, but 1/160th second can yield weird results).

Zebra

This feature, a real-time version of still photography's image review highlight "blinkies," is found in the Custom Settings 1 menu. It warns you when highlight levels in your image are brighter than a setting you specify. As noted earlier in this book, *over*exposure is your worst enemy, because blown-out details cannot be reclaimed, while information in underexposed areas may still be visible.

Your camera's live histogram is one indicator, but videographers have been relying on the Zebra tool for ages. It gives you an overexposure alert *before* you take the picture, and can actually specify exactly how bright *too bright* is. When you want to use Zebra pattern warnings, access the menu entry and specify an IRE value from 70 to 100, plus 100+. A value of 100 IRE indicates pure white, so any Zebra pattern visible when using this setting (or 100+) indicates that part of your image is extremely overexposed. Any details in the highlights are gone, and cannot be retrieved. Settings from 70 to 90 can be used to make sure facial tones are not overexposed. As a general rule of thumb, Caucasian skin generally falls in the 80 IRE range, with darker skin tones registering as low as 70, and very fair skin or lighter areas of your subject edging closer to 90 IRE. Once you've decided the approximate range of tones that you want to make sure do *not* blow out, you can set the a68's Zebra pattern sensitivity appropriately and receive the flashing striped warning on the LCD of your camera. The pattern does not appear in your final image (nor in previews using an HDMI-connected external monitor), of course—it's just an aid to keep you from blowing it, so to speak.

Auto Slow Shutter

This movie-only entry in the Camera Settings 9 page is useful in very dark locations. It operates when ISO is set to Auto and the exposure mode is Aperture Priority, and enables the camera to use 1/30th second instead of the default 1/60th second, to avoid the need to increase ISO instead (and thus boost noise levels). This is a useful feature, since it works in any camera operating mode; there's no need to use Shutter Priority mode and set a slow shutter speed yourself in dark locations.

Audio Settings

Sound is an important part of most movies. Even when there is no dialog, music, or sound effects in a clip, the ambient sound produced by the surroundings adds an important feeling of presence. I am including a special section on sound near the end of this chapter, but you should keep the following sound settings in mind as you begin capturing video.

Audio Recording

This setting lets you turn audio recording for your movies on or off. You might want to disable audio recording if you are certain you don't want to have any sound recorded, or if you believe you might be bothered by sounds from the operation of the camera or lens that might be recorded. In my case, I always leave audio recording enabled, because you can always erase a soundtrack that you don't want or replace it with a new one, but you can never recover sounds that you didn't record in the first place.

Audio Recording Level

You can adjust the recording level of the camera's built-in or external microphones using this entry, which also enables/disables the audio level overlay on the screen while movies are captured. To use this feature, rotate the mode dial to the Movie position, and adjust the audio recording level using the entry in the Camera Settings 9 menu, as explained in Chapter 3.

Audio Level Display

The Sony a68 displays a moderately helpful pair of scales that show the relative volume level of the sound being recorded. Unless you have an add-on device with a headphone jack, you really can't monitor the quality of your sound, but this feature, at least, gives you a feeling for whether the sound level is too low, too high, or just about right.

Wind Noise Reduction

This setting activates or disables in-camera processing of your audio to remove the whistling sound produced by wind passing over the built-in microphones. (This entry has no effect on external microphones.) Wind noise reduction does degrade sound quality a little by emphasizing bass tones when recording at low volume, so you'll want to use it only when you have wind noises to contend with.

Other Settings

Two other settings deal with an autofocus issue specific to capturing video, and allow you to enable/disable SteadyShot electronic (not sensor-shift) image stabilization.

AF Track Duration (Movies)

This is a movies-only setting in the Camera Settings 4 menu, and operates exactly the same as the stills version. Separating the two options gives you the choice of using one type of tracking for stills, and another for movies, without the need to switch back and forth. You can choose from 5 (High), 4, 3 (Mid), 2, and 1 (Low). The High setting works best for me.

SteadyShot

This entry can be used to switch off the SteadyShot image stabilization feature for movie making, separately from the stabilization used for still images (available in the Camera Settings 8 menu). You might want to do that when the camera is mounted on a tripod, as the additional anti-shake feature is not needed in that situation, and slight movements of the tripod can sometimes "confuse" the system. However, it's rarely necessary to turn SteadyShot off, and I recommend leaving it turned on at all times unless you are using a tripod, or want a cinéma vérité, hand-held look.

Recording Video

Recording a video with the Sony a68 is extraordinarily easy to accomplish—just press the prominent red-accented Movie button to the right of the viewfinder to start, and press it again to stop. The previous section talked about specific settings to make; here are some more considerations as you prepare for your recording session:

- Set the camera's aspect ratio. The aspect ratio setting (3:2 or 16:9, accessed through the Camera Settings 1 menu) won't affect your *video* recording, but it will affect how you frame your images using the live view on the LCD screen prior to pressing the Movie button when the mode dial isn't set to the Movie position. So, if you want to know approximately how your video will be framed on the screen, set the aspect ratio to 3:2 if you're going to be recording in VGA; set it to 16:9 if you'll be using any of the other formats.
- Turn on autofocus. Make sure autofocus is turned on using the AF/MF switch on the lens or with the camera menus, as discussed in Chapter 6 (assuming you're using a Sony lens that will autofocus with this camera). You have the option of using manual focus if you want, but in most cases there is no reason not to rely on the camera's excellent ability to autofocus during movie making. You also can set the Autofocus Area using the Fn menu.
- Set white balance, Creative Style, and metering mode as you want them. These are three exposure-related functions that will work for your video shooting, so take advantage of them. Of course, for many purposes you may be content with Auto White Balance, the Standard Creative Style, and the Multi metering mode, but be aware that these settings are available if you want to use them for creative purposes. If you want to adjust any of these three settings, be sure to set the camera to a shooting mode, such as Program, in which those settings can be made; if you switch back to an Auto or Scene mode, the camera will revert back to its automatic settings. Make the settings before you start recording the movie, because you cannot adjust them during the recording. Don't worry about setting other exposure-related items, such as DRO, which will have no effect.

- Choose Aperture Priority mode and manual focus if you want to control the aperture. In most cases, when you press the red Movie button, the camera will adjust the exposure for you automatically, no matter what shooting mode the camera is set to for still images—Auto, Program, Manual, or even 3D Panorama or Continuous Advance Priority AE. The camera just records the movie, adjusting the aperture, shutter speed, and ISO to achieve a correct exposure. However, Sony provided the ability to maintain a fixed aperture if you want to. In order to do so, you need to use manual focus and Aperture Priority mode, and set your chosen aperture before starting to record the movie. If you then press the red Movie button, the camera will keep the aperture you have set, and do its best to expose the footage correctly using that aperture. The idea with this feature is to give you a way to achieve a defocused background by maintaining a wide aperture setting.
- Use the right card. You'll want to use an SD Class 6 memory card or better to store your clips; slower cards may not keep pace with the volume of data being recorded. Choose a memory card with at least 4GB capacity (8GB to 32GB are even better).
- Attach an external microphone if desired. One very welcome feature of the a68 is the presence of a jack for an external stereo microphone, a refinement that is lacking on many modern cameras that are capable of recording movies. You can obtain a high-quality microphone made by a company such as Shure or Audio-Technica, and, if you are on a quest for really superior audio quality, you can even obtain a portable mixer that can plug into this jack, such as the affordable Rolls MX124 Pro-MixIV, letting you use multiple high-quality microphones to record your soundtrack.
- Minimize zooming. While it's great to be able to use the zoom for filling the frame with a distant subject, think twice before zooming. Unless you are using an external mic, the sound of the zoom motor will be picked up and it will be audible when you play a movie. Any more than the occasional minor zoom will be very distracting to friends who watch your videos. And digital zoom will definitely degrade image quality. Don't use the digital zoom if quality is more important than recording a specific subject, such as a famous movie star, far from a distance.
- Use a fully charged battery. A fresh battery will allow about one hour of filming at normal (non-winter) temperatures, but that can be shorter if AF-F is used and there are many focus adjustments. Individual clips can be no longer than 29 minutes, however.
- **Keep it cool.** Video quality can suffer terribly when the imaging sensor gets hot so keep the camera in a cool place. When shooting on hot days especially, the sensor can get hot more quickly than usual; when there's a risk of overheating, the camera will stop recording and it will shut down about five seconds later. Give it time to cool down before using it again.
- Press the red-accented Movie recording button. You don't have to hold it down. Press it again when you're done.

MOVIE TIME

I've standardized on 64GB SDXC cards when I'm shooting movies; one of these cards will hold almost 8 hours of video at the highest quality setting. However, the camera cannot shoot a continuous movie clip for more than 29 minutes, so that is your limit for any given scene; as noted earlier, it's even less when SteadyShot is turned on. (Though you could start right back in again to record a second scene, if you still had space on your memory card and still had battery power.)

GETTING INFO

The information display shown on the LCD screen when shooting movies is fairly sparse, because there are not too many settings you can make. The screen will show recording time elapsed and time remaining and the REC indicator to show that you are shooting a movie. It will also show you the format you are using and any exposure-related settings that are in effect, including white balance, Creative Style, and exposure compensation.

Steps During Movie Making

Once you have set up the camera for your video session and pressed the red button, you have done most of the technical work that's required of you. Now your task is to use your skills at composition, lighting, scene selection, and, perhaps, directing actors, to make a compelling video production. Later in this chapter I will have some advice to give you in those areas, but first there are a few technical points you should bear in mind as the camera is (figuratively) whirring away.

■ Zoom, autofocus, and autoexposure all work. If you're new to the world of high-quality still cameras that also take video, you may just take it for granted that functions such as autofocus continue to work normally when you switch from stills to video. But until recently, most such cameras performed weakly in their video modes; they would lock their exposure and focus at the beginning of the scene, and you could not zoom while shooting the video. The a68 has no such handicaps, and, in fact, it is especially capable in these areas. Autoexposure works very well, and you can zoom to your heart's content (though, as I'll discuss later, I recommend that you zoom sparingly). Best of all, autofocus works like a charm; the camera can track moving subjects and quickly snap them back into sharp focus with the speedy phase-detection focusing mechanism made possible by the fixed translucent mirror. So don't limit yourself based on the weaknesses of past cameras; these a68 models open up new horizons of video freedom. Also, as I mentioned above, you have the ability to change to a different focus sensor while recording the movie.

- Exposure compensation works while filming. I found this feature to be quite remarkable. Although the autoexposure system works very well to vary the aperture when the ambient lighting changes, you also have the option of dialing in exposure compensation if you see a need for more or less brightness in a particular context. You could even use this function as a limited kind of "fade to black" in the camera, though you probably won't be able to fade quite all the way to black. Again, you may never need to adjust your EV manually while shooting video, but it's great to know that you have the option available.
- **Don't be a Flash in the pan.** With HD video, there is a possibility of introducing artifacts or distortion if you pan too quickly. That is, because of the way the lines of video are displayed in sequence, if the camera moves too quickly in a sideways motion, some of the lines may not show up on the screen quickly enough to catch up to the rest of the picture, resulting in a somewhat distorted effect and/or loss of detail. So, if at all possible, make your pans smooth and steady, and slow them down to a comfortable pace.

Tips for Shooting Better Video

Once upon a time, the ability to shoot video with a digital still camera was one of those "Gee whiz" gimmicks camera makers seemed to include just to have a reason to get you to buy a new camera. That hasn't been true for a couple of years now, as the video quality of many digital still cameras has gotten quite good. The a68 is a stellar example. It's capable of HD-quality video and is actually capable of outperforming typical modestly priced digital video camcorders, especially when you consider the range of lenses and other helpful accessories available for it.

Producing good-quality video is more complicated than just buying good equipment. There are techniques that make for gripping storytelling and a visual language the average person is very used to, but also pretty unaware of. While this book can't make you a professional videographer in half a chapter, there is some advice I can give you that will help you improve your results with the camera.

Producing high-quality videos can be a real challenge for amateur photographers. After all, by comparison we're used to watching the best productions that television, video, and motion pictures can offer. Whether it's fair or not, our efforts are compared to what we're used to seeing produced by experts. While this chapter can't make you into a pro videographer, it can help you improve your efforts.

There are a number of different things to consider when planning a video shoot, and when possible, a shooting script and storyboard can help you produce a higher quality video.

Stop That!

You might think that setting your a68 to a faster shutter speed will help give you sharper video frames. But the choice of a shutter speed for movie making is a bit more complicated than that. As you might guess, it's almost always best to leave the shutter speed at 1/30th or 1/60th second, and allow the overall exposure to be adjusted by varying the aperture and/or ISO sensitivity. We don't normally stare at a video frame for longer than 1/30th or 1/24th second, so while the shakiness of the *camera* can be disruptive (and often corrected by image stabilization), if there is a bit of blur in our *subjects* from movement, we tend not to notice. Each frame flashes by in the blink of an eye, so to speak, so a shutter speed of 1/30th or 1/60th second works a lot better in video than it does when shooting stills.

Higher shutter speeds actually introduce problems of their own. If you shoot a video frame using a shutter speed of 1/160th second, the actual moment in time that's captured represents only about 12 percent of the 1/30th second of elapsed time in that frame. Yet, when played back, that frame occupies the full 1/30th of a second, with 88 percent of that time filled by stretching the original image to fill it. The result is often a choppy/jumpy image, and one that may appear to be *too* sharp.

The reason for that is more social imprinting than scientific: we've all grown up accustomed to seeing the look of Hollywood productions that, by convention, were shot using a shutter speed that's half the reciprocal of the frame rate (that is, 1/48th second for a 24 fps movie). Movie cameras use a rotary shutter (achieving that 1/48th second exposure by using a 180-degree shutter "angle"), but the effect on our visual expectations is the same. For the most "film-like" appearance, use 24 fps and 1/60th second shutter speed.

Faster shutter speeds do have some specialized uses for motion analysis, especially where individual frames are studied. The rest of the time, 1/30th or 1/60th of a second will suffice. If the reason you needed a higher shutter speed was to obtain the correct exposure, use a slower ISO setting, or a neutral-density filter to cut down on the amount of light passing through the lens. A good rule of thumb is to use 1/60th second or slower when shooting at 24 fps; 1/60th second or slower at 30 fps; and 1/125th second or slower at 60 fps.

Lens Craft

I'll cover the use of lenses with the a68 in more detail in Chapter 9, but a discussion of the effects of lenses when shooting movies may be useful at this point. In the video world, not all lenses are created equal. The two most important considerations are depth-of-field, or the beneficial lack thereof, and zooming. I'll address each of these separately.

Depth-of-Field and Video

Have you wondered why professional videographers have gone nuts over still cameras that can also shoot video? The producers of *Saturday Night Live* could afford to have Alex Buono, their director of photography, use the niftiest, most expensive high-resolution video cameras to shoot the opening sequences of the program. Instead, Buono opted for a pair of digital SLR cameras. One thing that makes digital still cameras so attractive for video is that they have relatively large sensors, which provides improved low-light performance and results in the oddly attractive reduced depth-of-field, compared with professional video with smaller sensor cameras.

Figure 8.2 provides a comparison of the relative size of sensors. The typical size of a professional video camera sensor is shown at lower left. The APS-C sensor used in the a68 is shown just north of it. You can see that it is much larger, especially when compared with the sensor found in the typical point-and-shoot camera shown at right. Compared with the sensors used in many pro video cameras and the even smaller sensors found in the typical computer camcorder, the a68's image-grabber is much larger.

As you'll learn in Chapter 9, a larger sensor calls for the use of longer focal lengths to produce the same field of view, so, in effect, a larger sensor has reduced depth-of-field. And *that's* what makes cameras like the a68 attractive from a creative standpoint. Less depth-of-field means greater control over the range of what's in focus. Your a68, with its larger sensor, has a distinct advantage over consumer camcorders in this regard, and even does a better job than many professional video cameras.

Zooming and Video

When shooting still photos, a zoom is a zoom. The key considerations for a zoom lens used only for still photography are the maximum aperture available at each focal length ("How *fast* is this lens?), the zoom range ("How far can I zoom in or out?"), and its sharpness at any given f/stop ("Do I lose sharpness when I shoot wide open?").

When shooting video, the priorities may change, and there are two additional parameters to consider. The first two I listed, lens speed and zoom range, have roughly the same importance in both still and video photography. Zoom range gains a bit of importance in videography, because you can always/usually move closer to shoot a still photograph, but when you're zooming during a shot, most of us don't have that option (or the funds to buy/rent a dolly to smoothly move the camera during capture). But, oddly enough, overall sharpness may have slightly less importance under certain conditions when shooting video. That's because the image changes in some way many times per second (24/60 times per second with the a68), so any given frame doesn't hang around long enough for our eyes to pick out every single detail. You want a sharp image, of course, but your standards don't need to be quite as high when shooting video.

Here are the remaining considerations:

- Zoom lens maximum aperture. The speed of the lens matters in several ways. A zoom with a relatively large maximum aperture lets you shoot in lower light levels, and a big f/stop allows you to minimize depth-of-field for selective focus. Keep in mind that the maximum aperture may change during zooming. A lens that offers an f/3.5 maximum aperture at its widest focal length, may provide only f/5.6 worth of light at the telephoto position.
- Zoom range. Use of zoom during actual capture should not be an everyday thing, unless you're shooting a kung-fu movie. However, there are effective uses for a zoom shot, particularly if it's a "long" one from extreme wide angle to extreme close-up (or vice versa). Most of the time, you'll use the zoom range to adjust the perspective of the camera *between* shots, and a longer zoom range can mean less trotting back and forth to adjust the field of view. Zoom range also comes into play when you're working with selective focus (longer focal lengths have less depth-of-field), or want to expand or compress the apparent distance between foreground and background subjects. A longer range gives you more flexibility.
- Linearity. Interchangeable lenses may have some drawbacks, as many photographers who have been using the video features of their digital SLRs have discovered. That's because, unless a lens is optimized for video shooting, zooming with a particular lens may not necessarily be linear. Rotating the zoom collar manually at a constant speed doesn't always produce a smooth zoom. There may be "jumps" as the elements of the lens shift around during the zoom. Keep that in mind if you plan to zoom during a shot, and are using a lens that has proved, from experience, to provide a non-linear zoom. (Unfortunately, there's no easy way to tell ahead of time whether you own a lens that is well-suited for zooming during a shot.)

Keep Things Stable and on the Level

Camera shake's enough of a problem with still photography, but it becomes even more of a nuisance when you're shooting video. While the a68's image-stabilization feature can help minimize this, it can't work miracles. Placing your camera on a sturdy tripod will work much better than trying to hand-hold it while shooting.

Shooting Script

A shooting script is nothing more than a coordinated plan that covers both audio and video and provides order and structure for your video. A detailed script will cover what types of shots you're going after, what dialogue you're going to use, audio effects, transitions, and graphics.

Storyboards

Action should be a part of your video, even when shooting otherwise static scenes, as in Figure 8.3. The best way to be sure that you have the right mix of shots, angles, and action elements is to use a storyboard. A storyboard is a series of panels providing visuals of what each scene should look like. While the ones produced by Hollywood are generally of very high quality, there's nothing that says drawing skills are important for this step. Stick figures work just fine if that's the best you can do.

Figure 8.3 Action can be part of even the most static scenes.

Figure 8.4 A storyboard is a series of simple sketches or photos to help visualize a segment of video.

The storyboard just helps you visualize locations, placement of actors/actresses, props and furniture, and also helps everyone involved get an idea of what you're trying to show. It also helps show how you want to frame or compose a shot. You can even shoot a series of still photos and transform them into a "storyboard" if you want, such as in Figure 8.4.

Storytelling in Video

Today's audience is used to fast-paced, short-scene storytelling. In order to produce interesting video for such viewers, it's important to view video storytelling as a kind of shorthand code for the more leisurely efforts print media offers. Audio and video should always be advancing the story. While it's okay to let the camera linger from time to time, it should only be for a compelling reason and only briefly. It only takes a second or two for an establishing shot to impart the necessary information.

Provide variety too. Change camera angles and perspectives often and never leave a static scene on the screen for a long period of time. (You can record a static scene for a reasonably long period and then edit in other shots that cut away and back to the longer scene with close-ups that show each person talking.)

When editing, keep transitions basic! I can't stress this one enough. Watch a television program or movie. The action "jumps" from one scene or person to the next. Fancy transitions that involve exotic "wipes," dissolves, or cross fades take too long for the average viewer and make your video ponderous.

Composition

In movie shooting, several factors restrict your composition, and impose requirements you just don't always have in still photography (although other rules of good composition do apply). Here are some of the key differences to keep in mind when composing movie frames:

■ Horizontal compositions only. Some subjects, such as basketball players and tall buildings, just lend themselves to vertical compositions. But movies are generally shot and shown in horizontal format only. (Unless you're capturing a clip with your smartphone; I see many vertically oriented YouTube videos.) So if you're shooting a conventional video and interviewing a local basketball star, you can end up with a worst-case situation like the one shown in Figure 8.5. If you want to show how tall your subject is, it's often impractical to move back far enough to show him full-length. You really can't capture a vertical composition. Tricks like getting down on the floor and shooting up at your subject can exaggerate the perspective, but aren't a perfect solution.

Figure 8.5
Movie shooting requires you to fit all your subjects into a horizontally oriented frame.

- Wasted space at the sides. Moving in to frame the basketball player as outlined by the yellow box in Figure 8.5 means that you're still forced to leave a lot of empty space on either side. (Of course, you can fill that space with other people and/or interesting stuff, but that defeats your intent of concentrating on your main subject.) So when faced with some types of subjects in a horizontal frame, you can be creative, or move in *really* tight. For example, if I was willing to give up the "height" aspect of my composition, I could have framed the shot as shown by the green box in the figure, and wasted less of the image area at either side.
- Seamless (or seamed) transitions. Unless you're telling a picture story with a photo essay, still pictures often stand alone. But with movies, each of your compositions must relate to the shot that preceded it, and the one that follows. It can be jarring to jump from a long shot to a tight close-up unless the director—you—is very creative. Another common error is the "jump cut" in which successive shots vary only slightly in camera angle, making it appear that the main subject has "jumped" from one place to another. (Although everyone from French New Wave director Jean-Luc Goddard to Guy Ritchie—Madonna's ex—have used jump cuts effectively in their films.) The rule of thumb is to vary the camera angle by at least 30 degrees between shots to make it appear to be seamless. Unless you prefer that your images flaunt convention and appear to be "seamy."
- The time dimension. Unlike still photography, with motion pictures there's a lot more emphasis on using a series of images to build on each other to tell a story. Static shots where the camera is mounted on a tripod and everything is shot from the same distance are a recipe for dull videos. Watch a television program sometime and notice how often camera shots change distances and directions. Viewers are used to this variety and have come to expect it. Professional video productions are often done with multiple cameras shooting from different angles and positions. But many professional productions are shot with just one camera and careful planning, and you can do just fine with your a68.

Here's a look at the different types of commonly used compositional tools:

- Establishing shot. Much like it sounds, this type of composition establishes the scene and tells the viewer where the action is taking place. Let's say you're shooting a video of your offspring's move to college; the establishing shot could be a wide shot of the campus with a sign welcoming you to the school in the foreground. Another example would be for a child's birthday party; the establishing shot could be the front of the house decorated with birthday signs and streamers or a shot of the dining room table decked out with party favors and a candle-covered birthday cake. Or, in Figure 8.6, upper left, I wanted to show the studio where the video was shot.
- **Medium shot.** This shot is composed from about waist to head room (some space above the subject's head). It's useful for providing variety from a series of close-ups and also makes for a useful first look at a speaker. (See Figure 8.6, upper right.)

- Close-up. The close-up, usually described as "from shirt pocket to head room," provides a good composition for someone talking directly to the camera. Although it's common to have your talking head centered in the shot, that's not a requirement. In Figure 8.6, middle left, the subject was offset to the right. This would allow other images, especially graphics or titles, to be superimposed in the frame in a "real" (professional) production. But the compositional technique can be used with a68 videos, too, even if special effects are not going to be added.
- Extreme close-up. When I went through broadcast training, this shot was described as the "big talking face" shot and we were actively discouraged from employing it. Styles and tastes change over the years and now the big talking face is much more commonly used (maybe people are better looking these days?) and so this view may be appropriate. Just remember, the

Figure 8.6 Use a full range of shot types.

a68 is capable of shooting in high-definition video and you may be playing the video on a high-def TV; be careful that you use this composition on a face that can stand up to high definition. (See Figure 8.6, middle right.)

- "Two" shot. A two shot shows a pair of subjects in one frame. They can be side by side or one subject in the foreground and one in the background. This does not have to be a head-to-ground composition. Subjects can be standing or seated. A "three shot" is the same principle except that three people are in the frame. (See Figure 8.6, lower left.)
- Over-the-shoulder shot. Long a composition of interview programs, the "over-the-shoulder shot" uses the rear of one person's head and shoulder to serve as a frame for the other person. This puts the viewer's perspective as that of the person facing away from the camera. (See Figure 8.6, lower right.)

Lighting for Video

Much like in still photography, how you handle light pretty much can make or break your videography. Lighting for video can be more complicated than lighting for still photography, since both subject and camera movement are often part of the process.

Lighting for video presents several concerns. First off, you want enough illumination to create a useable video. Beyond that, you want to use light to help tell your story or increase drama. Let's take a better look at both.

Illumination

You can significantly improve the quality of your video by increasing the light falling in the scene. This is true indoors or out, by the way. While it may seem like sunlight is more than enough, it depends on how much contrast you're dealing with. If your subject is in shadow (which can help them from squinting) or wearing a ball cap, a video light can help make them look a lot better.

Lighting choices for amateur videographers are a lot better these days than they were a decade or two ago. An inexpensive incandescent video light, which will easily fit in a camera bag, can be found for \$15 or \$20. You can even get a good-quality LED video light for less than \$100. Work lights sold at many home improvement stores can also serve as video lights since you can set the camera's white balance to correct for any color casts. You'll need to mount these lights on a tripod or other support, or, perhaps, to a bracket that fastens to the tripod socket on the bottom of the camera.

Much of the challenge depends upon whether you're just trying to add some fill light on your subject versus trying to boost the light on an entire scene. A small video light will do just fine for the former. It won't handle the latter. Fortunately, the versatility of the a68 comes in quite handy here. Since the camera shoots video in Auto ISO mode, it can compensate for lower lighting levels and still produce a decent image. For best results though, better lighting is necessary.

Creative Lighting

While ramping up the light intensity will produce better technical quality in your video, it won't necessarily improve the artistic quality of it. Whether we're outdoors or indoors, we're used to seeing light come from above. Videographers need to consider how they position their lights to provide even illumination while up high enough to angle shadows down low and out of sight of the camera.

When considering lighting for video, there are several factors. One is the quality of the light. It can either be hard (direct) light or soft (diffused) light. Hard light is good for showing detail, but can also be very harsh and unforgiving. "Softening" the light, but diffusing it somehow, can reduce the intensity of the light but make for a kinder, gentler light as well.

While mixing light sources isn't always a good idea, one approach is to combine window light with supplemental lighting. Position your subject with the window to one side and bring in either a supplemental light or a reflector to the other side for reasonably even lighting.

Lighting Styles

Some lighting styles are more heavily used than others. Some forms are used for special effects, while others are designed to be invisible. At its most basic, lighting just illuminates the scene, but when used properly it can also create drama. Let's look at some types of lighting styles:

- Three-point lighting. This is a basic lighting setup for one person. A main light illuminates the strong side of a person's face, while a fill light lights up the other side. A third light is then positioned above and behind the subject to light the back of the head and shoulders. (See Figure 8.7.)
- Flat lighting. Use this type of lighting to provide illumination and nothing more. It calls for a variety of lights and diffusers set to raise the light level in a space enough for good video reproduction, but not to create a particular mood or emphasize a particular scene or individual. With flat lighting, you're trying to create even lighting levels throughout the video space and minimize any shadows. Generally, the lights are placed up high and angled downward (or possibly pointed straight up to bounce off of a white ceiling). (See Figure 8.8.)
- "Ghoul lighting." This is the style of lighting used for old horror movies. The idea is to position the light down low, pointed upward. It's such an unnatural style of lighting that it makes its targets seem weird and ghoulish.
- Outdoor lighting. While shooting outdoors may seem easier because the sun provides more light, it also presents its own problems. As a general rule of thumb, keep the sun behind you when you're shooting video outdoors, except when shooting faces (anything from a medium shot and closer) since the viewer won't want to see a squinting subject. When shooting another human this way, put the sun behind her and use a video light to balance light levels between the foreground and background. If the sun is simply too bright, position the subject in the shade and use the video light for your main illumination. Using reflectors (white board panels or aluminum foil—covered cardboard panels are cheap options) can also help balance light effectively.

Figure 8.7 With three-point lighting, two lights are placed in front and to the side of the subject (45-degree angles are ideal) and positioned about a foot higher than the subject's head. Another light is directed on the background in order to separate the subject and the background. There's also a supplementary hair light above, behind, and to the left of the model.

Figure 8.8 Flat lighting is another approach for creating even illumination. Here the lights can be bounced off of a white ceiling and walls to fill in shadows as much as possible. It is a flexible lighting approach since the subject can change positions without needing a change in light direction.

Audio

When it comes to making a successful video, audio quality is one of those things that separates the professionals from the amateurs. We're used to watching top-quality productions on television and in the movies, yet the average person has no idea how much effort goes in to producing what seems to be "natural" sound. Much of the sound you hear in such productions is actually recorded on carefully controlled sound stages and "sweetened" with a variety of sound effects and other recordings of "natural" sound.

Your a68 has a pair of stereo microphones on its front surface, able to capture Dolby Digital Audio, and a port on the side for an external microphone. You can also use an adapter plugged into the Multi Interface shoe, or a microphone designed specifically for Sony cameras, such as the Sony ECM-XYSTM1 mic. If you stick with the built-in microphones, you must be extra careful to optimize the sound captured by those fixed sound-grabbers. You will find an Audio Recording entry in the Camera Settings 9 menu (it just turns sound on or off), as well as a Wind Noise Reduction on/off switch. But that's as far as your camera adjustments go.

Tips for Better Audio

Since recording high-quality audio is such a challenge, it's a good idea to do everything possible to maximize recording quality:

■ Turn off any sound makers you can. Little things like fans and air handling units aren't obvious to the human ear, but will be picked up by the microphone. Turn off any machinery or devices that you can plus make sure cell phones are set to silent mode. Also, do what you can to minimize sounds such as wind, radio, television, or people talking in the background.

- Make sure to record some "natural" sound. If you're shooting video at an event of some kind, make sure you get some background sound that you can add to your audio as desired in postproduction.
- Consider recording audio separately. Lip-syncing is probably beyond most of the people you're going to be shooting, but there's nothing that says you can't record narration separately and add it later. It's relatively easy if you learn how to use simple software video-editing programs like iMovie (for the Macintosh) or Windows Movie Maker (for Windows PCs). Any time the speaker is off-camera, you can work with separately recorded narration rather than recording the speaker on-camera. This can produce much cleaner sound.

WIND NOISE REDUCTION

The a68 does offer a low-cut filter feature that can further reduce wind noise; it's accessed with the Wind Noise Reduction item of the Camera Settings 9 menu, discussed in Chapter 3. However, this processing feature also affects other sounds, making the wind screen far more useful.

Working with Lenses

Although it's sometimes alarming for those of us who have been taking pictures a very long time, the recent tendency for larger companies to absorb smaller vendors has paid some big dividends, most notably in the huge selection of lenses available for the Sony A-mount camera line that includes the a68.

In my youth, I managed a camera store for a while, and had access to a broad range of different models, and so used both Konica and Minolta cameras for many years—dating back to the Konica Autoreflex T (the first SLR with autoexposure/through-the-lens metering) and the legendary Minolta SRT-101. Only a few years into the digital SLR era, the two companies joined forces as Konica Minolta, and in turn saw their technology eventually taken over by Sony in 2006. Bye-bye Konica Minolta 7D, hello Sony Alpha models, like the company's first entry, the Alpha DSLR-A100, each with a legacy of hundreds of lenses from the sorely missed Minolta lineup.

Thanks to the head start provided by Konica and Minolta (and boosted by Minolta-compatible lenses from third parties), your Sony Alpha a68 camera can be used with a very broad range of high-quality lenses, suitable for a user base that extends from novice photo enthusiasts to advanced amateur and professional photographers. It's this mind-bending assortment of high-quality lenses available to enhance the capabilities of cameras like the Sony a68 that make the camera line so attractive. Hundreds of current and older lenses introduced by Minolta, Sony, and third-party vendors since the late 1980s can be used to give you a wider view, bring distant subjects closer, let you focus closer, shoot under lower light conditions, or provide a more detailed, sharper image for critical work. Other than the sensor itself, the lens you choose for your camera is the most important component in determining image quality and perspective of your images.

This chapter explains how to select the best lenses for the kinds of photography you want to do.

But Don't Forget the Crop Factor

From time to time you've heard the term *crop factor*, and you've probably also heard the term *lens multiplier factor*. Both are misleading and inaccurate terms used to describe the same phenomenon: the fact that cameras like the Sony Alpha (and most other affordable digital SLRs) provide a field of view that's smaller and narrower than that produced by certain other (usually much more expensive) cameras, when fitted with exactly the same lens.

Figure 9.1 quite clearly shows the phenomenon at work. The outer rectangle, marked 1X, shows the field of view you might expect with a 100mm lens mounted on a so-called "full-frame" digital model like the Sony a99 II, or a 35mm film camera, like the 1985 Minolta Maxxum 7000 (which happened to be the first SLR to feature both autofocus and motorized advance, something we take for granted in the digital age). The rectangle marked 1.5X shows the field of view you'd get with that 100mm lens installed on a Sony a68. It's easy to see from the illustration that the 1X rendition provides a wider, more expansive view, while the other one is, in comparison, *cropped*.

The cropping effect is produced because the sensor of the Alpha a68 is smaller than the sensor of a full-frame camera. The "full-frame" camera has a sensor that's the size of the standard 35mm film frame, $24\text{mm} \times 36\text{mm}$. Your Sony's sensor does *not* measure $24\text{mm} \times 36\text{mm}$; instead, it specs out at roughly $23.5 \times 15.6\text{mm}$, or about 66 percent of the area of a full-frame sensor, as shown by the yellow boxes in the figure. You can calculate the relative field of view by dividing the focal length

Figure 9.1 Sony offers digital cameras with fullframe (1X) crops, as well as 1.5X crops.

of the lens by .667. Thus, a 100mm lens mounted on a Sony Alpha a68 has the same field of view as a 150mm lens on a full-frame camera like the Sony a99. We humans tend to perform multiplication operations in our heads more easily than division, so such field of view comparisons are usually calculated using the reciprocal of .667—1.5—so we can multiply instead. (100 / .667=150; $100 \times 1.5=150$.)

This translation is generally useful only if you're accustomed to using full-frame cameras (usually of the film variety) and want to know how a familiar lens will perform on a digital camera. I strongly prefer *crop factor* to *lens multiplier*, because nothing is being multiplied; a 100mm lens doesn't "become" a 150mm lens—the depth-of-field and lens aperture remain the same. (I'll explain more about these later in this chapter.) Only the field of view is cropped. But the term *crop factor* isn't much better, as it implies that the 24×36 mm frame is "full" and anything else is "less." I get e-mails all the time from photographers who point out that they own full-frame cameras with 36mm $\times 48$ mm sensors. By their reckoning, the "half-size" sensors found in full-frame cameras like the Sony a99 are "cropped."

If you're an old-timer accustomed to using full-frame film cameras, you might find it helpful to use the crop factor "multiplier" to translate a lens's real focal length into the full-frame equivalent, even though, as I said, nothing is actually being multiplied. Throughout most of this book, I've been using actual focal lengths and not equivalents, except when referring to specific wide-angle or telephoto focal length ranges and their fields of view.

Sony's Alpha-bet Soup

Here's a quick translation of some of the nomenclature used when referring to various Sony lenses.

- APO. Denotes lenses including glass elements that focus photons with long frequencies (e.g., red) at the same point as those with short frequencies (blue/violet), thus reducing the objectionable purple fringe fuzziness around the edges of objects. Chromatic aberration (CA) comes in both axial/longitudinal (around the axis of the center of the lens), and is reduced to some extent by stopping down the lens, as well as a transverse/lateral (side to side) variety, which isn't affected by smaller f/stops.
- D/ADL. A D lens provides the camera with information about how far away the plane of focus is. Because Advanced Distance Integration (ADL) allows the lens to communicate distance data to the camera, the a68 can use it with compatible flashes to produce more advanced throughthe-lens (TTL) metering. Not all lenses include this feature (Sony has a complete list of ADL-compatible lenses on its website.)
- **DT.** This designation (Digital Technology) is applied to lenses that are designed for Sony's APS-C-format cameras only. They produce an image circle designed to cover APS-C size image sensors, and may not be useable on full-frame cameras like the A99 at all (or most) focal lengths without the automatic cropping feature.

DIGITAL TECHNOLOGY PLUS

There's more to Sony's digital lens technology than the size of the coverage circle. Many non-DT lenses were originally designed in the film era by Minolta, and in many cases Sony just slightly modified and rebadged them when the company assimilated Konica Minolta. Film is not particularly fussy about the angle at which photons approach the focal plane, but sensors include millions of tiny "wells" called photosites. At sharp angles, incoming photons may strike the sides of the wells, rather than the photosensitive area at their bottom.

Vendors like Sony solve this problem in two ways. They include tiny microlenses on the sensor (such as those found in the a68's improved 24M imager) to refocus the light on the photosites. Another solution is to design lenses especially for digital capture, featuring recessed rear elements calculated to focus the light at a less steep angle.

Often the rear components are coated to reduce reflections. This reduces the effects of light bouncing from the sensor back to the lens and thence reflecting back to the sensor. Such reflections are especially troublesome with photons that approach from a less acute angle than lenses designed for film.

- ED. These lenses feature extra-low dispersion glass, a higher quality glass that reduces chromatic aberration or "color fringing."
- IF. Internal focus lenses do not change their physical length as you focus on subjects that are closer or farther away. Instead, lens elements move inside the lens barrel to accomplish focusing.
- Macro. Designates a lens suitable for close-up photography, because it can focus at relatively short distances from the camera. Strictly speaking, all lenses marked Macro aren't necessarily close-up lenses. My old Sony SAL1870 18-70mm f/3.5-5.6 DT lens has Macro emblazoned on it, but it focuses no closer than 1'2.7" and produces only a near-macro .25X magnification.
- OSS. Stands for Optical SteadyShot, which is Sony's image stabilization technology built into the lens itself using shifting lens elements, as opposed to in-body image stabilization (IBIS) found in other Sony camera product lines, and which employs moving the sensor itself.
- Reflex. A catadioptric or "mirror" lens folds the image path back and forth to produce a shorter, relatively lighter telephoto optic. The discontinued Sony SAL500F80 500mm f/8 Reflex Super Telephoto (and its original Minolta counterpart) were/are highly prized as the world's only mirror lenses with autofocus capabilities. I purchased one of these from keh.com, and it's shown mounted on the a68 in Figure 9.2. It is furnished with a neutral-density filter that provides the exposure equivalent (but not depth-of-field) of an f/11 aperture, which reduces the limitations of its fixed f/8 aperture. Mirror lenses all produce distinctive "doughnut hole" defocused highlights that some find objectionable, but many don't. (See Figure 9.3.)

Figure 9.2 Compact 500mm f/8 mirror telephoto lens.

Figure 9.3
Mirror lenses produce distinctive "doughnut hole" specular highlights.

- **SAL.** Stands for Sony Alpha Lens, as opposed to SEL (for Sony E-Mount Lens). See the Lens Mounts and Motors section that follows for more information.
- SAM/SAM II. Smooth Autofocus Motor. This terminology is often applied to Sony's less expensive, "budget" lenses. I'll explain the motor situation in more detail in the next section, too.
- SSM/SSM II. Supersonic wave motor, a piezoelectric motor that provides smooth and silent autofocus operation. When Sony replaces a current lens with an updated model of the same focal length and aperture range, it often adds a II to the model name.
- G. Some lenses carry a G designation, originally inherited from Minolta's nomenclature to distinguish the best, "pro" quality optics. Lenses with the G descriptor include Sony's most costly large-aperture lenses designed for professional photographers, and are often based on updated Minolta designs. They feature ED glass, which minimizes chromatic aberration, and quiet, responsive focusing thanks to their supersonic wave motor and internal focusing.
- T* (pronounced T-Star). This designation refers to an anti-reflective optical coating developed by Carl Zeiss as a way to increase the efficiency of light transmission and reduce contrast-robbing flare caused by internal reflections.
- ZA. Many Sony lenses are based on Zeiss technology, and are given the ZA designation so you'll know your optics' illustrious heritage.

Lens Mounts and Motors

If you're new to the Sony realm, you need to know that the company markets two entirely separate lens mounts, A-mount and E-mount, with several variations on each. Many focal lengths are offered in both versions, so it's important to realize that, say, an 18-200mm E-mount lens is not an exact substitute for Sony's 18-200mm A-mount lens, and can't be used on your a68 camera. (Although, confoundingly, the *reverse* is true; you can use the vast majority of A-mount lenses on an E-mount camera, with the proper adapter.) Here's what you need to know, in a nutshell.

■ E-Mount. All Sony E-mount lenses are designed for use with the company's mirrorless product line, such as the old NEX models and current Sony Alpha axxxx (APS-C format) products like the Sony a6300. There is one variation on the basic E-Mount, the so-called FE series of lenses, intended for Sony full-frame models including the a7x series. FE lenses will work just fine on either full-frame or APS-C E-mount cameras; the physical mount is identical. Conversely, standard APS-C E-mount lenses can be used on the full-frame a7x series, too; the full-frame cameras can automatically crop the image to suit the smaller APS-C coverage circle. Instead of, say, 42 megapixels, you might end up with a cropped 18-megapixel image when using an APS-C lens on a full-frame mirrorless a7R II camera. None of these lenses can be used with the a68, so you should avoid buying, borrowing, or otherwise acquiring them for your personal use. I'm including this description here solely for reference.

■ A-Mount. The A-mount lenses are all descended from the original Minolta autofocus mount introduced in 1985. Virtually all A-mount optics can be used with your a68, as well as earlier SLT and compatible cameras past and future. Just as with the mirrorless lens lineup, A-mount lenses are available in both full-frame and APS-C formats. You can use either type with your a68, subject to the potential quality differences that derive from using lenses not designed for digital sensors, as I pointed out in the DT discussion earlier.

The majority of the available full-frame lenses are either original Minolta or Konica Minolta branded optics, or Sony badged holdovers. These are generally designed for film cameras, and can be used on A-mount full-frame models (such as the Sony SLT-A99). Sony also introduces new full-frame lenses. I tend to purchase mine from keh.com, which has a wonderful treasure trove of mint Minolta lenses at bargain prices. The fabled 70-210mm f/4 "beercan" Minolta lens is a favorite of mine, especially since, on the a68, it has a useful 105-315mm equivalent focal length. I also love my Minolta 100-400mm f/4.5-6.7 zoom (see Figure 9.4), a versatile optic that cost me about \$400 in near-mint condition. It's slow, but performs well at f/8 to f/11.

Figure 9.4 Minolta lenses like this 100-400mm f/4.5-6.7 zoom are bargains for a68 owners.

Other important differences among A-mount lenses include how they achieve autofocus, and whether they can communicate fully with the camera. In their original and most basic configuration (that is, the original Minolta lenses), a set of electronic contacts on the rear of the lens allowed the camera to adjust the aperture based on the camera's exposure calculations. In use, the camera generally calculates exposure and focuses with the lens set to its widest aperture, and then stops down to the "taking" aperture automatically at the moment of exposure. A-mount lenses don't have (or need) an aperture ring to adjust the f/stop, like some other camera systems.

Focus, on the other hand, is achieved in one of two ways. With the original Minolta design, which was carried over for decades, an autofocus motor built into the body of all Minolta, Konica Minolta, and Sony cameras physically twists a screwdriver-style blade in the lens mount that mates with a matching slot on the mount of the lens. All this system did was achieve autofocus, thanks to the camera body's phase detect AF system (described in Chapter 6), which manipulated the lens's focusing elements until the system deemed the image sharp.

The original screw-drive system worked and was, for the most part, fast enough, but was noisy and did not tell the camera the exact (or approximate) distance between the camera and the subject that was in focus. In time, lenses with autofocus motors *in the lens itself* were introduced. They tended to be faster and quieter (although not always), and extra contacts on the back of the lens/mount allowed full communication between the camera and optics. Advanced Distance Integration (described earlier), let the camera know the distance to the subject, resulting in better flash exposures, especially when shiny backgrounds that could fool the TTL exposure system were involved.

Currently, Sony offers two types of in-lens autofocus motors:

- SSM/SSM II (SuperSonic Motor). This is the high-end AF motor, and is especially well suited for longer telephoto lenses, such as the Sony 300mm f/2.8 optic, because such lenses can tax the capabilities of a screwdriver system not designed for heavy-duty applications. SSM lenses are fast-focusing and quiet, which makes them a good choice for video, concert photography, and sports.
- SAM/SAM II (Smooth Autofocus Motor). The SAM system is less expensive to produce, which is why you'll find it on more Sony lenses, particularly the less costly optics. It's not as fast or quiet as the SSM motors, but does generally produce less noise than lenses that use the inbody screwdriver focus mechanism. They would not be my first choice for video, but, as the Stones have been saying (for almost 50 years!), you can't always get what you want.

Your First Lens

The Sony a68 is most often purchased with a lens, sometimes the SAL-18552 DT 18-55mm f/3.5-5.6 SAM II zoom lens, which adds only about \$100 to the price tag of the body alone, or available separately for \$220, and is thus an irresistible bargain. But there are better choices as a first lens, such as a 16-50mm f/2.8 or a pair of wide to medium telephoto lenses I'll describe shortly. You can also buy the a68 as a body alone, like I did, because I already had a cupboard full of compatible lenses. So, you'll need to make a decision about what lens to buy, or decide what other kind of lenses you need to fill out your complement of Sony optics. This section will cover "first lens" concerns, while later in the chapter we'll look at "add-on lens" considerations.

When deciding on a first lens, there are several factors you'll want to consider:

■ Cost. Even with a relatively low-cost camera body (especially for one with a 24M sensor!), you might have stretched your budget a bit to purchase your a68, so you might want to keep the cost of your first lens fairly low. Fortunately, there are excellent lenses available that will add from \$100 to \$300 to the price of your camera if purchased at the same time. Bundled prices and rebates can make better-quality lenses available at reasonable cost. Others cost a little more, but have very desirable features.

- Zoom range. If you have only one lens, you'll want a fairly long zoom range to provide as much flexibility as possible. Once you "graduate" from the 18-55mm kit lens, you'll find several other (pricey) options. For example, one of the most popular basic lenses for the Alpha, the DT 18-250mm f/3.5-6.3 and the DT 18-200mm f/3.5-6.3 optics have 11.0X to an astounding 13.8X zoom ranges, with both extending from moderate wide-angle/normal out to long telephoto. These lenses are fine for everyday shooting, portraits, and some types of sports. They're not cheap, starting at about \$650, but may be worth the cost to you if such a long range is desirable.
- Adequate maximum aperture. You'll want an f/stop of at least f/3.5 to f/4 for shooting under fairly low light conditions. The thing to watch for is the maximum aperture when the lens is zoomed to its telephoto end. You may end up with no better than an f/6.3 maximum aperture if you buy a kit lens. That's not great, but you can often live with it.
- Image quality. Your starter lens should have good image quality, because that's one of the primary factors that will be used to judge your photos. Even at a low price, the 18-55mm lens sold with the Alpha as a kit includes two aspherical elements that minimize distortion and chromatic aberration; it's plenty sharp enough for most applications.
- Size matters. A good walking-around lens is compact in size and light in weight.
- Fast/close focusing. Your first lens should have a speedy autofocus system. Close focusing (to 12 inches or closer) will let you use your basic lens for some types of macro photography.

Buy Now, Expand Later

The a68 is commonly available with several good, basic lenses that can serve you well as a "walk-around" lens (one you keep on the camera most of the time, especially when you're out and about without your camera bag). The number of options available to you is actually quite amazing when you consider third-party lenses, even if your budget is limited to about \$100 to \$400 for your first lens. For a camera like the a68, many are turning to a lens with a longer zoom range, such as the 18-200mm zoom (see Figure 9.5). Because so many older Sony lenses are available at bargain prices (from keh.com and others), I'm going to include some discontinued optics in my overview. Sony's best-bet first lenses are as follows:

- Sony SAL-18552 DT 18-55mm f/3.5-5.6 zoom lens. This lens is sharp, small in size, and is fast enough at the wide-angle end of its zoom range for most available light shooting. Priced at \$220 if purchased separately, this lens is an all-around good choice.
- Sony SAL1650 DT 16-50mm f/2.8 SSM zoom lens. At the other end of the price scale for this basic focal length range is this \$800 specimen, which boasts a large constant maximum aperture (that is, it is an f/2.8 lens at 50mm, while the 18-55 kit lens is *two* stops slower at 55mm), and excellent sharpness. If you have the money, this is a good "starter" lens.

Figure 9.5
The older DT
18-200mm f/3.5-6.3
zoom is a versatile
lens with an 11X
zoom range.

- Sony SAL-24105 24-105mm f/3.5-4.5 zoom lens. This discontinued lens is not inexpensive at about \$500, but, if you can find one, it may be a smart choice if you intend to shoot indoor or outdoor sports. It's faster at its longest focal length, and provides the equivalent of a moderate wide angle to short telephoto 5X zoom in one compact lens.
- Sony SAL-18250 18-250mm f/3.5-6.3 high-magnification zoom lens. If you have \$650 to spare, this lens is truly a do-everything lens with a near-14X zoom range that takes you from true wide angle to long telephoto in one swoop. It's great for sports, landscapes, and portraits, even though a bit slow at f/6.3 at the telephoto end. Sony also offers the similar, slightly smaller SAL-18200 18-200mm f/3.5-6.3 lens for about \$50 less.
- Sony SAL-18200 18-200mm f/3.5-6.3. I purchased this lens some time ago for use with my APS-C format A-mount cameras, and have been very pleased with it. It's slightly smaller and a bit lighter than the SAL-18250, but if you can find one it carries a reasonable price tag, making it an affordable all-in-one compact zoom lens. I like the bokeh its circular aperture provides at large lens openings, but it is a bit slow at f/6.3 when cranked out to the 200mm zoom setting.
- Sony SAL-16105 DT 16-105mm f/3.5-5.6 zoom lens. Slightly wider and with twice as much telephoto reach as the kit lens, this one will let you shoot landscapes, portraits, and some sports with equal ease, and is more compact than the 18-250/18-200 lenses, while still being affordable to the serious photographer at \$700. It focuses as close as 1.25 feet. This is another upgrade from the kit lens that serious photographers will appreciate.

- Sony SAL-1680Z Carl Zeiss Vario-Sonnar T* DT 16-80mm f/3.5-4.5 zoom lens. Slightly wider and longer than the kit lens, and a tad faster when fully zoomed, this one should be your first "pro" lens. It is remarkably compact, and has the famed Carl Zeiss image quality and rugged mechanics. Buy this if you're looking to work your lenses hard without compromising quality, and are willing to compromise your budget with its \$900 price tag.
- Sony SAL-55200 DT 55-200mm f/4-5.6 telephoto zoom lens. One main advantage of this lens is its low cost—about \$150. Mated with the 18-55mm kit lens, you're covered for focal lengths from wide to long telephoto at a very attractive price.
- Sony SAL-75300 75-300mm f/4.5-5.6 telephoto zoom lens. This older, hard-to-find lens is another \$250 bargain, but sacrifices some of the short telephoto range (55-70mm) for a longer reach, out to a long 300mm. (Remember, a 300mm focal length on an a68 is the equivalent of 450mm on a full-frame camera—truly super-telephoto range.) This is a compact lens (weighing just 18 ounces) that also can be used with any full-frame camera Sony might introduce in the future. It focuses as close as 5 feet at 300mm, which allows you to shoot skittish creatures (and humans) from a non-threatening distance.
- Sony SAL-2470Z Carl Zeiss Vario-Sonnar T* 24-70mm f/2.8 SSM zoom lens. If you have \$1,998 or more to spare, this lens is truly wonderful in terms of image quality and speed. It's great for sports, landscapes, and portraits.
- Sony SAL-2875 28-75mm f/2.8 zoom lens. Half the price of the 24-70mm Zeiss lens (around \$900), this one weighs a third less, too, at 20 ounces, and makes a great all-around zoom.

Your Second (and Third...) Lens

There are really only two advantages to owning just a single lens. One of them is creativity. Keeping one set of optics mounted on your a68 all the time forces you to be especially imaginative in your approach to your subjects. I once visited Europe with only a single camera body and a 35mm f/2 lens. The experience was actually quite exciting, because I had to use a variety of techniques to allow that one lens to serve for landscapes, available-light photos, action, close-ups, portraits, and other kinds of images. Sony makes an excellent "35mm" lens (actually, it's the SAL-20F28 20mm f/2.8 wide-angle lens, which provides the equivalent field of view on the Sony APS-C). At \$700, this lens is expensive—and very sharp. It focuses down to 9.5 inches, and would be perfect for my Europe experiment today, although my personal choice would be the sublime SAL-35F15G 35mm f/1.4 lens, which is a little longer and a lot more expensive at \$1,400.

Of course, it's more likely that your "single" lens is actually a zoom, which is, in truth, many lenses in one, taking you from, say, 16mm to 80mm (or some other range) with a rapid twist of the zoom ring. You'll still find some creative challenges when you stick to a single zoom lens's focal lengths.

The second advantage of the unilens camera is only a marginal technical benefit since the introduction of the Sony Alpha. If you don't exchange lenses, the chances of dust and dirt getting inside your Alpha and settling on the sensor are reduced (but *not* eliminated entirely). Although I've known some photographers who minimized the number of lens changes they made for this very reason, reducing the number of lenses you work with is not a productive or rewarding approach for most of us. The Alpha's automatic sensor cleaning feature has made this "advantage" much less significant than it was in the past.

It's more likely that you'll succumb to the malady known as *Lens Lust*, which is defined as an incurable disease marked by a significant yen for newer, better, longer, faster, sharper, anything-er optics for your camera. (And, it must be noted, this disease can *cost* you significant yen—or dollars, or whatever currency you use.) In its worst manifestations, sufferers find themselves with lenses that have overlapping zoom ranges or capabilities, because one or the other offers a slight margin in performance or suitability for specific tasks. When you find yourself already lusting after a new lens before you've really had a chance to put your latest purchase to the test, you'll know the disease has reached the terminal phase.

Your Wide Angle/Normal Options

Here's a (very) quick overview of some of the more desirable wide angle to normal lenses that I haven't already mentioned.

- Sony SAL50F18 DT 50mm f/1.8 SAM. This is an inexpensive (less than \$200) fast normal lens, and it can be used as a macro lens with an extension tube set. It's an affordable choice for night street photography and other low-light situations.
- Sony SAL30M28 DT 30mm f/2.8 SAM. I bought this sub-\$200 macro lens specifically for use in taking "product" shots for my books using the a68's highly useful focus peaking feature.
- Sony SAL50M28 50mm f/2.8 Macro. This is your more expensive macro option at around \$600, and is suited for the most exacting close-up work. It provides a moderate working distance from your subject so that avoiding shadows will be less of a problem.
- Sony SAL1118 DT 11-18mm f/4.5-5.6. At \$800 or less, this is your best (and only) Sony option for extra wide-angle zoom coverage. I love this lens for architecture, landscapes, and indoor sports that can benefit from a wide perspective—such as martial arts or wrestling photos taken from mat level.
- Sony SAL50F14 50mm f/1.4. Relatively inexpensive for an f/1.4 lens at \$450, this rebadged Minolta holdover stands up surprisingly well in comparison to its pricier Zeiss rival, described next. I originally purchased this lens for use on my old Sony DSLR-A850, as my first (of many) full-frame A-mount lenses. (See Figure 9.6.)

- Sony SAL50F14Z Planar T* 50mm 1.4 ZA lens. At \$1,500 it costs three times as much as the old Minolta-based version, but has that impeccable Zeiss build and image quality. If you won't settle for less than the best, this is it.
- Sony SAL16F28 16mm f/2.8 Fisheye. This \$999 optic will please those looking for a fast fisheye lens with decent image quality, and lots of distortion. It's quite a bit sharper than the third-party alternatives from Sigma, Rokinon, and others.
- Sony SAL24F20Z Distagon T* 24mm f/2 ZA SSM lens. It's \$1,300, and only does one thing: gives you Zeiss quality in a wide angle with a fast f/2 maximum aperture. This would be a basic lens for photojournalists, and, as a bonus, it's one of a good selection of Sony lenses that are fully compatible with A-mount full-frame cameras, should you ever upgrade to the a99 or its expected successors.
- Sony SAL1635Z Vario Sonnar T* 16-35mm f2.8 ZA SSM. This optic is the professional or well-heeled amateur photographer's bread-and-butter lens for photojournalism, landscapes, wedding, and urban scenes. A stop slower but more versatile than its 24mm f/2 prime cousin, your \$2,000 buys you an f/2.8 constant aperture and fast SSM focusing in a very useful focal length range for your a68 or any full-frame camera you purchase in the future.

Longer Lenses

Prices start to go up quickly when you get into the longer focal lengths, especially since Sony sprinkles in a generous helping of Zeiss optics in this range.

■ Sony SAL55300 DT 55-300 f/4.5-5.6 SAM. This \$300 lens is the least expensive way to jump into the short telephoto to supertelephoto range. With an f/4.5 maximum aperture, it's likely to be the slowest 55mm lens you ever use, but the f/5.6 maximum aperture at 300mm is still usable under bright sunlight.

- Sony SAL18135 DT 18-135 f/3.5-5.6 SAM. This mild wide-angle-to-medium tele lens is also hampered by its relatively stingy maximum aperture at 135mm, but its \$500 price tag is relatively reasonable given the lack of acceptable alternatives. Unless you need a walk-around lens in this range, I'd recommend pairing the 18-55mm kit lens and the 55-300mm zoom for a greater range at almost the same total price, with only the need to switch lenses as a serious drawback.
- Sony SAL70300G2 70-300 f/4.5-5.6 G SSM II. A relatively new lens, this replacement for an earlier G lens has improved optics and autofocus, covers the range sports photographers and others who work primarily with telephotos, and is quite affordable at \$1,150.
- Sony SAL85F28 85mm f/2.8 / Sony SAL85F14Z Planar T* 85mm f1.4 ZA. Sony offers two prime lenses with an 85mm focal length. The older f/2.8 version, at less than \$300, is the one you can afford; the \$1,700 f/1.4 Zeiss Planar is the one you really want. The Zeiss has wonderful bokeh that makes it ideal for portraits with creamy backgrounds, and is quite sharp wide open or closed down a stop.
- Sony SAL100M28 100mm f/2.8 macro. When photographing skittish bugs and other critters, or when encountering difficult lighting conditions, it's often best to move back a bit for your close-up photos. The extra distance, plus reduced depth-of-field of this 100mm f/2.8 lens, can be ideal in such situations. If you need its features, this lens's \$800 price won't be much of an obstacle.
- Sony SAL135F28 135mm 2.8 STF. This manual focus Minolta/Sony legacy lens, with "smooth transition focus" has been called the "ultimate cream machine." If you want beautiful bokeh (the blur of out-of-focus areas), this optic is worth every penny of its \$1,400 price. Don't confuse the STF lens with ordinary soft focus or defocus control optics; this lens is designed from the ground up with an *apodization* lens element to smooth out-of-focus areas. Apodization uses a concave neutral-gray lens element as a filter to optimize bokeh. It's marked in T-stops from T/4.5 to T/6.7 for accurate exposure control.
- Sony SAL135F18Z Sonar T*135mm f/1.8 ZA. I like the shallow depth-of-field of this lens's maximum aperture for sports photography, since it's roughly equivalent of a 202mm f/1.8 lens on a full-frame camera in terms of field of view. That's almost a tad too long for portraits, but I'd like it for three-quarter-length shots, or even some head-and-shoulders captures. The prices for the lenses I'm listing start to climb from this point on, and this one sells for around \$1,800.
- Sony SAL70400G 70-400mm f/4-5.6 SSM. This \$2,000 lens, if you can find one, is great for sports photography, as it gives the shooter the flexibility to follow action from the short telephoto to super telephoto range, and it has a usable f/5.6 maximum aperture even at 400mm.
- Sony SAL70400G2 70-400mm f/4-5.6 G SSM II. The older version of this lens can sometimes be found for several hundred dollars cheaper, but this newer version at \$2,200 is ideal for field sports and wildlife photography.

- Sony SAL70200G2 70-200mm f/2.8G SSM II. I once estimated that 80 percent of what I shoot can be captured with a 70-200mm lens, making it easier to justify this \$3,000 optic. For my personal shooting, I admit I more often turn to Sony's 70-200mm f/4 FE lens with my full-frame and APS-C mirrorless Sony cameras. But this would be my dream lens if I were working with the a68 exclusively.
- Sony SAL300F28G2 300mm f/2.8 G SSM II. Full-time professional sports photographers working with the Sony platform count this \$7,500 lens as their basic lens for football, soccer, track, lacrosse, hockey, and similar sports. While Canon and Nikon still dominate the field, this updated lens may help convince some converts.
- Sony SALF4G 500mm f/4 G SSM. You won't see many of these \$13,000 lenses in amateur hands, other than through rental avenues, but this lens can't be beat for sports and wildlife photography, especially when the animals on the field or on the veldt pose potential dangers for the shooter. Me, I'm sticking to my old Minolta 500mm f/8 AF mirror lens, which is still available for around \$500 to \$600 from Amazon, KEH, and others.

What Lenses Can Do for You

A saner approach to expanding your lens collection is to consider what each of your options can do for you and then choosing the type of lens that will really boost your creative opportunities. Here's a general guide to the sort of capabilities you can gain by adding a lens to your repertoire.

- Wider perspective. Your 18-55mm f/3.5-5.6 lens has served you well for moderate wide-angle shots. Now you find your back is up against a wall and you can't take a step backward to take in more subject matter. Perhaps you're standing on the rim of the Grand Canyon, and you want to take in as much of the breathtaking view as you can. You might find yourself just behind the baseline at a high school basketball game and want an interesting shot with a little perspective distortion tossed in the mix. There's a lens out there that will provide you with what you need, such as the SAL-1118, DT 11-18mm f/4.5-5.6 super-wide zoom lens or SAL-16F28 16mm f/2.8 fisheye lens. Your extra-wide choices may not be abundant, but they are there. Figure 9.7, upper left shows the perspective you get from an ultra-wide-angle lens.
- Bring objects closer. A long lens brings distant subjects closer to you, offers better control over depth-of-field, and avoids the perspective distortion that wide-angle lenses provide. They compress the apparent distance between objects in your frame. In the telephoto realm, Sony is right in the ballgame, with lenses like the telephoto zooms I mentioned earlier to some super highend models like the SAL-70200G 70-200mm f/2.8 G-series telephoto zoom. Remember that the Sony Alpha's crop factor narrows the field of view of all these lenses, so your 70-200mm lens looks more like a 105mm-300mm zoom through the viewfinder. Figure 9.7 lower center and upper right were taken from the same position, but with an 85mm and 500mm focal length, respectively.

Figure 9.7 An ultra-wide-angle lens, an 85mm telephoto, and a 500mm super-telephoto provided these views of the old and new cathedrals in Salamanca, Spain.

- Bring your camera closer. Sony has three excellent close-up lenses, the SAL-30M28 30mm f/2.8 macro lens (which I mounted on my SLT-A58 to capture most of the shots of the a68 and its lenses that you see in this book), the SAL-50M28 50mm f/2.8 macro lens, and the SAL-100M28 100mm f/2.8 macro lens. The 30mm lens is most reasonably priced, but the 50mm and 100mm versions are not out of order for someone who wants to shoot close-up subjects but wants to stay farther away from a subject to provide more flexibility in lighting and enough distance to avoid spooking small wildlife.
- Look sharp. Many lenses, particularly the higher-priced Sony optics, are prized for their sharpness and overall image quality. While your run-of-the-mill lens is likely to be plenty sharp for most applications, the very best optics are even better over their entire field of view (which means no fuzzy corners), are sharper at a wider range of focal lengths (in the case of zooms), and have better correction for various types of distortion. That, along with a constant f/2.8 aperture, is why the 70-200mm f/2.8 lens I mentioned earlier sells for so much.
- More speed. Your basic telephoto lens might have the perfect focal length and sharpness for sports photography, but the maximum aperture won't cut it for night baseball or football games, or, even, any sports shooting in daylight if the weather is cloudy or you need to use some ungodly fast shutter speed, such as 1/4000th second. You might be happier with the Sony SAL-135F18Z Carl Zeiss Sonnar T* 135mm f/1.8 telephoto lens, used to capture Figure 9.8.

Figure 9.8 A fast lens can be useful for available-light photography under dim conditions, as you can see from this shot, taken in an indoor arena.

Zoom or Prime?

Zoom lenses have changed the way serious photographers take pictures. One of the reasons that I own 12 SLR film bodies is that in ancient times it was common to mount a different fixed focal length prime lens on various cameras and take pictures with two or three cameras around your neck (or tucked in a camera case) so you'd be ready to take a long shot or an intimate close-up or wide-angle view on a moment's notice, without the need to switch lenses. It made sense (at the time) to have a bunch of bodies (two to use, one in the shop, one in transit, and a collection of backups). Zoom lenses of the time had a limited zoom range, were heavy, and not very sharp (especially when you tried to wield one of those monsters hand-held).

That's all changed today. Lenses like the sharp Sony lenses I've already described, including the top-of-the-line Carl Zeiss optics, have zoom ranges up to 13.8X, and are light in weight. The best zooms might seem expensive, but they are actually much less costly than the six or so lenses replaced. When selecting between zoom and prime lenses, there are several considerations to ponder. Here's a checklist of the most important factors. I already mentioned image quality and maximum aperture earlier, but those aspects take on additional meaning when comparing zooms and primes.

- Logistics. As prime lenses offer just a single focal length, you'll need more of them to encompass the full range offered by a single zoom. More lenses mean additional slots in your camera bag, and extra weight to carry. Even so, you might be willing to carry an extra prime lens or two in order to gain the speed or image quality that lens offers.
- Image quality. Prime lenses usually produce better image quality at their focal length than even the most sophisticated zoom lenses at the same magnification. Zoom lenses, with their shifting elements and f/stops that can vary from zoom position to zoom position, are in general more complex to design than fixed focal length lenses. That's not to say that the very best prime lenses can't be complicated as well. However, the exotic designs, aspheric elements, and other tweaks can be applied to improving the quality of the lens, rather than wasting a lot of it on compensating for problems caused by the zoom process itself. Figure 9.9 shows an image taken with an 85mm f/1.8 telephoto prime lens at f/4. With a zoom lens, shooting at f/4 would require using the maximum aperture, which is generally not the sharpest f/stop for a zoom. The same f/4 aperture on the prime lens allowed closing down the aperture more than one full stop, producing a sharper image under the same lighting conditions.
- Maximum aperture. Because of the same design constraints, zoom lenses usually have smaller maximum apertures than prime lenses, and the most affordable zooms have a lens opening that grows effectively smaller as you zoom to the telephoto position. The difference in lens speed verges on the ridiculous at some focal lengths. For example, the 18mm-55mm basic zoom gives you an f/5.6 medium telephoto lens when zoomed all the way out, while prime lenses in the 50-55mm focal length commonly have f/1.8 or faster maximum apertures. Indeed, the fastest Sony lenses are all primes, and if you require speed, a fixed focal length lens is what you should rely on.

■ **Speed.** Using prime lenses takes time and slows you down. It takes a few seconds to remove your current lens and mount a new one, and the more often you need to do that, the more time is wasted. If you choose not to swap lenses, when using a fixed focal length lens, you'll still have to move closer or farther away from your subject to get the field of view you want. A zoom lens allows you to change magnifications and focal lengths with the twist of a ring and generally saves a great deal of time.

Figure 9.9 An 85mm f/1.8 lens was perfect for this hand-held photo of Rock and Roll Hall of Famer Dave Mason.

Categories of Lenses

Lenses can be categorized by their intended purpose—general photography, macro photography, and so forth—or by their focal length. The range of available focal lengths is usually divided into three main groups: wide-angle, normal, and telephoto. Prime lenses fall neatly into one of these classifications. Zooms can overlap designations, with a significant number falling into the catchall wide-to-telephoto zoom range. This section provides more information about focal length ranges, and how they are used.

Any lens with an equivalent focal length of 10mm to 20mm is said to be an *ultra-wide-angle lens*; from about 20mm to 40mm (equivalent) is said to be a *wide-angle lens*. Normal lenses have a focal length roughly equivalent to the diagonal of the film or sensor, in millimeters, and so fall into the range of about 45mm to 60mm (on a full-frame camera). Telephoto lenses usually fall into the 75mm and longer focal lengths, while those from about 300mm to 400mm and longer often are referred to as *super-telephotos*.

Using Wide-Angle and Wide-Zoom Lenses

To use wide-angle prime lenses and wide zooms, you need to understand how they affect your photography. Here's a quick summary of the things you need to know.

- More depth-of-field. Practically speaking, wide-angle lenses offer more depth-of-field at a particular subject distance and aperture. (But see the following sidebar for an important note.) You'll find that helpful when you want to maximize sharpness of a large zone, but not very useful when you'd rather isolate your subject using selective focus (telephoto lenses are better for that).
- Stepping back. Wide-angle lenses have the effect of making it seem that you are standing farther from your subject than you really are. They're helpful when you don't want to back up, or can't because there are impediments in your way.
- Wider field of view. While making your subject seem farther away, as implied above, a wideangle lens also provides a larger field of view, including more of the subject in your photos.

DOF IN DEPTH

The depth-of-field advantage of wide-angle lenses is diminished when you enlarge your picture; believe it or not, a wide-angle image enlarged and cropped to provide the same subject size as a telephoto shot would have the *same* depth-of-field. Try it: take a wide-angle photo of a friend from a fair distance, and then zoom in to duplicate the picture in a telephoto image. Then, enlarge the wide shot so your friend is the same size in both. The wide photo will have the same depth-of-field (and will have much less detail, too).

- wider lens and you'll discover that your lawn now makes up much more of the photo. So, wideangle lenses are great when you want to emphasize that lake in the foreground, but problematic when your intended subject is located farther in the distance.
- Super-sized subjects. The tendency of a wide-angle lens to emphasize objects in the fore-ground, while de-cmphasizing objects in the background, can lead to a kind of size distortion that may be more objectionable for some types of subjects than others. Shoot a bed of flowers up close with a wide angle, and you might like the distorted effect of the larger blossoms nearer the lens. Take a photo of a family member with the same lens from the same distance, and you're likely to get some complaints about that gigantic nose in the foreground.
- Perspective distortion. When you tilt the camera so the plane of the sensor is no longer perpendicular to the vertical plane of your subject, some parts of the subject are now closer to the sensor than they were before, while other parts are farther away. So, buildings, flagpoles, or towering interior subjects appear to be falling backward (as in Figure 9.10). While this kind of apparent distortion (it's not caused by a defect in the lens) can happen with any lens, it's most apparent when a wide angle is used.
- Steady cam. You'll find that you can more easily hand-hold a wide-angle lens at slower shutter speeds, without need for SteadyShot, than you can with a telephoto lens. The reduced magnification of the wide-lens or wide-zoom setting doesn't emphasize camera shake like a telephoto lens does.
- Interesting angles. Many of the factors already listed combine to produce more interesting angles when shooting with wide-angle lenses. Raising or lowering a telephoto lens a few feet probably will have little effect on the appearance of the distant subjects you're shooting. The same change in elevation can produce a dramatic effect for the much-closer subjects typically captured with a wide-angle lens or wide-zoom setting.

Avoiding Potential Wide-Angle Problems

Wide-angle lenses have a few quirks that you'll want to keep in mind when shooting so you can avoid falling into some common traps. Here's a checklist of tips for avoiding common problems:

■ Symptom: converging lines. Unless you want to use wildly diverging lines as a creative effect, it's a good idea to keep horizontal and vertical lines in landscapes, architecture, and other subjects carefully aligned with the sides, top, and bottom of the frame. That will help you avoid undesired perspective distortion. Sometimes it helps to shoot from a slightly elevated position so you don't have to tilt the camera up or down.

 $\textbf{Figure 9.10} \ \ \textbf{Tilting the camera back produces this "falling back" look in architectural photos.}$

- Symptom: color fringes around objects. Lenses are often plagued with fringes of color around backlit objects, produced by *chromatic aberration*, which comes in two forms: *longitudinal/axial*, in which all the colors of light don't focus in the same plane, and *lateral/transverse*, in which the colors are shifted to one side. Axial chromatic aberration can be reduced by stopping down the lens, but transverse chromatic aberration cannot. Both can be reduced if you purchase lenses with low diffraction index glass and which incorporate elements that cancel the chromatic aberration of other glass in the lens. For example, a strong positive lens made of low-dispersion crown glass (made of a soda-lime-silica composite) may be mated with a weaker negative lens made of high-dispersion flint glass, which contains lead.
- Symptom: lines that bow outward. Some wide-angle lenses cause straight lines to bow outward, with the strongest effect at the edges. In fisheye (or *curvilinear*) lenses, this defect is a feature, as you can see in Figure 9.11. When distortion is not desired, you'll need to use a lens that has corrected barrel distortion. Manufacturers like Sony do their best to minimize or eliminate it (producing a *rectilinear* lens), often using *aspherical* lens elements (which are not cross-sections of a sphere). You can also minimize barrel distortion simply by framing your photo with some extra space all around, so the edges where the defect is most obvious can be cropped out of the picture.

Figure 9.11 Many wide-angle lenses cause lines to bow outward toward the edges of the image; with a fisheye lens, this tendency is considered an interesting feature.

- Symptom: dark corners and shadows in flash photos. The Sony Alpha's built-in electronic flash is designed to provide even coverage for fairly wide lenses. If you use a wider lens, you can expect darkening, or *vignetting*, in the corners of the frame. At wider focal lengths, the lens hood of some lenses (my 16mm-80mm f/3.5-4.5 zoom lens is a prime offender) can cast a semicircular shadow in the lower portion of the frame when using the built-in flash. Sometimes removing the lens hood or zooming in a bit can eliminate the shadow. Mounting an external flash unit can solve both problems. Its higher vantage point eliminates the problem of lens hood shadow, too.
- Symptom: light and dark areas when using a polarizing filter. If you know that polarizers work best when the camera is pointed 90 degrees away from the sun and have the least effect when the camera is oriented 180 degrees from the sun, you know only half the story. With lenses having a focal length of 10mm to 18mm (the equivalent of 16mm-28mm), the angle of view (107 to 75 degrees diagonally, or 97 to 44 degrees horizontally) is extensive enough to cause problems. Think about it: when a 10mm lens is pointed at the proper 90-degree angle from the sun, objects at the edges of the frame will be oriented at 135 to 41 degrees, with only the center at exactly 90 degrees. Either edge will have much less of a polarized effect. The solution is to avoid using a polarizing filter with lenses having an actual focal length of less than 18mm (or 28mm equivalent).

Using Telephoto and Tele-Zoom Lenses

Telephoto lenses also can have a dramatic effect on your photography, and Sony is especially strong in the long-lens arena, with lots of choices in many focal lengths and zoom ranges. You should be able to find an affordable telephoto or tele-zoom to enhance your photography in several different ways. Here are the most important things you need to know. In the next section, I'll concentrate on telephoto considerations that can be problematic—and how to avoid those problems.

- Selective focus. Long lenses have reduced depth-of-field within the frame, allowing you to use selective focus to isolate your subject. You can open the lens up wide to create shallow depth-of-field, or close it down a bit to allow more to be in focus. The flip side of the coin is that when you want to make a range of objects sharp, you'll need to use a smaller f/stop to get the depth-of-field you need. Like fire, the depth-of-field of a telephoto lens can be friend or foe. Figure 9.12 shows an iguana in its "natural" habitat (the Bioparc zoo in Valencia, Spain), photographed using a short telephoto lens and wider f/stop to de-emphasize the background.
- **Getting closer.** Telephoto lenses bring you closer to wildlife, sports action, and candid subjects. No one wants to get a reputation as a surreptitious or "sneaky" photographer (except for paparazzi), but when applied to candids in an open and honest way, a long lens can help you capture memorable moments while retaining enough distance to stay out of the way of events as they transpire.

- Reduced foreground/increased compression. Telephoto lenses have the opposite effect of wide angles: they reduce the importance of things in the foreground by squeezing everything together. This compression even makes distant objects appear to be closer to subjects in the foreground and middle ranges. You can use this effect as a creative tool.
- Accentuates camera shakiness. Telephoto focal lengths hit you with a double-whammy in terms of camera/photographer shake. The lenses themselves are bulkier, more difficult to hold steady, and may even produce a barely perceptible seesaw rocking effect when you support them with one hand halfway down the lens barrel. Telephotos also magnify any camera shake. It's no wonder that Sony's image stabilization feature is popular when using longer lenses.
- Interesting angles require creativity. Telephoto lenses require more imagination in selecting interesting angles, because the "angle" you do get on your subjects is so narrow. Moving from side to side or a bit higher or lower can make a dramatic difference in a wide-angle shot, but raising or lowering a telephoto lens a few feet probably will have little effect on the appearance of the distant subjects you're shooting.

Figure 9.12 A wide f/stop helped isolate this iguana from its background.

Avoiding Telephoto Lens Problems

Many of the "problems" that telephoto lenses pose are really just challenges and not that difficult to overcome. Here is a list of the seven most common picture maladies and suggested solutions.

- Symptom: flat faces in portraits. Head-and-shoulders portraits of humans tend to be more flattering when a focal length of 50mm to 85mm is used. Longer focal lengths compress the distance between features like noses and ears, making the face look wider and flat. A wide angle might make noses look huge and ears tiny when you fill the frame with a face. So stick with 50mm to 85mm focal lengths or zoom settings, going longer only when you're forced to shoot from a greater distance, and wider only when shooting three-quarters/full-length portraits, or group shots.
- Symptom: blur due to camera shake. First, make sure you have SteadyShot turned on! Then, if possible, use a higher shutter speed (boosting ISO if necessary), or mount your camera on a tripod, monopod, or brace it with some other support. Of those three solutions, only the second will reduce blur caused by *subject* motion; SteadyShot or a tripod won't help you freeze a racecar in mid-lap.
- Symptom: color fringes. Chromatic aberration is the most pernicious optical problem found in telephoto lenses; it can be partially fixed using the a68's lens correction features found in the Custom Settings 6 menu and described in Chapter 4. There are others, including spherical aberration, astigmatism, coma, curvature of field, and similarly scary-sounding phenomena. The best solution for any of these is to use a better lens that offers the proper degree of correction, or stop down the lens to minimize the problem. But that's not always possible. Your second-best choice may be to correct the fringing in your favorite RAW conversion tool or image editor. Photoshop's Lens Correction filter offers sliders that minimize both red/cyan and blue/yellow fringing.
- Symptom: lines that curve inward. Pincushion distortion is found in many telephoto lenses. You might find after a bit of testing that it is worse at certain focal lengths with your particular zoom lens. Like chromatic aberration, it can be partially corrected using tools like Photoshop's Lens Correction filter.
- Symptom: low contrast from haze or fog. When you're photographing distant objects, a long lens shoots through a lot more atmosphere, which generally is muddied up with extra haze and fog. That dirt or moisture in the atmosphere can reduce contrast and mute colors. Some feel that a skylight or UV filter can help, but this practice is mostly a holdover from the film days. Digital sensors are not sensitive enough to UV light for a UV filter to have much effect. So you should be prepared to boost contrast and color saturation in your Creative Style menu or image editor if necessary.

- Symptom: low contrast from flare. Lenses are furnished with lens hoods for a good reason: to reduce flare from bright light sources at the periphery of the picture area, or completely outside it. Because telephoto lenses often create images that are lower in contrast in the first place, you'll want to be especially careful to use a lens hood to prevent further effects on your image (or shade the front of the lens with your hand).
- Symptom: dark flash photos. Edge-to-edge flash coverage isn't a problem with telephoto lenses as it is with wide angles. The shooting distance is. A long lens might make a subject that's 50 feet away look as if it's right next to you, but your camera's flash isn't fooled. You'll need extra power for distant flash shots, and probably more power than your Alpha's built-in flash provides, unless you increase the ISO setting to ISO 3200.

Telephotos and Bokeh

Bokeh describes the aesthetic qualities of the out-of-focus parts of an image and whether out-of-focus points of light—circles of confusion—are rendered as distracting fuzzy discs or smoothly fade into the background. Boke is a Japanese word for "blur," and the h was added to keep English speakers from rendering it monosyllabically to rhyme with broke. Although bokeh is visible in blurry portions of any image, it's of particular concern with telephoto lenses, which, thanks to the magic of reduced depth-of-field, produce more obviously out-of-focus areas.

Bokeh can vary from lens to lens, or even within a given lens depending on the f/stop in use. Bokeh becomes objectionable when the circles of confusion are evenly illuminated, making them stand out as distinct discs, or, worse, when these circles are darker in the center, producing an ugly "doughnut" effect. A lens defect called spherical aberration may produce out-of-focus discs that are brighter on the edges and darker in the center, because the lens doesn't focus light passing through the edges of the lens exactly as it does light going through the center. (Mirror or *catadioptric* lenses also produce this effect.)

Other kinds of spherical aberration generate circles of confusion that are brightest in the center and fade out at the edges, producing a smooth blending effect, as you can see at right in Figure 9.13. Ironically, when no spherical aberration is present at all, the discs are a uniform shade, which, while better than the doughnut effect, is not as pleasing as the bright center/dark edge rendition. The shape of the disc also comes into play, with round smooth circles considered the best, and nonagonal or some other polygon (determined by the shape of the lens diaphragm) considered less desirable. Most Sony lenses have near-circular irises, producing very pleasing bokeh.

If you plan to use selective focus a lot, you should investigate the bokeh characteristics of a particular lens before you buy. Sony user groups and forums will usually be full of comments and questions about bokeh, so the research is fairly easy.

Figure 9.13 Bokeh is less pleasing when the discs are prominent (left), and less obtrusive when they blend into the background (right).

Add-ons and Special Features

Once you've purchased your telephoto lens, you'll want to think about some appropriate accessories for it. There are some handy add-ons available that can be valuable. Here are a couple of them to think about.

Lens Hoods

Lens hoods are an important accessory for all lenses, but they're especially valuable with telephotos. As I mentioned earlier, lens hoods do a good job of preserving image contrast by keeping bright light sources outside the field of view from striking the lens and, potentially, bouncing around inside that long tube to generate flare that, when coupled with atmospheric haze, can rob your image of detail and snap. In addition, lens hoods serve as valuable protection for that large, vulnerable, front lens element. It's easy to forget that you've got that long tube sticking out in front of your camera and accidentally whack the front of your lens into something. It's cheaper to replace a lens hood than it is to have a lens repaired, so you might find that a good hood is valuable protection for your prized optics.

When choosing a lens hood, it's important to have the right hood for the lens, usually the one offered for that lens by Sony or the third-party manufacturer. You want a hood that blocks precisely the right amount of light: neither too much light nor too little. A hood with a front diameter that is too small can show up in your pictures as vignetting. A hood that has a front diameter that's too large isn't stopping all the light it should. Generic lens hoods may not do the job.

When your telephoto is a zoom lens, it's even more important to get the right hood, because you need one that does what it is supposed to at both the wide-angle and telephoto ends of the zoom range. Lens hoods may be cylindrical, rectangular (shaped like the image frame), or petal shaped

(that is, cylindrical, but with cutout areas at the corners that correspond to the actual image area). Lens hoods should be mounted in the correct orientation (a bayonet mount for the hood usually takes care of this).

Telephoto Extenders

Telephoto extenders, like the SAL-14TC 1.4X C-series tele-converter lens and SAL-20TC 2.0X C-series tele-converter lens multiply the actual focal length of your lens, giving you a longer telephoto for much less than the price of a lens with that actual focal length. These extenders fit between the lens and your camera and contain optical elements that magnify the image produced by the lens. Available in 1.4X and 2.0X configurations from Sony, an extender transforms, say, a 200mm lens into a 300mm or 400mm optic, respectively. Given the Alpha's crop factor, your 200mm lens now has the same field of view as a 450mm or 600mm lens on a full-frame camera. At around \$550 each, they're quite a bargain, aren't they?

Actually, there are some downsides. While extenders retain the closest focusing distance of your original lens, autofocus is maintained only if the lens's original maximum aperture is f/4 or larger (for the 1.4X extender) or f/2.8 or larger (for the 2X extender). The components reduce the effective aperture of any lens they are used with, by one f/stop with the 1.4X extender, and 2 f/stops with the 2X extender.

Macro Focusing

Some telephotos and telephoto zooms available for the Sony Alpha have particularly close-focusing capabilities, making them *macro* lenses. Of course, the object is not necessarily to get close (get too close and you'll find it difficult to light your subject). What you're really looking for in a macro lens is to magnify the apparent size of the subject in the final image. Camera-to-subject distance is most important when you want to back up farther from your subject (say, to avoid spooking skittish insects or small animals). In that case, you'll want a macro lens with a longer focal length to allow that distance while retaining the desired magnification.

Sony makes three lenses with official macro designations, in 30mm, 50mm, and 100mm focal lengths. You'll also find macro lenses, macro zooms, and other close-focusing lenses available from Sigma, Tamron, and Tokina. If you want to focus closer with a macro lens, or any other lens, you can add an accessory called an *extension tube*, like the ones shown in Figure 9.14. These add-ons move the lens farther from the focal plane, allowing it to focus more closely. You can also buy add-on close-up lenses, which look like filters, and allow lenses to focus more closely.

Although I use extension tubes for extreme close-ups, Sony's macro lenses, like the 30mm f/2.8 lens shown in Figure 9.15, do the best job for most subjects, providing close, automatic focus and a wide enough maximum aperture to allow selective focus for shots like Figure 9.16.

Figure 9.14 Extension tubes enable any lens to focus more closely to the subject.

Figure 9.15 Sony's 30mm f/2.8 macro lens.

Figure 9.16 Close focusing and a wide maximum aperture allow for selective focus effects.

SteadyShot and Your Lenses

Vendors like Nikon and Canon sell special lenses with anti-shake features built in. With your Sony Alpha a68, *every* lens you own has image stabilization. SteadyShot provides you with camera steadiness that's the equivalent of at least two or three shutter speed increments. This extra margin can be invaluable when you're shooting under dim lighting conditions or hand-holding a long lens for, say, wildlife photography. Perhaps that shot of a foraging deer calls for a shutter speed of 1/1000th second at f/5.6 with your lens. Relax. You can shoot at 1/160th second at f/11 and get virtually the same results, as long as the deer doesn't decide to bound off.

Or, maybe you're shooting a high school play without a tripod or monopod, and you'd really, really like to use 1/15th second at f/4. Assuming the actors aren't flitting around the stage at high speed, your wide-angle lens can grab the shot for you at its wide-angle position. However, keep these facts in mind:

- SteadyShot doesn't stop action. Unfortunately, no stabilization is a panacea to replace the action-stopping capabilities of a higher shutter speed. Image stabilization applies only to camera shake. You still need a fast shutter speed to freeze action. SteadyShot works great in low light, when you're using long lenses, and for macro photography. It's not always the best choice for action photography, unless there's enough light to allow a sufficiently high shutter speed. If so, stabilization can make your shot even sharper.
- Stabilization might slow you down. The process of adjusting the sensor to counter camera shake takes time, just as autofocus does, so you might find that SteadyShot adds to the lag between when you press the shutter and when the picture is actually taken. That's another reason why image stabilization might not be a good choice for sports.
- Use when appropriate. Sometimes, stabilization produces worse results if used while you're panning. You might want to switch off SteadyShot when panning or when your camera is mounted on a tripod.
- **Do you need SteadyShot at all?** Remember that an inexpensive monopod might be able to provide the same additional steadiness as SteadyShot. If you're out in the field shooting wild animals or flowers and think a tripod isn't practical, try a monopod first.

Fine-Tuning the Focus of Your Lenses

In Chapter 4, I introduced you to the a68's AF Micro Adjustment feature, which, I noted, that you might not ever need to use, because it is applied only when you find that a particular lens is not focusing properly. If the lens happens to focus a bit ahead or a bit behind the actual point of sharp focus, and it does that consistently, you can use the adjustment feature, found in the Custom Settings 6 menu, to "calibrate" the lens's focus.

Why is the focus "off" for some lenses in the first place? There are lots of factors, including the age of the lens (an older lens may focus slightly differently), temperature effects on certain types of glass, humidity, and tolerances built into a lens's design that all add up to a slight misadjustment, even though the components themselves are, strictly speaking, within specs. A very slight variation in your lens's mount can cause focus to vary slightly. With any luck (if you can call it that) a lens that doesn't focus exactly right will at least be consistent. If a lens always focuses a bit behind the subject, the symptom is *back focus*. If it focuses in front of the subject, it's called *front focus*.

You're almost always better off sending such a lens in to Sony to have them make it right. But that's not always possible. Perhaps you need your lens recalibrated right now, or you purchased a used lens that is long out of warranty. If you want to do it yourself, the first thing to do is determine whether or not your lens has a back focus or front focus problem.

For a quick-and-dirty diagnosis (*not* a calibration; you'll use a different target for that), lay down a piece of graph paper on a flat surface, and place an object on the line at the middle, which will represent the point of focus (we hope). Then, shoot the target at an angle using your lens's widest aperture and the autofocus mode you want to test. Mount the camera on a tripod so you can get accurate, repeatable results.

If your camera/lens combination doesn't suffer from front or back focus, the point of sharpest focus will be the center line of the chart, as you can see in Figure 9.17. If you do have a problem, one of the other lines will be sharply focused instead. Should you discover that your lens consistently front or back focuses, it needs to be recalibrated. Unfortunately, it's only possible to calibrate a lens for a single focusing distance. So, if you use a particular lens (such as a macro lens) for close-focusing, calibrate for that. If you use a lens primarily for middle distances, calibrate for that. Close-to-middle distances are most likely to cause focus problems, anyway, because as you get closer to infinity, small changes in focus are less likely to have an effect.

Lens Tune-Up

The key tool you can use to fine-tune your lens is the AF Micro Adj entry in the Custom Settings 6 menu. You'll find the process easier to understand if you first run through this quick overview of the menu options:

■ AF Adjustment Setting. On: This option enables AF fine-tuning for all the lenses you've registered using the menu entry. If you discover you don't care for the calibrations you make in certain situations (say, it works better for the lens you have mounted at middle distances, but is less successful at correcting close-up focus errors), you can deactivate the feature as you require. You should set this to On when you're doing the actual fine-tuning. Adjustment values range from −20 to +20. Off: Disables autofocus micro adjustment.

Figure 9.17 Correct focus (top), front focus (middle), and back focus (bottom).

- **Amount.** You can specify values of plus or minus 20 for each of the lenses you've registered. When you mount a registered lens, the degree of adjustment is shown here. If the lens has not been registered, then +/-0 is shown. If "--" is displayed, you've already registered the maximum number of lenses—up to 30 different lenses can be registered with each camera.
- Clear. Erases *all* user-entered adjustment values for the lenses you've registered. When you select the entry, a message will appear. Select OK and then press the center button to confirm.

Evaluate Current Focus

The first step is to capture a baseline image that represents how the lens you want to fine-tune autofocuses at a particular distance. You'll often see advice for photographing a test chart with millimeter markings from an angle, and the suggestion that you autofocus on a particular point on the chart. Supposedly, the markings that actually *are* in focus will help you recalibrate your lens. The problem with this approach is that the information you get from photographing a test chart at an angle doesn't actually tell you what to do to make a precise correction. So, your lens back focuses three millimeters behind the target area on the chart. So what? Does that mean you change the Saved Value by -3 clicks? Or -15 clicks? Angled targets are a "shortcut" that don't save you time.

Instead, you'll want to photograph a target that represents what you're actually trying to achieve: a plane of focus locked in by your lens that represents the actual plane of focus of your subject. For that, you'll need a flat target, mounted precisely perpendicular to the sensor plane of the camera. Then, you can take a photo, see if the plane of focus is correct, and if not, dial in a bit of fine-tuning in the AF Fine Tuning menu, and shoot again. Lather, rinse, and repeat until the target is sharply focused.

You can use the focus target shown in Figure 9.18, or you can use a chart of your own, as long as it has contrasty areas that will be easily seen by the autofocus system, and without very small details that are likely to confuse the AF. Download your own copy of my chart from www.dslrguides.com/FocusChart.pdf. (The URL is case sensitive.) Then print out a copy on the largest paper your printer can handle. (I don't recommend just displaying the file on your monitor and focusing on that; it's unlikely you'll have the monitor screen lined up perfectly perpendicular to the camera sensor.) Then, follow these steps:

- 1. **Position the camera.** Place your camera on a sturdy tripod with a remote release attached, positioned at roughly eye-level at a distance from a wall that represents the distance you want to test for. Keep in mind that autofocus problems can be different at varying distances and lens focal lengths, and that you can enter only *one* correction value for a particular lens. So, choose a distance (close-up or mid range) and zoom setting with your shooting habits in mind.
- 2. **Set the autofocus mode.** Choose the autofocus mode (AF-C or AF-S) you want to test. (Because AF-A mode just alternates between the two, you don't need to test that mode.)

Figure 9.18 Use this focus test chart, or create one of your own.

- 3. Level the camera (in an ideal world). If the wall happens to be perfectly perpendicular, you can use a bubble level, plumb bob, or other device of your choice to ensure that the camera is level to match. Many tripods and tripod heads have bubble levels built in. Avoid using the center column, if you can. When the camera is properly oriented, lock the legs and tripod head tightly.
- 4. **Level the camera (in the real world).** If your wall is not perfectly perpendicular, use this old trick. Tape a mirror to the wall, and then adjust the camera on the tripod so that when you look through the viewfinder at the mirror, you see directly into the reflection of the lens. Then, lock the tripod and remove the mirror.
- 5. **Mount the test chart.** Tape the test chart on the wall so it is centered in your camera's viewfinder.
- 6. **Photograph the test chart using AF.** Allow the camera to autofocus, and take a test photo, using the remote release to avoid shaking or moving the camera.
- 7. **Make an adjustment and rephotograph.** Navigate to the Custom Settings 6 menu and choose AF Micro Adj. Make sure the feature has been turned on, then press down to Amount and make a fine-tuning adjustment, plus or minus, and photograph the target again.
- 8. **Lather, rinse, repeat.** Repeat steps 6 and 7 several times to create several different adjustments to check.
- 9. **Evaluate the image(s).** If you have the camera connected to your computer with a USB cable, so much the better. You can view the image(s) after transfer to your computer. Otherwise, *carefully* open the camera card door and slip the memory card out and copy the images to your computer.
- 10. **Evaluate focus.** Which image is sharpest? That's the setting you need to use for this lens. If your initial range doesn't provide the correction you need, repeat the steps between –20 and +20 until you find the best fine-tuning. Once you've made an adjustment, the a68 will automatically apply the AF fine-tuning each time that lens is mounted on the camera, as long as the function is turned on.

MAXED OUT

If you've reached the maximum number of lenses (which is unlikely—who owns 30 lenses?), mount a lens you no longer want to compensate for, and reset its adjustment value to ± -0 . Or you can reset the values of all your lenses using the Clear function and start over.

Making Light Work for You

Successful photographers and artists have an intimate understanding of the importance of light in shaping an image. Rembrandt was a master of using light to create moods and reveal the character of his subjects. Artist Thomas Kinkade's official tagline is "Painter of Light." The late Dean Collins, co-founder of Finelight Studios, revolutionized how a whole generation of photographers learned and used lighting. It's impossible to underestimate how the use of light adds to—and how misuse can detract from—your photographs.

All forms of visual art use light to shape the finished product. Sculptors don't have control over the light used to illuminate their finished work, so they must create shapes using planes and curved surfaces so that the form envisioned by the artist comes to life from a variety of viewing and lighting angles. Painters, in contrast, have absolute control over both shape and light in their work, as well as the viewing angle, so they can use both the contours of their two-dimensional subjects and the qualities of the "light" they use to illuminate those subjects to evoke the image they want to produce.

Photography is a third form of art. The photographer may have little or no control over the subject (other than posing human subjects) but can often adjust both viewing angle *and* the nature of the light source to create a particular compelling image. The direction and intensity of the light sources create the shapes and textures that we see. The distribution and proportions determine the contrast and tonal values: whether the image is stark or high key, or muted and low in contrast. The colors of the light (because even "white" light has a color balance that the sensor can detect), and how much of those colors the subject reflects or absorbs, paint the hues visible in the image.

As a photographer, you must learn to be a painter and sculptor of light if you want to move from *taking* a picture to *making* a photograph. This chapter provides an introduction to using the two main types of illumination: *continuous* lighting (such as daylight, incandescent, or fluorescent sources) and the brief, but brilliant snippets of light we call *electronic flash*.

The Elements of Light

Unless you're extraordinarily lucky, or supremely observant, great lighting, like most things of artistic value, doesn't happen by accident. It's entirely possible that you'll randomly encounter a scene or subject that's bathed in marvelous lighting, illumination that perfectly sculpts an image in highlights and shadows. That's what happened when I encountered the stark geometric shapes of the fountain in the infrared shot shown in Figure 10.1. All I really needed to do was walk around the fountain until I found the best angle. The light was already there; I just needed to be lucky enough to encounter and recognize it, and then capture it in monochrome for an even starker effect.

Figure 10.1 Recognizing and using interesting illumination allows you to sculpt your photographs with light.

But how often can you count on such luck? Ansel Adams, producer Samuel Goldwyn, and golfer Gary Player have all been credited with originating the phrase, "The harder I work, the luckier I get." If you work at learning what light can do, and how to use it, you'll find yourself becoming luckier too.

Knowledge, patience, and the ability to use the lighting tools at your disposal are the keys to great lighting. Ansel Adams was known for his patience in seeking out the best lighting for a composition, and he *did* actually say, "A good photograph is knowing where to stand." You have to possess the ability to *recognize* effective lighting when it is already present, and have the skill to manipulate the light when it is not.

One of my favorite stories is about photographer George Krause, who spent the early part of his career shooting photographs *only* on overcast days, under diffuse, low-contrast illumination. That kind of lighting can be exceptionally challenging, because there is no interplay of highlights and shadows to add depth to a composition. Only when Krause was convinced that he understood soft lighting did he move on to work with more dramatic applications of light. Check out Krause's *Shadow*, taken in Seville, Spain more than 40 years ago. You might have to Google it, but as I write this it can be seen at http://grainsoflight.tumblr.com/post/901724818. Does the photo show an old woman—or an old woman followed by a dark secret?

Continuous Lighting—or Electronic Flash?

Continuous lighting is exactly what you might think: uninterrupted illumination that is available all the time during a shooting session. Daylight, moonlight, and the artificial lighting encountered both indoors and outdoors count as continuous light sources (although all of them can be "interrupted" by passing clouds, solar eclipses, a blown fuse, or simply by switching off a lamp). Indoor continuous illumination includes both the lights that are there already (such as incandescent lamps or overhead fluorescent lights indoors) and fixtures you supply yourself, including photoflood lamps or reflectors used to bounce existing light onto your subject.

The surge of light we call electronic flash is produced by a burst of photons generated by an electrical charge that is accumulated in a component called a *capacitor* and then directed through a glass tube containing xenon gas, which absorbs the energy and emits the brief flash. Electronic flash is notable because it can be much more intense than continuous lighting, lasts only a brief moment, and can be much more portable than supplementary incandescent sources. It's a light source you can carry with you and use anywhere.

Your Sony a68 incorporates a flip-up built-in electronic flash. (See Figure 10.2.) You can also work with an external flash, either mounted on the camera's accessory shoe or used off-camera and linked with a cable or triggered by a slave light (which sets off a flash when it senses the firing of another unit). Studio flash units are electronic flash, too, and aren't limited to "professional" shooters, as there are economical "monolight" (one-piece flash/power supply) units available in the \$200 to

Figure 10.2 Your camera's builtin flash is always available.

\$300 price range. Those who want to set up a home studio with some cash to spare can buy a couple to store in a closet and use to set up a home studio, or use as supplementary lighting when traveling away from home.

There are advantages and disadvantages to each type of illumination. Here's a quick checklist of pros and cons:

- Lighting preview—Pro: continuous lighting. With continuous lighting, such as incandescent lamps or daylight (see Figure 10.3), you always know exactly what kind of lighting effect you're going to get and, if multiple lights are used, how they will interact with each other. With electronic flash, the general effect you're going to see may be a mystery until you've built some experience, and you may need to review a shot on the LCD, make some adjustments, and then reshoot to get the look you want. (In this sense, a digital camera's review capabilities replace the Polaroid test shots pro photographers relied on in decades past.)
- Lighting preview—Con: electronic flash. Some external flash have a modeling light function (consisting of a series of low-powered bursts that flash for a period of time), but this feature is no substitute for continuous illumination, or an always-on modeling lamp like that found in studio flash. As the number of flash units increases, lighting previews, especially if you want to see the proportions of illumination provided by each flash, grows more complex.
- Exposure calculation—Pro: continuous lighting: Your a68 has no problem calculating exposure for continuous lighting, because the lighting remains constant and can be measured through a sensor that interprets the light reaching the viewfinder. The amount of light available just before the exposure will, in almost all cases, be the same amount of light present when the shutter is released. The a68's Spot metering mode can be used to measure and compare the proportions of light in the highlights and shadows, so you can make an adjustment (such as using more or less fill light) if necessary. You can even use a hand-held light meter to measure the light yourself and set the camera manually.

Figure 10.3 You always know how the highlights will look, and how the shadows will fall, when using continuous illumination.

- Exposure calculation—Con: electronic flash. Electronic flash illumination doesn't exist until the flash fires, and so it can't be measured by the a68's exposure sensor until the exposure. Instead, the light must be measured by metering the intensity of a pre-flash triggered an instant before the main flash, as it is reflected back to the camera and through the lens. The a68 cameras actually have two exposure measuring modes using the pre-flash: the ADI (Advanced Distance Integration) flash mode, which adds in distance information to calculate flash exposure, and Pre-Flash TTL, which uses only the information from the pre-flash reflected back to the camera from the subject. (These can be set under Flash Control in the Camera Settings 2 menu.) If you have a do-it-yourself bent, there are hand-held flash meters, too, including models that measure both flash and continuous light.
- Evenness of illumination—Pro/con: continuous lighting. Of continuous light sources, day-light, in particular, provides illumination that tends to fill an image completely, lighting up the foreground, background, and your subject almost equally. Shadows do come into play, of course, so you might need to use reflectors or fill-in light sources to even out the illumination further, but barring objects that block large sections of your image from daylight, the light is spread fairly evenly. Indoors, however, continuous lighting is commonly less evenly distributed. The average living room, for example, has hot spots and dark corners. But on the plus side, you can see this uneven illumination and compensate with additional lamps or reflectors.
- Evenness of illumination—Con: electronic flash. Electronic flash units, like continuous light sources such as lamps that don't have the advantage of being located 93 million miles from the subject, suffer from the effects of their proximity. The *inverse square law*, first applied to both gravity and light by Sir Isaac Newton, dictates that as a light source's distance increases from the subject, the amount of light reaching the subject falls off proportionately to the square of the distance. In plain English, that means that a flash or lamp that's 12 feet away from a subject provides only one-quarter as much illumination as a source that's 6 feet away (rather than half as much). (See Figure 10.4.) This translates into relatively shallow "depth-of-light."
- Action stopping—Pro: electronic flash. When it comes to the ability to freeze moving objects in their tracks, the advantage goes to electronic flash. The brief duration of electronic flash serves as a very high "shutter speed" when the flash is the main or only source of illumination for the photo. Your Sony a68's shutter speed may be set for 1/160th second during a flash exposure, but if the flash illumination predominates, the *effective* exposure time will be the 1/1000th to 1/50000th second or less duration of the flash, as you can see in Figure 10.5, by Cleveland photographer Kris Bosworth, because the flash unit reduces the amount of light released by cutting short the duration of the flash. The only fly in the ointment is that, if the ambient light is strong enough, it may produce a secondary "ghost" exposure, as I'll explain later in this chapter.

- Action stopping—Con: continuous lighting. Action stopping with continuous light sources is completely dependent on the shutter speed you've dialed in on the camera. And the speeds available are dependent on the amount of light available and your camera's ISO sensitivity setting. Outdoors in daylight, there will probably be enough sunlight to let you shoot at 1/2000th second and f/6.3 with a non-grainy sensitivity setting of ISO 400. That's a fairly useful combination of settings if you're not using a super-telephoto with a small maximum aperture. But inside, the reduced illumination quickly has you pushing your Sony a68 to its limits. For example, if you're shooting indoor sports, there probably won't be enough available light to allow you to use a 1/2000th second shutter speed (although I routinely shoot indoor basketball at ISO 1600 and 1/500th second at f/4). In many indoor sports situations, you may find your-self limited to 1/500th second or slower.
- Cost—Pro: continuous lighting. Incandescent or fluorescent lamps are generally much less expensive than external electronic flash units, which can easily cost several hundred dollars. I've used everything from desktop high-intensity lamps to reflector floodlights for continuous illumination at very little cost. There are lamps made especially for photographic purposes, too, priced up to \$50 or so. Maintenance is economical, too; many incandescent or fluorescents use bulbs that cost only a few dollars.
- Cost—Con: electronic flash. Electronic flash units aren't particularly cheap. The lowest-cost dedicated flash designed specifically for the Sony digital cameras (the HVL-F20AM) is less than \$149. Such units are limited in features, however, and intended for those with entry-level cameras. Plan on spending some money (roughly \$400 to \$550, depending on the model) to get the features that a sophisticated electronic flash such as the HVL-F43AM and other more advanced units offer.

Figure 10.4
A light source that is twice as far away provides only one-quarter as much illumination.

Figure 10.5 Electronic flash can freeze almost any action.

- Flexibility—Pro: electronic flash. Electronic flash's action-freezing power allows you to work without a tripod in the studio (and elsewhere), adding flexibility and speed when choosing angles and positions. Flash units can be easily filtered, and, because the filtration is placed over the light source rather than the lens, you don't need to use high-quality filter material. For example, theatrical lighting gels, which may be too flimsy to use in front of the lens, can be mounted or taped in front of your flash with ease to change the color or quality of light falling on a scene.
- Flexibility—Con: continuous lighting. Because incandescent and fluorescent lamps are not as bright as electronic flash, the slower shutter speeds required (see "Action stopping," above) mean that you may have to use a tripod more often, especially when shooting portraits. The incandescent variety of continuous lighting gets hot, especially in the studio, and the side effects range from discomfort (for your human models) to disintegration (if you happen to be shooting perishable foods like ice cream).

Continuous Lighting Basics

While continuous lighting and its effects are generally much easier to visualize and use than electronic flash, there are some factors you need to take into account, particularly the color temperature of the light. (Color temperature concerns aren't exclusive to continuous light sources, of course, but the variations tend to be more extreme and less predictable than those of electronic flash.)

Color temperature, in practical terms, is how "bluish" or how "reddish" the light appears to be to the digital camera's sensor. Indoor illumination is quite warm, comparatively, and appears reddish to the sensor. Daylight, in contrast, seems much bluer to the sensor. Our eyes (our brains, actually) are quite adaptable to these variations, so white objects don't appear to have an orange tinge when viewed indoors, nor do they seem excessively blue outdoors in full daylight. Yet, these color temperature variations are real and the sensor is not fooled. To capture the most accurate colors, we need to take the color temperature into account in setting the color balance (or *white balance*) of the a68—either automatically using the camera's smarts or manually using our own knowledge and experience.

Color temperature can be confusing, because of a seeming contradiction in how color temperatures are named: warmer (more reddish) color temperatures (measured in degrees Kelvin) are the *lower* numbers, while cooler (bluer) color temperatures are *higher* numbers. It might not make sense to say that 3,400K is warmer than 6,000K, but that's the way it is. If it helps, think of a glowing red ember contrasted with a white-hot welder's torch, rather than fire and ice.

The confusion comes from physics. Scientists calculate color temperature from the light emitted by a mythical object called a black body radiator, which absorbs all the radiant energy that strikes it, and reflects none at all. Such a black body not only *absorbs* light perfectly, but it *emits* it perfectly when heated (and since nothing in the universe is perfect, that makes it mythical).

At a particular physical temperature, this imaginary object always emits light of the same wavelength or color. That makes it possible to define color temperature in terms of actual temperature in degrees on the Kelvin scale that scientists use. Incandescent light, for example, typically has a color temperature of 3,200K to 3,400K. Daylight might range from 5,500K to 6,000K. Each type of illumination we use for photography has its own color temperature range—with some cautions. The next sections will summarize everything you need to know about the qualities of these light sources.

Daylight

Daylight is produced by the sun, and so is moonlight (which is just reflected sunlight). Daylight is present, of course, even when you can't see the sun. When sunlight is direct, it can be bright and harsh. If daylight is diffused by clouds, softened by bouncing off objects such as walls or your photo reflectors, or filtered by shade, it can be much dimmer and less contrasty.

Daylight's color temperature can vary quite widely. It is highest (most blue) at noon when the sun is directly overhead, because the light is traveling through a minimum amount of the filtering layer we call the atmosphere. The color temperature at high noon may be 6,000K. At other times of day, the sun is lower in the sky and the particles in the air provide a filtering effect that warms the illumination to about 5,500K for most of the day. Starting an hour before dusk and for an hour after sunrise, the warm appearance of the sunlight is even visible to our eyes when the color temperature may dip to 5,000K to 4,500K, as shown in Figure 10.6.

Because you'll be taking so many photos in daylight, you'll want to learn how to use or compensate for the brightness and contrast of sunlight, as well as how to deal with its color temperature. I'll provide some hints later in this chapter.

Figure 10.6 At dawn and dusk, the color temperature of the sky may dip as low as 4,500K.

Incandescent/Tungsten Light

The term *incandescent* or *tungsten illumination* is usually applied to the direct descendants of Thomas Edison's original electric lamp. Such lights consist of a glass bulb that contains a vacuum, or is filled with a halogen gas, and contains a tungsten filament that is heated by an electrical current, producing photons and heat. Tungsten-halogen lamps are a variation on the basic tungsten lightbulb (which is gradually being regulated out of existence), using a more rugged (and longer-lasting) filament that can be heated to a higher temperature, housed in a thicker glass or quartz envelope, and filled with iodine or bromine ("halogen") gases. The higher temperature allows tungsten-halogen (or quartz-halogen/quartz-iodine, depending on their construction) lamps to burn "hotter" and whiter. Although popular for automobile headlamps today, they've also been popular for photographic illumination.

Although incandescent illumination isn't a perfect black body radiator, it's close enough that the color temperature of such lamps can be precisely calculated (about 3,200K–3,400K, depending on the type of lamp) and used for photography without concerns about color variation (at least, until the very end of the lamp's life).

The other qualities of this type of lighting, such as contrast, are dependent on the distance of the lamp from the subject, type of reflectors used, and other factors that I'll explain later in this chapter.

Fluorescent Light/Other Light Sources

Fluorescent light has some advantages in terms of illumination, but some disadvantages from a photographic standpoint. This type of lamp generates light through an electro-chemical reaction that emits most of its energy as visible light, rather than heat, which is why the bulbs don't get as hot. The type of light produced varies depending on the phosphor coatings and type of gas in the tube. So, the illumination fluorescent bulbs produce can vary widely in its characteristics. Today, with the phasing out of traditional tungsten incandescent lightbulbs, we're seeing more use of compact fluorescent lamps (CFLs) and, increasingly, LED bulbs. The prices for both types have continually dropped to the point where you can buy CFL or LED lamps for \$5 or so. Eventually, LEDs will replace CFL lamps entirely.

Of course, the switch from traditional incandescent bulbs is not great news for photographers. Different types of lamps have different "color temperatures" that can't be precisely measured in degrees Kelvin, because the light isn't produced by heating. Worse, fluorescent lamps have a discontinuous spectrum of light that can have some colors missing entirely. A particular type of tube can lack certain shades of red or other colors, which is why fluorescent lamps and other alternative technologies such as sodium-vapor illumination can produce ghastly looking human skin tones. Their spectra can lack the reddish tones we associate with healthy skin and emphasize the blues and greens popular in horror movies.

Adjusting White Balance

In most cases, the Sony a68 will do a good job of calculating white balance for you, so Auto White Balance, described in Chapter 3, can be used as your choice most of the time. Use the preset values or set a custom white balance that matches the current shooting conditions when you need to. The only really problematic light sources are likely to be fluorescents. Vendors, such as GE and Sylvania, may actually provide a figure known as the *color rendering index* (or CRI), which is a measure of how accurately a particular light source represents standard colors, using a scale of 0 (some sodium-vapor lamps) to 100 (daylight and most incandescent lamps). Daylight fluorescents and deluxe cool white fluorescents might have a CRI of about 79 to 95, which is perfectly acceptable for most photographic applications. Warm white fluorescents might have a CRI of 55. White deluxe mercury vapor lights are less suitable with a CRI of 45, while low-pressure sodium lamps can vary from CRI 0 to 18.

Remember that if you shoot RAW, you can specify the white balance of your image when you import it into Photoshop, Photoshop Elements, or another image editor using your preferred RAW converter, including Image Data Converter SR. While color-balancing filters that fit on the front of the lens exist, they are primarily useful for film cameras, because film's color balance can't be tweaked as extensively as that of a sensor.

Electronic Flash Basics

Until you delve into the situation deeply enough, it might appear that serious photographers have a love/hate relationship with electronic flash. You'll often hear that flash photography is less natural looking, and that the built-in flash in most cameras should never be used as the primary source of illumination because it provides a harsh, garish look. Available ("continuous") lighting is praised, and built-in flash photography seems to be roundly denounced.

In truth, however, the bias is against *bad* flash photography. Indeed, flash has become the studio light source of choice for pro photographers, because it's more intense (and its intensity can be varied to order by the photographer), freezes action, frees you from using a tripod (unless you want to use one to lock down a composition), and has a snappy, consistent light quality that matches daylight. (While color balance changes as the flash duration shortens, some Sony flash units can communicate to the camera the exact white balance provided for that shot.) And even pros will cede that electronic flash has some important uses as an adjunct to existing light, particularly to fill in dark shadows.

But electronic flash isn't as inherently easy to use as continuous lighting. As I noted earlier, electronic flash units are more expensive, don't show you exactly what the lighting effect will be, unless you use a second source called a *modeling light* for a preview (some flashes, such as the HVL-F58AM have pulsed light rudimentary modeling light capabilities built in), and the exposure of electronic flash units is more difficult to calculate accurately.

How Electronic Flash Works

The electronic flash you work with can be the a68's pop-up flash, one mounted on the camera by slipping it onto the hot shoe, or one linked by a cable connected to an adapter mounted on the shoe. In all cases, the flash is triggered at the instant of exposure, during a period when the sensor is fully exposed by the shutter.

The a68 has electronic shutter options, which I'll describe later, and a conventional vertically traveling physical shutter that consists of two curtains. The front curtain opens and moves to the opposite side of the frame, at which point the shutter is completely open. The flash can be triggered at this point (so-called *front-curtain sync*, which is the default mode), making the flash exposure. Then, after a delay that can vary from 30 seconds to 1/160th second, a second, *rear curtain* begins moving across the sensor plane, covering up the sensor again. If the flash is triggered just before the rear curtain starts to close, then the optional *rear-curtain sync* is used. In both cases, though, a shutter speed of 1/160th second is (ordinarily) the *maximum* that can be used to take a photo, because that's the speed at which both the front and rear curtains are tucked out of the way, leaving the entire full frame exposed to capture the flash burst.

Figure 10.7 illustrates how this works, with a fanciful illustration of a generic shutter (your a68's shutter does *not* look like this). As an exposure is made using the conventional (non-electronic) shutter, the curtains move as follows:

- 1. Both curtains open. With a camera like the a68, the sensor remains completely exposed behind the semi-transparent mirror, so that the image that's being captured can be viewed on the electronic viewfinder and LCD monitor.
- 2. Front curtain closes. As the exposure begins, the front curtain rises to cover the sensor.

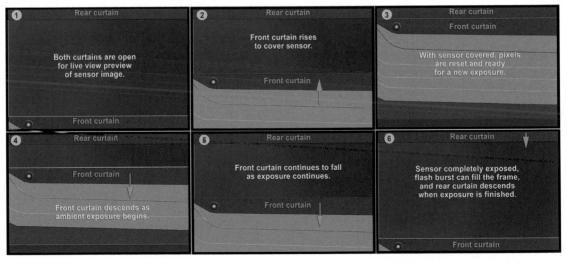

Figure 10.7 A focal plane shutter has two curtains, the lower, or front curtain, and an upper, rear curtain.

- 3. Prior image is dumped. When the sensor is completely covered, the preview image is dumped, resetting the pixels so that the exposure can begin.
- 4. Front curtain begins to descend. As the front curtain drops, the sensor is gradually exposed to light, and the *ambient* exposure (using the available light in the scene) begins.
- 5. Front curtain continues to descend. More of the sensor is uncovered, and the ambient exposure continues.
- 6. Both curtains open. With the sensor fully exposed, the electronic flash's brief burst can fill the frame.
 - If this burst takes place as soon as the curtains are fully open, then *front-curtain sync*, which is the default, has been used. Following the flash, the sensor continues to be exposed for the length of the exposure, which can range from 1/160th second to 30 seconds (or longer, with a Bulb exposure).
 - The burst can also take place *at the very end* of the exposure, just before the rear curtain starts to descend. This is called *rear-curtain sync*.
 - When the exposure is finished, the rear curtain descends and the captured image is conveyed off the sensor to the camera's internal buffer, and thence to your memory card. The rear curtain then ascends to the top of the frame, exposing the sensor again and a preview image for the next picture appears in the EVF and LCD monitor.

Keep in mind that the a68 *always* defaults to front-curtain sync unless you explicitly select another sync mode using the Fn button or Flash Mode entry in the Camera Settings menu.

And Now for Something Completely Different...

If you've absorbed that, things are about to get *really* interesting. The a68 has a special mode available from the Custom Settings menu, in which the physical front curtain is simulated electronically, reducing the time lag between shutter releases.

The feature is called e-Front Curtain Shutter. Recall that the sensor of the a68 is always exposed and feeding its image to the EVF and LCD monitor; in order to capture an image within a specified period of time, the sensor needs to *stop* collecting the image so the exposure can begin. In normal operation, as described above, when you press the shutter release down all the way, the shutter closes and the camera dumps the image you were previewing, resetting the pixels and leaving the sensor blank and ready to capture an exposure. When the e-Front Curtain Shutter is enabled, the physical front shutter doesn't close: the image is dumped *electronically*, and then the sensor immediately begins capturing an image. The physical rear curtain shutter then closes at the end of the exposure.

The advantages of the electronic front curtain are that the camera can respond more quickly with less shutter lag, there is no possibility of vibration caused by the physical front curtain shutter bouncing at the end of its travel, and an electronic front curtain shutter is quieter. As the a68's mirror never flips up and down during exposure, SLT-type cameras are already quieter than dSLR models, which have a mirror flapping about before and after the exposure.

However, an electronic front curtain shutter can exhibit problems with certain lenses and very fast shutter speeds. In such cases, when you are using an unusually wide aperture, such as f/1.8, some areas of the photo may exhibit a secondary (ghost) image. The aperture of an affected lens requires the "leaves" to travel a greater distance, and there may simply not be enough time. An overexposure may result. If you encounter that problem, turn the e-curtain option off; otherwise, you can do as I do and leave it on all the time.

Avoiding Sync Speed Problems

Using a shutter speed faster than the maximum sync speed can cause problems. Triggering the electronic flash only when the shutter is completely open makes a lot of sense if you think about what's going on. To obtain shutter speeds faster than 1/160th second, the a68 exposes only part of the sensor at one time, by starting the rear curtain on its journey before the front curtain has completely opened. That effectively provides a briefer exposure as the slit of the shutter passes over the surface of the sensor. If the flash were to fire during the time when the front and rear curtains partially obscured the sensor, only the slit that was actually open would be exposed.

You'd end up with only a narrow band, representing the portion of the sensor that was exposed when the picture was taken. For shutter speeds *faster* than the top sync speed, the rear curtain begins moving *before* the front curtain reaches the bottom of the frame. As a result, a moving slit, the distance between the front and rear curtains, exposes one portion of the sensor at a time as it moves from the top to the bottom. Figure 10.8 shows three views of our typical (but imaginary) focal plane shutter. At left is pictured the closed shutter; in the middle version you can see the front curtain has moved about 1/4 of the distance down from the top; and in the right-hand version, the rear curtain has started to "chase" the front curtain across the frame toward the bottom.

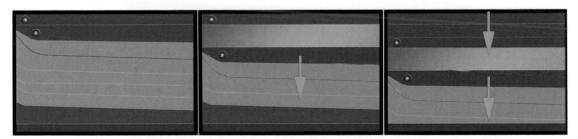

Figure 10.8 A closed shutter (left); partially open shutter as the front curtain begins to move downward (middle); only part of the sensor is exposed as the slit moves (right).

If the flash is triggered while this slit is moving, only the exposed portion of the sensor will receive any illumination. You end up with a photo like the one shown in Figure 10.9. Note that a band across the bottom of the image is black. That's a shadow of the rear shutter curtain, which had started to move when the flash was triggered. Sharp-eyed readers will wonder why the black band is at the *bottom* of the frame rather than at the top, where the rear curtain begins its journey. The answer is simple: your lens flips the image upside down and forms it on the sensor in a reversed position. You never notice that, because the camera is smart enough to show you the pixels that make up your photo in their proper orientation during picture review. But this image flip is why, if your sensor gets dirty and you detect a spot of dust in the upper half of a test photo, if cleaning manually, you need to look for the speck in the *bottom* half of the sensor.

I generally end up with sync speed problems only when shooting in the studio, using studio flash units rather than my Sony dedicated unit. That's because if you're using either type of "smart" flash, the camera knows that a strobe is attached, and remedies any unintentional goof in shutter speed settings. If you happen to set the a68's shutter to a faster speed in S or M mode, the camera will automatically adjust the shutter speed down to the maximum sync speed as soon as you flip up the internal flash or attach and turn on an external flash (or prevent you from choosing a faster speed if the flash is powered up). In A or P, where the a68 selects the shutter speed, it will never choose a shutter speed higher than 1/160th second when using flash.

But when using a non-dedicated flash, such as a studio unit plugged into the a68's PC/X connector or into an adapter attached to the accessory shoe, the camera has no way of knowing that a flash is connected, so shutter speeds faster than 1/160th second can be set inadvertently.

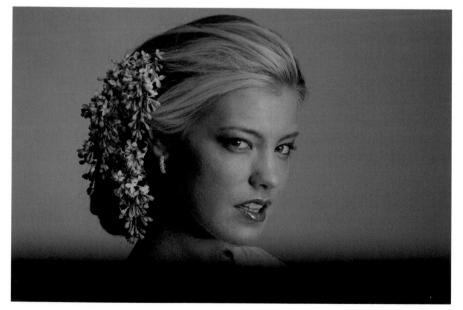

Figure 10.9
If a shutter speed faster than 1/160th second is used with flash, you can end up photographing only a portion of the image.

Note that the a68 can use a feature called *high-speed sync* that allows shutter speeds faster than the maximum sync speed with certain external dedicated Sony flash units. When using high-speed sync, the flash fires a continuous serious of bursts at reduced power for the entire duration of the exposure, so that the illumination is able to expose the sensor as the slit moves.

HS sync is set using the controls that adjust the compatible external flash units, which include the HVL-60M, HVL-F58AM, HVL-F56AM, HVL-F43AM/HVL-F43M, and HVL-F36AM. It cannot be used when working with multiple flash units. When active, the message H appears on the LCD panel on the back of the flash. You'll find complete instructions accompanying those flash units.

Ghost Images

The difference might not seem like much, but whether you use front-curtain sync (the default setting) or rear-curtain sync (an optional setting) can make a significant difference to your photograph if the ambient light in your scene also contributes to the image. At faster shutter speeds, particularly 1/160th second, there isn't much time for the ambient light to register, unless it is very bright. It's likely that the electronic flash will provide almost all the illumination, so front-curtain sync or rear-curtain sync isn't very important.

However, at slower shutter speeds, or with very bright ambient light levels, there is a significant difference, particularly if your subject is moving, or the camera isn't steady. In any of those situations, the ambient light will register as a second image accompanying the flash exposure, and if there is movement (camera or subject), that additional image will not be in the same place as the flash exposure. It will show as a ghost image and, if the movement is significant enough, as a blurred ghost image trailing in front of or behind your subject in the direction of the movement.

As I mentioned earlier, when you're using front-curtain sync, the flash goes off the instant the shutter opens, producing an image of the subject on the sensor. That happens whether you're using the mechanical shutter or the optional electronic Front Curtain option from the Custom Settings menu. Then, the shutter remains open for an additional period (which can be from 30 seconds to 1/160th second). If your subject is moving, say, toward the right side of the frame, the ghost image produced by the ambient light will produce a blur on the right side of the original subject image, making it look as if your sharp (flash-produced) image is chasing the ghost. For those of us who grew up with lightning-fast superheroes who always left a ghost trail behind them, that looks unnatural (see Figure 10.10).

So, Sony provides rear (second) curtain sync to remedy the situation. In that mode, the shutter opens, as before. The shutter remains open for its designated duration, and the ghost image forms. If your subject moves from the left side of the frame to the right side, the ghost will move from left to right, too. *Then*, about 1.5 milliseconds before the rear shutter curtain closes, the flash is triggered, producing a nice, sharp flash image *ahead* of the ghost image. Voilà! We have monsieur *le Flash* outrunning his own trailing image.

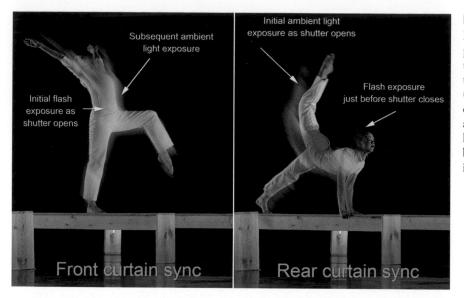

Figure 10.10
Front-curtain sync produces an image that trails in front of the flash exposure (left), whereas rearcurtain sync creates a more "natural looking" trail behind the flash image (right).

EVERY WHICH WAY, INCLUDING UP

Note that although I describe the ghost effect in terms of subject matter that is moving left to right in a horizontally oriented composition, it can occur in any orientation, and with the subject moving in *any* direction. (Try photographing a falling rock, if you can, and you'll see the same effect.) Nor are the ghost images affected by the fact that modern shutters travel vertically rather than horizontally. Secondary images are caused between the time the front curtain fully opens, and the rear curtain begins to close. The direction of travel of the shutter curtains, or the direction of your subject, does not matter.

Slow Sync

Another flash synchronization option is *slow sync*, which is actually an exposure option that tells the a68 to use slower shutter speeds when possible, to allow you to capture a scene by both flash and ambient illumination. To activate Slow Sync, press the Fn button, navigate to the flash options, and choose Slow Sync.

Then, the exposure system will try to use longer shutter speeds with the flash, so that an initial exposure is made with the flash unit, and a secondary exposure of subjects in the background will be produced by the slower shutter speed. This will let you shoot a portrait of a person at night and, much of the time, avoid a dark background. Your portrait subject will be illuminated by the flash, and the background by the ambient light. It's a good idea to have the camera mounted on a tripod or some other support, or have SteadyShot switched on to avoid having this secondary exposure produce ghost images due to camera movement during the exposure.

Because Slow Sync is a type of exposure control, it does not work in Manual mode or Shutter Priority mode (because the a68 doesn't choose the shutter speed in those modes).

Determining Exposure

Calculating the proper exposure for an electronic flash photograph is a bit more complicated than determining the settings by continuous light. The right exposure isn't simply a function of how far away your subject is, even though the inverse square law I mentioned does have an effect: the farther away the subject is, the less light is available for the exposure. The a68 can calculate distance if you're using a lens with "DT" in its name (these lenses transmit distance codes to the camera), based on the autofocus distance that's locked in just prior to taking the picture.

But, of course, flash exposure isn't based on distance alone. Various objects reflect more or less light at the same distance so, obviously, the camera needs to measure the amount of light reflected back and through the lens. Yet, as the flash itself isn't available for measuring until it's triggered, the a68 has nothing to measure.

The solution is to fire the flash twice. The initial shot is a pre-flash that can be analyzed, then followed by a main flash that's given exactly the calculated intensity needed to provide a correct exposure. As a result, the primary flash may be longer for distant objects and shorter for closer subjects, depending on the required intensity for exposure. This through-the-lens evaluative flash exposure system when coupled with distance information from a DT lens is called *ADI flash exposure* (ADI stands for Advanced Distance Integration), and it operates whenever you have attached a Sony dedicated flash unit to the a68, and a lens that provides distance integration information. (Check the documentation that came with your lens to see if it is compatible with ADI.)

Using the Built-In Flash

The Sony a68's built-in flash is a handy accessory because it is available as required, without the need to carry an external flash around with you constantly. This section explains how to use the flip-up flash.

Your a68 automatically pops up the built-in flash when there is insufficient light and you are using Auto, Portrait, Macro, and Night View/Night Scene modes. In PASM modes (Program, Aperture Priority, Shutter Priority, and Manual), you'll need to flip up the flash manually. In modes that do not pop up the flash, including Flash Off mode, the flash will not pop up. If the flash is already up, because you switched to a non-flash mode from a PASM, or if you have set Flash Off as the flash mode using the Fn button, the flash will not fire. The a68 pops up the flash in Fill Flash mode in all Scene modes except for Night Scene and Hand-held Twilight. It won't pop up if you have set the flash mode to Off or Auto.

When using a flash-compatible mode with the built-in flash, if you want the a68 to issue a few additional low-light pre-flashes prior to taking the picture to reduce red-eye effects, turn the feature on with the Red eye reduc. option in the Camera Settings 3 menu.

When using semi-automatic or manual exposure modes (or any Scene mode in which flash is used), if Red-eye reduction is turned on in the Camera Settings 3 menu (as described in Chapter 3), the red-eye reduction flash will emit as you press down the shutter release to take the picture, theoretically causing your subjects' irises to contract (if they are looking toward the camera), and thereby reducing the red-eye effect in your photograph.

Setting Flash Modes

To set the various flash modes (which may or may not be available, depending on which exposure mode you're using), press the Fn button on the back of the camera to the right of the LCD, navigate to the flash options using the control wheel buttons, and choose:

- Flash Off. The flash never fires; this may be useful in museums, concerts, or religious ceremonies where electronic flash would prove disruptive.
- Autoflash. The flash fires as required, depending on lighting conditions.
- Fill-flash. The a68 balances the available illumination with flash to provide a balanced lighting effect.
- Slow Sync. The a68 combines flash with slow shutter speeds, so that the subject can be illuminated by flash, but the longer shutter speed allows the ambient light to illuminate the background.
- **Rear Sync.** Fires the flash at the end of the exposure, producing more "realistic" "ghost" images, as described earlier in this chapter.
- Wireless. Allows an optional external flash mounted on the camera's multi interface shoe to trigger one or more external flash units that support wireless off-camera flash; there's no need for any cable connection between the camera and the remote flash unit. This option is grayed out unless you have an external flash mounted and powered up; the a68's built-in flash cannot be used to trigger other units wirelessly.
- H (High-speed sync). Available only when the HVL-60M, HVL-F56AM, HVL-F43AM, or HVL-F42AM flash units are attached, it allows synchronizing those flashes at shutter speeds higher than 1/160th second.

USING WIRELESS FLASH

To work with wireless flash, attach the compatible dedicated flash unit, such as the HVL-FV60M, to the accessory shoe on top of the camera. Turn on both flash and the camera, then press the Fn button, select Flash Mode, and choose Wireless. You can then remove the external flash from the camera, and pop up the a68's built-in flash to trigger the external unit wirelessly. The external flash can be set to one of several different channels, as explained in the directions furnished with the dedicated flash. Ordinarily, you won't need to switch channels, unless another photographer using a Sony flash is in the same vicinity, and you don't want your flash to trigger when the other shooter's flash is fired.

RADIO WIRELESS

Early in 2016, Sony announced the pending release of a new wireless radio flash control system for its electronic flash. It consists of the FA-WRC1M radio commander and FA-WRR1 receiver, and can provide control for 15 units in five groups separated by up to 30 meters. As I write this, no further details are available on this wireless system, and the first units won't be shipping until well after this book goes to press. Only scant information has been provided, so I don't know how it might work with A-mount cameras like the a68. As more information becomes available, I'll try to provide updates on my web page, www.sonyguides.com.

Flash Exposure Compensation

It's important to keep in mind how the a68's exposure compensation system (discussed in Chapter 3) works when you're using electronic flash. To activate exposure compensation for flash, press the Fn button and navigate to Flash Comp., then press the center button. The Flash Comp. screen appears (see Figure 10.11), with its plus/minus scale. Use the left/right control wheel keys to add or subtract exposure. Pressing the right button adds exposure to an image; pressing the left button subtracts exposure. This function is not available when using Auto or Scene exposure modes, nor when you have used the Flash Off option from the Flash menu.

Figure 10.11
Adjust flash exposure using this screen.

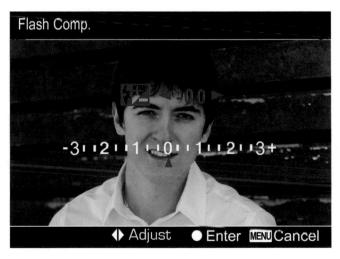

Flash Control

I described the Flash Control menu setting in Chapter 3. Your choices are as follows:

- ADI (Advanced Distance Integration) flash. This setting takes advantage of a distance encoding feature built into many Sony lenses, which uses focusing data to provide the flash with more accurate distance information. The distance data is combined with light metering data from the pre-flash to provide more precise flash exposure control. ADI enables the camera to avoid being deceived by highly reflective or very dark subjects.
- Pre-Flash TTL. In this mode, only information from measuring the amount of light reflected from the subject during the pre-flash is used to calculate exposure. The system can be fooled by subjects that have highly reflective or very dark areas. You might need to use this mode when working with lenses that don't have the distance encoder feature. (Most Sony lenses do. Exceptions are the SAL16F28 16mm f/2.8 fisheye; SAL20F28 20mm f/2.8; SAL28F28 28mm f/2.8; SAL135F28 135mm f/2.8; and SAL500F80 500mm f/8 mirror lens. If you're using third-party lenses, check with your vendor.)

Red Eye Reduction

The other key flash-related control is the Red Eye Reduction option in the Camera Settings 3 menu as described in Chapter 3. You can turn it on or off. When activated, the a68's flip-up flash issues a few brief bursts prior to taking the photo, theoretically causing your subjects' pupils to contract, reducing the effect (assuming the person is looking at the camera during the bursts). This option works only with the built-in flash, and doesn't produce any pre-bursts if you have an external flash attached. In most cases, the higher elevation of the external flash effectively prevents red eye anyway.

Using the External Electronic Flash

As I write this, Sony offers four accessory electronic flash units that are compatible with the a68's new-style multi interface shoe: the HVL-F60M, HVL-F43M, HVL-F32M, and HVL-F20M. These external units can be mounted on the camera, connected to the camera's multi interface shoe with a cable or (except for the HVL-F20M) used off-camera with wireless connectivity when triggered by another *external* flash used as a controller/master. Each can also function as the controller/master mounted on the a68 camera to trigger other flash units wirelessly.

In addition, there are earlier Sony flash units designed for the older Minolta/Sony proprietary hot shoe. Older flashes can be used with the a68 camera if you purchase an inexpensive adapter, such as the Sony ADP-MAA (about \$25). Or, you can skip the adapter and use these legacy flash units

off-camera in wireless mode, triggered by an on-camera master/controller. Although they are discontinued, I'll describe some of these earlier flash units because you may already own one or can find one used at a price that's hard to resist. I don't recommend the legacy flash/adapter approach, because older units operate using a more limited communication protocol, which I'll describe later. But because some of you may have an older flash, or can pick one up used at a decent price, it doesn't make sense to pretend that these discontinued models don't exist, because they still can work with your a68, especially as remote/slave units.

Guide Numbers, Hot Shoes, and More

Before I describe the flash units themselves, there are a few aspects you need to understand in order to compare electronic flash. If you're a veteran Sony (or Minolta) shooter, you can skim over this section, or skip it entirely. Those new to photography or the Sony realm should find this information useful.

Guide Numbers

The first thing you need to learn when comparing flash units is that Sony incorporates the Guide Number (GN) of each flash in the product name. So, what's a Guide Number? The GN designation derives from the good old days prior to automatic flash units and through-the-lens flash metering, when flash exposures had to be calculated mathematically. Those days are very long ago, indeed, as Honeywell introduced Auto/Strobonar flash units way back in the 1960s.

Guide numbers are a standard way of specifying the power of a flash when used in manual, non-autoexposure mode. Divide the guide number by the distance to determine the correct f/stop to use at full power. With a GN of 197 at ISO 100, you would use an aperture of around f/19.7 for a subject that's 10 feet from the camera (197 divided by 10), or around f/9.5 for a subject at a distance of 20 feet. Because most countries in the world use metric measurements, guide numbers are given using values for both meters and feet. Thus, Sony's HVL-F60M unit has a guide number of 60/197 in meters/feet, and the 60 GN is incorporated into the unit's product name.

The Guide Number data is most useful for comparing the relative power of several flash units that you're considering. According to the Inverse Square Law, a flash unit with a GN of 200 (in feet) puts out four times the amount of light as one with a GN of about 100. If your accessory flash has a zoom head, which can change coverage to match the focal length setting of your lens, the GN will vary according to the zoom setting, as wider zoom settings spread the same light over a broader area than a telephoto zoom setting.

Hot Shoes

Starting in 1988, Minolta phased in a proprietary hot shoe, the so-called *iISO* shoe, which was supposedly more rugged and secure than the original ISO 518 shoe, based on a design that dates back to 1913, when it was used to attach viewfinders to a camera (electronic flash hadn't been invented yet). No other vendors, including Canon and Nikon, embraced Minolta's design and continued to use the industry standard shoe. The ISO 518 standard doesn't specify any electronic connections between camera and flash, other than the "dumb" triggering circuit, so when sophisticated electronic flash units with TTL metering and other capabilities were developed, each vendor created their own hot shoe version with the necessary electrical contacts for their cameras and flash units. The chief consequence for non-Minolta/Sony shooters was that you could mount dedicated flash units from one brand onto the ISO 518 shoe of another vendor's camera, and trigger that flash in manual, non-TTL mode.

When Sony purchased Konica Minolta's camera technology it began redesigning legacy features, and the old iISO hot shoe came under scrutiny. In 2012, Sony introduced a 21+3-pin hot shoe which it dubbed the *multi interface shoe*, which resembles a standard ISO 518 hot shoe with its "dumb" contacts. However, tucked away at the front of the shoe are additional electrical contacts

that allow intelligent TTL flash metering communication between the camera and flash, and much more. (See Figure 10.12.) For example, a whole series of stereo microphones from Sony and others, designed to plug into the multi interface shoe, are available. As I noted earlier, you can purchase adapters that allow you to connect older iISO flash to the a68, or to attach new model flash units to a camera that has the original iISO hot shoe.

Figure 10.12 The foot of current Sony flash units and other accessories is designed to fit the Sony multi interface shoe.

Cable Connections

In some cases, you can get your external flash off the camera without using a wireless connection by linking an HVL-F60M and a68 with a physical cable. The gear needed for the hook-up can be costly, so I don't recommend it, but if you want to go that route, here's the way to go. Purchase the Sony FA-CS1M multi interface shoe adapter (about \$50). It slides to the a68 camera's multi interface shoe, and has a four-pin TTL socket on the front. Connect that socket to a matching four-pin outlet located on the underside of the HVL-F60M, beneath a protective terminal cap, using a 4.9-foot FA-MC1AM cable (\$60). If you need more length, the FA-EC1AM extension cable (\$60) adds another 4.9 feet to your connection. The HVL-F43M does not have the four-pin socket, and connecting it to a cable requires some additional adapters, so you're better off not going that way.

HVL-F60M Flash Unit

This \$550 flagship of the Sony accessory flash line (shown in Figure 10.13) is the most powerful unit the company offers, with an ISO 100 guide number (GN) of 60 in meters or 197 in feet at ISO 100. As I noted earlier, the GN does not indicate actual flash range but it's useful when comparing several flash units in terms of their general power output.

You can use this large unit as a main flash, or allow it to be triggered wirelessly by another compatible flash unit. A pre-flash burst of light from the triggering master/controller unit causes a remote flash unit to fire. When using flash wirelessly, Sony recommends rotating the unit so that the flashtube is pointed to the location where light should be directed, while the front (light sensor) of the flash is pointed toward the camera. In wireless mode, you can control up to three groups of flashes, and specify the output levels for each group, giving you an easy way to control the lighting ratios of multiple flash units.

This flash automatically adjusts for focal length settings from 24mm to 105mm, and a built-in slide-out diffuser panel boosts

Figure 10.13 The Sony HVL-F60M is the top-of-the-line external flash unit and includes a bonus LED light for video.

wide-angle coverage to 15mm. You can zoom coverage manually, if you like. There's also a slide-out "white card" that reflects some light forward even when bouncing the flash off the ceiling, to fill in shadows or add a catch light in the eyes of your portrait subjects. A built-in LED lamp allows continuous illumination.

Bouncing is particularly convenient and effective, thanks to what Sony calls a "quick shift bounce" system. This configuration is particularly effective when shooting vertical pictures. With most other on-camera external flash units, as soon as you turn the camera vertically, the flash is oriented vertically, too, whether you're using direct flash or bouncing off the ceiling (or wall, when the camera is rotated). The HVL-60M's clever pivoting system allows re-orienting the flash when the camera is in the vertical position, so flash coverage is still horizontal, and can be tilted up or down for ceiling bounce.

The 15.9-ounce unit uses convenient AA batteries in a four-pack, but can also be connected to the FA-EB1AM external battery adapter (you just blew another \$250), which has room for 6 AA batteries for increased capacity and faster recycling. It automatically communicates white balance information to your camera, allowing the a68 to adjust WB to match the flash output.

You can even simulate a modeling light effect. A test button on the back of the flash unit can be rotated for flash mode (one test flash, with no modeling light); three low-power flashes at a rate of two flashes per second, as a rough guide; and a more useful (but more power-consuming) mode that flashes for 40 flashes per second for 4 seconds (160 continuous mini-bursts in all). This switch also has a HOLD position that locks all flash operations except for the LCD data display on the flash, and the test button. Use this when you want to take a few pictures without flash, but don't want to turn off your flash or change its settings.

The HVL-F60M can function as a main flash, or be triggered wirelessly by another compatible flash unit. The pre-flash from the second "main" flash is used to trigger the remote, wireless flash unit that has been removed or disconnected from the camera. When using flash wirelessly, Sony recommends rotating the unit so that the flashtube is pointed where you want the light to go, but the front (light sensor) of the flash is directed at the flash mounted on the camera. In wireless mode, you can control up to three groups of flashes, and specify the output levels for each group, giving you an easy way to control the lighting ratios of multiple flash units.

When High-Speed Sync (HSS) is activated, you can take flash pictures at any shutter speed from 1/500th to 1/4000th second. The MODE button on the back of the flash is used to choose either TTL or Manual flash exposure. Then use the Select button and flash plus/minus keys to activate HSS mode. HSS appears on the data panel of the flash, and an indicator appears on the camera's LCD monitor. See the High-Speed Sync sidebar on the following page for more details.

Another feature I like is the HVL-F60M's multiple flash feature, which allows you to create interesting stroboscopic effects with several images of the same subject presented in the same frame. If you want to shoot subjects at distances of more than a few feet, however, you'll need to crank up the ISO setting of your a68, as the output of each strobe burst is significantly less than when using the flash for single shots.

This flash unit can provide a simulated modeling light effect at two flashes per second or at a more useful (but more power-consuming) 40 flashes per second for 4 seconds for 160 continuous minibursts. In wireless off-camera flash, the HVL-60M can function as the main (on-camera) flash in wireless mode or it can be the remote flash, triggered wirelessly by another compatible flash unit, as discussed earlier.

HIGH-SPEED SYNC

Those who are frustrated by an inability to use a shutter speed faster than 1/160th second will love the High-Speed Sync (HSS) mode that allows for flash at 1/500th to 1/4000th second! (HSS is also available with the HVL-F43M, HVL-F32M, and the discontinued HVL-58AM and HVL-F36AM.) This is ideal when you want to use a very wide aperture for selective focus with a nearby subject with flash; HSS at a fast shutter speed such as 1/1000th second is one way to avoid overexposure. The MODE button on the back of the flash is used to choose either TTL or Manual flash exposure. You can then use the MENU button and plus/minus keys to activate HSS mode; HSS appears in the unit's data panel as confirmation of the mode.

Keep in mind that flash output is much lower in High-Speed Sync than in conventional flash photography. That's because less than the full duration of the flash is used to expose each portion of the image as it is exposed by the slit passing in front of the sensor. As a result, the effective flash (distance) range is much shorter.

In addition, HSS will not work when using multiple flash units or when the flash unit is set for left/right/up bounce flash or when the wide-angle diffuser is being used. (If you're pointing the flash downward, say, at a close-up subject, HSS can be used.)

HVL-F58AM Flash Unit

This now-discontinued, but readily available unit was the top-of-the-line Sony accessory flash line until replaced by the HVL-F60M. It has an ISO 100 guide number of 58/190 (meters/feet). Most of the features of the HVL-F60M are found in this unit, including zoom settings, diffuser, and pivoting system. It lacks the built-in LED lamp, however.

The HVL-F58AM too can function as a main flash, or be triggered wirelessly by another compatible flash unit. Like the F60M, you can control up to three groups of flashes in wireless mode, and specify the output levels for each group, giving you an easy way to control the lighting ratios of multiple flash units. It also features High-Speed Sync, and multiple flashes for those cool strobe effects.

HVL-F43M Flash Unit

This less pricey (\$400) electronic flash (shown in Figure 10.14) shares many of the advanced features of the HVL-F60M, but has a lower guide number of 43/138 (meters/feet). Features shared with the high-end unit include HSS, automatic white balance adjustment, and automatic zoom with the same coverage of focal lengths and the slide-out diffuser, as well as a built-in bounce card. I find its built-in video light particularly useful for impromptu movies, although it's unfortunate that it can't be used at the same time as Sony's slide-on microphone that also occupies the multi interface shoe.

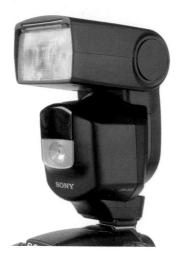

Figure 10.14
The Sony HVL-F43M is a more affordable external flash unit.

The Sony HVL-F32M.

Its quick-shift function allows you to direct the flash upward or to the side by rotating the head. This unit also can be used in wireless mode as a master/controller or remote/slave, and it also offers the quick-shift bounce feature. The HVL-F43M is a tad lighter (at 12 ounces) than its bigger sibling and runs on four AAs. This flash replaces the similar HVL-F43AM unit, which uses the older iISO hot shoe.

HVL-F36AM Flash Unit

Although discontinued, you can easily find this versatile flash available online or in used condition. It uses the old iISO hot shoe, so you'll need an adapter. The guide number for this lower-cost Sony flash unit is (surprise!) 36/118 (meters/feet). Although (relatively) compact at 9 ounces, you still get some big-flash features, such as wireless operation, auto zoom, and high-speed sync capabilities. Bounce flash flexibility is reduced a little, with no swiveling from side to side and only a vertical adjustment of up to 90 degrees.

HVL-F32M Flash Unit

The \$300 HVL-F32M is Sony's newest electronic flash unit. (See Figure 10.15.) It features a high-speed synchronization mode, wireless control, and automatic white balance compensation. In wireless mode, it can be used only on Channel 1 (as I'll describe shortly), but can function as both a master/controller and remote/slave. The flash is powered by a pair of AA batteries and it is resistant to both dust and moisture. Those who love to use bounce flash will like the built-in bounce sheet and retractable wide-angle panel that spreads the light to cover the equivalent of a 16mm lens.

HVL-F20M Flash Unit

The least-expensive Sony flash (see Figure 10.16) is the HVL-F20M (\$150), designed to appeal to the budget conscious, especially those who need just a bit of a boost for fill flash, or want a small unit (just 3.2 ounces) on their camera. It has a guide number of 20 at ISO 100, and features simplified operation. For example, there's a switch on the side of the unit providing Indoor and Outdoor settings (the Indoor setting tilts the flash upward to provide bounce light; with the outdoor setting, the flash fires directly at your subject). This flash can serve as a master/controller on the a68 to trigger off-camera flash units wirelessly, but cannot be used as a remote/slave flash. There are special modes for wide-angle shooting (use the built-in diffuser to spread the flash's coverage to that of a lens with a very wide field of view or choose the Tele position to narrow the flash coverage to that of a 50mm or longer lens for illuminating more distant subjects). While it's handy for fill flash, owners of an a68 camera will probably want a more powerful unit as their main electronic flash.

Figure 10.16 The HVL-F20M flash unit is compact and inexpensive.

BATTERY TIP

You may not use your flash very often, but when you do, you want it to operate properly. The problem with infrequent flash use is that conventional nickel-metal hydride batteries lose their charge over time, so if your flash unit is sitting in your bag for a long time between uses, you may not even be aware that your rechargeable batteries are pooped out. Non-rechargeable alkaline cells are not a solution: they generally provide less power for your flash, and replacing them can be costly. The Energizer Lithium Ultimate AA batteries last up to three times longer, but they sell for about \$10 for four.

I've had excellent luck with a kind of battery available from Panasonic (and, in some countries, from Fujitsu) called *eneloop* cells. They retain their charge for long periods of time—as much as 75 percent of a full charge over a three-year period (let's hope you don't go that long between uses of your flash). They're not much more expensive than ordinary rechargeables, and can be revitalized up to 1,500 times. They're available in capacities of 1500 mAh to 2700 mAh. I use the economical models with 1900 mAh capacity.

Wireless and Multiple Flash

Wireless, off-camera flash relies on the camera and flash units' ability to communicate with each other through a series of coded bursts of light. These include the pre-flash that fires before your actual exposure starts to "set up" the additional flash units, and tell them exactly how much light to emit to match what the through-the-lens metering system of the camera deems sufficient.

The a68's built-in flash can be used to transmit these codes to control compatible off-camera units as the flash "master," or you can use an add-on flash mounted on the camera as a master to control other flashes. That means, of course, that you must have at least one external flash to operate wirelessly. You'll generally use the a68's built-in flash as the Master, and a compatible unit (such as the F60M or F43M) as the slave that's triggered by the master flash. Just follow these steps:

- 1. **Set off-camera flash for slave mode.** You can activate slave mode on the external flash using the Mode button on the flash itself. (It's the left-most button on the back of the F43AM, for example; press until the WL indicator appears on the LCD.) You can also simply mount it on the a68, turn it on, and select Wireless from the Flash Mode entry in the Camera Settings 2 menu. Pressing the shutter release halfway transfers any settings you make on the camera to the attached flash.
- 2. **Remove flash from camera.** The large red LED on the front of the unit will flash. That signal is a dual indicator showing that the flash is charged and ready to fire, and that it is in slave mode and awaiting a signal from the Master flash.
- 3. Elevate the built-in flash. It can now be used as the Master to trigger one or more slave units.
- 4. **Test your connection.** Better safe than sorry. Press the a68's AEL button. The built-in flash will emit a low-intensity pulse, and any slave units will respond with bursts of their own about a half-second later.
- 5. **Take your photos.** Place your flash units. The slaves will fire if they are in direct line-of-sight of the Master flash, or detect its illumination as it bounces off reflectors, walls, or other surfaces. You can always test to see if all slaves are communicating as you change your lighting arrangements, using the AEL button.

That's easy enough, but if you want to get into more advanced lighting, you need to master the concepts. Individual compatible flash have their own specific controls, and discussing all the features of every Sony flash is beyond the scope of this book. But here are some of the key concepts to electronic flash and wireless flash that will get you started:

- Master flash. The *master* is the flash that commands each of the additional flashes when using wireless mode. It can be your a68's built-in flash, or another flash, such as the F60M or F43M mounted *on the camera*. (The Master flash must be attached to the camera.)
- Slave flashes. For wireless operation, you need at least one more flash unit in addition to the master.

- Channel controls. Sony's wireless flash system offers users the ability to determine on which of two possible channels the flash units can communicate, Channel 1 or Channel 2. Both the Master and all Slave units must be set to the same Channel. By default, Sony equipment is shipped set to Channel 1, but you might find yourself needing to change to Channel 2 should you be working in the same area as another Sony photographer, to avoid conflict.
- **Groups.** Sony's wireless flash system lets you designate multiple flash units in either of two separate groups, which Sony designates as RMT and RMT2, but which photographers have traditionally called Group 1 and Group 2. You can then have flash units in one group fire at a different output than flash units in another group. This lets you create different intensities between groups.
- Using flash ratios. You can control the intensity of multiple off-camera flash to adjust each unit's relative contribution to the image, for more dramatic portraits and other effects.

Channels

Channels are the discrete lines of communication used by the Master flash to communicate with each of the remote units. The pilots, ham radio operators, or scanner listeners among you can think of the channels as individual communications frequencies.

If you're working alone, you'll seldom have to fuss with channels. Just remember that all the flash units you'll be triggering must be using the same channel, exactly like a CB radio or walkie-talkie. (Google these terms if you're younger than 40.) If every flash isn't set for the same channel, they will be unable to "talk" to each other, good buddy. Consult your particular flash's manual to learn how to set the channel for your unit. On the F60M, Menu Tab 1's WL CH entry will let you select a channel; with the F43M, hold down the Fn button for more than three seconds and specify a channel with Custom Function 2.

The channel ability is most important when you're working around other photographers who are also using the Sony system. Each photographer sets his or her flash units to a different channel as to not accidentally trigger other users' strobes. (At big events with more than two photographers using Sony flash, you may need to negotiate.) Don't worry about Canon or Nikon photographers at the same event. Their wireless flash systems use different communication systems that won't interfere with yours.

It's always a good idea to double-check your flash units before you set them up to make sure they're all set to the same channel, and this should also be one of your first troubleshooting questions if a flash doesn't fire the first time you try to use it wirelessly.

Groups (RMT and RMT2)

Each flash unit can be assigned to one of two groups, labeled RMT and RMT2. Remember that all the external flashes you are using must be set to the *same* channel, but once they are active on the same channel, they can be divided into groups.

All the flashes in a particular group perform together as if they were one big flash, using the same output level and flash compensation values. That means you can control the relative intensity of flashes in each group, compared to the intensity of flashes assigned to a different group. A particular group needs at least one flash unit, but can have more.

For example, you could assign one (or more) flash to RMT, and use it as the main light in your setup. RMT2 could be used as the fill light, hair light, or background light. The power output of each group could be set individually, so your main light(s) in RMT might be two or three times as intense as the light(s) in RMT2. You don't *have* to use both groups, but it is an option.

But there's a lot more you can do if you've splurged and own two or more compatible external flash units (some photographers I know own five or six Sony flash units). Sony wireless photography lets you collect individual strobes into these *groups*, and control all the flash units within a given group together. You can operate as few as two strobes in two groups. You can also have them fire at equal output settings versus using them at different power ratios. Setting each group's strobes to different power ratios gives you more control over lighting for portraiture and other uses.

This is one of the more powerful options of the Sony wireless flash system. I prefer to keep my flash units set to different groups normally. I can always set the power ratio to 1:1 if I want to operate the flash units all at the same power. If I change my mind and need to make adjustments, I can just change the wireless flash controller and then manipulate the different groups' output as desired.

Radio Control

Just before this book went to press, Sony announced the introduction of a radio control flash system, using the Sony FA-WRC1M Wireless Radio Commander (\$348) and FA-WRR1 Wireless Radio Receiver (\$198). Initially, these were announced for use with Sony's full-frame a7 II mirrorless cameras, but I suspect they will eventually be compatible with A-mount cameras like the a68 and a77 II, since they share the same multi-interface shoe and other external connections with the E-mount models. A firmware upgrade may be required. To use the system, you must own one radio commander, *plus* one radio receiver for *each* remote flash you want to control wirelessly. Then add in the cost of the flash, making this radio control quite an expensive system. I'll have updates at www.sonyguides.com when I know more.

More Advanced Lighting Techniques

As you advance in your Sony a68 photography, you'll want to learn more sophisticated lighting techniques, using more than just straight-on flash, or using just a single flash unit. Entire books have been written on lighting techniques. (If you're *really* into complex lighting setups, you might want to check out my book, *David Busch's Quick Snap Guide to Lighting*.) I'm going to provide a quick introduction to some of the techniques you should be considering.

Diffusing and Softening the Light

Direct light can be harsh and glaring, especially if you're using the flash built into your camera, or an auxiliary flash mounted in the hot shoe and pointed directly at your subject. The first thing you should do is stop using direct light (unless you're looking for a stark, contrasty appearance as a creative effect). There are a number of simple things you can do with both continuous and flash illumination.

- **Try a soft box.** Inexpensive attachments like the one shown in Figure 10.17 can provide the equivalent of a miniature photo studio "soft box," although in a much smaller, more convenient size.
- Use window light. Light coming in a window can be soft and flattering, and a good choice for human subjects. Move your subject close enough to the window that its light provides the primary source of illumination. You might want to turn off other lights in the room, particularly to avoid mixing daylight and incandescent light (see Figure 10.18).
- **Use fill light.** Your a68's flash makes a perfect fill-in light for the shadows, brightening inky depths with a kicker of illumination.

Figure 10.17 Soft boxes use Velcro strips to attach to third-party flash units (like the one shown) or any Sony external flash.

- Bounce the light. All the Sony external flashes have a swivel that allows them to be pointed up at a ceiling for a bounce light effect. As I noted, two of them let you bounce the light off a wall. You'll want the ceiling or wall to be white or have a neutral gray color to avoid a color cast.
- Use reflectors. Another way to bounce the light is to use reflectors or umbrellas that you can position yourself to provide a greater degree of control over the quantity and direction of the bounced light. Good reflectors can be pieces of foamboard, Mylar, or a reflective disk held in place by a clamp and stand. Although some expensive umbrellas and reflectors are available, spending a lot isn't necessary. A simple piece of white foamboard does the job beautifully. Umbrellas have the advantage of being compact and foldable, while providing a soft, even kind of light. They're relatively cheap, too, with a good 40-inch umbrella available for as little as \$20.

Figure 10.18
Window light
makes the perfect
diffuse illumination
for informal
soft-focus portraits
like this one.

Using Multiple Light Sources

Once you gain control over the qualities and effects you get with a single light source, you'll want to graduate to using multiple light sources. Using several lights allows you to shape and mold the illumination of your subjects to provide a variety of effects, from backlighting to side lighting to more formal portrait lighting. You can start simply with several incandescent light sources, bounced off umbrellas or reflectors that you construct. Or you can use more flexible multiple electronic flash setups.

Effective lighting is the one element that differentiates great photography from candid or snapshot shooting. Lighting can make a mundane subject look a little more glamorous; it can make subjects appear to be soft when you want a soft look, or bright and sparkly when you want a vivid look, or strong and dramatic if that's what you desire. As you might guess, having control over your lighting means that you probably can't use the lights that are already in the room. You'll need separate, discrete lighting fixtures that can be moved, aimed, brightened, and dimmed on command.

Selecting your lighting gear will depend on the type of photography you do, and the budget you have to support it. It's entirely possible for a beginning a68 photographer to create a basic, inexpensive lighting system capable of delivering high-quality results for a few hundred dollars, just as you can spend megabucks (\$1,000 and up) for a sophisticated lighting system.

Basic Flash Setups

If you want to use multiple electronic flash units, the Sony flash units in wireless mode will serve admirably. The two higher-end models can be used with Sony's wireless feature, which allows you to set up to three separate groups of flash units (several flashes can be included in each group) and trigger them using a master flash and the camera. Just set up one master unit and arrange the compatible slave units around your subject. You can set the relative power of each unit separately, thereby controlling how much of the scene's illumination comes from the main flash, and how much from the auxiliary flash units, which can be used as fill flash, background lights, or, if you're careful, to illuminate the hair of portrait subjects.

Studio Flash

If you're serious about using multiple flash units, a studio flash setup might be more practical. The a68 has no built-in PC/X flash connection port, but adapters to provide one are readily available. Such adapters can accept a cable from non-dedicated studio flash units. It can also operate wireless units like the Pocket Wizard and RadioPopper transmitters using the accessory shoe.

The traditional studio flash is a multi-part unit, consisting of a flash head that mounts on your light stand, and is tethered to an AC (or sometimes battery) power supply. A single power supply can feed two or more flash heads at a time, with separate control over the output of each head.

When they are operating off AC power, studio flash don't have to be frugal with the juice, and are often powerful enough to illuminate very large subjects or to supply lots and lots of light to smaller subjects. The output of such units is measured in watt seconds (ws), so you could purchase a 200ws, 400ws, or 800ws unit, and a power pack to match.

Their advantages include greater power output, much faster recycling, built-in modeling lamps, multiple power levels, and ruggedness that can stand up to transport, because many photographers pack up these kits and tote them around as location lighting rigs. Studio lighting kits can range in price from a few hundred dollars for a set of lights, stands, and reflectors, to thousands for a highend lighting system complete with all the necessary accessories.

A more practical choice these days are *monolights* (see Figure 10.19), which are "all-in-one" studio lights that sell for about \$200 to \$400. They have the flash tube, modeling light, and power supply built into a single unit that can be mounted on a light stand. Monolights are available in AC-only and battery-pack versions, although an external battery eliminates some of the advantages of having a flash with everything in one unit. They are very portable, because all you need is a case for the monolight itself, plus the stands and other accessories you want to carry along. Because these units are so popular with photographers who are not full-time professionals, the lower-cost monolights are often designed more for lighter duty than professional studio flash. That doesn't mean they aren't rugged; you'll just need to handle them with a little more care, and, perhaps, not expect them to be used eight hours a day for weeks on end. In most other respects, however, monolights are the equal of traditional studio flash units in terms of fast recycling, built-in modeling lamps, adjustable power, and so forth.

Figure 10.19
All-in-one "monolights" contain flash, power supply, and a modeling light in one compact package (umbrella not

included).

Other Lighting Accessories

Once you start working with light, you'll find there are plenty of useful accessories that can help you. Here are some of the most popular that you might want to consider.

Soft Boxes

Soft boxes are large square or rectangular devices that may resemble a square umbrella with a front cover, and produce a similar lighting effect. They can extend from a few feet square to massive boxes that stand five or six feet tall—virtually a wall of light. With a flash unit or two inside a soft box, you have a very large, semi-directional light source that's very diffuse and very flattering for portraiture and other people photography.

Soft boxes are also handy for photographing shiny objects. They not only provide a soft light, but if the box itself happens to reflect in the subject (say you're photographing a chromium toaster), the box will provide an interesting highlight that's indistinct and not distracting.

You can buy soft boxes or make your own. Some lengths of friction-fit plastic pipe and a lot of muslin cut and sewed just so may be all that you need.

Light Stands

Both electronic flash and incandescent lamps can benefit from light stands. These are lightweight, tripod-like devices (but without a swiveling or tilting head) that can be set on the floor, tabletops, or other elevated surfaces and positioned as needed. Light stands should be strong enough to support an external lighting unit, up to and including a relatively heavy flash with soft box or umbrella reflectors. You want the supports to be capable of raising the lights high enough to be effective. Look for light stands capable of extending six to seven feet high. The nine-foot units usually have larger, steadier bases, and extend high enough that you can use them as background supports. You'll be using these stands for a lifetime, so invest in good ones.

Backgrounds

Backgrounds can be backdrops of cloth, sheets of muslin you've painted yourself using a sponge dipped in paint, rolls of seamless paper, or any other suitable surface your mind can dream up. Backgrounds provide a complementary and non-distracting area behind subjects (especially portraits) and can be lit separately to provide contrast and separation that outlines the subject, or which helps set a mood.

I like to use plain-colored backgrounds for portraits, and white seamless backgrounds for product photography. You can usually construct supports for these yourself from cheap materials and tape them up on the wall behind your subject, or mount them on a pole stretched between a pair of light stands.

Snoots and Barn Doors

These fit over the flash unit and direct the light at your subject. Snoots are excellent for converting a flash unit into a hair light, while barn doors give you enough control over the illumination by opening and closing their flaps that you can use another flash as a background light, with the capability of feathering the light exactly where you want it. Barn doors are shown in Figure 10.20.

Figure 10.20
Barn doors allow
you to modulate the
light from a flash or
lamp, and they are
especially useful for
hair lights and background lights.

Index

AF Track Sensitivity options, 74–75

	AF w/Shutter options, 119
A (Aperture Priority) mode, 13, 16, 171–172	AF-A (Automatic AF) mode, 18, 222
accessory shoe, 47	AF-C (Continuous AF) mode, 18, 221, 235
AC-PW 10AM adapter, 30	AF-MF (Autofocus/Manual focus) switch,
action, stopping, 241–242, 328–330	28–29, 50
Adams, Ansel, 325	AF-S (Single-shot AF) mode, 18, 235
ADI (Advanced Distance Integration)	A-mount lenses, 293
flash, 344	aperture
lenses, 289	display all information, 40
Adobe RGB vs. sRGB, 95	in exposure triangle, 157
AE Lock, 40, 44, 119–120	indicator, 42, 44
AF (autofocus) modes. See autofocus	locking in, 172
AF Area Auto Clear options, 112	Aperture Priority mode
AF area modes	for flash, 68
Center, 225, 227	for video, 272
choosing, 223	APO lenses, 289
Expand Flexible Spot, 228	Area Setting options, 149
Flexible Spot, 226	aspect ratios
Wide, 224–225	3:2 and 16:9, 12
Zone, 225	display all information, 40
AF Area Points options, 112–113	LCD display for Viewfinder mode, 42
AF Drive Speed (Stills) options, 73–74	setting for recording video, 271
AF Focus area, display all information, 40	stills options, 56–57
AF Illuminator (Stills) options, 73	Audio Recording options, 96–97
AF Micro Adjustment options, 125	audio settings, using with movies, 269–270
AF Range Control Assist options, 110–111	Audio Signals options, 142
AF Track Duration (Movies) setting, 270	audio tips, 285–286
	audio 1108, 200-200

A

Auto HDR, 184–185
Auto Level Display options, 105
Auto Mode options, 13–14, 92
Auto Object Framing (Stills) options, 91–92
auto racing, focus guidelines for, 235
Auto Review options, 105
Auto Slow Shutter (Movies) options, 96, 269
Autoexposure lock/Zoom Out/Slow Sync
button, 33

autofocus, 18. *See also* Focus modes; manual focus

area to focus on, 222–223 Automatic AF, 222 Center Lock-On AF, 229–230 circles of confusion, 217–218 components, 218–220 Continuous AF, 221 contrast detection, 215–217 Eye AF, 116–117, 231

Face Detection, 229–230

function of, 210–211

information display, 43 Lock-On AF, 228

phase detection, 212-215

sensors, 211

Single-shot AF, 221

summary, 234-236

system location, 211

using with video, 271

autofocus drive screw, 26-27

Autofocus/Manual (AF-MF) focus switch, 28–29, 50

Automatic AF (AF-A) mode, 18, 222 Autumn Leaves style, 207, 260 AVCHD (Advanced Video Coding High Definition), 264–265, 267

AWB (Auto White Balance) setting, 255. See also WB (white balance) B

backgrounds, using for lighting, 359 backlighting, 155 barn doors and snoots, using for lighting, 360

basketball, focus guidelines for, 235 battery

compartment door, 49

for external electronic flash, 351 battery charger BC-VM10A, 4-6

battery charger BC-VM10A, 4battery pack NP-FM500H

in box, 3–4 charging, 5–6 features of, 5

battery status

display all information, 40 information display, 43 LCD display for Viewfinder mode, 42

birds in flight, focus guidelines for, 235

blur, introducing, 173, 248

bokeh and telephotos, 313-314

bottom of camera, 49

bouncing light, 355

Bracket Order options, 124

bracketing, 180-181, 185-188

brightness levels, number of, 190. See also highlight levels; histograms

brightness settings

for monitor, 140–141 for viewfinder, 142

built-in flash, 20-21, 325-326, 341-344. See also flash

bulb exposures, 246 B/W style, 207, 260

Red Eye Reduction, 70–71

Smile/Face Detect., 90-91
Soft Skin Effect (Stills), 91
SteadyShot, 93-94
White Balance, 78–80
Wind Noise Reduction, 98
Zoom, 83–86
Center AF area mode, 225, 227
Center button, 33
Center focus point, 19
Center Lock-On AF, 89–90, 229–230
Center metering, 17, 162–163, 168–169
CFLs (compact fluorescent lamps), 333
channels, using with Master flashes, 353
charging batteries, 5-6. See also battery
chromatic aberration
compensation, 126
reduction, 289
circles of confusion, 217-218
Cleaning Mode options, 145
Clear stylc, 207, 260
close-ups, taking in video, 282–283
CMOS imagers, 204
color balance, adjusting for finder, 142
Color Space (Stills) options, 94-96. See also
Partial Color effect; Peaking Color
and Level options
color temperature
and continuous lighting, 331-332
explained, 253
setting white balance by, 257
composition, considering for video,
280–283
concerts, focus guidelines for, 235
Continuous Advance Priority AE, 16, 200
Continuous AF (AF-C) mode, 18, 221, 235
Continuous Bracket Drive mode, 67

continuous lighting, 331–334. See also lighting and color temperature, 331–332

vs. electronic flash, 325–331

Continuous Priority Auto exposure, 13 continuous shooting, 67, 122, 250–252 contrast

changing, 193 detection, 215–217 viewing in histogram, 191–192

control dial, 9

control wheel, 9, 33. See also front control dial

Control wheel/Center button, 33–34 Creative Styles

display all information, 40 information display, 44 LCD display for Viewfinder mode, 42 options, 81 setting for video, 271 using, 205–207, 258–260

CRI (color rendering index), 334 crop factor, 288–289 cross-type focus points, improvement of, 214

curtains on focal plane shutter, 335–336 Custom 1/Zoom In button, 32–33 Custom Key Settings options, 129–132

Custom Settings menu

AEL w/Shutter, 119–120 AF Area Auto Clear, 112 AF Area Points, 112–113 AF Micro Adjustment, 125

AF Range Control Assist, 110-111

AF w/Shutter, 119

Auto Level Display, 105

Auto Review, 105

Bracket Order, 124

Custom Key Settings, 129-132 Dial/Wheel Ev Comp, 132–133 Dial/Wheel Lock, 133 Dial/Wheel Setup, 132 DISP button, 105-106 e-Front Curtain Shutter, 121-122 Exp. Comp. Set, 123 Exposure Settings Guide, 108 Eye-Start AF, 116-117 Face Registration, 124–125 FINDER/MONITOR, 117 Flexible Spot Points, 114 Focus Magnifier Time, 104 Function Menu Set, 127–129 Grid Line, 104 Lens Compensation, 125–127 Live View Display, 108-109 MOVIE Button, 133 Peaking Color, 107 Peaking Level, 106–107 Priority Setup, 118–119 Release w/o Lens, 118 SteadyShot w/Shutter, 120-121 Superior Auto, 122–123 Wide AF Area Display, 114

D

Zebra, 102-104

Zoom Setting, 114-116

D/ADL lenses, 289
darkness, showing, 248, 250
database file full error, 40. See also image
database
Date/Time Setup options, 148–149
daylight, 332
Daylight Savings Time, 9
DC power terminal, 30
Deep style, 207, 260

degrees Kelvin, 331	E
Delete options, 134–135, 144	ED lenses, 290
deleting, images, 22	e-Front Curtain Shutter options, 121–122,
Demo Mode options, 145–146	336
depth-of-field	electrical contacts, 26, 50
increasing, 217	electronic flash. See also flash
preview button, 28	avoiding sync speed problems, 337–339
and video, 276	vs. continuous lighting, 325–331
of wide-angle lenses, 306	curtains, 335
Dial/Wheel options, 132–133	determining exposure, 341
diffusing light, 355-356	focal plane shutter, 335
digital noise, dealing with, 203-207. See	freezing action, 329–330
also NR (noise reduction)	function of, 335–337
diopter correction, adjusting, 7, 31-32	ghost images, 339–340
DISP button	HS (high-speed) sync, 339
explained, 33–34	slow sync, 340–341
options, 105–106	E-mount lenses, 292
pressing, 23	Enlarge Image options, 137–138
using to review images, 38	equivalent exposure, 161
display all information, 39-40	establishing shot, taking in video, 281
Display Media Information options, 153	EVF (electronic viewfinder), 36–45
display panel, 47–48	Exp. Comp. Set options, 123
Display Rotation options, 136	Expand Flexible Spot AF area mode, 228
display screens, LCD vs. EVF, 36-37	Expanded Flexible Spot focus point, 19
Distance scale/Depth-of-field scale, 50	exposure. See also M (manual) exposure
D-Range Optimizer	bracketing, 180–181
display all information, 40	button, 46–47
information display, 43	calculation of, 162–165, 326, 328
Drive button, 47	determining for electronic flash, 341
Drive mode	-
button, 48	and light, 159–161
display all information, 40	locking, 33
information display, 43	setting for movies, 268–269
LCD display for Viewfinder mode, 42	triangle, 156–157
options, 66–67	variations, 158
DRO (dynamic range optimization), 42, 67,	exposure compensation. See also flash
80, 182–183	exposure compensation information display, 40, 44
DT (Digital Technology) lenses, 289,	LCD display for Viewfinder mode, 42
295–296	
	options, 75

exposure differential, determining, 187
exposure evaluation. See histograms
Exposure modes

A (Aperture Priority), 171–172 choosing, 165 display all information, 40 information display, 43 LCD display for Viewfinder mode, 42 M (Manual) exposure, 176–179 P (Program auto), 174

exposure scale, LCD display for Viewfinder mode, 42

Exposure Settings Guide options, 108 Exposure Step options, 76 exposure value, 44, 174–175 exposures, ultra-fast, 240–244 exposures remaining

S (Shutter Priority), 173–174

information display, 43 LCD display for Viewfinder mode, 42

extension tubes, 315–316 external electronic flash

battery tip, 351 cable connections, 346 GN (Guide Numbers), 345 high-speed sync, 349 hot shoes, 346 HVL units, 347–351 using, 344–345

external meters, calibrating, 165 external microphone, attaching for video, 272 eye sensor, 31–32

eyepiece cup, in box, 3
Eye-Start AF options, 116–117, 231. See also
autofocus

F

face detection

display all information, 40 information display, 44 LCD display for Viewfinder mode, 42 On and Off settings, 90–91, 230–2301

Face Registration options, 124–125 File Format (Movies) options, 65 File Number options, 150 files, transferring to computers, 11. See also

images; photographs fill light, using, 355 Fill-flash mode, setting, 342

filter thread, 50

Finder Color Temperature options, 142 FINDER/MONITOR

button, 36 options, 47, 117

fireworks, shooting, 248-249

flash. See built-in flash; electronic flash; pop-up flash; wireless flash

button, 28–29 master and slave, 352 setups, 357 studio setup, 357–358

flash charge progress, display all information, 40

Flash Compensation options, 40, 69 Flash Control options, 69, 344

flash exposure compensation, 44, 343. See also exposure compensation

Flash modes

display all information, 40 information display, 43 LCD display for Viewfinder mode, 42 options, 68 setting, 342

flash units, 347–351	focus ring, 49-50
Flash/Accessory shoe, 47	focus stacking, 236-238
flat lighting, using for video, 284–285	focusing
Flexible Spot	on area of frame, 220
AF area mode, 226	beginning and stopping, 218-219
focus point, 19	folders, creating and naming, 150-152
options, 114	For Viewfinder display, 9-10, 107
fluorescent light, 333	Format options, 149-150
Fn (Function)/Image Rotation button,	formatting memory cards, 11-12
33–34	front control dial, 27-28. See also control
focal plane shutter, 335	wheel
focus	front-curtain sync, 335-336
display all information, 40	f/stops and shutter speeds, 160
evaluating, 320–322	Function button/Image rotation button, 33
fine-tuning for lenses, 317–322	Function Menu Set options, 127-129
getting into, 210–211	
guidelines, 235–236	0
test chart, 320-322	G
focus area	G lenses, 292
LCD display for Viewfinder mode, 42	ghost images, 339-340
options, 71–72	global shutter, 266
Focus Magnifier options, 86-87, 104,	GN (Guide Numbers), 345
232–233	graphic display, 39, 107
Focus modes. See also autofocus	gray cards, 162, 164
accessing, 220	grayscale images, 190
Automatic AF, 222	Grid Line options, 41, 104
choosing, 17–18	groups, using with wireless flashes, 354
Continuous AF, 221	
display all information, 40	ш
LCD display for Viewfinder mode, 42	Н
options, 71	H (high-speed sync) mode, setting for flash
Single-shot AF, 221	342
starting and stopping, 220-221	Halsman, Philippe, 241
focus peaking, 40, 42, 107-108, 233-234	hand grip, 27–28
focus points	Hand-held Twilight mode, 15, 200–201
cross-type, 214–215	HDMI (High-Definition Multimedia
number of, 210–211	Interface)
selecting, 18–19	options, 146–147
-	terminal, 30

184–188	database, recovering, 152. See also
HDR Painting effect, 83, 262	Image Extraction option, 123
Help Guide, 14	Image Index options, 135
High Contrast Monochrome effect, 83, 262	image parameters, setting, 253-256
High ISO Noise Reduction, 203-205. See	image quality
also ISO	display all information, 40
highlight levels, getting warning about,	information display, 43
102-104. See also histograms	LCD display for Viewfinder mode, 42
histograms, 38-45, 107. See also brightness	image resolution
levels; live histogram	display all information, 40
getting information from, 190–192	LCD display for Viewfinder mode, 42
lines on horizontal axis, 194	Image Size (Stills) options, 55
primary channels, 195–197	Image size/Aspect ratio
shape of, 195	information display, 43
tonal range, 189–190	LCD display for Viewfinder mode, 42
using, 192–198	images. See also files; photographs
viewing contrast in, 191–192	deleting, 22
hot shoes, 344, 346	enlarging, 137-138
HS (high-speed) sync, setting, 339, 349	playing back, 22
HVL-F20M flash unit, 351	previous and next, 22
HVL-F32M flash unit, 350	processing, 258–260
HVL-F36AM flash unit, 350	protecting, 138–139
HVL-F43M flash unit, 349–350	remaining, 40
HVL-F58AM flash unit, 349	reviewing, 22-23, 38-45, 105
HVL-F60M flash unit, 347–348	rotating, 22–23, 136
	scrolling within, 22–23
	incandescent/tungsten light, 333
	index screen, viewing, 135
icons	information, displaying, 22, 39-41, 43-44
on menus, 54	instruction manual, 4
on mode dial, 13	Intelligent Auto mode, 68, 198-199
IF (internal focus) lenses, 290	interlacing and progressive scan, 266-267
illumination. See also light	internal flash, 29. See also flash
evenness of, 328	IRE (Institute of Radio Engineers) values,
for video, 283	103–104, 269
Illustration effect, 83, 262	

LED bulbs, 333

lens bayonet, 50

using reflectors for, 355

for video, 283-285

lithium-ion battery pack. See battery pack	memory cards
NP-FM500H	access lamp, 33, 36
live histogram, 42, 197. See also histograms	choosing for video, 272
Live View	display all information, 40
display options, 108–109	door, 27–28
LCD preview, 37	formatting, 11–12
locking exposure, 33	information display, 43
Lock-on AF, 19, 228	inserting, 8
Long Exposure. NR/High ISO NR (Stills)	LCD display for Viewfinder mode, 42
options, 87–89	for movies, 273
long exposures	re-formatting, 149–150
noise, 204–205	for shooting movies, 263
taking, 245–246	transferring images from, 23
working with, 247–250	Memory options, 98–99
low-cut filter feature, using for video, 286	Memory Recall registers, 12-13, 16, 40, 200
	Memory Stick PRO Duo cards, using, 8
NA.	MENU button, 31–32
M	menus
M (Manual) exposure, 13, 16, 176–179. See	anatomy of, 52-53
also exposure	grayed-out areas of, 53
Mac, transferring images to, 24	icons, 54
macro	Merge to HDR and bracketing, 185–188
focusing, 315-316	Metering mode
lenses, 290	choosing, 17, 165, 167–170
mode, 15, 199	display all information, 40
manual for camera, 4	information display, 44
Manual Exposure flash mode, 68	LCD display for Viewfinder mode, 42
manual focus. See also autofocus	options, 78
in contrast detection, 216	setting for video, 271
focus peaking, 233-234	methods versus modes, 165
focus stacking, 236–238	MF (Manual focus) mode, 18
setting for video, 272	Micro-B USB cable, in box, 4. See also USB
using, 232	(Universal Serial Bus)
Master flash, 352–353	microphones
media information, displaying, 153	terminal for, 30–31
medium shot, taking in video, 281	using, 47
,,	mid-tones, metering, 164–165
	mid-tones, metering, 104-107

Miniature effect, 83, 262

Minolta	Movie recording button, pressing, 272
lenses, 293	movie resolution
and Sony hot shoe, 344	display all information, 40
mirror, translucent, 26	information display, 43
mirror lenses, 290–291	LCD display for Viewfinder mode, 42
mirror lift tab, 26–27	movies. See also video
mode dial	audio settings, 269–270
automatic modes, 13	Auto Slow Shutter, 269
features, 46-47	displaying media information for, 153
Guide, 13, 144, 171	exposure settings, 268–269
icons and labels on, 13	information display, 273
locating, 12	interlacing and progressive scan, 266-267
lock release, 13	SDXC cards, 273
manual mode, 13	MP4 file format, using with movies, 265
semi-automatic mode, 13	Multi metering, 17, 168
specialized modes, 13	Multi/Micro USB terminal, 30
modeling light, 334	
modes versus methods, 165	N.
Monitor Brightness options, 140–141	N
monochrome	neck strap, 4, 28–29
display panel, 47–48	Neutral style, 207, 260
effects, 83	neutral-density filters, using, 248
monolights, using, 358	New Folder options, 151
mounting lenses, 6–7	Night Portrait mode, 15, 200
Movie button, 32–33, 133	Night Scene
movie making	mode, 15, 200
directional controls, 22	style, 207, 260
overview, 21	No Card warning, displaying, 8
steps during, 273–274	No Display info, 41
Movie mode	NP-FM500H battery pack. See battery pack
AF Track Duration, 270	NP-FM500H
AF Track Sensitivity, 75	NR (noise reduction), 77, 87-89. See also
Auto Slow Shutter, 96	digital noise; Wind Noise Reduction
choosing, 267–268	options
File Format, 65, 264	NTSC video format, 267
MP4 file format, 265	number of shots remaining, 12
Record Setting, 66	
record setting, 264–265	
SteadyShot, 94, 271	

using, 13, 16, 93, 200

0 object framing, display all information, 40 ON/OFF button, 9, 47 optical viewfinders, 36. See also viewfinder OSS (Optical SteadyShot) lenses, 290 outdoor lighting, using for video, 284 overexposure, 163, 194 overheating warning, display all information, 40 P P (Program auto) mode, 13, 16, 174 "Painter of Light," 323 PAL video format, 268 Panorama options, 60-65 Partial Color effect, 83, 262. See also Color Space PC computer, transferring images to, 24 Peaking Color and Level options, 106-107. See also Color Space performances, focus guidelines for, 235 pets, focus guidelines for, 235 phase detection, 212-215 photographs. See also files; images; pictures making vs. taking pictures, 324 transferring to computers, 23-24 Picture Effects, 40, 42, 44, 81-83, 261 pictures, taking, 324. See also photographs Playback button, 33, 36 histograms, 197-198 Playback menu 4K Still Image Playback, 138 Delete, 134-135 Display Rotation, 136

Enlarge Image, 137–138

Image Index, 135

mode, 33-34 Protect, 138-139 Rotate, 137 Slide Show, 137 Specify Printing, 139 View Mode, 135 Pop Color effect, 82, 261 pop-up flash, 29. See also flash port covers, 28-29 Portrait mode, 15, 199 focus guidelines, 235 style, 207, 260 Posterization effect, 82, 261 power, turning on, 9-11, 27-28, 48 Power Ratio options, 70 Power Save Start Time options, 144-145 Pre-Flash TTL, 344 preview button, 27-28 prime vs. zoom lenses, 304-305 printing, specifying, 139 Priority Setup options, 118-119 Program Auto flash mode, 68 progressive scan and interlacing, 266-267 Protect options, 138-139

Q

Quality (Stills) options, 57–60 Quick Navi screen, switching to, 9–10

R

radio wireless flash, 343, 354
RAW, shooting, 205. See also JPEG vs.
RAW options
Rear Sync mode, setting, 342
rear-curtain sync, 335–336
rechargeable batteries. See battery charger
BC-VM10A

Record Setting (Movies) options, 66	sequential scanning, 266
recording video, 271–272	Setting effect off, display all information,
Recover Image Database options, 152	40
Red Eye Reduction, 70–71, 341, 344	Setting Reset options, 153
reflectors, using for lighting, 355	Setup menu
Reflex lenses, 290	Area Setting, 149
Release w/o Lens options, 118	Audio Signals, 142
resetting settings, 153	Cleaning Mode, 145
resolution. See image resolution; movie	Date/Time Setup, 148-149
resolution	Delete Confirm, 144
Retro Photo effect, 82, 262	Demo Mode, 145-146
reviewing images, 22–23, 38–45, 105	Display Media Information, 153
RGB (red, green, blue)	File Number, 150
color space, 95	Finder Color Temperature, 142
histogram, 196	Folder Name, 151-152
Rich-tone Monochrome effect, 83, 262	Format, 149–150
rolling shutter, 266	HDMI Settings, 146–147
rotating images, 22–23, 136–137	Language, 148
	Mode Dial Guide, 144
	Monitor Brightness, 140-141
S	New Folder, 151
S (Shutter Priority) mode, 13, 16, 173–174	Power Save Start Time, 144-145
SAL (Sony Alpha Lens), 3, 292, 295-301	Recover Image Database, 152
SAM/SAM II (Smooth Autofocus Motor)	Select REC Folder, 150
lenses, 292, 294	Setting Reset, 153
SCN (Scene Selection), 13-15, 40, 93, 199	Tile Menu, 143
screen, tilting, 46	Upload Settings, 143
scrolling within images, 22-23	USB Connection, 147
SD (Secure Digital) cards, using, 8	USB LUN Setting, 148
SDXC (extended capacity) cards, using, 8,	Version, 153
273	Viewfinder Brightness, 142
Select REC Folder options, 150	Volume Settings, 142
self-timer	sharpness, achieving, 212
drive modes, 67	Shooting modes
lamp, 27–28	Auto and Scene, 198–201
using, 19–20	with flash, 34
sensor plane, 47-48	selecting, 12–16
Sepia style, 207, 260	Sweep Panorama mode, 202
	without flash, 33

shooting script, using for video, 278	Samu Manager Sci. J. DDO D
shots remaining, number of, 12	Sony Memory Stick PRO Duo cards, using, 8 speaker, 28–29
shoulder strap, in box, 4	Specify Printing options, 139
shutter, closed vs. open, 337	Sports Action mode, 15, 199, 235
Shutter Priority flash mode, 68	Spot metering, 17, 169–170
shutter release, 27, 47	sRGB color space, 95
shutter speed	SSM/SSM II lenses, 292, 294
button, 48	Standard style, 207, 260
choosing, 240	SteadyShot
display all information, 40	information display, 44
in exposure triangle, 157	LCD display for Viewfinder mode, 42
and f/stops, 160	and lenses, 317
indicator, 44	Movies options, 94, 271
information display, 44	Shutter options, 120–121
LCD display for Viewfinder mode, 42	Stills options, 93
M (Manual) mode, 16	warning, 40
Single Bracket Drive mode, 67	still images, displaying media information
Single Shooting Drive mode, 67	for, 153
Single-shot AF (AF-S), 221, 235	Stills options
Slave flashes, 352	and 4K Still Image Playback, 138
Slide Show options, 137	AF Drive Speed, 73–74
slow sync, 340-342	AF Illuminator, 73
smile shutter, information display, 44	AF Track Sensitivity, 74-75
Smile/Face Detect. options, 90-91	Aspect Ratio, 56–57
snoots and barn doors, using for lighting,	Auto Object Framing, 91–92
360	Color Space, 94–96
soccer, focus guidelines for, 235	Image Size, 55
soft boxes, using, 355, 359	Long Exposure. NR/High ISO NR, 87–89
Soft Focus effect, 83, 262	Quality, 57–60
Soft High-key effect, 83, 262	Soft Skin Effect, 91
Soft Skin Effect (Stills) options, 91	SteadyShot, 93
softening light, 355-356	storage folder, creating, 149–150
Sony lenses. See also lenses	storyboards, using for video, 278-279
expanding collection of, 295–298	storytelling in video, 279–280
in-lens autofocus motors, 294	streaks, creating, 247
longer lenses, 299–301	street photography, focus guidelines for,
nomenclature, 289–292	235
wide angle/normal options, 298–299	studio flash, using, 357–358

U Sunset mode, 15, 199 UHD (Ultra High Definition) format, 264 style, 207, 260 ultra-wide-angle lenses, 306 Superior Auto options, 68, 122-123, 199 underexposure, 163, 194 super-telephoto lenses, 306 Upload Settings options, 143 Sweep Panorama mode, 13, 16, 63, 200, 202 UPstrap neck strap, 4 sync speed problems, avoiding, 337-339 USB (Universal Serial Bus). See also Micro-B USB cable connection options, 147 T LUN Setting options, 148 T* lenses, 292 port, 24 telephoto extenders, 315-316 terminal, 30 telephoto lenses, 290-291, 306 avoiding problems, 312-313 and bokeh, 313-314 and tele-zoom lenses, 310-314 Version options, 153 Tele-Zoom Continuous AE, 252-253 VGA option, 267 three-point lighting, using for video, video. See also movies 284-285 lighting for, 283-285 thumbnails, displaying, 22 recording, 271–272 Tile menu options, 52, 143 video tips tilting screen, 46 audio, 285-286 time camera shake, 278 setting, 148-149 composition, 280-283 and timed exposures, 246 creative lighting, 284 timer. See self-timer depth-of-field, 276 tonal range, 189-190 lighting styles, 284–285 top of camera, 46-48 low-cut filter feature, 286 Toy Camera effect, 82, 261 sensor sizes, 276 transferring shooting script, 278 files to computers, 11 shutter speeds, 275 photos to computers, 11 storyboards, 278-279 Trash/Custom 2 button, 33, 35 storytelling, 279 tripod socket, 49 wind noise reduction, 286 tungsten light, 333 zooming, 277 two-shot, taking in video, 283 View Mode options, 135

viewfinder. See also optical viewfinders brightness options, 142 diopter correction, 7 eyepiece, 31-32 versus LCD monitor, 11 mode, 41-42 For Viewfinder display, 9-10, 107 views choosing, 38-45 cycling among, 23 Vivid style, 207, 260 Volume Settings options, 142 W Watercolor effect, 83, 262 waterfalls, blurring, 248-249 WB (white balance). See also AWB (Auto White Balance) setting adjusting, 19, 334 Bracket Drive mode, 67 button, 47-48 customizing, 257 display all information, 40 information display, 43 LCD display for Viewfinder mode, 42 options, 78-80 setting by color temperature, 257 setting for video, 271

Wide AF area mode, 114, 224–225

avoiding problems, 307-310

Wide focus point, 18 wide-angle lenses

depth-of-field, 306 using, 306–307

wide-zoom lenses, using, 306–310 Wind Noise Reduction options, 98, 270, 286. See also NR (noise reduction) window light, using, 355–356 wireless flash, using, 342–343, 352–354. See also flash

X

XAVC S video format, 264-265, 267

Z

ZA (Zeiss) lenses, 292, 297, 299–300 Zebra mode

vs. histograms, 197–198 LCD display for Viewfinder mode, 42 options, 102–104 using with movies, 269

Zone AF area mode, 225 Zone focus point, 19 zoom

buttons, 22–23 options, 83–86, 114–116 vs. prime lenses, 304–305 ring, 49–50 scale, 49–50 and video, 277

rockynool

Don't close the book on us yet!

Interested in learning more on the art and craft of photography? Looking for tips and tricks to share with friends? For updates on new titles, access to free downloads, blog posts, our eBook store, and so much more visit rockynook.com/information/newsletter